NEW DIRECTIONS
IN AMERICAN ART

Rethinking Regionalism

John Steuart Curry and the Kansas Mural Controversy

M. SUE KENDALL

Published by the Smithsonian Institution Press

Washington, D.C. London

11370616

The paper in this book meets the guidelines for
permanence and durability of the Committee on
Production Guidelines for Book Longevity of the
Council on Library Resources.

Cover:
John Steuart Curry, *The Tragic Prelude,*
1937–42, oil and tempera on canvas,
north wall of the East Corridor,
Kansas Statehouse murals. Photo
courtesy Jack H. Brier, Kansas Secretary of State

Library of Congress Cataloging in
Publication Data

Kendall, M. Sue.
Rethinking regionalism.

(New directions in American art; v. 2)
Bibliography: p. 157
Includes index.
1. Curry, John Steuart, 1897–1946.
2. United States in art.
I. Title. II. Series
ND237.C88K4 1986 759.13
84-40612
ISBN 0-87474-568-3 (alk. paper)
ISBN 0-87474-567-5 (pbk.: alk. paper)

Contents

To Phil

List of Illustrations

Titles are of works by John Steuart Curry unless otherwise noted.

2
Photograph of John Steuart Curry sketching Grant Wood
Photo courtesy John W. Barry, Cedar Rapids, Iowa

3
John Steuart Curry and Mattie Farnham in Arabian costume
Courtesy John Steuart Curry Papers, Archives of American Art, Smithsonian Institution, Washington, D.C.

4
Self Portrait with Mirror 1925–29
oil on canvas
Courtesy Peter A. Juley and Son Collection, National Museum of American Art, Smithsonian Institution, Washington, D.C.

5
Head of Negro 1927
pastel on paper 20¾ × 15¾ in.
Courtesy Collection, Whitney Museum of American Art, New York Purchase. Acq #35.18
Photo courtesy Peter A. Juley and Son Collection, National Museum of American Art, Smithsonian Institution, Washington, D.C.

6
Baptism in Kansas 1928
oil on canvas 40 × 50 in.
Courtesy Collection, Whitney Museum of American Art, New York Acq #31.159

7
Vern Sizemore baptizing the Kaiser boy
Photo courtesy Kansas State Historical Society

8
Mrs. Gertrude Vanderbilt Whitney poses for a *New York Times* photographer in 1931 alongside Curry's *Baptism in Kansas*
Courtesy John Steuart Curry Papers, Archives of American Art, Smithsonian Institution, Washington, D.C.

9
The Midwestern Regionalist Triumvirate: Thomas Hart Benton, Grant Wood, and John Steuart Curry
Courtesy John Steuart Curry Papers, Archives of American Art, Smithsonian Institution, Washington, D.C.

10
Manhunt 1934
lithograph 9¾ × 12⅞ in.
Courtesy Collection, Davenport Art Gallery, Davenport, Iowa

11
Grant Wood
Woman with Plants 1929
oil on upsom board 20½ × 15 in.
Courtesy Cedar Rapids Museum of Art, Cedar Rapids Art Association purchase

12
Vint Lawrence.
Parody of Curry's *Baptism in Kansas* 1980
Courtesy Vint Lawrence

13
The Runway 1932
oil on canvas
Photo courtesy Peter A. Juley and Son Collection, National Museum of American Art, Smithsonian Institution, Washington, D.C.

14
Line Storm 1934
oil and tempera on panel 31½ × 52 in.
Photo courtesy Peter A. Juley and Son Collection, National Museum of American Art, Smithsonian Institution, Washington, D.C.

15
John Steuart Curry and Grant Wood posing for a publicity photograph
Photo courtesy John W. Barry, Cedar Rapids, Iowa

16
Sun Dogs 1930
oil on canvas
Courtesy Permanent Collection, Kansas State University

17
William Allen White, editor and publisher
Photo courtesy *Emporia Gazette*

18
Curry in his studio on the campus of the University of Wisconsin, c. 1938
Courtesy State Historical Society of Wisconsin

19
Thomas Hart Benton
Jesse James 1936
oil and egg tempera on linen mounted panel 7 × 12 ft., detail from "A Social History of the State of Missouri" mural cycle in the Missouri State Capitol, Jefferson City.
Courtesy Walker–Missouri Division of Tourism

20
The Tragic Prelude I (John Brown) and II (Coronado, Padre Padilla, and the Plainsman) 1937
oil sketches for the Kansas Statehouse murals
oil on canvas 27 × 37½ in. (67.3 × 94 cm.) (I); 27 × 48.8 in. (67.3 × 122 cm.) (II)
Courtesy Helen Foresman Spencer Museum of Art, University of Kansas (Gift of Mr. and Mrs. C.L. Burt)

21
The Eight Panels in the Rotunda 1937
oil sketches for the Kansas Statehouse murals, oil on canvas
Photo Larry Colcher, Topeka, Kansas

22
Kansas Pastoral I (The Unmortgaged Farm) and II (Kansas Farm Family) 1937
oil sketches for the Kansas Statehouse murals
oil on canvas 67.3 × 110.5 cm. (27 × 44 in.) (I); 67.3 × 94 cm. (27 × 37½ in.) (II)
Courtesy Helen Foresman Spencer Museum of Art, University of Kansas (Gift of Mr. and Mrs. C.L. Burt)

23
Portrait Sketch of Van Wyck Brooks 1936
pastel
Courtesy John Steuart Curry Papers, Archives of American Art, Smithsonian Institution, Washington, D.C.

24
The Tragic Prelude 1937–42
east wall of the East Corridor, Kansas Statehouse murals
Courtesy Historical Society of Wisconsin

25
Kansas editor Paul Jones sporting his Pawnee Indian haircut, 1940
Paul A. Jones Coronado Cuarto Centennial Scrapbook
Courtesy Mrs. Paul A. Jones

26
Roadside billboard advertising the Coronado Entrada pageant, 1941
Paul A. Jones Coronado Cuarto Centennial Scrapbook
Courtesy Mrs. Paul A. Jones

27
Publicity materials prepared by the Kansas Coronado Cuarto Centennial Commission, 1941
Paul A. Jones Coronado Cuarto Centennial Scrapbook
Courtesy Mrs. Paul A. Jones

28
Poster advertising the Kansas premier of the Coronado Entrada
Paul A. Jones Coronado Cuarto Centennial Scrapbook
Courtesy Mrs. Paul A. Jones

29
Tourist Cabins 1934
oil on canvas 16 × 36 in.
Photo courtesy Kennedy Galleries, Inc., New York

30
Padre Juan de Padilla enters Kansas on foot with the expedition party of Francisco Coronado 1937–42
detail of *The Tragic Prelude,* section of east wall of the East Corridor, Kansas Statehouse
Photo Larry Colcher, Topeka, Kansas

31
Coronado Cuarto Cenennial edition of the *Salina Journal,* 30 June 1941
Paul A. Jones Coronado Cuarto Centennial Scrapbook
Courtesy Mrs. Paul A. Jones

32
Francisco Coronado in search of the Kingdom of Quivira, riding astride a golden Palomino 1937–42
detail of *The Tragic Prelude,* section of east wall of the East Corridor, Kansas Statehouse murals
Photo Larry Colcher, Topeka, Kansas

33
The Stockman 1929
oil on canvas 52 × 40 in.
Courtesy Collection, Whitney Museum of American Art, New York Acq #31.161
Photo Geoffrey Clements, New York

34
Curry sketching horses on the campus of the University of Wisconsin
Courtesy State Historical Society of Wisconsin

35
Belgian Stallions 1938
oil on panel
Photo courtesy Peter A. Juley and Son Collection, National Museum of American Art, Smithsonian Institution, Washington, D.C.

36
Frederic Remington
Coronado's March c. 1897
oil on panel
Courtesy Library of Congress, Washington, D.C.

37
Publicity poster for the Coronado Cuarto Centennial celebration in Kansas, 1941
Paul A. Jones Coronado Cuarto Centennial Scrapbook
Courtesy Mrs. Paul A. Jones

38
Model for Coronado figure sitting on a sawhorse in Curry's studio, 1940
Courtesy John Steuart Curry Papers, Archives of American Art, Smithsonian Institution, Washington, D.C.

39
Preliminary study for figure of Coronado in the Kansas Statehouse murals, 1940
oil on canvas 20½ × 20 in.
Photo courtesy Kennedy Galleries, Inc., New York

40
The Plainsman—figure study for *The Tragic Prelude* 1940
oil on board 30¼ × 20 in.
Photo courtesy Kennedy Galleries, Inc., New York

41
Comedy 1934
fresco in auditorium of Bedford Junior High School (now Kings Highway School) Westport, Connecticut 8 × 13 ft.
Photo courtesy Peter A. Juley and Son Collection, National Museum of American Art, Smithsonian Institution, Washington, D.C.

42
"Ode to Coronado," poem published in the Kansas press during the Coronado celebrations of 1941
Paul A. Jones Coronado Cuarto Centennial Scrapbook
Courtesy Mrs. Paul A. Jones

43
The Tragic Prelude 1937–42
sections of the north and east walls of the East Corridor, Kansas Statehouse murals
Photo Larry Colcher, Topeka, Kansas

44
The Tragic Prelude 1937–42 detail of John Brown north wall of the East Corridor, Kansas Statehouse murals
Courtesy John Steuart Curry Papers, Archives of American Art, Smithsonian Institution, Washington, D.C.

45
John Brown ascending the scaffold
wood engraving from *Frank Leslie's Illustrated Newspaper,* 17 December 1959, p. 33
Courtesy Library of Congress, Washington, D.C.

46
Photograph of John Brown taken in Boston by J. W. Black in May 1859
Courtesy Library of Congress, Washington, D.C.

47
Attributed to John C. Wolfe of Cincinnati
Portrait of John Brown
oil on canvas
Courtesy Kansas State Historical Society, Topeka

48
Currier & Ives from the original painting by Louis Ransom *John Brown Meeting the Slave-mother and her Child on the steps of Charlestown jail on his way to execution* 1863
Courtesy Library of Congress, Washington, D.C.

49
Thomas Hovenden (1840–95)
The Last Moments of John Brown 1884
oil on canvas 77⅜ × 63¼ in.
Courtesy Metropolitan Museum of Art, New York (Gift of Mr. and Mrs. Carl Stoeckel, 1897)

50
Eitaro Ishigaki (Federal Art Project, Works Progress Administration) with Chikenichi Yamasaki and Wolf Ubegi
detail of mural in the Harlem Courthouse, New York c. 1937–38
Courtesy WPA Photo Collection, Archives of American Art, Smithsonian Institution, Washington, D.C.

51
The Freeing of the Slaves 1942
oil and tempera on canvas, mural in the University of

Wisconsin law library 37 ft × 14 ft. (center), 11 ft. high at sides
Courtesy State Historical Society of Wisconsin

52
Detail of *The Freeing of the Slaves* 1942
Courtesy John Steuart Curry Papers, Archives of American Art, Smithsonian Institution, Washington, D.C.

53
Early charcoal sketch for the composition of *The Tragic Prelude,* Kansas Statehouse murals c. 1937
Courtesy John Steuart Curry Papers, Archives of American Art, Smithsonian Institution, Washington, D.C.

54
Preliminary scale drawings for *The Tragic Prelude* c. 1939
23 in. (height)
Courtesy State Historical Society of Wisconsin

55
Full-size cartoon for *The Tragic Prelude* 1940
charcoal on paper
Courtesy John Steuart Curry Papers, Archives of American Art, Smithsonian Institution, Washington, D.C.

56
Cover of the exhibition catalogue for *An Art Commentary on Lynching* featuring Curry's painting *The Fugitive*
Courtesy Archives of the University of Iowa Library

57
The Fugitive 1933–40
oil and tempera on canvas
Photo courtesy Peter A. Juley and Son Collection, National Museum of American Art, Smithsonian Institution, Washington, D.C.

58
The Manhunt 1931
oil on canvas 30 × 40¼ in.
Photo courtesy Peter A. Juley and Son Collection, National Museum of American Art, Smithsonian Institution, currently in the collection of Joslyn Art Museum, Omaha, Nebraska

59
Promotional poster for *Battle Hymn,* a play in three acts by Michael Blankfort and Michael Gold presented by the Federal Theatre Project of the WPA
Courtesy Library of Congress Federal Theatre Project Collection at George Mason University Library, Fairfax, Virginia

60
The Return of Private Davis from the Argonne 1928–40
oil on canvas 38 × 42 in.
Courtesy The Los Angeles Athletic Club Collection
Photo courtesy Hirschl & Adler Galleries, New York

61
Parade to War: Allegory 1938–39
oil on canvas 40½ × 56 in.
Photo courtesy Kennedy Galleries, Inc., New York

62
First Rally of the National Progressive Party 1938
oil on canvas 11½ × 15½ in.
Courtesy Collection Madison Art Center. Given in memory of Philip and Isabel La Follette by their family
Photo Diane Fellows

63
John Brown 1939
lithograph, 14¾ × 10⅞ in. Figure study for the Kansas mural, published in an edition of 250 by the Associated American Artists in 1940
Courtesy Collection, Davenport Art Gallery, Davenport, Iowa

64
John Brown, detail of *The Tragic Prelude* 1937–42
Courtesy Kansas State Historical Society, Topeka

65
Greek letters alpha and omega printed in red on the pages of John Brown's Bible, detail of *The Tragic Prelude*
Photo Larry Colcher, Topeka

66
Baptism in Big Stranger Creek 1932
lithograph 9⅞ × 13⅝ in.
Courtesy Collection, Davenport Art Gallery, Davenport, Iowa

67
The Gospel Train 1929
oil on canvas
Courtesy Peter A. Juley and Son Collection, National Museum of American Art, Smithsonian Institution, Washington, D.C.

68
Flight Into Egypt 1928
lithograph 4½ × 6⅝ in.
Courtesy Collection, Davenport Art Gallery, Davenport, Iowa

69
Sanctuary 1935
oil on canvas
Photo courtesy Peter A. Juley and Son Collection, National Museum of American Art, Smithsonian Institution, Washington, D.C.

70
The Prodigal Son 1929
watercolor
Photo courtesy Peter A. Juley and Son Collection, National Museum of American Art, Smithsonian Institution, Washington, D.C.

71
Mississippi Noah 1935
lithograph, second stone 9⅞ × 13¾ in.
Courtesy Collection, Davenport Art Gallery, Davenport, Iowa

72
Curry family portrait taken in 1916
Photo courtesy R. Eugene Curry, Armonk, New York

73
Photograph of John Steuart Curry in uniform as a volunteer for the Student Army Training Corps at Geneva College, September 1918
Courtesy John Steuart Curry Papers, Archives of American Art, Smithsonian Institution, Washington, D.C.

74
Facial study of John Brown for the Kansas Statehouse murals 1939
red chalk
Courtesy State Historical Society of Wisconsin

75
Henry Simon (b. 1901)
The Three Horsemen c. 1941–42
lithograph
Courtesy Library of Congress, Washington, D.C.

76
Kansas Pastoral II 1937
oil on canvas, oil sketch for the Kansas Statehouse murals
Courtesy Helen Foresman Spencer Museum of Art, University of Kansas (Gift of Mr. and Mrs. C. L. Burt)

77
Portrait of Chris L. Christensen 1941
oil and tempera on canvas 70¾ × 47¼ in.
Courtesy Division of Archives, University of Wisconsin-Madison
Photo P. Richard Eells

78
Detail sketch for The Unmortgaged Farm, detail of *Kansas Pastoral,* intended for the West Corridor, Kansas Statehouse murals
Courtesy State Historical Society of Wisconsin

79
The Homestead 1937–38
oil and tempera on canvas, mural in the Department of Interior Building, Washington, D.C. (Section of Painting and Sculpture)
Photo courtesy Public Buildings Service, General Services Administration, Washington, D.C.

80
Sketch for the Kansas farmer in *Kansas Pastoral* 1940
charcoal
Courtesy John Steuart Curry Papers, Archives of American Art, Smithsonian Institution, Washington, D.C.

81
Sketch for the Kansas mother in *Kansas Pastoral*
charcoal
Courtesy John Steuart Curry Papers, Archives of American Art, Smithsonian Institution, Washington, D.C.

82
The Unmortgaged Farm, detail of *Kansas Pastoral* 1937–42
sections of the south and west walls of the West Corridor, Kansas Statehouse murals
Photo Larry Colcher, Topeka, Kansas

83
Preliminary drawing for *Kansas Pastoral* c. 1940
Courtesy John Steuart Curry Papers, Archives of American Art, Smithsonian Institution, Washington, D.C.

84
Kansas Madonna, detail of *Kansas Pastoral* 1937–42
oil and tempera on canvas
section of the west wall of the West Corridor, Kansas Statehouse murals
Photo Larry Colcher, Topeka, Kansas

85
Kansas Madonna, detail of *Kansas Pastoral* 1937–42
Photo Larry Colcher, Topeka, Kansas

86
Oil sketches for the unexecuted mural planned for the Rotunda of the Kansas Statehouse 1937
oil on canvas 74.93 × 110.49 cm. (30 × 44 in.). Upper left: *The Homestead*; upper right: *Building the Barbed Wire Fences*; lower left: *The Plagues*; lower right: *Soil Erosion and Dust*
Photo courtesy Kennedy Galleries, Inc., New York

87
Sketch of an eroded hill in Barber County, Kansas c. 1937
Courtesy John Steuart Curry Papers, Archives of American Art, Smithsonian Institution, Washington, D.C.

88
Soil erosion on a farm in Walker County, Alabama, February 1937, photographed by Arthur Rothstein for the Farm Security Administration
Courtesy Library of Congress, Washington, D.C.

89
Photograph showing CCC enrollees constructing angular willow plantings, April 1936
Courtesy Soil Conservation Service, USDA, Madison, Wisconsin

90
Contour strip cropping and terracing on the Elmer Manske farm in Chase, Wisconsin, July 17, 1936
Courtesy Soil Conservation Service, USDA, Madison, Wisconsin

91
Erosion and Contour Strip Cropping c. 1937–40
oil on canvas 30 × 44½ in.
Courtesy Elvehjem Museum of Art, University of Wisconsin-Madison
(Gift of Mrs. John Steuart Curry)

92
Moses and the Eleventh Commandment n.d.
oil on paper 29 × 23 in.
Photo courtesy Kennedy Galleries, Inc., New York

93
Newspaper clipping in the John Steuart Curry Scrapbook at the Archives of American Art, source unidentified c. 1937
Courtesy John Steuart Curry Papers, Archives of American Art, Smithsonian Institution, Washington, D.C.

94
Revised sketch of grazing Hereford bull in *Kansas Pastoral* 1940
Courtesy State Historical Society of Wisconsin

95
Feeding Hogs, detail of *Kansas Pastoral* 1937–42
Photo Larry Colcher, Topeka, Kansas

96
Photograph of John Steuart Curry on a scaffold sketching the full-size cartoon of *The Tragic Prelude*
Courtesy John Steuart Curry Papers, Archives of American Art, Smithsonian Institution, Washington, D.C.

97
Record album cover of the rock group, "Kansas." 1974
CBS, Inc. Cover design: Ed Lee. Distributed by Columbia Records/CBS, Inc.

98
Photograph of the Statehouse Rotunda c. 1958.
Reproduced courtesy Calder M. Pickett

99
Two panels depicting corn and wheat proposed for the Rotunda of the Kansas Statehouse 1937–38
oil on canvas 91.5 × 122 cm. (36½ × 48¾ in.)
Courtesy Helen Foresman Spencer Museum of Art, University of Kansas (Gift of Mr. and Mrs. C. L. Burt)

100
Photograph of the Kansas Statehouse Rotunda and the West Corridor taken in 1981
Photo Larry Colcher, Topeka, Kansas

101
Self-portrait 1939
lithograph 11 × 9¼ in.
Courtesy Collection, Davenport Art Gallery, Davenport, Iowa

Preface

Consult almost any survey text on the history of American art and you will find mention of the 1930s phenomenon that has been termed Regionalism. The three names most closely associated with the movement are Thomas Hart Benton of Missouri, Grant Wood of Iowa, and John Steuart Curry of Kansas. During the period, in fact, they were popularly known as the "Midwestern Triumvirate of American Regionalism," as though occupying positions of authority rivaled only by Pompey, Caesar, and Crassus of ancient Rome. As a dominant force in American art, Regionalism was in decline by the late 1930s. Curry's last major recognition came in 1942 when his painting, *Wisconsin Landscape,* took first prize at the *Artists for Victory* exhibition held at the Metropolitan Museum of Art. Ironically, that same exhibition included a submission by a little-known young student of Thomas Hart Benton's named Jackson Pollock.[1] Within a decade, the emergence of Pollock's Abstract Expressionism would put the Regionalist movement of the 1930s in almost total eclipse for some time. Only recently have scholars returned to examine the Regionalists. Important new works have emerged on both Thomas Hart Benton and Grant Wood.[2] Surprisingly, however, there has been no major study of John Steuart Curry since his death in 1946.

The only book on Curry was published in 1943, three years before the artist's death, by Laurence Schmeckebier, a colleague of Curry's on the faculty of the University of Wisconsin. Schmeckebier's book was a valuable resource, with a biographical narrative and a large number of illustrations gathered between its covers. It was, on the other hand, a book without reference notes. It was not until 1970 that further information on Curry appeared. The fall 1970 issue of *Kansas Quarterly* was guest edited by Bret Waller, then Director of the University of Kansas Museum of Art and coordinator of a retrospective exhibition on Curry's work being held concurrently in the Kansas State Capitol Building, site of Curry's most important mural cycle. Among the contributions to the issue were an essay by Matthew Baigell on Curry's paintings of black freedom, a review of the treatment of Curry by the art critics, interviews with Curry's wife and daughter, and a provocative article by Calder M. Pickett (Professor in the William Allen White School of Journalism at the University of Kansas) that gave a brief account of the Kansas controversy over Curry's Statehouse murals as recorded in the local newspapers. It seems that on the one occasion that this Kansas Regionalist painter created public art in his native state, the local audience reacted so vehemently against it that they pressed the public officials to halt

funding of the project before it could be completed.

I had been reading at length about Curry in the writings of art critics and art historians, and in the pages of *Time* and *Life*, where the phrase "Curry of Kansas" appeared with such frequency that I had found myself pronouncing it as if it were all one word. In survey studies of American art, Curry-of-Kansas was mentioned for his part in the phenomenon that was known as Midwestern Regionalism of the 1930s. The dichotomy was drawn between Midwestern Regionalism and the Social Realism that prevailed in New York (East is East and Midwest is Midwest). Social Realists were credited with capturing the plight of the unemployed, the labor strikes, the celebrated Sacco and Vanzetti trials, and other causes of interest to the intellectual Left. The Midwestern Regionalists, on the other hand, seemed to be out feeding the chickens when anything of importance was going on in the 1930s, and theirs was presented as an art of rural nostalgia, a grassroots, homespun phenomenon of the American heartland. Illustrating a Ben Shahn drawing near a Grant Wood landscape served to heighten the contrast.

I soon found myself struck by the sheer irony of Curry-of-Kansas receiving such a hostile reception in the state of which he was presumed avatar, and I wondered why others were not similarly puzzled. It seemed to me as though the emperor were wearing no clothes but no one wished to mention it. As I considered Curry's paintings from two perspectives—that of the art historian and that of a local Kansan—I felt the confusion of two people describing the same object from different vantage points.

In this book I explore the confrontation of Curry and Kansas, and I suggest several ways in which we need a rethinking of the phenomenon of Regionalism in American art. This book will not answer all of the questions; in fact, it serves to raise additional questions. It is not a new biography of Curry, nor a catalogue raisonné of his works. It is, however, a case study of Regionalism in American art. The focus of the study is a single mural cycle, painted by John Steuart Curry for the Kansas Statehouse in Topeka in 1937–42. The concerns of this book arise from the imagery in the paintings and from the rhetoric that accompanied their appearance in Kansas.

As I followed the interactions between Curry and Kansas, part of what emerged was a cultural ailment Calvin Trillin has termed "rubophobia—not fear of rubes, but fear of being taken for a rube."[3] Rubophobia was but one aspect of the underlying cultural dissonance of which the Curry mural controversy was a symptom.

I have proceeded from the premise that a work of art does not exist in a vacuum, leading a life of its own, but is one aspect of material culture that holds interconnections to other spheres of influence within the culture at large. I have assumed that there are points of contact between the creation of a work of art, for example, and the world of ideas or the belief systems of individuals. I have explored the dialogue that this public mural created among the painter, the patrons, and the people who viewed it in their Statehouse. One way to discover the particular spheres of influence in a painting with recognizable subject matter is to let the object dictate the course of study—to attend to the artifact and allow questions to be suggested by the imagery that might lead to fruitful paths of inquiry. As I considered the Curry murals depicting the history of Kansas (which featured Coronado's early expedition, John Brown, and an idealized rural family against a lush pastoral setting), the questions that arose in my mind sent me to other traditions of thought—to the meaning of history in the Midwest and the notion of a usable past; to an examination of race relations and contemporary views on the Civil War; and to the conditions of agriculture and family life in the 1930s. Throughout my investigation, my goal has been to reconstruct a web of meaning for the murals, to reinsert the paintings into the cultural context in which they were produced and against which they were viewed in the late 1930s.

Although there has previously been no significant study of the Kansas murals since the project was aborted in 1942, I am not the first to write about them. Dorothy Conklin, a young art major at Kansas State Teachers College in Emporia, wrote to Curry in February 1941 before the murals had been installed in the State House. She wanted to make the murals the subject of her class paper; her letter was filled with eager inquiries about the paintings and requests for specific information about what Curry was trying to express. With characteristic reticence, Curry offered young Dorothy little in the way of enlightenment. He wrote, "I am very pleased that you want to write about my murals. . . . I would advise you to go to Topeka and write your own impressions of what you see." Regrettably, I never recovered a copy of Miss Conklin's term paper, but I have often thought about Curry's advice. I have gone to Topeka. And it is in the spirit of Curry's directive that I have undertaken my own investigation, which follows.

M.S.K.
Merion Station, Pennsylvania
November 1985

Acknowledgments

During the course of this study I have benefited greatly from the generous help of many institutions and individuals. The list of those who have contributed to this work in a variety of ways is long. While I am unable to name them all individually, I remain grateful nonetheless. Early research for this study was supported by a fellowship from the Samuel Kress Foundation. My work was generously supported by the William F. Stout Fellowship in 1980–81, and by a University of Minnesota doctoral dissertation fellowship in 1981–82.

I am deeply grateful to the late Laurence Schmeckebier for granting me permission to use the materials in the John Steuart Curry Papers at the Archives of American Art, Smithsonian Institution, Washington, D.C. I owe a large debt of gratitude as well to Mrs. Kathleen Curry for permitting me to reproduce the paintings and drawings of her late husband. Other members of the Curry family have also been both gracious and helpful in answering my questions and providing remembrances. I would like to thank in particular Eugene Curry of Armonk, New York; Ellen C. Schuster of Rush, New York; Renwick and Sue Curry of Palo Alto, California; and Nelle Curry Manville of Winchester, Kansas. I am also grateful to Dr. and Mrs. H. Kent Tenney of Madison, Wisconsin; to Ruth Struve, also of Madison; and to Lloyd Kirkham Garrison of New York City, all of whom shared their remembrances with me.

My doctoral dissertation director, Karal Ann Marling, has been an important source of intellectual stimulation and encouragement throughout the course of this study. It was she who first suggested that I undertake a study of the long-neglected Regionalist. This book owes much to her willingness to foster innovative approaches to the study of American art at the University of Minnesota.

In a broad-reaching endeavor such as this, one is indebted to the works of many scholars who have gone before. In the notes to each chapter, I have tried to acknowledge my formal debts to specific scholarly works. But much has also been gained through discussions with other colleagues, and in addition to those listed above I would also like to thank Wanda M. Corn, Timothy Garvey, William H. Goetzmann, Elaine May, Erika Doss, Anedith Nash, David Levering Lewis, and William Clebsch. Frederick Asher, Clarke Chambers, Ellen Stekert, and Melvin Waldfogel also read the manuscript and provided valuable insights. I have relied on the helpful assistance of the staffs of many institutions, but I would like to express special thanks to Nancy Sherbert and James Nottage of the Kansas State Historical So-

ciety, Janet Dreiling of the Helen Foresman Spencer Museum of Art at the University of Kansas, Karel Yasko of the General Services Administration, Washington, D.C., Eleanor Fink of the National Museum of American Art, the Kennedy Galleries, Inc., Paul Karlstrom and Betsy Currie of the Archives of American Art, and Douglas Helms, formerly of the National Archives. I would also like to thank Steve Carter for typing the manuscript.

Mrs. Paul A. Jones generously loaned materials from her late husband's papers. The staff of the Center for Advanced Study in the Behavioral Sciences at Stanford was immensely helpful in facilitating my access to needed resources for my research during the year that my husband was a fellow there. I would also like to thank the staffs of the University of Minnesota Library, the Stanford University Library, the Wisconsin State Historical Society, and Kansas Secretary of State Jack H. Brier and his staff. I owe a special thanks to Wanda M. Corn for bringing my work to the attention of the editorial board of the Smithsonian Institution Press for their series, New Directions in American Art. At the Press, it has been my good fortune to work with Maureen Jacoby, managing editor. Jeanne Sexton and Michelle K. Smith, my editors, have been diligent, helpful, and a true delight to work with. Special thanks are owed to them. I am also grateful to Alan Carter at the Smithsonian Press for his careful attention to the design of the book, and to Kathy Kuhtz and Gail Grella for keeing me informed of developments along the way.

Finally, I wish to express a special debt of gratitude to my family: to my parents, John and Ruth Harris, for encouraging in me at an early age the love of learning; to my sons, Mark and Reed, whose arrivals during the course of this project have been far greater sources of joy than of disruption; and lastly to my husband Phil, who has for many years been a supportive and encouraging presence in my life, a caring critic, and an unfailing best friend.

Chapter 1

Maynard Walker and the First Kansas Campaign

Someone more apt to learn from the past might well have been able to foresee the trouble ahead for John Steuart Curry, as he prepared to bring his art home to Kansas in the summer of 1937. By the time the invitation had arrived for him to decorate their Statehouse with his murals, Curry had, after all, already been trying unsuccessfully for a decade to persuade his fellow Kansans to appreciate his art. But now it seemed that the doors had finally swung open. In this offer, Curry sensed the promise of victory in his hard-fought battle for acceptance at home. More importantly, he saw the chance to create an epic mural cycle starring Kansas, the state he loved to paint.

The movement to bring Curry home had been initiated in the spring of 1937 by a group of newspaper editors. Concurrent and presumably independent editorials began to appear in newspapers all across the state calling for Kansas to redress her misdeeds and bring her most famous native son home to adorn the walls of the Capitol in Topeka with some of his widely celebrated mural art.[1] On May 4, Jack Harris of the *Hutchinson News* wrote to Curry, then in Madison, Wisconsin, presenting his views in no uncertain terms:

Dear Mr. Curry:
 Doubtless the thought originally came from the splendid work Benton has done in Missouri, but for a long while I have had the idea Kansas has a story that should be told in murals on the walls of the state house in Topeka. Obviously, you would be the person to do it. Having seen your work in the Department of Justice building in Washington within the past week, there is no question about it on the artistic side. The fact that you are a native Kansan is an added reason. A third, if you don't mind my saying so, is that the state owes you something for its past inappreciation.[2]

Two weeks later another letter arrived from Henry J. Allen informing Curry of the "discussion in Kansas about the desire of a great many people for some Curry murals in a public building, preferably the state house."[3] Allen was both editor of the *Topeka State Journal* and "owner of the only Frank Lloyd Wright-designed house in the state."[4] This latter distinction lent an aura of credibility to his opinions on matters of art. The newspaper provided Allen with the vehicle through which he could express those opinions. He forwarded a copy of his instigatory editorial on Curry mural art to the artist in his letter to him. Both editors Allen and Harris assured Curry of the widespread enthusiasm that had followed the publication of their editorial suggestions, and both mentioned the precedent of Thomas Hart Benton's commission: "While we haven't any Jesse James to work on as Benton had in Missouri," wrote Allen, "you could think up some mighty good substitutes in the person of John Brown and Jim Lane."[5]

The timing of the Curry invitation was influenced by the example of rival Missouri, which had commissioned Thomas Hart Benton to paint murals for its State Capitol building in Jefferson City in 1935.[6] But the Kansas commission materialized at a time when Curry himself was riding a wave of national publicity. The "Regionalism" of the Benton-Curry-Wood triumvirate had hit the cover of *Time* magazine in December 1934. The story was told in the popular press that late in the 1920s, when American art was under the stifling grip of French modernism, these three painters arose from the soil of the Middle West and set about to re-create the image of America in the likeness of the heartland. In place of the "arbitrary distortions and screaming colors" of recent French-inspired American isms, "these earthy Midwesterners" promised to create a truly American art.[7] In 1936, the premier issue of *Life* carried a four-page spread featuring "Curry of Kansas," and the nation bore witness to his dramatization of the "U.S. Scene" in *Tornado Over Kansas* (fig. 1, plate 2). In this painting, a frightened farm family scurries for the storm cellar as a wicked twister slithers across the open prairie, threatening to sweep the entire Kansas family up to the Land of Oz (and Toto, too).[8]

In biographical terms, the Kansas commission followed closely on Curry's celebrated return to the Midwest in 1936, after an absence of almost twenty years. Born on a farm near Dunavant, Kansas, Curry fled the Midwest at an early age to pursue a career as an artist. After seven years as an illustrator in and around New York, he went to Paris in 1927 to study painting. Ironically, it was on his return to the East Coast the following year that he began to earn his reputation as a so-called Regionalist by painting memories of Kansas from his studio in the fashionable art colony of Westport, Connecticut.[9]

By 1936, Curry had become the nation's first artist-in-residence when he accepted a position

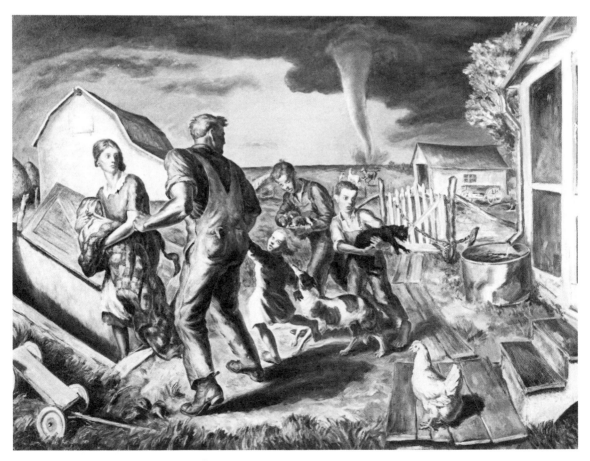

Fig. 1 *Tornado Over Kansas,* 1929, oil on canvas. Kansans called this portrayal of their state "uncivic" when the painting was exhibited there in 1931.

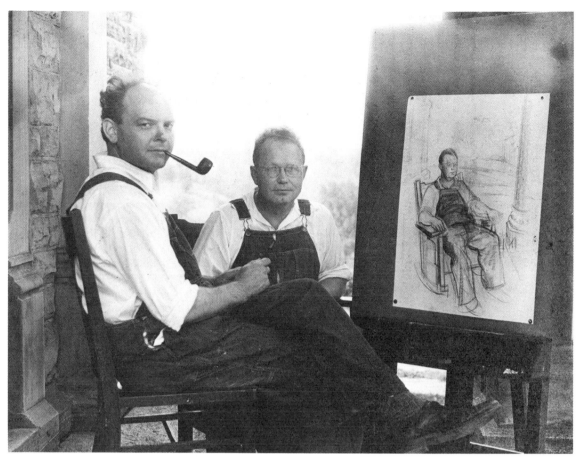

Fig. 2 Photograph of John Steuart Curry sketching Grant Wood during his visit to the Stone City Art Colony in July 1933.

with the University of Wisconsin's College of Agriculture.[10] This unique post was arranged largely through the efforts of Grant Wood, who had been trying for some time to persuade Curry to join him and Benton in the Middle West. The tenets of Wood's own militant version of a resident regionalism could scarcely achieve credibility alongside the constant embarrassment that Curry continued to live in Connecticut.[11] Benton, for his part, had made a loud and hasty retreat from New York the year before to go home to Missouri, thumbing his nose at the eastern art establishment along the way in a widely publicized essay defending his remigration to the heartland of America. Benton had been propelled back by the offer of the commission to decorate the Missouri State Capitol, as well as by a teaching position at the Kansas City Art Institute.[12] The only media event remaining to complete the homecoming of the Midwestern Triumvirate of American painting was to somehow get Curry, the Kansan, out of Connecticut—a

campaign that was waged, for the most part, without Curry's active participation.

It was no secret that John Steuart Curry wanted to paint murals for Kansas. He had intimated as much to a reporter from the *New York Herald-Tribune*; the news that he "would like nothing better than to be given a free hand to paint the Kansas scene on the walls of some state institution" was carried home when the New York article was run in the *Topeka Capital* in February 1935.[13] He had already made preliminary gestures toward securing a job to paint murals at the State Agricultural College in Manhattan, Kansas, but the college administration had proved unwilling to apply for a grant to fund the project.[14] When Curry's own efforts failed, his friends eagerly took up the challenge. Grant Wood went out to spend the weekend with the William Allen Whites at their home in Emporia, Kansas, to discuss possible schemes for getting Curry back. As the nationally recognized elder statesman of Pro-

gressive Republicanism in the Midwest, White was a mover and shaker; perhaps he could set the proper forces in motion to guarantee Curry's return. On April 16, 1936, Wood wrote to Curry of the plans, both tried and discarded, that resulted from their weekend of brainstorming:

[White] feels as I do that you should be back there but has found no definite opening so far. He had been thinking of approaching the University of Kansas but . . . that seems a hopeless proposition as long as Block and Mattern are there. White then suggested that he try to get backing from either the Carnegie Foundation or from Mrs. Whitney to put you on at a salary of, he suggested, 3,000 per year, to see what you could do there. He felt that the main thing was to get you back in the state.

After offering a polite but half-hearted apology for seeming to interfere, Wood admitted to a host of other advances he had already made in his dogged efforts on Curry's behalf. Of these, Wood had received positive responses from both the University of Illinois and Stephens College ("Benton would love to have you in Missouri").[15] Meanwhile, back in New York, other arch-advocates of the new Midwestern Regionalism had enlisted in the cause. Thomas Craven, New York art critic and Benton's longtime buddy, could be found cornering an unsuspecting William Allen White during a luncheon party at the offices of the *New York Times* and forcing him to renew his pledge to intervene on Curry's behalf.[16] Maynard Walker, art dealer for the Midwestern Triumvirate, had been actively conducting his own letter-writing campaign from New York to locate "some institution in the West" where Curry might paint murals or simply teach painting. "The whole point," explained Walker, "is that Curry's friends feel that he should be located in the West somewhere instead of this too effete East."[17]

Escape from the "too effete East" had been the motive most egregiously professed by Thomas Hart Benton to explain his own return to Missouri in 1935. "The great cities are outworn. . . . They offer nothing but coffins for living and thinking," were the sentiments offered by Benton in his essay of farewell to New York. From his perspective, American art was suffering under the "humorless mouthings of the indoctrinated intellectuals of New York's elevated circles." Perhaps in the hinterlands American art could be free of the pernicious influence of "those aesthetic orthodoxies, cults, and conformist principles which in the great cities tend to sterilize expression before it reaches maturity." Perhaps in middle America it could undergo "a new and freer and more objective consideration of the things that are American." Like the American expatriates to Europe following World War I, Benton sensed that advanced urban

American civilization was going bankrupt. But his own vision of hope for redemption lay in "an appreciation of the drama of life, of the values of simple existence which stand apart from ends and purposes," in "the vast driving energies of this country" that seemed somehow to reside, for Benton, in the American heartland:

In those outlying places of the great rivers and fields which, in the self-satisfied vanities of the great cities, are regarded as the abodes of hicks and stuffed shirts, the promise of an artistic future seems to lie.[18]

The "promise of an artistic future" blossoming in the heart of the Middle West was also the implicit theme of Grant Wood's regionalist manifesto, "Revolt against the City," published in the same year as his exodus from New York.[19] Although Wood had admittedly studied abroad in the 1920s, he had made his own "Return from Bohemia" even earlier than had Benton, and was publicly proclaiming the virtues of residing in the Middle West as early as 1931.[20] Wood strengthened the ties to his native Iowa by counting himself among "those of us who have never deserted our own regions for long," and there was at least a kernel of truth to *Time*'s hyperbolic claim that Wood "hates to leave his native Iowa where his fellow-citizens have been buying his pictures and singing his praise almost since he began painting."[21]

Curry, on the other hand, was at least mildly ambivalent about moving back. Benton had spoken of his own return to Missouri in an imagery of escape and homecoming.[22] But Curry, months after his relocation to Madison, still referred to his "state of worry over our removal from the East."[23] The contrast between Benton's active "escape" and Curry's passive "removal" is not merely coincidental. In fact, Curry rather enjoyed the social soirees of life in the Westport art colony. So far he had entertained his Regionalist expression at a safe distance, far removed from Kansas itself. His daylight hours may well have been spent painting the creek baptisms, revival meetings, and somber prairie landscapes of his youth. But in the evenings you might just find him presiding as the witty auctioneer at the Silvermine Artist Guild's annual "Fakir Show and Dance Grotesque." At this fashionable bohemian affair, paintings and sculpture in parodies of local styles were held up to ridicule (along with "a large stock of bizarre knick-knacks") and sold at outrageous prices by auctioneer Curry, as he solemnly pounded a wooden box with a tin soup spoon.[24] Or perhaps, after a long day of painting backwoods Kansas folkways, the long-distance Regionalist might be stepping out in full Arabian sheik regalia for the

Artists' Masque Ball at the Westport Country Club (see fig. 3).[25]

If Curry seemed to be less convinced than Benton of the evils of eastern ways, he also had never known the kind of hometown appreciation that Wood was enjoying in Iowa. When Jack Harris had written to Curry in 1937 to pose the idea of a mural commission, and alluded to the state's "past inappreciation," they both knew very well what he meant by it. Kansans had severely criticized an exhibition of Curry paintings sent there in 1931, and had for the most part remained indifferent to the East Coast accolades that were sent to them through the mail by Curry's agent in New York. The courtship of Curry and Kansas was instilled with a ring of unrequited love that made for good news copy. When in 1935 the first Curry canvas was bought in Kansas, the headlines were carried in the New York press and over the AP wires. When Curry finally left Connecticut in 1936 to move to Madison, *Life* magazine impishly announced that Wisconsin's apparent intention was to steal Curry from his native state, which had notably failed to buy his pictures.[26] This national reprimand no doubt helped to raise the funds in Kansas to bring Curry home. But the circumstances surrounding his earlier rejection—the lines of battle and the fortunes of the combatants—help to illuminate the contours of this phenomenon that has come to be known as Regionalism in American painting.

The identification of Curry with Kansas has become firmly entrenched in the folklore of American art history. The association is so strong, in fact, that a recent publication, a widely acclaimed book on nationalism in twentieth-century American art, discusses the phenomenon of Regionalism as though Curry painted his Kansas-inspired pictures without ever leaving the state. The assumption is that "all along Wood and Curry had kept their home bases in the nation's midwestern heartland." This cornfed image of a resident regionalism is quite compelling. "At home in Kansas," the author imagines, "Curry continued to depict the violent drama of nature in the Plains country and the folksy simplicity of its people."[27] But, as we shall see, Curry never did quite feel "at home" in Kansas, and the Kansas-inspired pictures that earned him his Regionalist reputation were executed between evening soirees at the Westport, Connecticut, art colony. The implications and resonant effects of Curry's ties to East Coast art centers have long been overlooked in the overriding tendency to identify him with Midwestern Regionalism of the 1930s along with Benton of Missouri and Wood of Iowa. But Curry's ambivalent relation to Kansas is crucial to an understand-

Fig. 3 John Steuart Curry and Mattie Farnham in Arabian costume at the Westport Artists' Masque Ball in 1931.

ing of the Regionalist paintings that remain to us today in the lexicon of American art. His physical and psychological distance from that state is at least as important as his preoccupation with it.

Suggestive issues begin to take shape at those flash points when Curry comes into direct contact with Kansas, a region whose art and values he has been widely presumed to reflect. The confrontation between the painter and his region comes at two discrete and distinct junctures in the artist's career. The first encounter occurs in 1930–31, when a traveling exhibition of Curry paintings was sent from New York to Kansas for exhibition. This initial campaign, spearheaded by New York art dealer Maynard Walker to seek the state's endorsement of Curry's works, will be discussed later in this chapter. The second confrontation occurs in the years 1937–42, when Curry was ceremoniously brought back to Kansas to paint murals for the Statehouse in Topeka—an event that will form the larger concern of this study.

Until 1928, John Steuart Curry had been just another young midwestern boy who had left the farm to pursue his American dream in the urban centers of the eastern seaboard. Until then, he was but one among a horde of young New York magazine illustrators working in the American tra-

dition of Howard Pyle and Harvey Dunn. Curry had begun study in Dunn's Tenafly, New Jersey, school of illustration in December 1919. By 1921, he was producing his own illustrations for magazines such as *Boy's Life, St. Nicholas,* and the *Saturday Evening Post.* For several promising years he earned his living as an illustrator, and by 1924 he was able to leave his rented loft in Greenwich Village with his new bride and buy his own studio at Otter Ponds in the art colony at Westport, Connecticut. But Curry could sense that his illustrating career was in serious jeopardy. Publishers were becoming increasingly dissatisfied with his work, and at the end of 1925 he had lost nearly all of the established commissions he had acquired under the aegis of Harvey Dunn. Curry's 1943 biographer attributes the decline of his illustrating career to his blossoming as a creative artist and his unwillingness to submit to the "dextrous handling and repetition of stereotyped patterns" characteristic of more successful illustrators. At the time, however, another opinion was freely offered by Westport neighbor James Daughtery, an established artist who had taken the needy Curry on to assist him with a painting job commissioned for the Philadelphia Sesquicentennial Exposition of 1926. Daughtery bluntly fingered Curry's problem by suggesting that he simply did not know how to draw. He further advised that if Curry wished to become a painter, he should promptly seek training in draftsmanship at Schoukhaieff's Russian Academy in Paris. The discouraged but aspiring young painter was sailing for Schoukhaieff's on borrowed money by October of that year.[28]

The first half of 1927 was spent in disciplined figure study at the Russian Academy. After hours, Curry could be found copying the works of the old masters in the Louvre or sketching the bohemian life he enjoyed at the Café du Dôme, in the Latin Quarter, and at Montmartre.[29] Curry returned to Westport in June 1927, and by August 1928 had produced the first Regionalist painting that made his career.[30] What happened in those months leading up to the painting of *Baptism in Kansas* (fig. 6; plate 1) is a story that may never fully be known. But in the hindsight of Curry's fame as a Regionalist, the story has gained the drama of embellishment in the telling. Thomas Craven, as he recreated the image of Curry, alone in "a small house in the woods near Westport," seemed almost to liken Curry's seclusion to Christ's sojourn in the wilderness.

Here, with iron courage, he swore he would produce one picture of strength and beauty, or acknowledge defeat and retire to the dust bowl. On his first trial, he painted from memory an alfresco ceremonial, the fa-

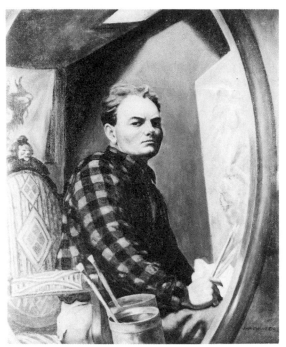

Fig. 4 *Self Portrait with Mirror,* 1925–29, oil on canvas. The artist at his studio in Westport, Connecticut.

mous *Baptism in Kansas,* which, on its exhibition at the Corcoran Gallery, was instantly acclaimed as the work of a new master of American genre.[31]

Curry, himself, recalls a more practical turn of events in his letter to *Life* magazine responding to its inquiry some years later about the painting's origins.

The "Baptism in Kansas" was painted in August, 1928. I was in a state of desperation trying to get along at illustration, or anything I could do. I took a month off and painted this picture. It was painted without notes or sketches from memory of a baptism that took place in 1915.[32]

Whatever the circumstances leading up to its making, *Baptism in Kansas* did, in fact, meet with almost instant success. Curry exhibited the painting at the Corcoran Gallery of Art in Washington, D.C., in the fall of 1928. It was immediately singled out for praise by *New York Times* art critic Edward Alden Jewell. "Religious fanaticism of the hinterlands saturates the scene," wrote Jewell in his column on November 4 about the painting he hailed as "a gorgeous piece of satire." Immediately following the exhibition, Curry was granted membership in the Whitney Studio Club of New York, and was given a stipend of fifty dollars per

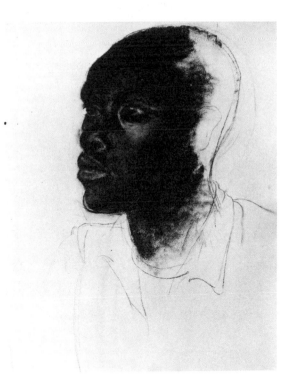

Fig. 5 *Head of Negro,* 1927, pastel on paper. Curry made this portrait sketch of a black youth shortly after returning from Europe to Westport. (Courtesy Collection, Whitney Museum of American Art, New York. Purchase. Acq #35.18)

Fig. 6 *Baptism in Kansas,* 1928, oil on canvas. The famous "Regionalist" painting that launched Curry's career. (Courtesy Collection, Whitney Museum of American Art, New York. Acq #31.159)

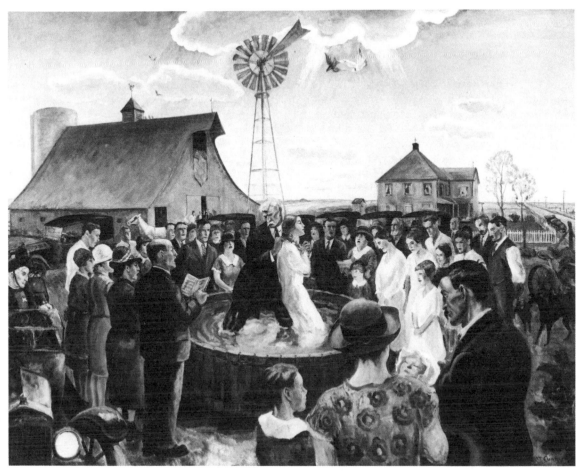

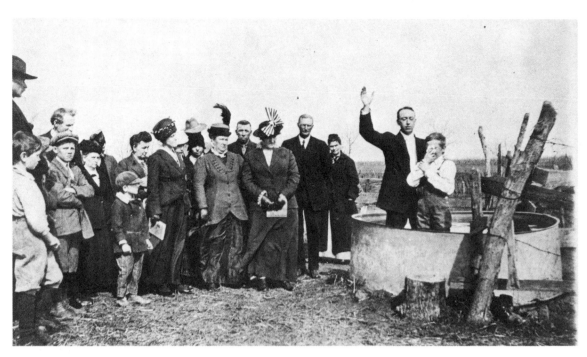

Fig. 7 Vern Sizemore baptizing the Kaiser boy near Linn, Washington County, Kansas, circa 1915.

week for the next two years by Mrs. Gertrude Vanderbilt Whitney to subsidize his painting career.[33] Curry's fame as a fresh American talent grew with the appearance of his first one-man show at the Whitney Studio Club Galleries in January 1930.[34] "Curry appears like a young Lochinvar out of the west," wrote Margaret Bruening on February 1, 1930, for the *New York Evening Post*. His exhibition at the Ferargil Galleries in New York the following autumn brought even more resounding praise. "Kansas Has Found Her Homer," rang the headlines of Edward Alden Jewell's panegyrical review in the *New York Times*.[35]

In 1930, Mrs. Gertrude Vanderbilt Whitney purchased Curry's *Baptism in Kansas* for the collection that would be housed in the recently built Whitney Museum of American Art, which ceremoniously opened its doors to the public on November 18, 1931.[36] When the *New York Times* featured Mrs. Whitney at the opening as "the patron and founder of a new museum," the photograph showed her posing proudly beside Curry's *Baptism in Kansas,* standard-bearer of the new American art (fig. 8).[37]

By 1930, Benton, Curry, and Wood had already arrived at their new painterly modes quite independently of each other. Thomas Hart Benton's *Boomtown,* 1928, signaled the arrival of those local thematic preoccupations that would land him on the cover of *Time* in 1934 as the leader of those "earthy Midwesterners" of the new Regionalist movement (see fig. 9).[38] In 1930, the year of the Whitney purchase of *Baptism in Kansas,* Grant Wood's *American Gothic* created a sensation at the Art Institute of Chicago and earned the Iowa artist national fame for his native expression of wit.[39]

Early on, the accretion of American subject matter in the works of this midwestern trio to include the indigenous icons and folkways of the heartland was championed by nativist boosters as 100 percent Americanism. In New York, *Times* critic Jewell delighted to discover in Curry "a brush capable of speaking American without an accent."[40] Promoting Regionalism as a wave of militant grass roots opposition to the "crazy parade of Cubism, Futurism, Dadaism, [and] Surrealism" that had dominated American art since the Armory Show of 1913, *Time* emphasized the artists' ties to the soil in swelling rhetoric of resounding cadence: "From Missouri, from Kansas, from Ohio, from Iowa, came men whose work was destined to turn the tide of artistic taste in the U.S."[41]

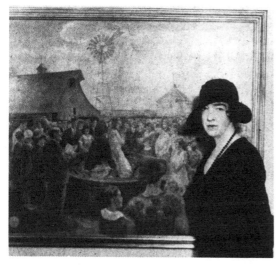

Fig. 8 Mrs. Gertrude Vanderbilt Whitney poses for a *New York Times* photographer in 1931 alongside Curry's *Baptism in Kansas,* which she has just purchased for the collection of the Whitney Museum of American Art.

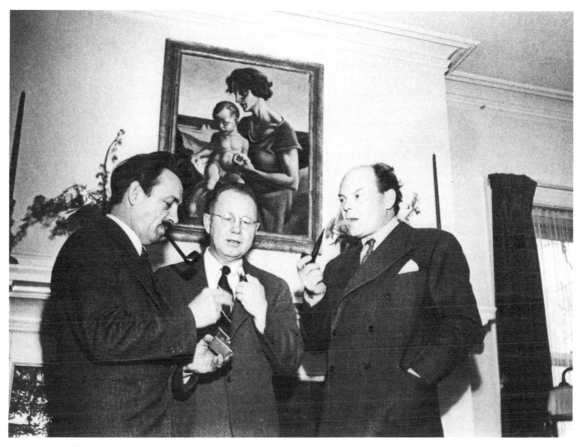

Fig. 9 The Midwestern Regionalist Triumvirate: Thomas Hart Benton, Grant Wood, and John Steuart Curry at Benton's Kansas City home in March of 1938.

Thomas Hart Benton later reflected on the efforts of this promotional scheme:

We came in the popular mind to represent a home-grown, grass-roots artistry which damned 'furrin' influence and which knew nothing about and cared nothing for the traditions of art as cultivated city snobs, dudes, and *ass*thetes knew them. A play was written and a stage erected for us. Grant Wood became the typical Iowa small towner, John Curry the typical Kansas farmer, and I just an Ozark hillbilly. We accepted our roles.[42]

The sheer irony of this homespun image of John Steuart Curry being plucked from the plains as a new-found American "primitive" should be readily discernible. But from his haven in the Westport art colony the Paris-trained painter of prairie life began to play along. In the summer of 1933, Curry traveled to Iowa to meet face-to-face with Grant Wood.[43] Wood had established the Stone City Colony and Art School the previous summer to promote the development of regional art. On Curry's arrival at Stone City, he and Wood donned matching blue jean bib overalls and rolled up their shirtsleeves to pose for a series of publicity photographs taken by a courier from the *Cedar Rapids Gazette*.[44] It was one of these publicity shots that finally made its way to the pages of *Time*'s announcement of the midwestern stirrings of a truly American art. Here was a reformed John Steuart Curry, dressed no longer in the bohemian chic of Arabian sheikdom he had previously sported at the Westport Artists' Masque Ball, but in the bibbed overalls of an honest-to-god, down-home Kansas farmer.[45]

It had not taken Curry's New York agent very long to surmise that if his new client were going to be promoted as a savior of American art, risen from the soil of the heartland to combat the pernicious influence of foreign derivative styles—if Curry were going to be convincingly presented to prospective patrons as the boy-wonder of the Plains—then it would be immensely helpful if the folks back home could be induced to cooperate. If Maynard Walker expected to be able to develop a viable market for the oil paintings of this stickit New York magazine illustrator, and if he expected to be able to capitalize on the appeal of the alliterative appellation, "Curry of Kansas," then something would have to be done on the home front to let unsuspecting Kansans in on the secret.

The one-man show of paintings that had prompted New York art critics to hail Curry as the Homer of Kansas was invited to be exhibited at the Art Institute of Chicago in 1931. As representative of the Ferargil Galleries, in charge of handling Curry's works, Maynard Walker wasted no time in trying to find a place in Kansas that would

accept the exhibition after its tenure in Chicago. He was finally able to persuade the Mulvane Museum in Topeka to accept the exhibition.[46] Before the show opened, Walker had already begun to mount an extensive letter-writing campaign to get Curry's paintings appreciated and bought in his home state. "I have been writing to everybody in Topeka about the work of John Steuart Curry. It's really great stuff," Walker confided to one local Kansas worthy.[47] He wrote to United States Senator Arthur Capper of Topeka, enclosing an impressive array of Curry credentials clipped from the pages of various New York newspapers that had covered Curry's rising fame, and suggested that Capper finance a gift to the Mulvane Museum of a Curry painting. The Senator politely declined.[48]

The Curry promotion in Topeka was, in Walker's words, "a flop." A Topeka spokesman, L. T. Hull, wrote to Ferargil Galleries that "the public resented the so-called crude angle towards Kansas" they sensed in paintings such as *The Tornado, Holy Rollers,* and *Manhunt* (fig. 10).[49] It seemed that most Kansans found little pleasure in seeing their miserable weather, their religious fanaticism, and their lynch mobs captured in paint for all the world to see. Incredulous of the Kansas reception, Walker would not be dissuaded. He decided to forego his Topeka campaign and redirect his efforts to the outlying reaches of the state. Walker strategically targeted the most prominent citizens, the most influential newspaper editors, and the most highly respected statesmen in Kansas and proceeded to send them glowing letters on Curry's behalf.

In this second wave of attack, Walker wisely solicited the help of William Allen White. White had been a college classmate of Curry's father's. He had already promised the young artist that if Curry would come to Kansas with his paintings, White would guarantee him an audience in any Kansas town in which he might wish to speak, and would also provide "an interested group that would go to your exhibits."[50] With White's support, Walker organized a special show of Curry paintings to tour in Kansas and to be shown at the Kansas City Art Institute in Missouri.[51] White, for his part, was true to his word. Before the Kansas City opening of the show on December 6, 1931, White wrote to a hundred people in that town about the exhibition, and he promised to do the same when the show went from there to Wichita.[52] Walker wrote to the Kansas City Art Institute, sending along a host of selected clippings from the New York presses so that the folks back home would "recognize how important Curry is in Eastern art circles" and be persuaded that "rec-

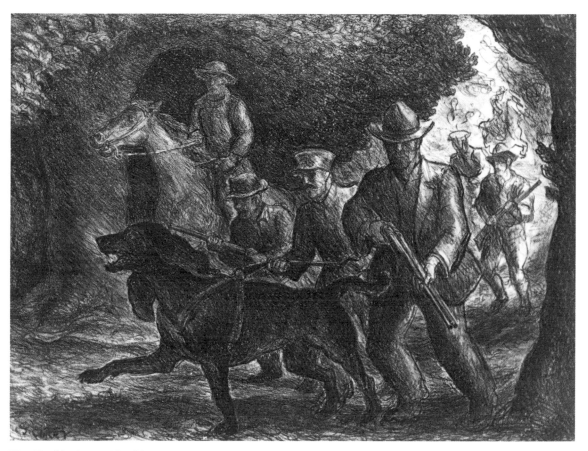

Fig. 10 *Manhunt,* 1934, lithograph from a portfolio entitled "The American Scene, Series 2," published by the Contemporary Print Group, New York. The suite was composed of six lithographs by Thomas Hart Benton, John Steuart Curry, William Gropper, Russel Limbach, Charles Locke, and Raphael Soyer.

ognition from his native section could never come at a better time than now."[53] Together, Walker and White arranged for the exhibition of Curry's paintings to travel widely in the state in 1931—to the Spooner-Thayer Gallery at the state university at Lawrence, to the campus of the Kansas State Agricultural College in Manhattan, and to the City Club of Emporia.[54] When the Wichita Art Center responded negatively to Walker's request to exhibit there, White was called in to apply the necessary pressure that would change minds—and it worked.[55]

For Walker, merely getting a few Kansas galleries to acquiesce in agreeing to show Curry's paintings was just not enough. He saw no advantage in the pictures being "simply put up and gaped at." He wanted the state's endorsement, and he wanted them to vote with their wallets:

I cannot see that there is much point in having shows in any of these places unless someone is actively interested and will either subscribe funds or raise funds for keeping one of Curry's pictures permanently in some public institution in each of the cities where the exhibition is held. Transporting and arranging a show of this kind is tremendously expensive and takes much effort. . . . The point is that these pictures are being appreciated and recognized in Eastern cities, where collectors are beginning to want them, and I feel it would be a sad loss of time and a great injustice to Curry to route them around cities out there unless they were given proper recognition.

Curry's unique contribution and importance in American art is rapidly being noised abroad here. The Whitney Museum opened the other day and his painting was honored by being reproduced twice in the *New York Times* Rotogravure Section. Another painting was reproduced in the Rotogravure Section of the *Herald Tribune* and also in the *New York American.* You understand these paintings were singled out from some 500 paintings shown at the Whitney Museum. Curry was men-

tioned among the first Americans in critical articles by Edward Alden Jewell, appearing in last Sunday's *Times* and in a story in the *Times* Magazine Section, which I am sending you herewith. His large painting 'The Tornado,' which you saw in the exhibition, was accepted by the National Academy of Design and was seriously considered for the Second Altman Prize.

I mention all this to assure you that his fame is on the ascendancy and if Kansas is to do anything about it, she had better get busy.[56]

But Kansans were not about to "do anything about it" in 1931. Walker had tried to get the results he desired by aiming straight for their provincial inferiority complex. But his condescending intimidations and threatening tone did little more, it seems, than spark a defensive posture in proud Kansans who were not given to being told what to do by high-minded New York art dealers. Moreover, Curry had managed to offend most of his Kansas gallery-goers even without the help of the arrogant and bombastic rantings of Maynard Walker.

Curry had run into trouble with his characterization of Kansas.[57] He had conjured up the images of his Kansas childhood in those reflective moments at his Westport studio—images whose salient typology helped to create for him a unique sense of place and time that he had long ago left behind. But what Curry seemed to set forth as positive virtues about this special place were perceived as making fun of the worst aspects of the state. Curry's images of tornadoes and tank baptisms were an embarrassment to those thin-skinned Kansans who were concerned about perpetuating negative stereotypes. Local worthies who prided themselves on the progress of their state had little tolerance for the kind of image that Curry was parading before his New York admirers. The needs of a community to assert its own self-worth were meeting head on with the needs of a prodigal son to reclaim his past. Curry's New York audience, weary of the monotony of the mass culture and commercialization all around them, had appreciated the novelty of witnessing a country baptism in a stock tank. Images such as these provided them with a window on a lesser-known world—back to the "real America" that seemed somehow to exist only long ago and far away. In a curious sort of way, they had discovered a pure, unchanging, and primitive culture existing within their own, and it was made all the more attractive in those isolationist years between the wars because it was indigenous. Like Mabel Dodge Luhan and other expatriates who "rediscovered" the land and native dwellers of the American Southwest after World War I, Curry's urban patrons foresaw a source of aesthetic and spiritual renewal in the rediscovery of the Ameri-

can heartland.[58] The time-honored rituals and indigenous folkways of the American Middle West seemed to harbor a wellspring of redemption for the neurotic, mechanized, and fast-paced urban civilization in the East. Curry was no American Gauguin, and the Kansas plains no isles of Marquesas, but the values set forth in those early paintings of Kansas evoked the continuity of more primitive cultures and the concomitant folkways that naturally emerge from the daily integration of man with the cycles of nature.

The confrontation in the late 1920s between the needs of some urban dwellers to seek out the roots of American culture, and the opposing needs of their newly found American primitives to see themselves as modern and up-to-date by city standards was the underlying theme of another "regionalist" expression of the period. Ruth Suckow's short story, "Midwestern Primitive," was written in 1928, the same year that Curry produced *Baptism in Kansas*.[59] Suckow's story offers a heuristic literary allegory for the kind of confrontation that actually developed between Curry and Kansas in 1931.

The plot of "Midwestern Primitive" can be recounted straightforwardly. The story opens in the small midwestern town of Shell Spring, where Bert Statzer is busily preparing her table for dinner guests expected to arrive momentarily from the East. The guest of honor is the "famous writer," Harry Whetstone, whose entire traveling entourage is being brought to dinner at Bert's fledgling tea room by a big-city acquaintance of Bert's culture-conscious neighbor, Mrs. Elliott. It is obvious from the start that Bert has made every effort to prepare things "just as they did in the real Eastern tea rooms Mrs. Elliott had told her about." Bert had obsessed over every detail of the preparations—"the little fringed napkins of pink crepe, the tinted glass goblets which [she] had sent away for, the spray of sweet peas at every place, one pink and then the next one lavender, made of tissue paper." She nervously changed her old apron for "the bright green smock" she would wear to do the serving—"it was like the one she'd seen in the photograph of 'Betty Lee's Tea Room' in the cooking magazine." She ceremoniously added a few extra nuts to each plate of salad ("nice salads were things people here in town didn't fuss with"). We are made privilege to Bert's loftiest expectations for this dinner:

Bert was taking the roast chicken from the oven. Roasted, not fried. 'People in the East never think of *frying* chicken.' Mrs. Elliott had never tasted fried chicken all the time that she was in the East. Bert wanted these people to be able to say they had eaten as good a meal here in the Hillside Inn as ever they had

got in any city restaurant. She had followed the menus in the cooking magazine. . . . She had got ideas wherever she could, but was she sure? She wanted to show these people that even if she did live out here in Shell Spring, she knew how things ought to be.

But there was one potential flaw in Bert's plans to impress her distinguished guests from the city—her German immigrant mother:

The coffee cups were all set out on the little old sewing table that [Bert] was using for a serving table. She was going to serve her coffee with dessert, the right way. 'Ach, let 'em have their coffee!' Mrs. Hohenschuh pleaded. She thought it was terrible to deprive people of their coffee all through a meal.[60]

Bert's mother, Mrs. Hohenschuh, was a constant embarrassment to her. Mrs. Hohenschuh just wouldn't comply with Bert's earnest attempts to impress her tea room guests. " 'She doesn't know one person from another,' Bert complained, 'doesn't see why these people are any different from any others.' " Bert had bought her mother "a nice up-to-date dress" in Dubuque for the author's visit, but when she came down wearing her own respectable percale housedress, Bert ordered her to "stay out of sight."[61]

Dinner without Mrs. Hohenschuh went fairly smoothly for Bert. She was, however, somewhat disappointed that the guests had not shown more delight in her preparations. " 'Well, this is familiar,' " they had said with an air of cool indifference. " 'Standardization, I tell you. It gets into all the corners.' " As Bert puzzled over the meaning of these statements, she saw to her horror that her mother was approaching the house from the garden. Mrs. Hohenschuh came lumbering up the steps carrying a big bottle of her homemade dandelion wine, and apologized to the guests for " 'having to go all that time without your coffee.' " Their faces lit up at the sight of the little old German farm woman toting her homemade spirits. While Bert "burned with humiliation" in the kitchen, Mrs. Hohenschuh took all the guests out to show them her flower beds. ("Mrs. Hohenschuh always thought it her duty as a hostess to take her guests out and show them everything she had".)[62]

" 'Well,' " said Mrs. Hohenschuh, 'I don't know as there's anything you folks'll care much about looking at (she didn't mean that; she said it in a rich, comfortable tone). I only got the same old kind of flowers I've always had, they ain't any of these new-fangled kinds with fancy names here.' " The author's smartly dressed female companion protested—" 'Oh, we adore seeing them!' " Mrs. Hohenschuh, "her deep comfortable voice rich with chuckles and drolleries of German inflec-

tion," waddled about among the flower beds and pointed out the varieties, as her guests bubbled with enthusiasm. There were moss roses in a flat matted bed in patches of color that reminded one of the women of the colors in patchwork quilts. Another guest happened on "real old honest-to-God peppermint" that she hadn't smelled for years. There were flower pots set out and slips started in them, with familiar foliage in them like their grandmothers used to have. Harry Whetstone poked around the woodsheds and a tool shed, "where pans of seeds were set about in the midst of a clutter of ancient furniture. It was like going back thirty years." Mrs. Hohenschuh picked one of each kind of flower for each person—pansies, tiger lilies, and "zinnies." Inside, they lingered over the "old faded purple plush album that held all the family pictures." And they reverently handled each of Mrs. Hohenschuh's most prized "curios" that she kept on a shelf in the bookcase—shells, old feathers from the peacock they used to have out on the farm, a cocoanut husk with stamps and an address label on it, a glass paperweight with snowfall inside. As Bert cowers in humiliation, Mrs. Hohenschuh sees the delighted visitors on their way, promising that next time she will make them all fried chicken and let them have their coffee with their meal.[63]

Ruth Suckow often wrote about the conflicts that ensued when the values of older midwestern folk came under attack by a younger generation eager to keep up with the 1920s. The insular patterns of nineteenth-century country life had by then been penetrated by the movies, the automobile, and the rise of mass advertising. The clash between the values and cultural expectations of Mrs. Hohenschuh and her aspiring daughter, Bert, could be easily extended to incorporate the experiences of many rural families after World War I. In "Midwestern Primitive," Suckow incorporates yet a third social type that was emerging in the 1920s—the urban dwellers who had fled their rural roots, and who had both tried and tired of the new mass culture of the cities. They were trying now to "come home" and recapture the uniqueness of their past, searching for the texture of life as it used to be lived. The antiques craze of that period was symptomatic of an even broader cultural trend among city dwellers toward the fervent rediscovery of America.[64]

The city tourists in Suckow's short story were not unlike those ardent New Yorkers who favored Curry's Kansas-inspired scenes. Paintings of rolling prairies and country baptisms, of gospel trains and medicine shows could evoke for the urban viewer a rich matrix of resonant associations to a familiar, if vanishing, way of life. Paradoxically, the

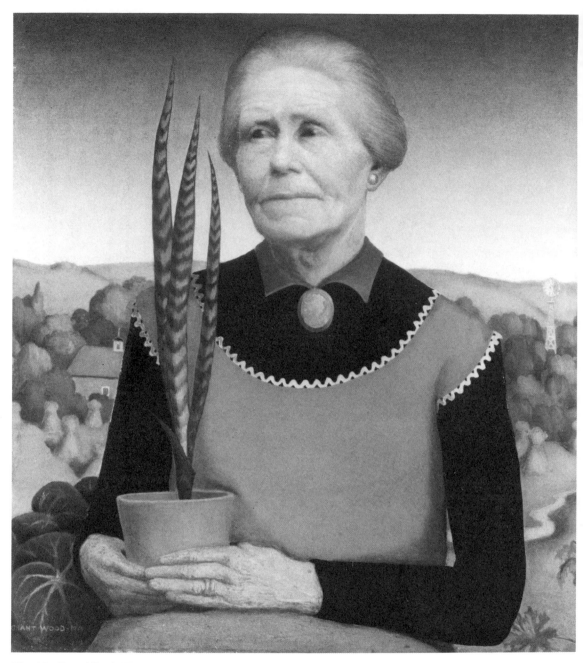

Fig. 11 Grant Wood, *Woman with Plants,* 1929, oil on upsom board. (Courtesy Cedar Rapids Museum of Art, Cedar Rapids Art Association purchase) Wood was a great admirer of Ruth Suckow's writings about Iowa. Suckow's "Midwestern Primitive" appeared in *Harper's* magazine the year before Wood painted this portrait of his seventy-one-year-old mother. This midwestern woman, with her cameo brooch, her rickrack-trimmed apron, and her snake plant, seems almost to have stepped out of the pages of Suckow's short story.

remembrance need not be a positive one to warrant its appeal. Even the sight of a threatening tornado could summon a kind of atavistic recognition for someone whose formative years were spent in the Middle West. In 1931, a Connecticut real estate broker wrote to Curry and offered to buy *The Tornado,* which he had just seen illustrated in an arts magazine:

I think I find in the photograph a certain native quality which interests me because I was born and brought up in Michigan and while I never have seen a tornado of just this kind I can well remember school being let out and running for dear life for home, with the branches torn off the trees, windows broken and roofs coming off around me, but at any rate the whole picture seems to strike a sort of home chord in me.[65]

Curry, if the truth be known, had never seen "a tornado of just this kind" either when he painted the canvas in question.[66] But he, like the Connecticut broker, retained vivid childhood memories of scurrying for safety in the storm cellar at the news that a funnel cloud was approaching. Tornadoes, like the hurricanes of the East or the earthquakes of California, were a kind of regional disaster indigenous to the Middle West, capable of evoking a certain vague sense of place and of striking "a sort of home chord."

But the people still living in Kansas in 1931 were viewing Curry's images from a fundamentally different perspective, bringing with them a contrary array of values, expectations, and needs. For Curry to parade their tornadoes and religious fanaticism before sophisticated New York gallery-goers was tantamount to Mrs. Hohenschuh dragging out the old curios for Bert's urbane guests. For those pretentious Kansans who were suffering from a crisis of confidence in their own cultural patterns, and who were sensitized by a deep-rooted provincial inferiority complex, Curry's paintings were a burning humiliation. Not surprisingly, they sought an altogether different typology of Kansas that would bespeak the pastoral beauty of its terrain and the savoir faire of its progressive citizens. Even the long-suffering William Allen White was moved to complain. "God knows I wouldn't have you paint Corot into the Kansas landscape, nor Turner into our skies," he told Curry, "and yet Kansas has its ineffable beauty even if in that beauty there is everything which in your more gloomy moods you see."[67] White was responding to the wave of negative criticism that had arisen at the opening of Curry's exhibition in Kansas City. To his considerable discomfort, White suddenly found himself caught in the middle between the artist he had promised to promote and the Kansas dignitaries he had strong-armed into helping him. To plead his case with the artist,

he enclosed for Curry's benefit a copy of one of these repercussions, written to him by the honorable Mrs. Elsie J. Nuzman Allen of Wichita, art collector and wife of the former governor of Kansas:

Dear Will:
 Last week I saw the exhibit in Kansas City and feel just as I did when I saw the pictures in Topeka last year. Many canvases are the same. 'Gospel Train', 'The Baptism', and 'Interior of a Kansas Home' were missing. I feel Mr. Curry has a great force in delineating the subjects he has chosen, but to say he portrays the "spirit" of Kansas is entirely wrong, I think. To be sure, we have cyclones, gospel trains, the medicine man, and the man hunt, and we have had an automobile tip over a bank and kill a man, as he portrayed in his canvas "The Death of Ray Goddard". But why paint outstanding, friekish [*sic*] subjects and call them the "spirit" of Kansas?
 The strongest canvas in his show, I think, is his own self portrait, and that countenance alone reveals the man; one whose boyhood has only seen the most sordid conditions of life, and one who has not yet been able to see any of the glories of his home state, of the beauties of the . . . broad, far-reaching landscapes, to say nothing of such scenes as the Flint Hills. . . .
 I wonder if this sort of work that Mr. Curry is doing is not just a phase through which he will pass, and will soon come to see something beautiful in life and particularly life in Kansas.
 I was glad when I noted that Mrs. Whitney had bought four of his canvases. For a year and a half I have had letters from interested friends, beseaching [*sic*] that somebody buy his pictures in order that he might continue his work. I wonder if Mrs. Whitney did not recognize in him a strong young artist, but principally bought because she thought in building up her purely American museum of art that she was acquiring something peculiarly typical of Kansas soil and the middle west.
 All this because Mr. Curry is said to paint the very spirit of Kansas and not because I wish to criticize him as an artist, but just his theme. I do not wish to broadcast my feeling about this matter, and I probably am all wrong, but being Kansas born I cannot agree with the enthusiasm of the art critics of the New York Times and the Kansas City Star.

(signed) Mrs. Henry J. Allen[68]

Now Henry Allen was one of White's closest political cronies. They had served together in the Red Cross during World War I—White had even published a book memorializing their shenanigans. *The Martial Adventures of Henry and Me* sold some fifty thousand copies by presenting itself as "the story of two fat middle-aged men who went to war without their wives."[69] When the Kansas Bull Moosers had wanted to put Henry Allen on the gubernatorial ticket in 1914, it fell to Will White to get Elsie on the telephone and finagle her consent.[70]

 As a consequence, it was no small embarrassment that the exhibition that White had so strongly promoted was backfiring. More than that,

it was tough to argue with Elsie's sage analysis of Curry's sudden fame back East. There was an overwhelming consensus in Kansas that Curry was painting images that did not reflect the true character of the state, but rather sought to cater to shop-worn eastern stereotypes about the region. Mrs. Whitney and her confrères may well have sensed "something peculiarly typical of Kansas soil and the middle west" in Curry's pictures, but Kansans were quick to recognize familiar stereotypes they had tried so hard to live down. Eastern ideas about their state seemed to lie along two recurring prejudices—that Kansas was a place out there in the middle of the country that had a lot of tornadoes and a sizable lunatic fringe.

The first component of this image of Kansas has been stated rather succinctly in the pages of the *New York Times*:

The stereotyped conception of the physical Kansas is a flat, treeless plain reaching endlessly under an enormous sky, swept by scorching winds in summer and bitter blizzards in winter, tormented by tornadoes in spring and fall, and plagued often by grasshoppers that eat every green thing.[71]

Kansans themselves, however, were quick to point out that parts of their state were hilly and dotted with trees, and that any reliable statistic would show that the incidence of tornadoes per square mile was less in Kansas than in neighboring Iowa.[72] In its dogged efforts to dispel the image of Kansas as a cyclone-ridden wasteland, the Chamber of Commerce needed Curry's paintings just about as much as it needed that other popularizer of the dread stereotype, *The Wizard of Oz,* released to movie audiences in 1939.

The notion that Kansas was a hotbed of religious and political fanaticism had been around at least since the days when Carry Nation went about closing saloons with the gentle persuasion of her trusty hatchet. But if there were any doubts remaining about the character of the state by 1924, they were quickly dispelled by the vitriolic essay that appeared in H. L. Mencken's *American Mercury* that October. "Why Men Leave Kansas" was the revenge of a former Wichita editor on the many "cranks and uplifters" that had driven him to leave Kansas and migrate eastward in search of sanity.[73] Time and again it had been noted that a kind of "fervent response . . . bordering on fanaticism . . . is regarded by many easterners as characteristic of the people of Kansas":

In abolition, prohibition, Populism, anti-tobacco legislation, Brinkley worship, Winrodism, etc., they have gone off the deep end with desperate seriousness, and in so doing earned for themselves the name of being a humorless, puritanical people, incapable of joy and grudging in their attitude toward those happier than themselves.[74]

At times, the threads of these two prominent stereotypes about the wretched Kansas clime and the fanaticism of her people became intertwined into one scurrilous opprobrium. A case in point appeared when the *New York Times* referred to "the popular view of [Kansas] as 82,000 square miles of monotony so boring and dull as to be in itself a sufficient cause of religious and moral excesses."[75]

Kansans had ample reason to be testy about seeing their notorious cyclones and lunatics immortalized in Curry's paintings. Perhaps no other state except Arkansas had received such a bad national press. William Allen White had noted the nascent problem at the turn of the century:

Go east and you hear them laugh at Kansas; go west and they sneer at her; go south and they 'cuss' her; go north and they have forgotten her. Go into any crowd of intelligent people gathered anywhere on the globe, and you will find the Kansas man on the defensive.[76]

Like Bert's tea room guests, Curry's New York admirers who were seeking to recover a lost American past in the 1920s may well have treasured a glimpse of indigenous folkways and the rituals of backwoods Kansas religion. But Kansans wanted their art to reflect their psychic needs: "We need writers and artists to proclaim the beauty of Kansas and to demonstrate the intelligence of the majority and not the eccentricity of the lunatic fringe."[77]

Fig. 12 Vint Lawrence, parody of Curry's *Baptism in Kansas.* Although it never achieved the half-life of Grant Wood's *American Gothic, Baptism in Kansas* has remained an icon of ole' time religion. This parody accompanied an article by Henry Fairlie in the August 2 and 9 1980 issue of *The New Republic* on the danger of born again politics. A color reproduction of Curry's *Baptism in Kansas* was on the front cover.

And so, despite the massive two-pronged attack on the state launched by Maynard Walker from New York, there would be no Kansas sales of Curry art in 1931. The paintings and scrapbook of New York credentials were packed up and shipped east. Curry took the rejection quite hard. The grandiloquence of Walker's salesmanship had seemed to obscure the dire straits Curry had found himself in financially. His stipend from Mrs. Whitney was expiring. All the ravings of enthusiastic critics combined could not buy the groceries. The Great Depression was on; his wife was ill, had been for some time; and he was developing a drinking problem. He was, by various accounts, "up against it financially," "starving to death," and "in the slough of despond."[78] At the end of the 1931 exhibition tour, Curry confided to a friend: "Things look bad as far as selling anything and I can't do it even with the million dollars worth of publicity that I have gotten."[79] In February 1932, Walker wrote to Curry with even more bad news of prospective sales that had fallen through, and he urged him to keep his head up—"You'll be on the crest of the wave yet drinking champagne and nothing else."[80] But for Curry, the crest of the wave was nowhere in sight. In April he literally ran away from home to join the circus. He traveled with the Ringling Brothers–Barnum and Bailey Circus on its spring tour through New England, sketching the animals and acrobats (see fig. 13) and mingling with other wayward souls who had themselves run away from one thing or another.[81] Then, in July, his wife, Clara, died of heart disease.[82] Curry's close friend, Thomas Craven, recalls only that "in 1932, he underwent an emotional crisis, the agony of which will never be known, for he tore himself away from those whom he might have taken into his confidence."[83]

By the time John Steuart Curry showed up at Grant Wood's Stone City art colony in the summer

Fig. 13 *The Runway,* 1932, oil on canvas. In this painting made during his tour with the Ringling Brothers Circus, Curry seems to emphasize the psychological angst of these circus performers.

of 1933, he had already renewed his commitment to painting the land and lore of his midwestern roots. He had opened a studio in New York and had begun to teach classes at Cooper Union and the Art Students League in New York City. In 1934, he married a Westport divorcée, Kathleen Gould, and settled into family life with her seven-year-old daughter. His new wife was "an English girl, acquainted with the world," the daughter of a British army officer who had spent much of her childhood in India. In this new milieu, Curry soon "recovered his old vigor and enthusiasm." Home again at Westport, he painted *The Line Storm* (fig. 14), returning once again to Kansas-inspired themes in this dramatic depiction of a hay wagon scurrying for cover beneath a dark and threatening midwestern sky.[84]

In 1931, Maynard Walker had offered to sell Curry's masterpiece, *The Tornado,* at a price "considerably below the cost of a second-hand Ford." Four years later the Hackley Museum in Muskegon, Michigan, purchased the painting for "about ten times the sum Kansas had declined to pay."[85] By 1935, private collectors were paying anywhere from $250 to $2,000 to own a Curry canvas.[86] The artist was "jubilant" over the first sale of one of his paintings to a Kansas institution in 1933. "Kansas Heals Breach with a Native Son" rang the headlines of the *New York Herald-Tribune.*[87] When the offer of the commission to decorate the Kansas Capitol arrived, Curry thought he was finally riding "the crest of the wave." Recognition at home had been a long time coming, but he could finally accomplish the thing he most wanted to do—paint murals for Kansas. In August of 1937, John Steuart Curry left for Topeka to examine the walls of the Statehouse corridors and to begin his sketches for the mural project that would occupy the next four years of his life.

Fig. 14 *Line Storm,* 1934, oil on canvas. By 1936 this painting was owned by the playwright and screenwriter Sidney Howard (*Gone With the Wind, It Can't Happen Here*). He said that it allowed him to get "as large a slice of the U.S.A. as it is possible to get into a cramped New York apartment."

Chapter 2
Versions of the Past

The chance to paint murals for Kansas was a dream come true for John Steuart Curry. He had been seeking acceptance from his home state since he had first turned to memories of Kansas as inspiration for his paintings; but approval seemed a long time in coming. The paintings he had exhibited there in 1931 had offended Kansans. By leaving the Midwest and earning fame in the East, the artist had become an outsider to those Kansans who had never left the farm. Curry's paintings seemed to ridicule their eccentricities in the same way that condescending New Yorkers had been doing for years. How could some bohemian painter living in an East Coast art colony ever claim to portray the true "spirit of Kansas"? And if he genuinely admired the state, why had he left it in the first place? Such questions bothered many Kansans during Curry's first attempts to gain their support.

Art critic Edward Alden Jewell of the *New York Times* had been quick to read Curry's paintings of Kansas as satire.[1] Most Kansans who viewed the traveling exhibition in 1931 also attributed a somewhat malicious intent to Curry's peculiar typification of their state. It was not as though they totally lacked a sense of humor about themselves. Kansas newsmen were notorious for their scathing editorial criticisms of the state. These free-speaking editors were often relentless in exposing the quirks and inconsistencies of human behavior in their region. But there was one important difference—they had proven their real affection for the place by continuing to live there. William Allen White was no exception. He could get away with his biting satires because, in spite of it all, he chose to stay at home. For all his national fame and his friendship with presidents, Will White still freely identified himself as a small-town country editor from Emporia. Real Kansans could smile knowingly among themselves at their wretched weather and the doings of local crackpots, but the image they preferred to present to outsiders was one of progress and pastoral bliss. Curry had committed the unpardonable cultural sin of sharing their secrets with strangers. It was one thing to laugh among themselves, but to be laughed at was not to be tolerated.

It was not until Curry began to forsake his eastern ways that Kansans began to reconsider their position and accept him as their own. The intimidating approach of his New York agent, Maynard Walker, had proven to be the wrong one in soliciting their support. That Curry pleased New York art critics and turned the head of Mrs. Whitney not only failed to impress most native Kansans, it actually worked against him. It helped to confirm their worst suspicions about his motives—

he had become just like all those other sneering outsiders.

The appearance of *Time*'s 1934 article on Midwestern Regionalism seemed to result in improved relations between Curry and Kansas.[2] A photograph of Curry wearing farmers' overalls and visiting Grant Wood in Iowa (fig. 15) proclaimed to the nation the artist's unabashed identification with the Middle West. The article on those "earthy Midwesterners" left no doubt in the minds of its readers that America's heartland now had something to offer the centers of East Coast art. Benton, Curry, and Wood were dubbed the standard-bearers of regional pride. Following the lead of Iowa and Missouri, Kansas began to rally behind her native son. Local writers made little mention of Curry's earlier eastern success. This time around,

he was presented to his fellow Kansans as "a simple man who paints in overalls instead of a smock."[3] Newspaper coverage of Curry's return to Kansas to paint murals in 1937 glossed over his lofty New York credentials of years past to emphasize his hometown ties:

You can take a boy out of the country but you can't take the country out of the boy, the old saying goes. John Steuart Curry left a Dunavant, Kas., farm twenty years ago to learn to paint, but the farm never left him throughout his studies in Chicago, New York, and Paris.

Now Kansans are beginning to see that what really matters in Curry's paintings of tornadoes, thunderstorms, . . . hayloads and homesteads is the strong feel of 'country' in them.[4]

The question of Curry's reputation as a mural painter and of his qualifications to decorate the Statehouse walls was of little concern to this local

Fig. 15 John Steuart Curry and Grant Wood posing for a publicity photograph at the Stone City Art Colony, July 1933. This photograph appeared with the December 24, 1934 *Time* magazine article announcing the new midwestern Regionalism.

writer. More important was the artist's ties to Kansas soil and a lengthy account of the two-day visit he made to his parents' farm in Winchester:

At the meal of fried chicken, potatoes mashed with cream, other vegetables and iced tea, the talk was of the hot weather, the crops, [and] the school days of the children, when John first did drawings for the high school annual.[5]

In point of fact, Curry *had* recently demonstrated his abilities as a mural painter under a prestigious contract from the federal government. On May 9, 1934, painter George Biddle wrote to his former schoolmate, Franklin Roosevelt, and suggested that our country follow the precedent of the Mexicans and have some American artists paint murals in our federal buildings at workmen's wages; this casual letter between old friends helped to launch a mural renaissance in America that is still in evidence on the walls of post office buildings across the country.[6] By October, the Section of Painting and Sculpture was organized under the Treasury Department to embellish federal buildings with the highest quality work of American artists. John Steuart Curry was one of only eleven painters appointed without submitting to competition to carry out the first showcase mural project—the decoration of the recently built Justice Building in Washington, D.C. By the time Curry arrived in Kansas in August 1937, he had been named a winner in yet another mural competition sponsored by the Section, this one to decorate the Department of Interior Building in the nation's capital.[7] If Kansans were at all impressed by these credentials, one is hard pressed to uncover it in the local newspapers. At least one reporter was sage enough to know that a dinner of fried chicken down on the farm and some unfledged drawings in a high school yearbook would win more favors with the folks at home than any kudos garnered in the East.

The process by which Kansas came to welcome Curry home to paint murals for the Capitol was gradual. The momentum had begun in 1934 with the appearance of Curry's second wave of Kansas-inspired pictures and his growing self-identification with the Midwest. By deliberately affecting the persona of a down-home Kansas farmer, and by stressing his associations with the heartland whenever he was interviewed, Curry convinced a number of Kansans that they had misjudged him in 1931. "Kansas did not acclaim [Curry] just because the critics called him great," read one Kansan's account—"It was not until she was convinced there was no malice, no caricature, or no irony, in his paintings, but instead sincerity, love and sympathy, that she accepted him as her own."[8] *Time*'s article had helped tremendously in building this new image of an artist-in-overalls.

Then too the first purchase of a Curry painting by a Kansas institution was made in 1935 by the State Agricultural College in Manhattan. The campus Friends of Art had sponsored a drive for funds the previous year that resulted in the purchase.[9] Curry dispatched three canvases to the college: *Sun Dogs* (fig. 16) was a winter landscape of the open prairie with a glowing parhelion in the sky above; *Storm Over the Missouri* featured threatening clouds over a riverscape; and *Manhunt* showed a Kansas posse using bloodhounds to stalk the scent of a trail. Not surprisingly, the college selection passed over Curry's bad weather and lynch mobs and settled on the rather banal sunset over the plains.[10]

Nonetheless, Curry was greatly encouraged by the sale. He had grown increasingly embarrassed at the neglect he suffered in Kansas. When quizzed by reporters in 1933 about the dismal lack of sales in his home state, he rationalized and defended the state's position—"Why should Kansas want any of my work? It has Kansas."[11] He tried desperately to dispel the notion that nobody in Kansas liked his paintings. He named for reporters "a list of Kansans" (totaling two!) who had bought his canvases: Mrs. Mateel Howe Farnham, daughter of Ed Howe of the *Atchison Globe*, and Mr. E. G. Thompson of Kiowa, Kansas.[12] What he withheld, however, was the fact that Mattie Farnham was currently a former Kansan and fellow artist who was living near Curry in Westport—none other than the Arabian concubine companion with whom he had been photographed at the Westport Artists' Masque Ball. The other Kansas patron was a garage-keeper who had accepted one of Curry's early watercolors in exchange for repair work on the artist's car.[13] The purchase of *Sun Dogs* by a Kansas state institution using funds raised from within the state was, by comparison, a giant step toward genuine acceptance at home.

Another indication of the improved relations between Curry and Kansas is the appearance of an editorial by William Allen White on September 30, 1936. Commenting on Curry's employment by the University of Wisconsin after being turned down by Kansas institutions, White laments the loss in the pages of his *Emporia Gazette*:

John Curry wanted to come home to Kansas last year, tried to get some sort of a status in some Kansas college. . . . His heart turned back to Kansas and much good it did him. He wanted to honor the state by coming here to live but 'there was no room at the inn.' So John Curry has gone to Wisconsin State university where they have provided a job for him . . . [and] Wisconsin will reap the seed of his genius which was sown in Kansas.

Fig. 16 *Sun Dogs,* 1930, oil on canvas. Forgoing Curry's paintings of lynch mobs and stormy weather, Kansans chose to buy this winter scene of a parhelion over the prairie.

Fig. 17 William Allen White, editor and publisher of the *Emporia Gazette,* at work in July 1936. Curry's father had been a classmate of Will White's at the University of Kansas.

It takes something more than factories, something more than crowded towns and cities, something more than per capita wealth to make a civilization, and Kansas would be able to hold her head a little higher if she could have taken John Curry under her wing.

White's editorial was reprinted by other papers across the state.[14] During the next few months, other Kansas newspapermen followed suit by writing their own editorials. Just when the nation's attention was being drawn for the first time to the heartland as the home of a new American art, Kansas was losing her famous native son to another midwestern state.[15] Shortly thereafter, the idea surfaced to have Curry decorate the Statehouse. By May 19, 1937, editors Harris and Allen had written to Curry in Madison to solicit his interest in coming home to paint murals for Kansas.[16] Curry was both surprised and delighted.[17] From these small beginnings, the plan to commission the artist began to take shape. Harris and Allen visited the governor of Kansas to advance the idea. On May 26, with Allen sitting in his office, Governor Huxman wrote a letter asking Curry to visit him and discuss the matter of murals.[18]

On Friday, June 19, the Kansas Editorial Association held a banquet in Hutchinson in honor of William Allen White, "the most loved and most distinguished member" of the Kansas press.[19] That evening the editors voted to approve a proposal by Jack Harris to undertake a twenty-thousand-dollar fund-raising drive to finance some murals for the State Capitol Building. Governor Huxman, a guest at the dinner, heartily endorsed the association's proposal. Although no further decisions were made that evening, Harris strongly urged that John Steuart Curry be asked to do the job. After all, what better way to pay tribute to William Allen White than to honor the young artist he had tried so hard to promote in 1931?

Jack Harris had originally considered the idea of securing a legislative appropriation to finance the mural project, as Missouri had done for Benton's Statehouse murals. He wrote to Curry that he thought it would have been entirely possible to secure such an appropriation. But Harris felt that to finance the murals through private contributions would be "even more desirable and escapes the political angles that otherwise might creep in." As Harris envisioned it, the Curry murals would be a gift to the state from all the people of Kansas. He believed that the specific subject matter should be left solely up to the artist. The Kansas editors would merely be responsible for collecting the funds from the people to pay the artist. It would all be very easy to arrange. Harris assured Curry that there was "no question of the success of the undertaking."[20]

As there was no precedent for such a project, Governor Huxman had to use his own judgment. There seemed to be no harm in the state's accepting a gift from the people of Kansas. And since taxpayers' money would not be spent, there seemed to be no need for legislative involvement in the matter. Yet some sort of organizational structure was called for. The governor appointed a committee of Kansas publishers or wives of publishers to direct the mural campaign. The committee was comprised of Jack Harris, *Hutchinson News;* Paul Jones, *Lyons Daily News;* Mrs. Will Beck, *Holton Recorder;* Mrs. Roy Bailey, *Salina Journal;* Clyde M. Reed, *Parsons Sun;* Henry J. Allen, *Topeka State Journal;* William Allen White, *Emporia Gazette;* Leslie Wallace, *Larned Tiller and Toiler;* and Mrs. Cora G. Lewis, *Kinsley Graphic.* This group then evolved into the Kansas Murals Commission, with Governor Huxman serving as chairman, Allen as vice-chairman, and Wallace as secretary. An executive committee was named, consisting of Mrs. Lewis and editors White, Harris, and Jones.[21] J. R. Burrow, president of the Central Bank of Topeka, was appointed treasurer of the group.[22]

The Kansas Murals Commission held its first meeting on July 19, 1937.[23] The first order of business was to decide who would be engaged to paint the murals. Behind the scenes, of course, the plan had been tailor-made for John Steuart Curry from its beginning. But news of the mural project had already leaked to the larger public, and a string of promoters began to line up behind their favorite local artists. A Wichita paper suggested that the wall space be divided up so that the works of several artists could be used.[24] Another commentator, referring to Curry, proposed that "before the contract for the job is handed over to one artist who is addicted to tornadoes and bleak prairie scenes, why not look over our other artist resources with a view of selecting specimens of their work as well?"[25] Some interested citizens were in favor of awarding the commission to a single artist, but preferred to name some local Kansan who had been residing in the state rather than bring Curry in from Wisconsin.[26]

The publishers of the monthly trade publication *Kansas Business* had a vested interest in who might be commissioned to paint a panel on Kansas industry. They were not opposed to having some Curry paintings represented in the Statehouse. Curry might do a credible job on some scene from early Kansas history, but to promote Kansas industry, they were backing a native Topekan artist, Kenneth M. Adams. Adams's artistic credentials were above reproach. Considered "one of the top notchers" in the art-

ists' colony at Taos, New Mexico, he had studied art in Chicago and New York, France and Italy. He had painted murals for public buildings in Washington, for a theater in Colorado Springs, and for a post office in Goodland, Kansas. What's more, Adams was a nephew of the late Col. Cyrus K. Holliday, founder of the Santa Fe Railroad and one of the founding fathers of Topeka. These businessmen were promoting an artist of proven talents "whose forebears shaped the transportation system of this state and had a vast beneficial effect upon industrial progress of Kansas." And their argument against giving Curry the entire mural contract was both concise and direct: "If we are honestly interested in securing typical reproductions of Kansas past and present, let's not be bowled over by a big name which we had no part in making."[27]

Between the announcement of the fund-raising drive on June 19 and the first official meeting of the Kansas Murals Commission exactly one month later, a host of suggestions was offered as to which Kansas artist(s) should be selected to paint murals for the Statehouse. There is some evidence to suggest that Thomas Hart Benton even approached the Murals Commission to hire one of his assistants for the job.[28] The situation was becoming complicated. One solution would be to hold a competition in which any interested artist might submit designs, and award the contract to the artist who submitted the best sketches. This plan required that the submissions be judged and, as one of the members put it, "none of the committee felt himself qualified to pass such an artistic judgment." The publishers then considered selecting a second committee of qualified art professionals to judge the competition sketches. This alternative was rejected for two reasons. The members agreed that to create a separate committee of judges to select the artist "would have been to invite antagonism." In addition, they felt that the expense of conducting such a talent search would have added substantially to the cost of the project. These were, at least, the reasons the Murals Commission paraded before the public. But from the very beginning, the mural project was conceived as a means by which the editors could get Curry back to Kansas to share his fame. Hiring someone else for the job would defeat their purpose. "So," Harris explained, after rejecting the idea of a competition because of its presumed expense, "the committee fell back on the preeminent reputation of Curry and decided he was [the] one for the work."[29]

At the first meeting of the Kansas Murals Commission, the members adopted a resolution proposed to William Allen White "tentatively

agreeing" on John Steuart Curry as the artist. Although the vote was unanimous, the Commission provided itself with a loophole in the resolution. Curry's appointment would remain tentative until he submitted sketches for the designs; these preliminary sketches would then be subject to final approval of the Commission.[30]

The addition of this loophole in the agreement hinted at underlying reservations about giving Curry free rein to paint whatever he liked on the walls of the Statehouse. One Kansan's account explained that the Commission "wanted to be certain that these murals . . . are not too 'modernistic' in style or execution, or will not register impressions about the state and its people which might be considered humiliating or injurious.[31] Other conditions were spelled out in the pages of the *Art Digest* under the headline, "Must Be Sane":

> John Steuart Curry, native son, has been invited by the State Art Commission of Kansas to depict Kansas history on the walls of the State Capitol in a 'sane and sensible manner.' Members of the commission, according to the New York *World Telegram,* were emphatic in asserting there would be no 'outlandish characterizations' of historical Kansas figures such as John Brown

Fig. 18 Curry in his studio on the campus of the University of Wisconsin, circa 1938. In this photographic portrait by Diemer of the artist as genius, the light symbolically strikes the artist's forehead (wisdom) and hand (consummate skill).

and Carry A. Nation, no controversial paintings such as those of Thomas H. Benton which aroused a furore at the Missouri Capitol. Also, there must not be 'too much modernism'. . . . Whether Curry will accept the commission's conditions is not known.[32]

Reaction to the Commission's requirements was varied. Kansas artists rose to Curry's defense, objecting that the Commission had no business telling Curry what he should or should not paint. They contended that if newspaper editors were granted the right to tell artists what to paint, then artists should have the right to tell editors what to print.[33]

For the most part, however, Kansans were more than happy to have a hand in choosing what would be painted on their Statehouse walls. Suggestions began to roll in as soon as the proposed project was announced in the press. From the beginning Curry made it clear that he would not be content to paint "a soft, soppy presentation" of Kansas history—"I don't see how I can leave out John Brown or Carry Nation," he argued; "they were expressions of a militant Free Soil and a militant prohibition sentiment" that were, for him, an important part of the Kansas past.[34] But whose version of history should be portrayed? And just how many versions were there? If history were a matter of undisputed truth, as many assumed it was, there would be no problem. But the mere act of trying to reconstruct the past and condense 400 years of human events onto a limited amount of wall space required a highly selective vision that was, by necessity, subjective. William Allen White immediately recognized the problems inherent in such a portrayal and tried to steer Curry away from doing a history painting. "Some of the editors are inclined to want a historical story," wrote White, "but it is so difficult to know what is the truth of history and it is almost impossible to select significant facts in a mural narration that will convey the truth."[35]

But the history of Kansas was, by far, the favored subject. And discerning "the truth of history" was far less troublesome for those interested citizens who offered their own suggestions for what should appear in Curry's murals. Unfortunately, each of the contributors held his own version of "the truth" of the Kansas past—no two versions were exactly alike. Gradually, it became evident that the suggestions could be lined up on one of two sides of a budding controversy, which was analyzed in the local newspaper:

On one side are those who think Kansas history should be 'raw, rough, and true', with adequate representation of some of the state's unreconstructed individualists who figured in the early-day history; the other camp, 'the Toners Down', prefer milder subjects such as waving wheat fields, bright-faced sunflowers, and maybe a smo-

kestack or two. . . . There is little hope for any common ground between the two factions. . . . 'What', ask the realists, 'would a history of Kansas be without saloon-smashing Carry Nation? Give us our bewhiskered John Brown, our Sockless Jerry Simpson, our he-men of the West—two-gun Wild Bill Hickok [sic] or a Bat Masterson.'[36]

One of the more interesting Kansas notables nominated for inclusion in the murals was Dr. John R. Brinkley. Charles Harger, publisher of the Ailene Reflector, led the local movement to have "Doc" Brinkley and a herd of goats featured in the murals. Brinkley was an eccentric physician famous for his goat-gland transplants—surgical procedures that promised to restore sexual potency to human males by transplanting vital parts from the testicles of Toggenberg goats.[37] The famous goat-gland specialist from Milford, Kansas, also owned and operated the first radio station in the state, giving medical advice and prescriptions for his nostrums over the air using a radio transmitter powerful enough to reach the far corners of the nation.[38] By 1930, Doc Brinkley's license to practice medicine in Kansas had been revoked and his license to broadcast was being threatened, so he ran for governor as a write-in candidate—and won. In a highly controversial move election officials threw out at least fifty thousand of the Brinkley ballots and declared the Democratic candidate the winner.[39] Brinkley ran again in 1932, splitting the Democratic vote in that year's New Deal landslide, and thus facilitated the rise of Republican Alfred M. Landon. Many would argue that Doc Brinkley opened the way for the Republican presidential nominee of 1936.[40] Small wonder, then, that Harger's suggestion of featuring Doc Brinkley and his goats in the Statehouse murals attracted a sizable local following.

"The proponents of a mild history," according to the Kansas City Star, "might permit a Coronado flanked by conquistadores, buffaloes covering the plains, or a covered wagon," but they would certainly not stand still for a panel devoted to Carry Nation's hatchet-swinging temperance crusade or to old Doc Brinkley's goats.[41] The closets of the Kansas past were replete with such "raw, rough, and true" historical figures, and that version of "truth" was exactly what they feared most from an artist like John Steuart Curry:

Perhaps the chief point in the controversy arises over the apprehension that Curry will do for Kansas what Benton did for Missouri.
In the Missouri statehouse, Mr. Benton painted murals with a slashing and perhaps bitter satire, using the caricature technique and emphasizing the ungainly peculiarities of Missouri hill-billies. He introduced the bandit James brothers [see fig. 19], Boss Prendergast, of Kansas City, and other rather unorthodox characters, judged from conventional mural philosophy.

Some of Curry's work has been of somewhat similar flavor. He has emphasized Kansas tornadoes, baptisms in watering troughs, hogs killing snakes, and other subjects which do not have any particular connection with the significant achievements of the state. Those who are not now enthusiastic about his technique fear that he will emphasize the ugly and repulsive features of Kansas history.[42]

These were some of the sentiments already brewing in Kansas when Curry arrived on the scene in early August to begin planning his mural sketches. On one side were the spirited backers of a lively Kansas history, colorful and unique in its tribute to the state's "unreconstructed individualists." They were out to show Missouri that Jesse James and Boss Prendergast could hold no candle to a Wild Bill Hickock, a Doc Brinkley, or a "Sockless Jerry" Simpson. On the other side were the civic boosters who wished to proclaim the "beauty of Kansas" and who did not wish to be reminded of the notorious and embarrassing lunatic fringe that made for colorful history. Curry decided that the artist would have to have the final say.

On August 3, Curry drove down from Madison to examine the space and layout for the intended mural cycle. He had the walls photographed for later reference and asked the state architect to make a sketch of the rotunda for his calculations. Curry planned to execute the murals in fresco, a technique in which colors suspended in water are applied directly to fresh plaster. The colors sink deep into the plaster, so that if the surface chips, the picture still remains. Curry estimated that the murals "would last 5,000 years" using this technique. The murals would cover an estimated eighteen hundred square feet of wall space. Some marble wainscoting in the rotunda would be removed and the walls replastered to make room for the paintings.[43]

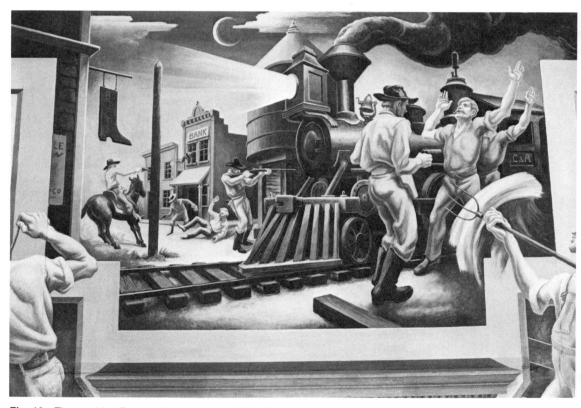

Fig. 19 Thomas Hart Benton, *Jesse James,* 1936, oil and egg tempera on linen mounted panel, detail from "A Social History of the State of Missouri," mural cycle in the Missouri State Capitol, Jefferson City. Other Benton scenes that made Kansans cringe included a vigilante lynching, a barroom shooting scene from the legend of Frankie and Johnny, and a woman changing a baby's diaper at an outdoor political meeting.

With reporters in Topeka, Curry was "carefully reticent" concerning his own ideas for what should appear in the murals. He reassured them that his approach to subject matter would be "very different" from Thomas Hart Benton's. "Benton's interpretation of Missouri history was logical," reasoned Curry, "because of his noted family's political interests and traditions. . . . He has a political tradition that I don't have. My tradition is agrarian." This stated distinction may have consoled Kansans fearful of having political aberrants, such as "Sockless Jerry" or old Doc Brinkley, affixed to their Statehouse walls for the next five thousand years. But no one in the "Toners Down" camp of history painting could have derived much comfort from Curry's final appraisal that "Benton did a good job" in the Missouri Capitol.[44]

John Steuart Curry was searching for a personal view of Kansas history. "I want to picture what I feel about my native state," he explained.[45] His acceptance of the mural commission marks a dramatic confrontation of the artist with his past— a past, both personal and historical, that had been continuously filtered through his memory and through his art during those long years since he had left the Kansas farm of his youth. Before composing his sketches for the mural cycle, Curry returned to that "old home farmstead" and tried to recover the texture of his past. He was born in 1897 on a farm "three cornfields east" of the town of Dunavant.[46] Dunavant was a railroad boomtown that was named after a Civil War general.[47] In the summer of 1916, just before he left the family farm, Curry had worked as a section hand on the old Northwestern Railroad out of Dunavant to earn money for tuition at the Art Institute of Chicago.[48] At that time Dunavant was a hub of commercial activity: four trains a day stopped in town, transporting grain and livestock to the Kansas City markets sixty miles away and bringing back mail, foodstuffs, hardware, and farm supplies.[49] In 1937, when Curry drove out to Dunavant, he found that the town was no more than a "windswept ruin at the crossroads—the eroded bones of a community killed by drought."

A few box-elder trees, dead long ago, stand on one side of the main highway; on the other side, among the sunflowers, an iron safe, half-buried in a pile of bricks, marks the grave of the Farmers' State Bank. The railroad is gone, and the white schoolhouse, and on the site of the Calvinist House of God stands a comfort station erected by an overland bus company.[50]

He left the deserted streets of his old home town and went back to the country school in Hickory Point where his teacher, Miss Jennie Mitchell, used to let him go to the blackboard and draw railroad engines "when ever I felt the urge." He

stood in the empty school room, reenacting the rituals of his childhood as he "drew an engine on the same black board like I had 32 years ago."[51]

Before returning to Madison, Curry spent several days studying Kansas history in the State Historical Society and in the public library in Topeka.[52] Back in Wisconsin, reflecting on the past, Curry sketched out his plans for the Statehouse murals. He submitted the designs in November at a meeting of the Kansas Murals Commission in Topeka.[53] For his theme he chose a history of Kansas, conceived in three discrete segments to accommodate the tripartite division of the Capitol floorplan. To accompany the preliminary oil sketches, Curry wrote the following description and explanation of his designs:

Since undertaking the project of murals for the State Capitol I have received many suggestions relating to subject matter and the mode of approach. In such a situation the court of last appeal must be the artist himself.

The theme I have chosen is historical in more than one sense. In great measure it is the historical struggle of man with nature. This struggle has been a determining factor in my art expression. It is my family's tradition and the tradition of a great majority of Kansas people. And though I fully realize the importance of Kansans in the fields of politics and the various phases of education and human welfare, these phases are removed from my vital experience and that experience is necessary for me to make a forceful art expression.

Back of the historical allegory is the great back drop of the phenomena of nature and to those [sic] who live and depend upon the soil for life and sustenance in these phenomena is God.

———

Tragic Prelude [fig. 20]

East and north wall of East Corridor (22' × 11'6") fronting on the Governor's Office.

In the words of William Allen White, the period depicted in these two panels was a 'tragic prelude to the tragic years to come.'

At the left of the East Corridor door Coronado and Padre Padilla, the Franciscan missionary, look out across the Kingdom of Quivira, above which float the omnipresent buzzards.

To the right of the archway stands the figure of the plainsman and buffalo hunter, behind him the slain buffalo, and behind them the thundering herds of buffalo pursued by Indians—and behind all a lurid sun which lights the scene on both walls.

Centered on the north wall (31' × 11'6") is the gigantic figure of John Brown. In his outstretched left hand the word of God and in the right a 'Beecher's bible.' Beside him facing each other are the contending free soil and pro-slavery forces. At their feet, two figures symbolic of the million and a half dead of the North and South.

In this group is expressed the fratricidal fury that first flamed on the plains of Kansas, the tragic prelude to the last bloody feud of the English-speaking people. Back of this group are the pioneers and their wagons on the endless trek to the West, and back of all the tornado

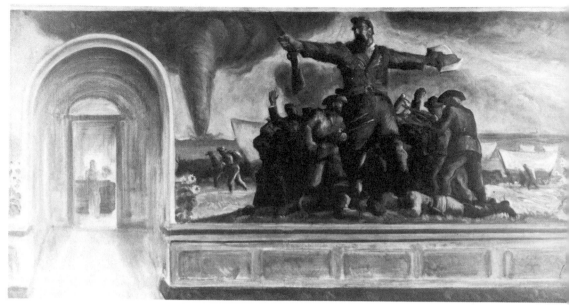

Fig. 20 *The Tragic Prelude* I (John Brown) and II (Coronado, Padre Padilla, and the Plainsman), 1937, oil sketches for the Kansas Statehouse murals, oil on canvas.

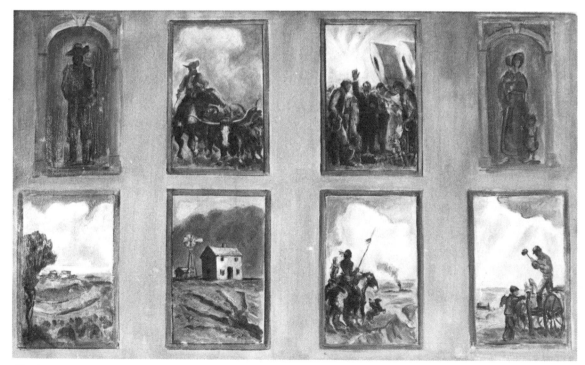

Fig. 21 *The Eight Panels in the Rotunda,* 1937, oil sketches for the Kansas Statehouse murals, oil on canvas. This is one of several different variations of plans for the Rotunda area. Curry worked on more than eight themes and experimented with them in varying combinations between 1937 and 1941.

and the raging prairie fire, fitting symbols of the destruction of the coming Civil War.

The Eight Panels in the Rotunda (11'6" × 7'5") [fig. 21]

These panels being grouped in separate pairs offer a problem in design—the designs are paired in idea and composition and preserve a common horizon line. These designs as submitted are not yet completed and must be understood from that point of view.

In the large detail sketch of these spaces some suggestion of how a sculptured figure would enhance the effect is given, and the effect with the marble removed from above the wainscoting is also shown.

Two panels are at the right of the East Corridor Entrance:

(1) *The Homestead*

Before the wooden shack sits the prairie wife paring potatoes. The child investigates the process; beside her the kitten; beyond, the wide expanse of open country.

(2) *Building the Barbed Wire Fences*

The building of the barbed wire fences ushered in a new era. Behind their barbs grew up a different civilization and doomed forever the roving life of the cattleman and wandering hunter.

Two panels are at left of the East Corridor Entrance:

The Plagues

(1) *Like ancient Egypt, Kansas is at times beset by plagues.*

In this panel is depicted drought and grasshoppers. In the foreground on the parched ground stand the stalks

of stripped and withered corn; before the blazing sun floats the cloud of hoppers.

(2) *Soil Erosion and Dust*

Sheet erosion and the shoe string gully are two of the great calamities of our nation, and in the midwestern plains can be added wind erosion. In the foreground of this panel is the clutching hand of erosion directed toward the abandoned farm home. Beyond is the threatening cloud of dust. This panel is designed as a significant warning and voices the concern of government and education forces interested in preserving the nation's resources.

Two panels are at the right of the West Corridor Entrance:

Corn and Wheat

In these two panels are two basic products of our fruitful land: wheat and corn.

Two panels are at the left of the West Corridor Entrance:
(1) Commemorating the sacrifice of life of those who forged westward on the old Santa Fe Trail.

This depicts the burial of a child. Before the rising sun the pioneer minister with raised hand pronounces the last benediction. Surrounding him the fellow travelers, back of them the wagons hitched and ready to proceed westward.

(2) *The Great Cattle Drives*

This panel depicts the great herds that for thirty years were driven from Texas to the roaring rail points of central and western Kansas.

Corridor Entrance off Rotunda:

Kansas Pastoral [fig. 22]

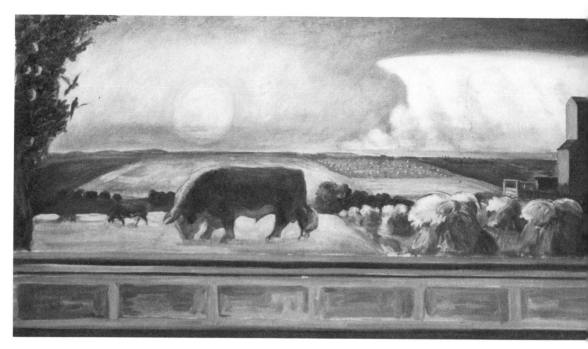

Fig. 22 *Kansas Pastoral* I (The Unmortgaged Farm) and II (Kansas farm family), 1937, oil sketches for the Kansas Statehouse murals, oil on canvas.

In this comparatively quiet corridor is portrayed Kansas in the time of fruitful Harvest.

In color and tone, and their unlimited possibilities of expression, will be portrayed the overpowering sensuousness of the land at sunset and in its time of abundant harvest.

On the north wall (22′ × 11′6″) are two spaces portraying the industry of the oil fields.

Here are shown the oil rig and refinery which again demonstrate the tremendous resources of the state. On the west wall stand the ten-foot figures of the young farmer, his wife and children, and back of them the ideal unmortgaged farm home—back of that the night and evening sky.

On the long wall to the south (29′ × 11′6″) a great reach of the Kansas landscape. In the foreground the Hereford bull, wheat field, feeding steers and hogs, a grain elevator, doves in osage orange trees. Behind all these are fields of corn and grain running back to the distant hill and the setting sun framed by the great turreted cloud to the north.

I have been accused of seeing only the dark and seamy side of my native state. In these panels I shall show the beauty of real things under the hand of a beneficent Nature—and we can suppose in these panels that the farm depicted is unmortgaged—that grain and cattle prices are rising on the Kansas City and Chicago markets—so that we as farmers, patrons, and artists can shout happily together, 'Ad Astra Per Aspera.'[54]

Curry's preliminary oil sketches, made on a scale of two inches to the foot, were approved "in design and spirit" by the Kansas Murals Commission on November 12, 1937.[55] Because the extremes of the Kansas climate "make plaster on

the stoutest walls in time crack and check," the initial plan to execute the murals in fresco was discarded in favor of painting directly on canvas mounted to panels of wood, a method that would also allow for rearranging of the murals in the event of any reconstruction of the Statehouse.[56] Curry estimated that it would require at least a year to complete the cartoon sketches—this to be done in Madison—and an additional two years of painting in the Statehouse to complete the project.[57] He offered to do the job for his home state for the sum of twenty thousand dollars, a price that was "even below 'WPA scale'."[58]

Curry's preliminary oil sketches for the Statehouse murals were widely publicized in the Kansas press.[59] People were particularly interested in the themes and characters Curry had chosen for his personal reconstruction of Kansas history. With so many suggestions as to what should properly be included in or excluded from a suitable history of the state, the unveiling of Curry's version of the Kansas past had been eagerly anticipated. Given the wealth of proposals that had been tendered, those elements Curry excluded from his version of history were as much of interest as those he selected. The headlines of the *Kansas City Journal-Post* extracted key elements from both categories: "Curry Passes Up Drys and Brinkley in Planning Capitol Murals but John

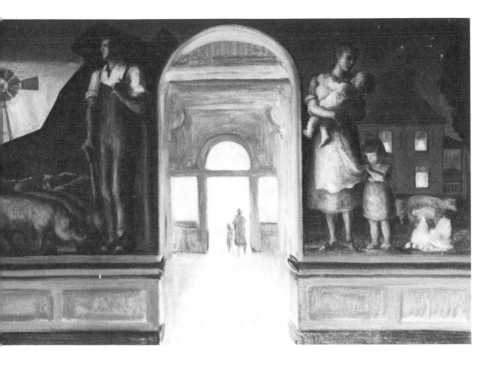

Brown and Dust Storms Go into Sketches Submitted Today to State Committee in Topeka." The feature article pointed immediately to the relative absence of the lunatic fringe. There was, the writer observed, "no suggestion of politics except John Brown to suggest any of the fanaticisms for which Kansas was once noted." Topics that had provoked the most heated discussions were summarily registered and singled out for comment:

The never-ending prohibition struggle is ignored. The Populist uprisings are passed over. Also, 'the Brinkley phenomenon'. Carry A. Nation is 'out'. So are the crusades against the cigaret, the Landon presidential campaign, the war on the public drinking cup and the legal ban on the eating of snake meat.

But there is a cyclone in the background of the John Brown scene which no one can overlook. There is a plainly depicted dust storm, and a record of what is happening through soil erosion.[60]

John Steuart Curry's pictorial reconstruction of Kansas history relies on his intensely personal view of the past. Since so many suggestions had been offered for the artist's consideration regarding what should appear in the murals, each element in Curry's composition reflects a cognitive process of deliberate choice. The obvious absence of some widely discussed proposed alternative, then, reveals an implicit rejection of one

view of history in favor of another. Similarly, the artist's final product is the result of careful decision making, of weighing and considering a number of alternatives to arrive at a highly selective and significant panorama of the past. Historiographers have long noted that, to some degree at least, every generation rewrites the past in its own image. The paintings that remain to us today on the walls of the Kansas State Capitol Building grew out of a particular cultural context. Although they may be said to depict the history of Kansas, the images have as much to do with the personal beliefs of the artist and the dominant cultural concerns of the 1930s as they do with any "real" or absolute notion of the "true" history of Kansas. When one views these paintings from a vantage point in the present, this dimension of meaning is lost to the puzzled onlooker. The pages that follow will explore that rich matrix of meanings and associations that these images held for the artist who created them and for the audience for whom they were intended. To this end, the paintings will be considered in light of the specific social and cultural contexts from which they emerged. The result will be an open-ended inquiry of their meaning based on questions arising from the visual imagery itself, from larger cultural concerns of the decade, and from the beliefs and convictions of the artist who imagined them into existence.

Chapter 3

In Search of
a Usable Past

To judge fairly of those who lived long before us . . . we should put quite apart both the usages and the notions of our own age . . . and strive to adopt for the moment such as prevailed in theirs.[1]—Lady Louisa Stuart, c. 1827

John Steuart Curry's murals for the Topeka State-house condense the vast panorama of the region's heritage into a personal conspectus of the Kansas past. From the prodigious storehouse of incidents and personae in the annals of the state's history, Curry prudently singles out a select series of scenes to portray in his narrative picture cycle. In setting out to depict the entire history of the state, the obvious problem arises as to where to begin the saga. The region that is now Kansas had been inhabited by American Indians for thousands of years before the relatively recent period of exploration and settlement by Europeans. The state, in fact, takes its name from the Kansa Indians who lived there.[2] It might seem altogether reasonable, then, to begin a history of the state with a nod to its indigenous population.

Any number of scenes from Indian life and lore could have lent themselves to pictorial expression in Curry's cycle of Kansas history. Near Medicine Lodge in Barber County, there is a natural amphitheater where the United States government and five tribes of Plains Indians signed peace treaties in 1867, opening western Kansas to white settlement and permitting the building of railroads to the Pacific coast. There were some five thousand Indians present at the signing of the treaties, which virtually put an end to Indian warfare in Kansas. According to the *Sketchbook of Kansas Landmarks* published in 1936, "Every five years a pageant is held in this amphitheater in commemoration of the event."[3] The Indian site became increasingly popular during the early 1930s. In 1931, the Kansas legislature voted to set aside four hundred acres here as a state park and appropriated ten thousand dollars to develop the amphitheater as a pleasure spot.[4] A mural panel devoted to the signing of the peace treaties at the Medicine Lodge amphitheater would have several virtues to recommend it. Owing to the ritual reenactment of the events in the popular historical pageants, the panel would be instantly recognizable as a familiar scene from local history. Furthermore, that moment in history serves as a nexus for the confrontation of several social forces—the indigenous Indian culture, the beginnings of white settlement, and the nascent overland transportation system—that were central to the subsequent development of the state. And from a dramatist's perspective, the pictorial portrayal of the mass meeting of minds at Medicine

Lodge would allow the artist to paint the backdrop of a rare phenomenon of nature as well as to manipulate a cast of thousands.

But Curry chose to begin his Kansas story not with a scene from the primeval Indian past, but rather with the arrival of Coronado, "the first white man known to enter Kansas."[5] Surveying the range of historical subject matter in the more than 2,500 murals created by the Federal Art Project of the Works Progress Administration (WPA), Francis V. O'Connor concludes that "the rich, ancient, archetypal lore and icons of our continent's Indian tribes" are curiously missing:

> Our muralists . . . sought to trace a national lineage which inevitably went back to our European origins. . . . The culture of the American Indian was not then—and is not today—a part of our usable past.[6]

The search for a "usable past" in the American experience has been identified by a growing number of cultural historians as a dominant mode of expression during the depression decade.[7] From the restoration of Colonial Williamsburg to John Ford's "Young Mr. Lincoln," the wholesale "rediscovery of America" in the New Deal era has been interpreted as evidence that in times of trouble depression America turned to the past as a foundation for the present.[8] This position was best articulated from within the culture by John Dos Passos:

> We need to know what kind of firm ground other men, belonging to generations before us, have found to stand on. . . . In times of change and danger when there is a quicksand of fear under men's reasoning, a sense of continuity with generations gone before can stretch like a lifeline across the scary present.[9]

But howevermuch a plundering of the past was exacerbated by the pressing psychological needs of hard times, history could also be used in the service of hard feelings. For those with an ideological ax to grind, the past could be summoned up as a lesson as well as a comfort. Writing in 1934, Joseph Wood Krutch was one observer who was mindful of this experiential bias in the writing of history:

> In Oscar Wilde's day it was still being said that America had no past. Two generations later Van Wyck Brooks was compelled to realize that we were at least two hundred years old, and he varied the complaint. What we lacked, he said, was a *usable past,* and with brilliant effect he set about to make one for us. Today the trouble seems to be that we have too many pasts, and that the proponents of one will have nothing to do with the others.[10]

Krutch went on to catalogue the rapid growth of usable pasts that had arisen since the appeal from Van Wyck Brooks in 1918.[11] The "usable past" of a Mencken, for example, could not always be reconciled with the past of a Granville

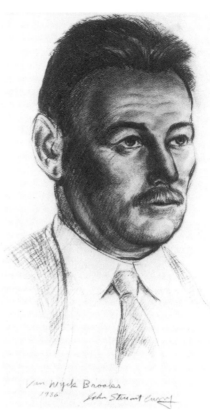

Fig. 23 *Portrait Sketch of Van Wyck Brooks,* 1936, pastel. Curry was a friend and neighbor of Brooks's in Westport.

Hicks, for whom the villain in history was not the grim shadow of the Puritan but rather the Spirit of Capitalism. In the face of these conflicting versions of the past, Krutch reveals the underlying pragmatism reflected in historical reconstructions:

> To one who confesses himself unashamedly skeptical and frankly eclectic it may possibly occur that neither the system of the anti-puritan nor the system of the Communist is more than a convenient fiction, and that a 'usable past' is not something which is discovered but something which is created—chiefly for the purpose of enriching or serving the present. . . . The past we believe in is the past which justifies today.[12]

The discussion that follows will suggest several ways in which John Steuart Curry's murals for Kansas may be said to rely on a curious admixture of each of these major uses of history at work in the 1930s—history in the service of ideology and history as a wellspring of spiritual renewal and emotional catharsis.[13] At times the scales may tip unevenly, favoring an emphasis on didactic propaganda or on psychic regeneration. But throughout Curry's reconstruction of Kansas history—in his decisions to choose Coronado, John Brown, the ravages of soil erosion, and the

scenes of pastoral bliss—there emerges a decidedly pragmatic approach to the available past. The particular way in which Curry appropriated certain salient aspects of the state's heritage to his own painted cycle of history, when viewed against his own cultural context, had perhaps as much to do with current concerns of the 1930s as it did with recording the events of days gone by. As these images are examined in more detail, questions will arise that bring the history of ideas to bear on the meaning of the works of art. In effect, the aim will be to unravel the ways in which art and ideology and current events intersect in this history painting.

The mural is a medium that involves a dialogue between the painter, the patron, and the public. It is, by virtue of residing on the wall for all to see, a social form of art. The mural renaissance of the 1930s held as its credo this conviction about the shared beliefs between the painter and the art audience. In 1936, Holger Cahill, director of the WPA's Federal Art Project, gave expression to this social role of mural painting:

Mural art is not studio art; by its very nature it is social. In its great periods it has always been associated with the expression of social meanings, the experience, history, ideas and beliefs of a community.[14]

This analysis of the murals for the Kansas State Capitol Building will incorporate those "social meanings" that attached themselves to Curry's historical protagonists during the 1930s. What were the ideas and beliefs of the community for whom the paintings were intended? How did that audience feel about Coronado, about John Brown, about grasshopper plagues and soil erosion on the plains? Was there a consensus about these heroes and events from their collective past? If not, what did each faction of the triad of patron, painter, and public believe about the issue, and why?

The ability to "read" and react to these images in the same way the 1930s Kansas audience would have done is difficult to recover because, as Lionel Trilling has observed about the past, "the great distracting buzz of implication has stopped and we are left only with what has been fully phrased and precisely stated." This iconological study of the Curry murals will, of course, consider those things that have been "fully phrased and precisely stated" about the paintings. But beyond that, it will, by drawing on the history of culture and ideas, weave a web of context that may help to recapture part of that "huge, unrecorded hum of implication" that surrounds these cultural expressions and that gives us access to their intrinsic meaning(s).[15]

John Steuart Curry's cycle of Kansas history opens with a panel devoted to the Spanish explorer, Coronado, and the Franciscan missionary, Father Juan de Padilla, looking out across the Kingdom of Quivira (see fig. 24). One way to ascertain what many Kansans believed about Coronado and Padre Padilla is to investigate the inscriptions that were recorded on roadside historical markers erected during the same period that Curry was planning his mural cycle. Since the selection of historical markers and their narrative content were both under the supervision of a state-appointed committee, these documents are useful in gauging a consensus among local experts regarding the state's history. Two markers are of particular importance in recovering the popular beliefs about Coronado and Padre Padilla among Kansans in the late 1930s. The first roadside historical marker was erected on Highway US-50N, west of Lyons, in Rice County:

Coronado and Quivira

Eighty years before the Pilgrims landed at Plymouth Rock Spanish explorers visited Kansas. Francisco Vasquez de Coronado, seeking gold in New Mexico, was told of Quivira by an Indian called Turk. Here were 'trees hung with golden bells and people whose pots and pans were beaten gold.' With 30 picked horsemen and a Franciscan Friar named Juan de Padilla, Coronado marched 'north by the needle' from a point in Texas until he reached Kansas. Here he found no gold, but a country he described as 'the best I have ever seen for producing all the products of Spain.' The Turk confessed he had deceived the Spaniards and one night was strangled. For 25 days in the summer of 1541 Coronado remained among the grass-hut villages of the Quiviran Indians, then returned to New Mexico. Padilla went with him, but the following year came back to Quivira as a missionary. Later he was killed by the Indians, the first Christian martyr in the present United States. Near this marker is the site of one of the largest villages in the 'Kingdom of Quivira.'[16]

The second roadside marker was erected at the intersection of Highways US-50N and US-77, one mile south of Herington, in Dickinson County:

Father Juan de Padilla and Quivira

In 1540 Francisco Vasquez de Coronado marched north from Mexico with 300 Spaniards in search of the 'Seven Golden Cities of Cibola.' With them were several priests, including Juan de Padilla, a Franciscan friar. When the golden cities proved to be only adobe pueblos the Spaniards went on to explore the Southwest and Padilla was among those who discovered the Grand Canyon. Later he marched with a party of 30 picked horsemen to the land of Quivira in Kansas. For 25 days in the summer of 1541 Coronado remained among the grass-hut villages of the Quiviran Indians, then returned to New Mexico. Padilla went with him, but the following year came back as a missionary. Here he was later killed by the Indians, the first Christian martyr in what is now the United States. Although the exact place of his death is unknown, there is a monument to Padilla in City Park in Herington.[17]

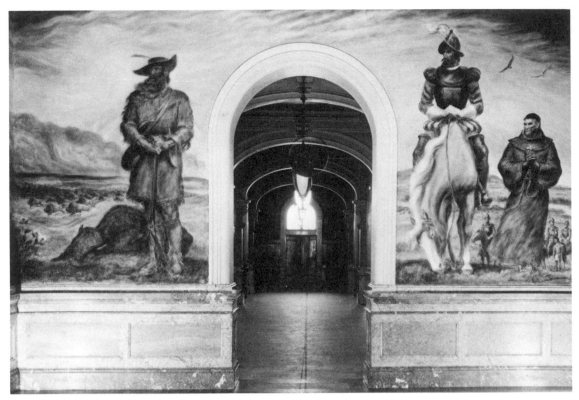

Fig. 24 *The Tragic Prelude,* 1937–42, east wall of the East Corridor, Kansas Statehouse murals.

In seeking to understand Curry's painted portrayal of Coronado and Padre Padilla, the text and context of these roadside historical markers are helpful for a number of reasons. The written texts, which are themselves a reflection of prevailing local opinion, provide an instructive literary analogue to Curry's pictorial history cycle. And the circumstances surrounding the production of these markers in the 1930s suggest a great deal about the ways in which history was deemed both useful and usable in Kansas.

The movement to erect roadside historical markers in Kansas began in 1934, when the State Chamber of Commerce developed a plan to capitalize on the advertising potentials of the burgeoning trends in highway tourism. Until then, it had been the practice to erect on the sites where the events had actually occurred historical markers usually consisting of a few words on a plaque or monument that was situated at some obscure and inaccessible location.[18] Inspiration for the roadside project was sparked by an incident that involved Roy F. Bailey, editor of the *Salina Journal* and then-president of the State Chamber of Commerce, and his twelve-year-old daughter:

Eight years ago, in the summer of 1934, a typical Kansas family was taking a vacation trip. On the way to the Atlantic coast, the members stopped at the George Washington Museum, just east of Uniontown, Pa., on US-40. There they spent several hours inspecting the hundreds of articles assembled because of their association with the Father of his Country, as well as the site of Fort Necessity, the Great Meadows, the grave of General Braddock just across the road, and many others of equal interest.

As the family climbed into the car, the twelve-year-old daughter sat silently for a few minutes, and then said, 'Daddy, does Kansas have any history?'

. . . Back to Kansas he went, and in the fall of that year he persuaded the Kansas Chamber of Commerce, of which he was president at the time, to authorize the appointment of a special committee on marking and mapping historic spots in the sunflower state.[19]

Several major selling points finally resulted in state funding for the roadside marker project. For six years the project was heavily promoted. The plan was endorsed by nearly every major organization in the state. Speeches were given in support of the proposal in almost every county in Kansas, but no funds were forthcoming. The turning point came when promoters linked the pro-

posal with the upcoming Coronado Entrada, the nationwide celebration of the 400th anniversary of the explorations of Coronado in the American Southwest. Governor Ratner, who had previously declined an appropriation, saw in this new presentation of the proposal the rich possibilities of increased tourist travel in the state. A boom in the state's tourist trade "meant more gasoline tax to build and improve highways, as well as the cash crop that would be harvested by hotels, eating places, drug stores and similar businesses directly, and all the others indirectly."[20] State history, which had long been of interest only to local antiquarians, was suddenly becoming quite useful.

Another major selling point to the proposal became instantly apparent to the governor's wife, a member of the DAR, who saw in the Coronado connection a unique opportunity to assert an ancient Kansas past to East Coast history-mongers:

For only 49 years after Columbus had discovered America, but 66 years before the settlement at Jamestown, and 79 years before the Pilgrims landed at Plymouth Rock, the territory which now is called Kansas, had been visited by its first tourists, headed by Don Francisco Vasquez de Coronada. And in 1542 Father Juan Padilla had been the first Christian martyr of the New World to give his life for his faith—somewhere in the area which now is Central Kansas.[21]

The early expeditions of Coronado and Father Padilla in Kansas threw up a serious challenge to shopworn East Coast claims to historical precedence in our national heritage. For a white explorer and a Christian martyr had visited Kansas soil a full "66 years before the settlement at Jamestown, and 79 years before the Pilgrims landed at Plymouth Rock." The roadside historical marker project, with Coronado and Father Padilla as its standard-bearers, could arouse among Kansans an interest "in the heritage of history which creates the state pride which is essential to the development of any commonwealth." The markers could create a "usable past" for the citizens of a state that had been scarred by slanderous stereotypes and given no place of grace in the annals of national history as seen through the eyes of eastern writers:

Today the men and women of Kansas—and most important of all—the children of the state, are being given a course in visual education that has made them realize that they need not take a back seat for the First Families of Virginia, or the citizens of any of the other states of the Union. Nor is that all. Every tourist who travels through Kansas is being given a similar education.[22]

By opening Kansas history with the early explorations of Coronado and Padre Padilla, Curry links the Kansas present to a long and noble heritage of white, Christian, European culture that

predates that of the eastern states. The revival of interest in our colonial past in the depression decade has been expounded by numerous cultural historians of the period—the George Washington Bicentennial celebration in 1932 and the restoration of Colonial Williamsburg are but two manifestations of the phenomenon.[23] It must have seemed to many in the 1930s that George Washington had slept virtually everywhere except, perhaps, in Kansas. In the midst of this national ballyhoo, Coronado emerged as a very useful figure indeed. Pushing Kansas history past its relatively recent statehood in 1861, all the way back to Coronado's visit in 1541, enabled Kansans to frustrate eastern claims to our national heritage.

This potential for regional one-upmanship was not lost on the members of the Kansas Murals Commission. Editor Bailey's wife was, in fact, a member of the Commission. So was Paul Jones, editor of the *Lyons Daily News* and author of a book on Coronado that opened with the following paragraph:

The tourist from the Atlantic seaboard, who rolls through Kansas in his automobile or views the prairie landscape from the observation car of a fast limited, expresses or politely represses a feeling of pity for those who are forced by circumstances to reside in a state where vistas are unbroken by forests, mountains or dashing waves; a section without history and traditions, where buildings are bright and new, where no moss or ivy clings, where there are no 'ruins grey that men revere.' He is surprised when told that visitors from Europe traveled through Kansas, remarking the fertility of her soil, the beauty of her skies and the majesty of her plains, 79 years before the Pilgrims set foot upon Plymouth Rock, 66 years before Captain John Smith swashbuckled through the streets of Jamestown and 235 years before the Declaration of Independence was signed in Philadelphia.[24]

Coronado and Quivira was published in early 1937, just as the Curry murals project was beginning to take shape.

And the connection between the Curry history paintings and the usefulness of the Coronado legend was anticipated in *Kansas Business* a full four months before the Curry mural sketches were unveiled to the Commission. The July 1937 article reported the intention of the state's editors to raise the $20,000 "for the purpose of applying several coats of history to the walls" of the Statehouse, and went on to comment:

The project is a worthy one. Kansas history antedates that of the eastern coast states whose efforts to glorify their origins have found expression in pictures, stories, music and drama. By comparison with eastern history, Kansas events dating back four hundred years to Coronado will require deep, strong pigments to set them forth properly.[25]

A month before Curry had even arrived in Topeka

for the initial visit to examine the available wall space, this article was announcing that among local folks it was "widely felt that the series of murals for the state house must begin with Coronado."[26] In this new era of national rediscovery, proud Kansas was not about to be dismissed as "a section without history."[27]

If Curry failed to read these wishes from the pages of *Kansas Business,* he most certainly was informed of them by Paul Jones of the Murals Commission. In fact, Jones was almost single-handedly responsible for the colossal Coronado craze that struck Kansas in the late 1930s. The state's participation in the Coronado Cuarto Centennial activities of 1940–41, and the prominent place given to Coronado and Padre Padilla in the Curry murals, are the direct result of the vigorous campaign of Paul Jones to "bring Coronado back to Kansas."[28]

In Kansas, Jones was deemed an extremely likable but somewhat eccentric old bird. In a state that was notoriously dry and Republican, Jones was both a Democrat and "a 'wet' of profound convictions." "Among other eccentricities, Paul Jones wears what he calls a 'Pawnee Indian haircut,' [see fig. 25] lives in a house as Spanish as Don Quixote's, dotes on red-hot Mexican dishes, which he eats from Mexican ware, and is known far and wide as the 'Admiral of the Kansas Navy'." Kansas, of course, being "just about as far away from the ocean as it is possible to get on this continent," had no navy.[29] The admiralty appellation stemmed from his dampness on the temperance issue and from a trait he shared with his "I-have-just-begun-to-fight" namesake—that "he loves nothing so much as the exchange of torrid verbal broadsides with some other political ship-of-the-line."[30] The Pawnee Indian haircut is an altogether different matter. It was achieved by shaving the head up to an area near the top of the skull, at which point the hair was permitted to grow straight up "like the roached mane of a mule."[31] This curious coif, which the Admiral believed to be imitative of that worn by Pawnee Indians when they visited Coronado at a site somewhere near the present-day Lyons, symbolized Jones's consuming devotion to the cult of that Spanish explorer.[32]

Paul Jones had first become obsessed with Coronado in 1927, after he and several other local history buffs discovered a group of potsherds near Lyons that seemed to suggest the location of an ancient Quiviran village site. This led Jones to believe that Don Francisco Vasquez Coronado must have passed very close to the site of his own home town of Lyons, Kansas. With this in mind, it became a matter of "immense personal

Fig. 25 Newspaper clipping showing Kansas editor Paul Jones sporting his Pawnee Indian haircut, 1940.

importance" to Jones to find out more about the Spanish conquistador. He read avidly on the subject, wrote numerous newspaper articles, and eventually published a book on Coronado. But there were still many unanswered questions, so Jones set out on an intensive research expedition that lasted for several months. He traveled all over the Southwest attempting to trace the exact route taken by the conquistador. He made no less than three trips to Mexico City, where on one occasion he bought an advertisement in a Mexican newspaper and offered a reward of a hundred pesos for any information leading to the burial place of Coronado or to knowledge of a lineal descendant. Soon he had amassed a number of esoteric and previously unknown facts about Coronado—his burial place in the Church of Santo Domingo, his date of birth, his ancestry and coat of arms, and the location of his wife's grave. These new findings were released in Jones's second book, *Coronado and Quivira.*[33]

Paul Jones may well have been "the Man Who Made His State Coronado-Conscious."[34] But the real impetus for the statewide preoccupation with Coronado in the 1930s was the imminent 400th anniversary of his travels in the American Southwest. The anniversary would occur in 1940 or 1941, depending on the location, but plans had been in the making since the idea to commemorate Coronado's explorations was conceived in the fall of 1930 by a public school teacher in New Mexico.[35] In 1939, the United States Coronado

Exposition Commission was established, consisting of the Vice-President of the United States, John N. Garner, the Speaker of the House, William B. Bankhead, the Secretary of the Interior, Harold L. Ickes, and the Secretary of Commerce, Harry L. Hopkins.[36] Two additional members from New Mexico were appointed to the Exposition Commission, and headquarters were established at Albuquerque.[37] The Seventy-sixth Congress appropriated $200,000 for the commemoration of the Coronado anniversary, and plans for the observance were launched. Government-sponsored celebration activities took chiefly four forms: the publication of historical books and pamphlets; the establishment and extension of historical museums; the promotion of hundreds of folk festivals throughout the Southwest that reflected the region's Spanish, Indian, and cowboy cultural traditions; and the staging of the "Coronado Entrada," a mammoth traveling outdoor pageant that was presented in twelve or more dramatic scenes. The actors in the production, which also included fifteen to twenty-five horses and other livestock as well, required a stage equal in size to that of a regulation football field.[38]

The Coronado Cuarto Centennial was largely the product of the state of New Mexico. The idea was conceived there and given momentum when the state legislature passed a bill in 1935 creating a corporation known as the New Mexico Fourth Centennial Coronado Corporation to keep the idea alive and generate funds for the celebration. It was the New Mexican congressional delegation that fought for and secured the necessary federal legislation to back the project. The only outside members of the federal commission were from New Mexico, and the national headquarters for the United States Coronado Exposition Commission was established at Albuquerque.[39] Coronado's travels in the United States are most closely linked to an area that now lies within the borders of New Mexico. In 1940, with 52 percent of New Mexico's population still Spanish-speaking, and with the lingering ceremonial rituals and traditions still being celebrated by the Spanish-descended and Indian populations, it could still be said of New Mexico that "life goes on much in the same manner as it did in the days of Coronado."[40] To celebrate the Spanish heritage of New Mexico was to acknowledge the continuity of cultural traditions that formed an integral part of the state's twentieth-century legacy.

Modern Kansas, on the other hand, was primarily an agricultural state, whose family farms were descended from the waves of nineteenth-century homesteaders, eastern settlers moving west to till their own spot of land. The character of Kansas did not derive from pueblo villages or Spanish missions, from Frijoles Cliff Dwellers or San Ildefonso potteries. And even if Coronado did, in fact, pass by the site of the Admiral's home town, modern-day Lyons was still no Taos. Paul Jones's early struggle to reclaim Coronado for Kansas was met with understandable indifference. "It is highly probable," wrote one observer, "that most of the people of Kansas care as little about Coronado as they do about *Merlin* or *Sancho Panza*."[41] Perhaps this was so, but neither had an advocate at work in Kansas as indomitable as Admiral Jones.

Early in 1936, Jones initiated interviews with other newspapers, telling the story of Coronado.[42] He set up a lecture tour and began giving speeches across the state. He found, however,

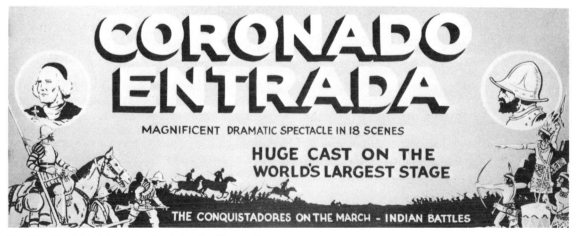

Fig. 26 Roadside billboard advertising the Coronado Entrada pageant, 1941.

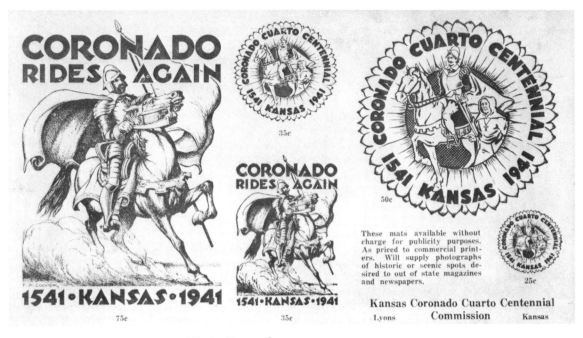

Fig. 27 Publicity materials prepared by the Kansas Coronado Cuarto Centennial Commission, 1941.

that Kansans "refused to become excited over anything so far in the past." So he went to the closing session of the 1939 state legislature and became "a one-man Coronado lobby." Jones "button-holed legislators in the lobbies and preached to them the gospel of the Coronado Cuarto Centennial."[43] Painting a vision of rampant tourism heralded by Spanish banners of red and yellow, he argued that it would be "good business" for the state to get involved:

Red and yellow fly all over the state. . . . 'Tourists see it and ask about it. They are informed of the celebration of Coronado's visit, and advised to see the community sights. For example: A tourist leaves Kansas City early in the morning, expecting to beat it across the state and stay in a Colorado cabin or hotel that night. At Merriam he sees red and yellow flying, thinks little of it, perhaps. At De Soto he sees more red and yellow, thinks it is for a chautauqua or something.

He pulls into Lawrence. More red and yellow. Now he stops and asks. He is told. Also told about the Indian display at Haskell Institute, the dioramas at Dyche museum, and other things. Halts an hour to see them. Is told about Curry murals, the famous rose garden, and the John Brown relics at Topeka. Stops there. Now it is lunch time. Gets the spare tire fixed while waiting, also buys a new shirt.

Goes on. Is stopped in Salina to see the Indian burial pits. Has to spend the night in a hotel at Hays. Sees Ft. Hays park and college fossil collection that evening. Women folks buy quite a bit of stuff.

A few hundred dollars invested in red and yellow bunting and flung to the Kansas breeze will return mil-

lions to the state. The Coronado celebration is a historical observance all right, but Kansas stands to profit by it.'[44]

These were just the words Kansas legislators wanted to hear in the closing years of the Great Depression. They immediately passed a twenty-thousand-dollar appropriation bill to finance the Cuarto Centennial celebration in Kansas. Then, with the promise of financial glory before them, they adopted red and yellow as the official colors for auto license tags for 1941 to help spread the gospel of Coronado on every highway in the state.[45] And so, with an idea borrowed from New Mexico to boost a sagging depression economy, Kansas jumped headlong into marketing Coronado to attract the burgeoning tourist trade through the American Southwest.

In 1939, Governor Ratner appointed a Kansas Coronado Centennial Commission to plan for the observance, and, not surprisingly, he named Paul Jones to head it.[46] It is also no coincidence that another familiar name appeared on the letterhead of the Kansas Coronado Commission—that of Roy Bailey, editor of the *Salina Journal*.[47] Bailey was already a firm believer in the usefulness of local history in this blossoming age of motor tourism. As president of the State Chamber of Commerce, Bailey had been barking the commercial virtues of history-mongering since the conception of his roadside marker plan in 1934.[48]

It is not very difficult to uncover the complicity involved in John Steuart Curry's choice to afford Coronado a starring role in his murals for Kansas. The development of the theme can best be traced through the somewhat incestuous constitution of certain state-appointed cultural commissions. Paul Jones, editor of the *Lyons Daily News,* served both as head of the Kansas Coronado Cuarto Centennial Commission and also on the ruling executive committee of the Kansas Murals Commission. The invitation to Curry in 1937 to paint murals for Kansas coincided with the publication of a book by Jones that offered Coronado as a healing antidote to a state pitied by easterners as "a section without history . . . where no moss or ivy clings."[49] Letters to Curry, still in Madison, about the Statehouse murals were written on the letterhead of the Centennial Commission and signed "Coronadoly Yours, Paul Jones."[50] Curry later made Jones a gift of one of the sketches for the Coronado mural panel as a tribute to the man who brought Coronado back to Kansas.[51]

As the wife of a newspaper publisher, Mrs. Roy Bailey had also been appointed to the Kansas Murals Commission. And so, at least two members of the Murals Commission knew just how "usable" the past could be. On the one hand, it could line the pockets of roadside merchants as that new breed of Americans—the motor tourists—mapped their way across the state, devouring local history and buying food, gasoline, and souvenirs along the way. On the other hand, a past predating that of the Atlantic seaboard could heal wounded pride and show the "Bert Statzer's" of the state that "they need not take a back seat for the First Families of Virginia, or the citizens of any of the other states of the Union."[52] In both of these respects, the Coronado saga was an altogether commodious choice of subject matter for the Curry murals. And the timing would be flawless: the murals were scheduled for installation in the Capitol Building late in 1940, just in time for the traveling Coronado Entrada to pass through Kansas the following year. One can best recapture a fitting context for Curry's Coronado panels by imagining them draped in the Spanish banners of red and yellow bunting flying everywhere in Kansas in the commemorative year of 1941. Add to that mental image of the murals an imaginary souvenir stand installed alongside them in the corridors of the Statehouse—offering Coronado key chains, perhaps, or Padre Padilla potholders—and you will begin to see these paintings as a Kansas audience might have experienced them.

Those civic boosters who went in search of a "usable past" for the theme of the Statehouse murals struck the motherlode in the story of Co-

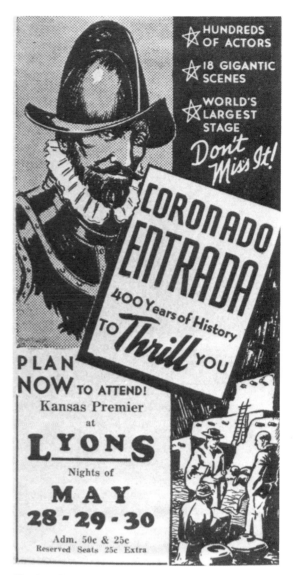

Fig. 28 Poster advertising the Kansas premier of the Coronado Entrada. The pageant played in five locations in Kansas in 1941, with fourteen separate showings throughout the state.

ronado. The latent appeal of unveiling some new Coronado murals during the commemorative years was surely set forth by the two mural commissioners, Jones and Bailey. And we need not imagine that our artist-in-overalls was altogether nescient of the profit to be made if his paintings could siphon some New Mexican tourists into nearby Kansas. In fact, Curry may have been more knowledgeable than either commissioner about the profitability of roadside tourism. In 1934 he submitted a series of paintings to accompany an article on auto tourism that appeared in *Fortune* (see fig. 29). "The Great American Road-

Fig. 29 *Tourist Cabins,* 1934, oil on canvas. Illustration for "The Great American Roadside," in the September 1934 issue of *Fortune,* where it appeared under the title *American Night Piece.*

side," with illustrations by John Steuart Curry, was an entrepreneur's guide to a booming young industry which, according to the author, "will gross, in this, the fifth year of the great world depression, something like $3,000,000,000."[53] Roadside business was showcased as a sure thing for the profit-conscious readers of *Fortune* because it relied on the one natural resource that even economic depression could not diminish—the fervent "restiveness" of the American people:

And . . . the Great American Roadside, where this people pauses to trade, is incomparably the most hugely extensive market the human race has ever set up to tease and tempt and take money from the human race. . . . After the autoist had driven round and round for awhile, it became high time that people should catch on the fact that as he rides there are a thousand and ten thousand little ways you can cash in on him en route. . . . And along the Great American Road, the Great American Roadside sprang up prodigally as morning mushrooms, and completed a circle which will whirl for pleasure and for profit as long as the American blood and the American car are so happily married.[54]

The "happy marriage" between the automobile and the restive American spirit could mean big profits for the roadside merchant, and *Fortune* informed its readers how they could capitalize on it. Like some ornithologist's notebook, tracking a rare avian route, *Fortune's* centerfold map (painted by Curry) charted the carefully calculated migration patterns of the *homo touristo,* with regional and seasonal variations well noted. Superimposed on Curry's painted map, the following guide:

The U.S. Migrations are seasonal, and the main streams diverge centrifugally with a light North-South warp. . . . Not the moon but the sun governs the strongest tides. . . . As the promise of sunshine draws them, so too are they compelled by nature (not in the raw, but medium-done). These two, Sun and Nature, supply the chief magnetic power of the five major meccas. . . . The five beaches along which these migrant waves break most abundantly are California (apoplectic showmanship and triple-distilled climate); Florida (for the low-bourgeois); New England (for history and natural beauty); the Great Lakes States (for woodland lakes, Indians, fishing); and the National Parks (Nature niftily packaged). But a thousand lesser appeals to American sentimentality and American curiosity tend to twirl and eddy the straight migratory trends . . . battlefields and other national shrines . . . Caves . . . Indians . . . Sentiment (Your Old Kentucky Home, Evangeline's Oak and Grave). Washington, for obvious patriotic reasons. For the same, every state capital. The wet states, for those who must still patronize bootleggers . . . and perhaps above all, as a one-man show, the Lincoln country.[55]

According to Curry's map and to *Fortune's* explication of it, Kansas was losing ground on at least two accounts. For the convenience of thirsty travelers, Curry's map tagged each state according to its current standing on the temperance issue since the repeal of prohibition the year before. Only Kansas and three southern states were still "Bone Dry." Beneath the Kansas label was the hopeful rejoinder: "non-intoxicating beverages only—Referendum in Nov." The only attraction offered the auto tourist en route through Kansas was a chance to stop near Wichita and see where Carry Nation smashed her first saloon. Worse

than that, Kansas and her contiguous neighbor-states north and south found themselves branded with the distasteful epitaph, "The Transient Belt." The text of the article spelled out the bad news that "the lodestones appear to be set about the periphery, and the roadman crosses but abhors the middle vacuum—the great transient states."[56] According to Curry's map, at least, Kansas lacked the right stuff to "draw the traveler to a halt and his silver from his pocket."[57]

Fortune's message was clear: The Great American Roadside was, above all else, "a mighty market place, 900,000 miles in length, $3,000,000,000 in girth, and founded upon a single word: restlessness."[58] When Paul Jones and Mrs. Roy Bailey spoke of cashing in on the tourist appeal of some well-chosen history paintings for their State Capitol Building, they knew that history was good business in 1941 "This is Coronado year in Kansas," one writer observed, "every village, town and city has been encouraged to provide something of interest for tourists during the summer of 1941."[59] John Curry could not escape knowing what Coronado murals might do for the "mighty market place" in Kansas.

So, too, did a number of other states. As the Cuarto Centennial year approached, more and more states pressed the claim that "Coronado slept here." Kansas may have sensed a winner in Coronado, but there were quite a few scholars who would argue that the Spanish conquistador had never set foot in the state. "The approach of the cuarto-centennial anniversary of Coronado's famous explorations," as noted in the Kansas Historical Quarterly, "has revived the perennial historical controversy over the exact location of Quivira."[60] As red and yellow bunting hung across Kansas, and as Curry's Coronado and Padre Padilla peered out across the plains of Quivira from the walls of the Statehouse in Topeka, scholars elsewhere were discounting the folly of what they called "the Quivira-in-Kansas idea."[61] The most ardent disbeliever was, perhaps, Texas scholar David Donoghue, who published widely on the topic.[62] To Donoghue, the "Quivira-in-Kansas idea" was the result of a nineteenth-century historian's mistranslations of the narratives of the expeditions and that historian's "limited knowledge of the western plains country." Through a detailed scientific analysis of the topographic descriptions found in the narratives, Donoghue, who had been trained as an engineer and a geologist, published new evidence that declared any route through Kansas to be "impossible."[63] Moreover, he ridiculed the non sequitur reasoning that was most recently being offered in support of locating Quivira in Kansas:

The latest support to the Quivira-in-Kansas theory is based on flimsy evidence supplied by 'certain spots of extremely rich soil' identified as archaeological remains of grass lodges presumably standing at the time of Coronado's alleged visit and occupied by the Quiviras or Wichitas![64]

Although the roadside historical marker near Herington and the Curry murals in the Statehouse placed "the land of Quivira in Kansas" as a matter of course,[65] historians had identified Quivira with various sites ranging from east Texas to southwestern Missouri, or as far north as Nebraska or the Dakotas![66]

As for Padre Padilla, nothing was sacred. There he was alongside Coronado, newly painted on the walls of the Statehouse (see fig. 30). And there was the Chamber of Commerce President, Roy Bailey, beaming proudly that "79 years before the Pilgrims landed at Plymouth Rock . . . Father Juan Padilla had been the first Christian martyr of the New World to give his life for his

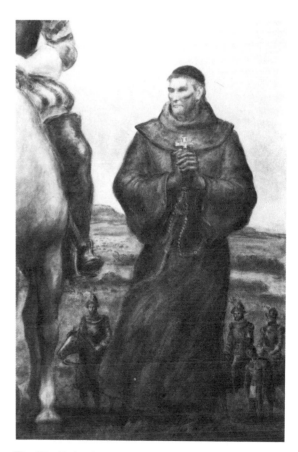

Fig. 30 Padre Juan de Padilla enters Kansas on foot with the expedition party of Francisco Coronado, detail of The Tragic Prelude, 1937–42, section of east wall of the East Corridor, Kansas Statehouse murals.

faith—somewhere in the area which now is Central Kansas."[67] A noble act, indeed; but what Bailey and the Curry murals publicity literature neglected to mention was that more than one state lay claim to the martyrdom site of the peripatetic padre. "Nebraska's fertile plains were baptized with the life blood of America's first Catholic martyr," or so said the *Catholic Historical Review*.[68] In Isleta, New Mexico, residents were just as certain that Padre Padilla's bones are contained in a cottonwood coffin that is buried in the earthen floor of their old Spanish mission.[69] And in Kansas, as if to take no chances, Padilla's grave site is marked by monuments in two separate locations: once in Herington, and again thirty miles away in Council Grove.[70] In 1936, Carlos Castañeda, building on the findings of David Donoghue, claimed that Fray Juan de Padilla had been slain not in Kansas, Nebraska, or New Mexico, but in Texas, in the center of the northern Panhandle.[71]

Clearly the Kansas connection to Coronado and Padre Padilla was under fire as the Cuarto Centennial year approached. But Curry and the State Chamber of Commerce had found a "usable past" around which the people of Kansas could rally. And rally they did. Despite the controversy brewing elsewhere, Kansans claimed Coronado and Padre Padilla as their own.[72] During the spring of 1941, many of the state's newspapers published a special supplement entitled, "Coronado Rides Again in Kansas," prepared as advance publicity for the cuarto centennial festivities. The *Salina Journal* issued a special forty-page Cuarto Centennial Entrada supplement presenting a number of articles on Coronado written by Kansans (see fig. 31). At the annual meeting of the Augusta Historical Society in 1941, a Mrs. Grimes reviewed Paul Jones's book, *Coronado and Quivira*. Mrs. Byron Hubbard of Chase, Kansas, delivered a lecture to the women's club on "The Artist and Coronado," featuring sketches by Curry and a number of other Kansas artists. And in July 1941, the Shawnee Mission Indian Historical Society sponsored a Coronado pageant in Johnson County, Kansas, in which more than a hundred people participated.[73] The headlines of the *Wichita Eagle* confirmed that the Coronado craze had caught on: "Hosts of Kansans to Find Coronado Show Next Year to Top New Mexican Effort."[74] Kansas had not only borrowed the idea from New Mexico, it planned to beat that state at its own game. With its dramatic landscape, its artist colonies, and the preservation of so much of its Native American culture, New Mexico had long been an established mecca for auto tourists. With all the ballyhoo about Coronado being stirred up, the

"transient state" of Kansas had finally found a way to ride on the coattails of New Mexico and bring some of that revenue to the Sunflower State.

John Steuart Curry's Coronado murals were deemed a genuine success. But in terms of the amount of interest they provoked from the viewer, it was neither Coronado, nor Padre Padilla, nor even the "omnipresent buzzards" hovering over Quivira that sparked the most lively comment. The star of the Curry murals was Coronado's horse. The padre was believed to have entered Kansas on foot.[75] But Curry painted the conquistador sitting astride a magnificent golden Palomino. "You can almost hear the golden creature crunching the emerald green prairie grass," wrote one admirer. According to reports in the Kansas press, "Everybody who sees the east wing murals agrees that the horse on which Coronado is riding is a fine bit of painting of horse flesh."[76]

Well, not quite everybody. Curry had managed to offend a good number of prominent Kansas cattlemen by having Coronado ride into Kansas on a horse of questionable pedigree. The first coat of underpainting on the Coronado panels

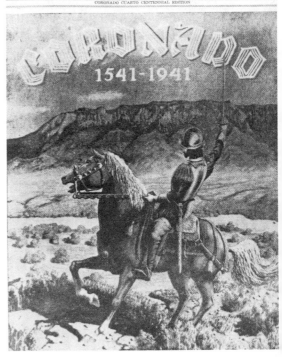

Fig. 31 Coronado Cuarto Centennial edition of the *Salina Journal,* June 30, 1941.

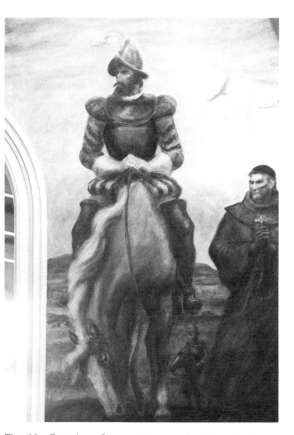

Fig. 32 Francisco Coronado in search of the Kingdom of Quivira, riding astride a golden Palomino, detail of *The Tragic Prelude,* 1937–42, section of east wall of the East Corridor, Kansas Statehouse murals.

was not yet dry when the headlines of the *Topeka Capital* queried, "Coronado Arrived in Kansas Astride a Scrub Pony?" The writer relayed the concern that "the murals in the Statehouse lobby will teach the schoolchildren of the Sunflower state" that "Coronado arrived in Kansas astride a Palomino stallion":

> The Palomino, "The Golden Horse," treasured now by California fanciers of horse flesh, is just a "scrub" according to the Kansas State Board of Agriculture.[77]

More than a dozen owners of Palominos had been rejected by the state's livestock registry office because the animals were not bred by registered sires or dams. According to state registry official A. W. Atchison, "A Palomino is just a yellow horse."[78]

The choice to place Coronado on a Palomino was neither fortuitous nor inconsequential. The concern it generated served to illustrate what Phil Stong had already noted in his study, *Horses and Americans*—that people are "much more particular about the pedigrees of their horses than they

are of those of their children." And even Stong considered that in 1939, Palominos were "on the freak side of the breeding business."[79] John Curry knew all of this. His own father was a Kansas stockman (see fig. 33), and young John had been sketching various breeds of horses on his father's ranch since childhood.[80] He painted steeplechasers in Paris in 1927, went to the International Stock Exposition in Chicago in 1937 to sketch grand champion Percheron stallions, and could often be found at the University Stock Pavilion in Wisconsin drawing prize breeds at local livestock shows.[81] One of Curry's paintings of Wisconsin Belgians (fig. 35) was used as the color frontispiece for Stong's book, *Horses and Americans.*[82] John Curry knew the world of horses, and he knew that the hybrid Palomino bearing Coronado might not sit well with traditional, pedigree-conscious Kansas horse breeders.

Curry also knew that he was actively breaking tradition by painting Coronado astride a golden Palomino. The most famous image of the conquistador to date was certainly that of Frederic Remington, in which Coronado is shown leading

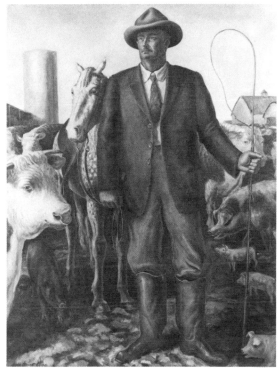

Fig. 33 *The Stockman,* 1929, oil on canvas. Courtesy Collection, Whitney Museum of American Art, New York Acq #31.161. The artist's father, Smith Curry, portrayed with riding boots and whip, holding the reins of an Appaloosa.

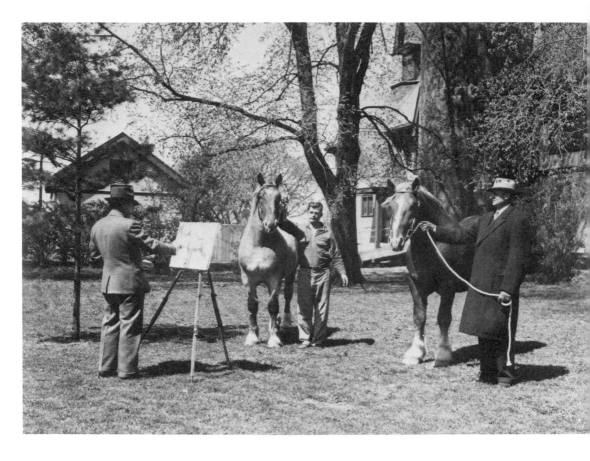

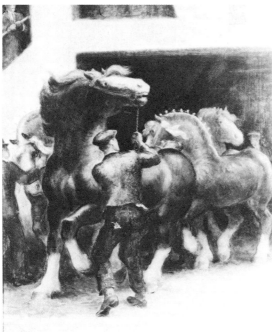

Fig. 34 Curry sketching horses on the campus of the University of Wisconsin. At far right is Dean of Agriculture Chris Christensen.

Fig. 35 *Belgian Stallions,* 1938, oil on panel. Curry often sketched the horses on show at the oval arena of the University of Wisconsin Stock Pavilion. These stallions are in the narrow runway about to enter the arena.

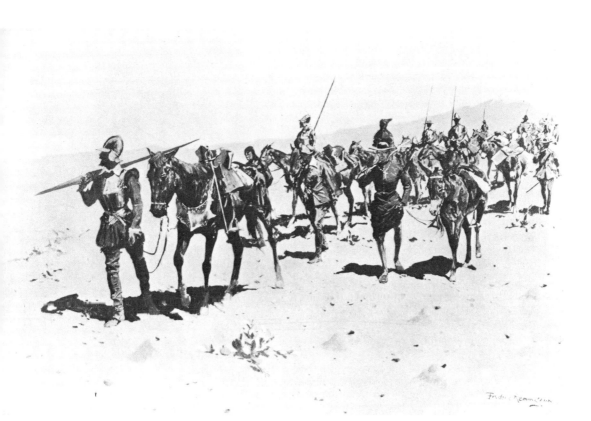

Fig. 36 Frederic Remington, *Coronado's March,* circa 1897, painting for Henry Inman, *Old Santa Fe Trail,* 1898, published by Crane and Company, Topeka, Kansas. Remington's Coronado appears understandably weary from his march through the Southwest in search of Quivira.

Fig. 37 Publicity poster for the Coronado Cuarto Centennial celebration in Kansas, 1941. Kansas promoters also reversed Remington's conception in their portrayal of Coronado.

an emaciated bay through the southwestern desert (see fig. 36). Remington's painting was widely illustrated, and Curry could easily have seen it in Stong's *Horses and Americans* or in Paul Jones's *Coronado and Quivira*. It had been used repeatedly as an illustration in a number of books on Kansas history.[83] In contrast to Remington's conception of a weary Coronado leading an emaciated horse, Curry's image is full of vigor. The well-fed and carefully groomed Palomino on which Coronado rides seems more likely to have just stepped out of the livestock exhibit than to have narrowly escaped starvation in the plains of Texas on the way to Quivira.

Whatever the "truth of history" might have been, few tourists would be lured to the Kansas Statehouse to see a frail and defeated Coronado leading a starving horse. Depression America had seen its fill of starving livestock in the documentary photographs of Dust Bowl drought taken by New Deal Farm Security Administration photographers.[84] Grim reality was not the stuff of a Sunday pleasure excursion.

Curry's Coronado had all the appeal of a Hollywood hero. The effect was deliberately contrived, including the golden Palomino, the latest champion of the silver screen. The white horse of virtue made popular by such early B-western heroes as Buck Rogers, Fred Thomson, and Hopalong Cassidy was being displaced in the late 1930s by the famous golden Palomino of Republic Studio's singing cowboy, Roy Rogers.[85] Moreover, Coronado was wearing a conquistador outfit that was rented from a Hollywood supply house.

Curry had written to United Costumers, Inc., in Hollywood and placed the following order: 1 Franciscan monk costume, $10.00; 1 conquistador costume, $20.00; 1 Union soldier uniform, $15.00; 1 Confederate soldier uniform, $15.00; and 1 Deerslayer costume, $15.00.[86] In painting his Kansas murals, Curry had various students at the University of Wisconsin don these Hollywood costumes and pose for him in his Madison studio (see figs. 38 and 39). As a result, the characters in his murals would be immediately recognizable and familiar to a movie-going audience, looking more like the heroes at the Bijou than a photograph in a history book. Curry's Plainsman (fig. 40) in his Kansas murals might well have been wearing the same costume worn by Gary Cooper when he starred in *The Plainsman*, a Cecil B. DeMille historical thriller of 1936.

In planning his opening mural cycle, Curry knew full well that a Palomino was more than "just a yellow horse." He was attuned to the most current popular cultural stereotypes and heroes. A virile Coronado riding through the West on a

Fig. 38 Model for Coronado figure sitting on a sawhorse in Curry's studio, 1940. Curry had University of Wisconsin students don Hollywood costumes and pose for the historical figures in his Kansas murals.

Fig. 39 Preliminary study for figure of Coronado in the Kansas Statehouse murals, 1940, oil on canvas.

Fig. 40 The Plainsman, figure study for *The Tragic Prelude,* 1940, oil on board.

unrecorded hum of implication" is a fleeting phenomenon, as volatile as a fad or a fashion, and all too often part of a lost reflection of shared knowledge possessed by people at some moment in the silent past.

In the late 1930s, at least, the Coronado legend was more than just a "usable past"—it was downright good business. The Curry murals featured a stunning hero in Hollywood costume riding a golden Palomino, and told the story of how he had single-handedly brought white, Christian culture to the savage West a full eighty years before anything worth knowing about happened on the eastern seaboard. It was a view of the Kansas past that was easy to love . . . and it was a hard act to follow, as Curry was soon to discover.

Fig. 41 *Comedy,* 1934, fresco in auditorium of Bedford Junior High School (now Kings Highway School) in Westport, Connecticut. Curry's fondness for Hollywood movies is evident in this tribute to popular culture. Curry and his wife Kathleen appear in the lower boxes flanking the stage, as Amos and Andy broadcast over "JSC" radio (the artist's initials).

golden Palomino was the stuff of Hollywood legend. Access to the Curry murals was not premised on "regional" distinctions at all. The artist had rejected those idiosyncratic themes of local interest that would be understood only by Kansans who happened to know the story behind why "Sockless Jerry" Simpson wore no socks, or why Old "Doc" Brinkley kept a herd of goats. His approach was integrative of American culture as a whole, not distinctive to a narrow locale. Curry's judgment of what was important in Kansas history is very much transregional in approach, filtered through current events in the popular realm, and presented in a visual language that was, thanks to Hollywood, recognizable and familiar to all participants in this new mass culture. The broad national appeal of the Benton-Curry-Wood brand of Regionalism was derived, at least in part, from its knowledge of and attention to operable stereotypes in the mass media.[87] By using Hollywood costumes, Curry presents distant historical figures in familiar terms. This is history wearing a 1930s costume. And if that sense of familiarity is lost to us today, it is because Lionel Trilling's "huge,

Ode To Coronado

We are hailing the Entrada
Of Francisco Coronado,
With his knights and Sancho
 Panzas
On the plains of early Kansas.
They had heard a golden
 rumor
In the halls of Montezumar:
Seven Cities very golden,
Was the tale there told—an
 old un—
But the one that he got sold
 on (Eugene Ware
Couldn't make a worser
 rhyme;
He wouldn't dare.)

Up he comes from Monte-
 zumar,
Following that "mazuma
 rumor;"
And he'll be a Kansas boomer
 when he comes.

We'll grow beards for Coro-
 nado when he comes;
In the lingo of the Gringo:
 "look like bums;"
For he'll be a Sunflower
 booster,
Just the way he allus uster;
And we'll spill an old red
 snooster
When he comes.

He'll be asking where Qui-
 vira's gold is had?
He'll be asking it of every
 wise old Dad.
He was asking old Dom Pedro
While parading thru Laredo;
When he passed thru Ama-
 rillo,
He was asking Fra Padilla

When he blinked his way
 thru Lyons,
All the pretty girls got eyin's:
"Senoritas! Kansas pretties!
Where's your Seven Golden
 Cities?"

Fra Padilla thought Cibola
Was this side of Minneola;
When he asked in Tonga-
 noxie,
They said "Nixy," they were
 foxy
When he passed thru old
 Concordia,
Marion Ellet said: 'Oh, Lordy
 ah!"
In Topeka—Jay B. Iden
Gave the greedy man a
 chidin'

Tom McNeal and Oscar
 Stauffer
Hadn't much advice to offer;

In the city of Lecompton
He got romped on and got
 stomped on,
But Sabetha told him:
 "Yeth—ah,"
And in Newton they were
 rootin':
"He'll be welcome; you're
 darn tootin';
There'll be carmen-and-
 saffron car tags when he
 comes."

He won't answer radio quiz-
 zes when he comes;
Seeing gold is what his biz is,
 when he comes;
He will wear chain mail like
 fetters,
But he will not mail chain
 letters;
He might spike a coca-cola in
 Iola or Paola
But his goal is old Cibola's
 golden plums!

He'll inspect the State House
 murals
When he comes;
He will measure Curry's bull
 and do odd sums;
There'll be miles of colored
 bunting;
He'll have rodeo riders
 stunting;
He'll have film stars past all
 counting,
When he comes.

Curry painted the Entrada of
 Francisco Coronado;
Not the Cid nor the Mikado—
 but Kid Cisco Coronado;
Who had heard of big bonan-
 zas in
Quivira, which is Kansas.
So, hurrah for the Entrada of
 Francisco Coronado;
And the Dons who are his
 chums;
Let us shout to every hearer;
"Welcome, Spaniards, to
 Quivira!"
And we'll kill a cocktail tod-
 dy when he comes.

Thus we're hailing the
 Entrada of Francisco
 Coronado,
And his armored knights
 from Spain,
We explain—with a pain,
How their quest was all in
 vain.
All these knights and Sancho
 Panzas
Lost their chain mail shirts in
 Kansas,
So they sang "Yes, No
 Bonanzas!
"We have no bonanzas
 today!" — C. L. Edson in
Topeka State Journal.

Fig. 42 "Ode to Coronado," newspaper clipping of a poem published in the Kansas press during the Coronado celebrations of 1941. Several stanzas at the end are devoted to the Curry murals. Note the references to film stars and "Kid Cisco Coronado."

Chapter 4
"The Tragic Prelude"

Act I of John Steuart Curry's three-part icono-graphic program for his Kansas murals opens with the arrival in 1541 of the state's "first tourists," Coronado and Padre Padilla.[1] The images are compelling. This segment of the mural cycle is painted on the adjoining east and north walls of the narrow East Corridor of the Kansas State-house, fronting on the governor's office. The physical restraints of the corridor prohibit the viewer from stepping back comfortably to view the murals, an effect that heightens the sensation of immediacy. The large-scale figures of Coronado, Padilla, and the Plainsman are painted in such a way that they inhabit a very shallow foreground space, a compositional device that further empha-sizes the imposing presence of these historical figures.

If there was a notion afoot in the 1930s that a mural should be a dialogue between the painter and the public, these murals are shouting for at-tention from casual passers-by. On the east wall, the mounted figure of a heroic Hollywood Coron-ado is commanding. The golden Palomino seems to invade the viewer's space, as the action in the picture spills forward into the Capitol corridor. This effect is due to the design of the composition. Coronado's body is painted precisely perpendicu-lar to the picture plane, not turned obliquely into an imaginary depth. The viewer is thus led to equate the plane defined by his upper torso with the actual surface of the canvas. The hooves of Coronado's horse almost come to rest on the marble wainscoting beneath the canvas, leaving no believable foreground space within the con-fines of the painting in which the Palomino's long neck and head might exist. If, by the strict frontal presentation of Coronado's torso, the viewer lo-cates the equestrian as residing on or near the surface of the canvas, then the Palomino's fore-quarters must therefore be located in the Capitol corridor with the viewer.

This compositional device of emphasizing the flatness of the canvas—rather than the illusion of a window on the world—and of having objects in the picture appear to exist in front of the canvas had been in use by American painters since the early 1920s.[2] The popularity of the technique blos-somed alongside the concomitant notion that a painting should communicate with its audience and be a harbinger of shared beliefs and social meanings. The result was a happy melding be-tween form and content or, as Curry phrased it, "a design significant to the subject."[3] Illusionistically, Curry's painting is calculated to produce the same three-dimensional, space-invading effect as that of the famous advertising billboard for milk, with El-sie-the-Cow's colossal bovine head protruding

sculpturally into space to catch the fleeting attention of roadside travelers. The perceived spatial invasion by Coronado's horse is viscerally disturbing to the viewer, and it serves as an effective compositional device to draw the observer's attention to an otherwise peripheral segment of the painted panorama.

Coronado, Padre Padilla, and the Plainsman are all looking directly to their right. Here Curry effects a modern application of baroque compositional formula, in which minor characters in the painting gesture toward the area in which the most important action is occurring. The viewer reads the gestures of these *repoussoir* figures as a directional clue to identifying the main characters or substance of the painting. In the Curry murals, the sideward glances of the three figures on the east wall indicate that the main action of the picture is taking place to their right, on the adjoining north wall. The implied continuity between the mural paintings on the east and north walls of the East Corridor is established in several ways: a continuous horizon line is maintained on both walls; both are illuminated from a single,

consistent source of light that emanates from behind the Plainsman; also, a prairie fire that begins on the east wall travels in an uninterrupted path to the north wall.

And what is painted on the north wall that so forcefully commands the attention of all the other characters in the mural? John Brown—"God's Angry Man." John Brown—"Terrible 'Saint'." John Brown—"The meteor of the war."[4] The ten-foot figure of the angry John Brown may well be one of the most stirring images in the lexicon of American art. One startled observer in 1941 drew the following analogy:

If Rudolf Hess showed up at your front door carrying Hermann Goering piggyback, you probably would gasp no louder than most people do at their first glimpse of Curry's John Brown.

There he stands, a rifle in one hand and a Bible in the other, his arms outstretched and his face tilted skyward in violent and anguished appeal. His hair and prophet's beard are whipped by the wind. His mouth is open as if calling upon God to smite down his enemies. Slain soldiers lie at his feet. In the distance a prairie fire rages and a tornado digs its black funnel across the parched plains. Here is the 'bleeding Kansas' of history to the life.[5]

Fig. 43 *The Tragic Prelude,* 1937–42, sections of the north and east walls of the East Corridor, Kansas Statehouse murals. The panel of John Brown can be seen at the far left, around the corner from the Plainsman. At the right of the photograph is the elevator located next to the governor's office.

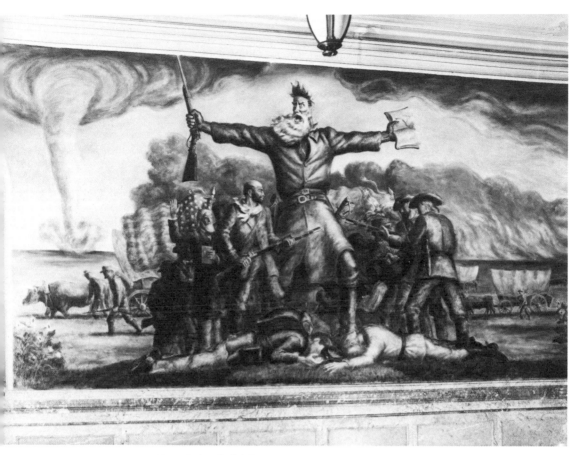

Fig. 44 *The Tragic Prelude,* 1937–42, detail of John Brown, north wall of the East Corridor, Kansas Statehouse murals.

John Brown (see plate 6) dominates the entire central third of the composition on the north wall. Curry's wrathful colossus virtually strides out of the picture, off the wall, and into the Capitol corridor. With furrowed brow and fiery eyes, he screams his rage. His arms are rigid and outstretched, as if held there, nailed to some invisible wooden cross. The smoke from the raging prairie fire and the dust from the approaching tornado part ways behind John Brown and allow an eerie blue-green light to illuminate and echo the form of his dramatic gesture. His right hand, stained with blood, clutches a Sharp's rifle; his left, "the word of God." Branded in red on the pages of the open Bible are the Greek letters alpha and omega, referring to apocalyptic Christian eschatology from The Revelation of Saint John the Divine: "I am Alpha and Omega, the beginning and the ending, saith the Lord, which is, and which was, and which is to come, the Almighty."[6]

"What I have tried to show," wrote Curry, "is Coronado and Padre Padilla looking out from the past on the future."[7] The future, in this condensation of Kansas history, was punctuated by the violent activities of John Brown. This mural segment was intended to express, in Curry's words, "the fratricidal fury that first flamed on the plains of Kansas, the tragic prelude to the last bloody feud of the English-speaking people."[8] The protagonist in this painted drama was Old John Brown, the spark that ignited the bloody conflagration of Civil War.

John Brown first arrived in Kansas in October 6, 1855. The events leading to his decision to leave his home in New England and go to the Kansas Territory revolved around his convictions and activities as an abolitionist. As early as 1837, Brown had become outraged by the murder of the abolitionist editor, Elijah Lovejoy, at Alton, Illinois. At a public meeting held on the occasion, Brown vowed to devote his life to the overthrow of slavery. The passage in 1850 of the Fugitive Slave Law reinforced Brown's commitment to the abolition of slavery.[9]

The passage of the Kansas-Nebraska Act in 1854 legislated that the peoples of the territory would be allowed to vote on whether they would endorse the existence of slavery in that region. As a result of the power of the vote, both Free-Soilers and proslavery proponents tried to pack Kansas with settlers sympathetic to their respective persuasions. That year, five of John Brown's sons left Ohio for Kansas in order to homestead and work for the success of the free-state vote there.[10]

Bloodshed soon erupted in the Kansas Territory between the proslavery and Free-Soil advocates. "Border Ruffians" from the neighboring slavery state of Missouri crossed into Kansas on several occasions to vote illegally in territorial elections and to deny the vote to bona-fide settlers who were in favor of a free-state decision. In March 1855, some five thousand proslavery Missourians rode across the border armed with guns and bowie knives, took control of the Kansas poll, prohibited the Free-Soilers from voting, and then rode back to Missouri having elected a proslavery legislature.[11] The violent confrontations that ensued would soon earn the territory the epithet "Bleeding Kansas."[12]

John Brown, still in New York, kept a close eye on activities taking place in the Kansas Territory through letters from his sons that described the proslavery depredations and pleaded with him to join them in their abolitionist cause. In 1855, Brown's son John wrote to his father with the following conviction:

If the question of Slavery or no Slavery in Kansas must be settled at the cartridge box, instead of at the ballot box, I pray the day may speedily come. Every day strengthens my belief that the sword, that final arbiter of all the great questions that have stirred mankind, will soon be called on to give its verdict.[13]

It was against this background of events that John Brown determined to leave New York and go to the Kansas Territory. En route, he traveled throughout the East gathering arms and ammunition from sympathetic supporters of the free-state settlers.[14] By the time he arrived on Kansas soil for the first time in the fall of 1855, he was armed for battle. Richard Warch provides the following account of the events that won John Brown his Kansas fame:

From the moment he entered the territory, Brown evidently relished its warlike atmosphere and itched to get into a fight. 'For one,' he wrote Mary in April, 1856, 'I have no desire (all things considered) to have slave-power cease from its acts of aggression. "Their foot shall slide in due time".' On May 21–22, almost as a fulfillment of Brown's wish, a force of proslavery agitators sacked the free-state town of Lawrence, burning buildings, destroying newspaper presses, and killing two

men. On the night of May 24, Brown struck a blow of reprisal. With four sons, a son-in-law, and two others, he entered the Pottawatomie settlement and brutally murdered five proslavery men.[15]

John Brown went into hiding after the Pottawatomie murders, although he was engaged in several other skirmishes against proslavery groups in the Kansas Territory. But the event that shaped his legendary fame was the raid on Harpers Ferry, Virginia, in 1859. His daring attempt to capture the federal arsenal there and to arm the slaves for insurrection resulted in his being tried and convicted of treason and hanged on December 2 of that year.[16] The cry "Sic semper tyrannis" may well have captured the sentiments of Virginians at the hanging of John Brown, but the verdict was a sectional one. To slaveholders and their sympathizers, Brown was perceived as a criminal and a murderer. But among a number of abolitionists, Brown's daring attack represented the highest embodiment of self-sacrifice—the willingness to give up one's life for the cause of social justice. Just before the execution, Emerson exalted Brown before an audience in Boston as a "Saint, whose fate yet hangs in suspense, but whose martyrdom, if it shall be perfected, will make the gallows as glorious as the Cross."[17]

The apotheosis of John Brown in abolitionist rhetoric entailed a fusion of sacred and secular history. Joining social change to biblical exegesis, many saw Brown's execution as a sacred event that paralleled and was prefigured by the crucifixion of Christ. Thoreau couched the event in precisely these terms:

Some eighteen hundred years ago Christ was crucified; this morning, perchance, Captain Brown was hung. These are two ends of a chain which is not without its links. He is not Old Brown any longer; he is an angel of light.[18]

There were intimations that the sectional conflict possessed a supernatural aspect, that the confrontation was between angels and demons, between good and evil. "The Battle Hymn of the Republic," first published in 1862, proclaimed the apocalyptic message that the Day of the Lord was at hand; many felt that John Brown was the instrument by which God had "sounded forth the trumpet that shall never call retreat."[19] John Steuart Curry was among those who believed, albeit simplistically, that John Brown was the catalyst for the subsequent outbreak of Civil War. As he explained to the Kansas Murals Commission,

Kansas was the starting place for the war between North and South. You can't paint Kansas history without painting that. And you can't paint that without including John Brown.[20]

Curry's belief that the Civil War had been launched in Kansas seems at least provincial, if not presumptuous. But he was not alone in this appraisal; several other writers and historians before him had helped to shape this concept. The proximate source for the title of the Brown panel, *The Tragic Prelude,* is a phrase that Curry attributes to William Allen White: that the period depicted was a "tragic prelude to the tragic years to come."[21] In his own writings of the previous decade, White was committed to the idea that Kansas was "the nation's tenth muse, the muse of prophecy."[22] "Kansas," White averred, "is the Mother Shipton, the Madame Thebes, the Witch of Endor, and the low barometer of the nation. When anything is going to happen in this country, it happens first in Kansas." From Abolition, Prohibition, and Populism to "the exit of the roller towel," issues that later appeared on the national agenda got their start, according to White, in the bellwether state of Kansas.[23]

Regarding the Civil War, however, White could easily have taken his cue from earlier histories of Kansas, such as that of Leverett Wilson Spring entitled *Kansas: The Prelude to the War for the Union.*[24] The *Tragic Prelude* epithet might also have been informed by the oratory of John J. Ingalls, a Civil-War-era Kansas senator, whose metaphor was thespian rather than musical: "Kansas was the prologue to a tragedy whose epilogue has not yet been pronounced."[25] Kirke Mechem of Topeka, whose play *John Brown* won the Maxwell Anderson award for poetic drama in 1938, alluded to a similar image in the final lines of scene 1.[26] The scene ends as the slain body of Thomas Barber, killed in the border skirmishes, is brought to the Free State Hotel in Lawrence. The curtain closes on an ireful John Brown, but not before he has offered this ominous warning:

. . . when the inevitable end
Of temporizing with iniquity comes
I strike your evil where I find it! Peace
And slavery? Never, never again!
 And this
 [He indicates the body]
Is but the prelude to disaster![27]

By the 1930s, the association of John Brown's Kansas activities with some sort of prelude to tragedy was a familiar image, if not a cliché. But if Curry stayed close to the literary tradition in the title of his Brown mural, his painted conception of the firey abolitionist demonstrates a noticeable deviation from artistic conventions. The painted tradition for depicting John Brown had charted a narrow course. The last days of John Brown (from the time of his capture at Harpers Ferry in October 1859 to the day of his hanging

six weeks later) were covered widely by newspapers and by various sketch artists from the picture weeklies. These renderings for the most part showed Brown as gaunt, weak, and defeated. The artist correspondent from *Harper's* sketched Brown as an impotent invalid, lying prone on the prison floor during his cross-examination by Virginia's Governor Wise.[28] The illustrator sent out from *Leslie's* weekly to cover Brown's hanging showed an emaciated figure ascending the gallows, leaning on the hand rail and being supported by a rather well-fed official (see fig. 45).

After Brown's death, the canonizing rhetoric that surrounded him called for another image of the man, one more fitting to the legend. Not being an important figure during his lifetime, Brown had never sat for an artist's portrait. There were, however, several photographs and daguerreotypes of him from which to launch a portrait tradition. One photograph in particular, taken by J. W. Black of Boston in May 1859 (fig. 46), was especially suited to the creation of eulogistic portraiture. In it, Brown is shown with a long gray beard; his head and upper torso are turned toward his left in three-quarter profile, but Brown looks out of the picture to make disarming eye contact with the viewer.

Black's photograph became the prototype for subsequent oil "portraits" of Brown produced shortly after his death. Nathun B. Onthank quickly turned out two such portraits by painting directly over enlargements of the photograph taken by Black.[29] It was one of these derivative oil portraits after the Black photograph, attributed to J. C. Wolfe of Cincinnati, that was hanging in the governor's office in the Kansas Statehouse when John Steuart Curry visited the governor in 1937 to discuss the mural project (see fig. 47).[30] Single-figure portraits of Brown that were translations in oil of Black's photograph constitute one strain of the pictorial heritage. But soon there emerged a second, more popular artistic convention for depicting the martyred abolitionist. The stance and physiognomic likeness of Brown still derived from Black's photograph in this new genre, but instead of a single-figure portrait, Brown becomes the central character in a group portrait that also incorporates supporting characters from the popular Whittier legend. John Greenleaf Whittier's poem, "Brown of Osawatomie," first appeared in the New York *Tribune* on December 5, 1859. The poem was reprinted widely, and rapidly popularized the legend that Brown had stooped to kiss a slave child on the way to the scaffold:

John Brown of Osawatomie spake on his dying day:
'I will not have to shrive my soul a priest in Slavery's
 pay.

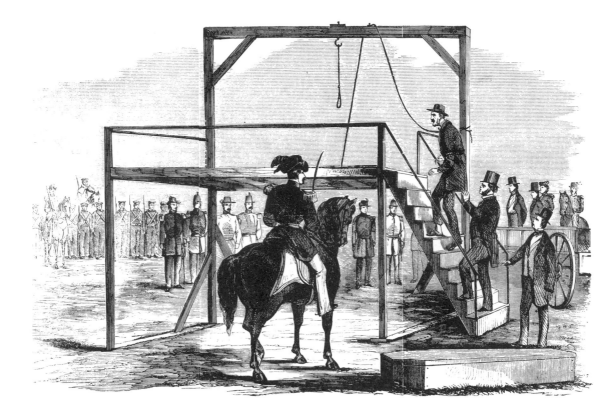

Fig. 45 *John Brown ascending the scaffold,* wood engraving, *Frank Leslie's Illustrated Newspaper,* December 17, 1859.

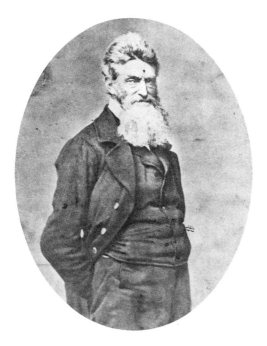

Fig. 46 Photograph of John Brown taken in Boston by J. W. Black in May 1859. The seminal likeness for subsequent portraits of Brown.

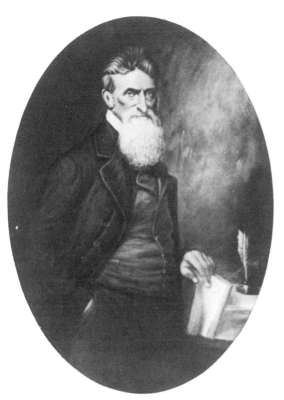

Fig. 47 Portrait of John Brown attributed to John C. Wolfe of Cincinnati, oil on canvas. A portrait that was hanging in the Kansas governor's office in 1937.

But let some poor slave-mother whom I have striven
 to free,
With her children, from the gallows-stair put up a prayer
 for me!'

John Brown of Osawatomie, they led him out to die;
And lo! a poor slave-mother with her little child pressed
 nigh.
Then the bold, blue eye grew tender, and the old, harsh
 face grew mild,
As he stooped between the jeering ranks and kissed the
 negro's child!

The shadows of his stormy life that moment fell apart;
And they who blamed the bloody hand forgave the
 loving heart.
That kiss from all its guilty means redeemed the good
 intent,
And round the grisly fighter's hair the martyr's aureole
 bent![31]

Louis L. Ransom first translated the Whittier legend into paint in 1860 in his *John Brown on His Way to Execution.*[32] The central figure in Ransom's painting is the bearded Brown, by way of Black's photograph. At Brown's feet there sits a slave mother holding a baby. Other figures include a slaveholder, a jailer, and a broken and discarded statue of Justice off to one side. Ransom's painting created a sensation when it was exhibited by P. T. Barnum at his museum in New York City during the summer of 1863.[33] Currier & Ives issued at least two versions of color lithographs based on the Ransom painting (see fig. 48).[34]

John Brown's Blessing was Thomas Noble's life-size rendition of the Whittier legend. Painted and exhibited in 1867, a large folio lithograph of it was issued the same year, but it was still popular enough in 1937 to be illustrated in the October issue of the *Negro History Bulletin.*[35]

The most famous Whittier-inspired portrait of John Brown was painted by Thomas Hovenden in 1884 and acquired by the Metropolitan Museum of Art in 1897.[36] *The Last Moments of John Brown* (fig. 49) is executed in the flashy, bravura brushwork that showcased the French academic training Hovenden had received at the École des Beaux-Arts.[37] Hovenden's John Brown is sentimentalized, even saccharine. With a flowing white beard and a smile in his eyes, Brown looks more like a Santa Claus caricature than a murderous threat to the republic, or a prisoner awaiting his condign punishment. Previous renditions, because they relied on a cut-and-paste approach to artistic composition, merely plucked the figure of Brown from the photograph by Black and landed him in the midst of a makeshift group portrait with a slave mother and child at his feet. With the benefit of his training abroad, Hovenden made Brown come to life—now he could bend, move, and actually kiss the slave child being held to him. Hovenden's interpretation of the Whittier legend remained immensely popular. In 1925, a replica of the Hovenden painting was exhibited at the National Academy of Design.[38] Coincidentally, it was the same year that a fledgling young artist named John Steuart Curry was invited to exhibit his work there also.[39]

John Curry had ample opportunity to become familiar with the established artistic conventions for painting John Brown. It would have been hard for him to miss seeing the life-size Hovenden replica at the National Academy, or the portrait of John Brown made in the single-figure genre that hung in the Kansas governor's office.[40] By 1937, the pictorial tradition for rendering John Brown had become firmly established, and boasted little variation. In the mid-thirties, artist Eitaro Ishigaki was commissioned by the New Deal's Federal Art Project of the WPA to include Brown among the historical characters that would adorn the walls of the Harlem Courthouse (see fig. 50). For Brown's likeness in the historical portrait collage, Ishigaki reverted to a cut-and-paste insert of the by-then

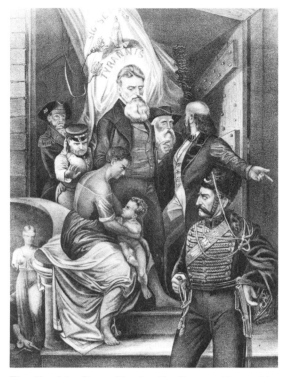

Fig. 48 *John Brown Meeting the Slave-mother and her Child on the steps of Charlestown jail on his way to execution,* 1863, colored lithograph by Currier & Ives from the original painting by Louis Ransom. Another edition of this colored lithograph was released in 1870 that included only Brown, the slave mother and her child, and the militia man in the foreground.

Fig. 49 Thomas Hovenden (1840–95), *The Last Moments of John Brown,* 1884, oil on canvas. (Courtesy Metropolitan Museum of Art, New York, Gift of Mr. and Mrs. Carl Stoeckel, 1897). John Brown enacting a scene from the legendary Whittier poem.

immortal photograph taken by J. W. Black. Artist Ishigaki apparently wished to show a more frontal pose, so he painted in a left arm whose shoulder seems to spring from somewhere on John Brown's chest. In his beefy left hand, Brown holds a rifle, an allusion to the violent side of his character that had been omitted in the earlier Whittier-inspired rendition. Next to Brown, Ishigaki included the requisite mother and child of the Whittier legend. But here, their adoring gaze is directed not at Brown, but past him to Abraham Lincoln, who flanks him in the mural.[41]

Compared with the artistic conventions emanating from Black's photograph and the Whittier legend, Curry's truculent abolitionist marks a radical departure. In fact, Curry's design for *The Tragic Prelude* grew out of an entirely different pictorial context. With Bible in one hand, rifle in the other, Brown fulminates against the evils of slavery, while slain soldiers of the North and South lie dead at his feet. The composition, using a large central figure with arms outstretched, actually derived from an earlier sketch Curry had

made for a mural to be housed in the recently built Department of Justice Building in Washington, D.C.[42] John Brown was nowhere to be found in the original sketch, whose subject was the freeing of the slaves and the welcoming of European immigrants. The central protagonist in this 1933 mural sketch was a slave, with arms uplifted in what detractors termed a "hallelujah" pose.[43] Curry revised and then resubmitted the sketches for *The Freeing of the Slaves* a number of times, but never secured the required approval from the Section of Fine Arts to execute his design.[44] In an attempt to soften the criticism of the hallelujah stance of his central figure, Curry varied the gesture in subsequent sketches. "Think the Negroes will be something different," he wrote to Rowan in a note accompanying one of the later sketches, "and I can make the gesture more one of rejoicing."[45] But even after alterations, the "praise de Lawd" gesture of Curry's freed slave suggested that it would generate the kind of public controversy the Section preferred to avoid.[46] A Federal Art Project artist, Attilo Pusterla, had been taken

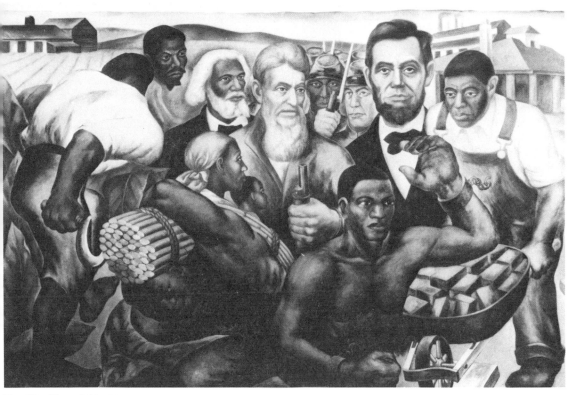

Fig. 50 Eitaro Ishigaki (Federal Art Project, WPA) with Chikenichi Yamasaki and Wolf Ubegi, detail of mural in the Harlem Courthouse, New York City, circa 1937–38.

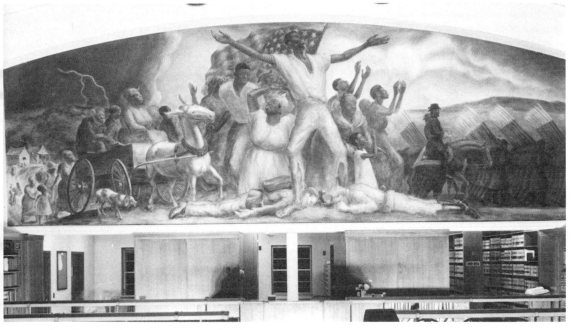

Fig. 51 *The Freeing of the Slaves,* 1942, oil and tempera on canvas, mural in the University of Wisconsin law library.

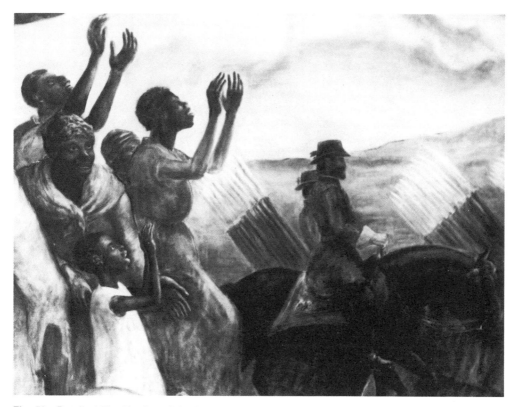

Fig. 52 Detail of *The Freeing of the Slaves,* 1942.

to task for his murals in the New York County Court House by local black leaders "who demanded that the artist explain just how the mural of a Negro child eating watermelon amid white eagles, wings spread, represented emancipation. Pusterla eventually replaced the child with Negro leader Frederick Douglass—without watermelon."[47]

Curry's emphasis on ecstatic religiosity in the gestures of the freed slaves spelled trouble to those officials in the nation's capital who had begun to hear the rumblings of protest among black leaders who resented the stereotypes being popularized by Hollywood films. In 1930, black and white audiences alike had lauded Marc Connelly's fish fry in the sky, *Green Pastures,* as a sensitive treatment of black southern folk religion.[48] And in 1928 even the NAACP organ, the *Crisis,* joined in the popular acclaim of King Vidor's *Hallelujah!,* and approved "the drama and the use of expressive hands to capture the mood of black religion."[49] But by 1934, black critics were calling for an end to the offensive stereotypes on the silver screen, and the *Crisis* announced that it was "high time the American Negro took up arms on the Hollywood front."[50] By 1936, the exaggerated

gesture of hallelujah praise in Curry's mural sketch was a red herring that the Commission of Fine Arts could not endorse. Charles Moore, chairman of the commission, reported that Curry's "emancipation sketches seem questionable as being violent expressions of emotions now undergoing the scrutiny of historical students." He called for "a less vociferous expression of the event" if the subject were to be handled at all.[51] But having already made several revisions to appease the authorities, Curry felt he could not make the slave's expression any "less vociferous" without compromising his original design beyond recognition. He abandoned the theme altogether.

The mural that finally appeared on the fifth floor of the Justice Building showed no trace of orgiastic religious expression or hallelujah praise. *Justice Defeating Mob Violence,* a somewhat more palatable painting, showed a fugitive taking refuge from a lynch mob on the steps of a courthouse beneath the robed figure of a judge.[52] Curry's original design for *The Freeing of the Slaves* did surface again, however, as a mural for the law library at the University of Wisconsin. Shortly after arriving in Madison in 1936, Curry became a very close friend of Lloyd K. Garrison, dean of the law

school. Garrison was the great-grandson of famed abolitionist William Lloyd Garrison, and was himself a member of the National Urban League and an ardent worker for civil rights for blacks.[53] "When John Curry first showed me the sketch which he had made for 'The Freeing of the Slaves,' " Garrison later recalled, "I thought it was one of the most impressive pictures I had ever seen." Garrison personally raised the funds to commission Curry to paint a mural for the reading room of the new law library in 1942. He found an anonymous donor willing to foot the entire bill, someone who "was particularly interested in the subject matter because of family associations with the Civil War and a family tradition of friendship for the Negroes."[54] Curry's mural was a smashing success. Helen Hayes, on a trip through Madison, made a special stop to see it. One onlooker remembers Miss Hayes "standing in the back of the

room with arms spread in the gesture of the central figure in the mural, reciting the 'Battle Hymn of the Republic.' "[55]

If Curry had had the prescience in 1937 to foresee that he would be able to execute his mural *The Freeing of the Slaves* a few years later in Wisconsin, he might have conceived an entirely new design for his Kansas murals. But as it was, there he sat in his studio, with a stack of mural sketches he liked and no wall to put them on. He had already devoted several months of work to creating and refining those proposals for the Justice Department commission, and the reply he had received by return post was a great disappointment: "The panel of the Freeing of the Slaves frankly met with no one's approval."[56] And so, since his deferential Kansas patrons seemed willing to leave matters of art to the artist, Curry used his Justice Department mural design, with a few

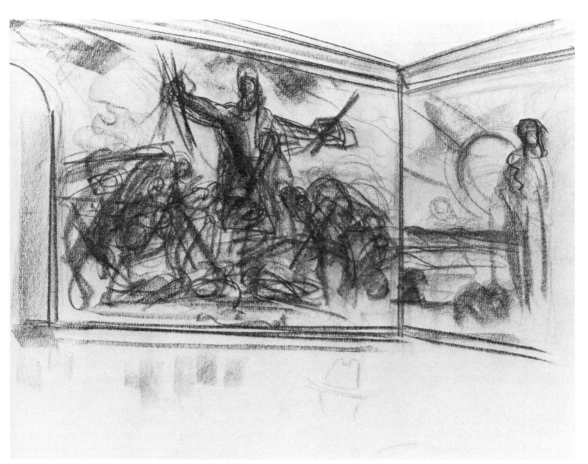

Fig. 53 Early charcoal sketch for the composition of *The Tragic Prelude,* circa 1937, Kansas Statehouse murals. A rough schematic rendering of the major areas of mass in the composition.

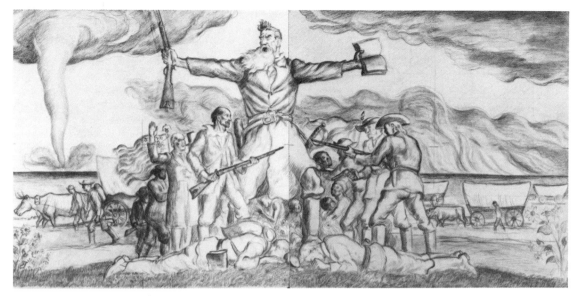

Fig. 54 Preliminary scale drawings for *The Tragic Prelude,* circa 1939. These preliminary drawings were made to the exact proportions of the final mural, on a scale of two inches to the foot.

interchangeable parts. There was still a somewhat symmetrical composition, with a design that built in intensity toward the center; there were still the two slain soldiers in blue and gray lying prone in the foreground; and there was still the large central figure with arms outstretched. But instead of a young freed slave, praising "De Lawd," there was Old John Brown.[57] Brown's arms are outstretched, but have been lowered significantly from the earlier hallelujah gesture of the slave. As if needing some explanation for standing there with his arms in the air, Brown is given attributes to hold—a Bible and a "Beecher's Bible." Curry rather enjoyed this play on words, Henry Ward Beecher having financed the transport of Sharp's rifles into the Kansas Territory in boxes labeled "Bibles."[58]

Next to Brown, Curry further localizes his generic design to the Kansas scene by painting in a tornado, that nemesis of the plains. The calculated apposition of John Brown and the Kansas twister invites the attentive viewer to decipher yet another rebus. Curry's painted cyclone refers to the "Cyclone of Kansas," as Brown was popularly known.[59] Curry also intended the tornado and the prairie fire to be "symbolic of the turmoil of the times."[60] The "Stormy Weather" metaphor for social upheaval was a favorite device in referring to the Civil War. Carl Sandburg's *Storm over the Land: A Profile of the Civil War* is but one of many examples circulating in the 1930s.[61]

Although Curry's design for *The Tragic Pre-*

lude panel had begun as a remake of the sketch intended for the Justice Department, Curry gradually revised and refined his conception of John Brown into a striking, complex image rich in symbolic implications. He would later assess that "in the panel of John Brown, I have accomplished the greatest painting I have yet done."[62] Matthew Baigell, author of *The American Scene: American Painting of the 1930s,* has named Curry's *Tragic Prelude* as "the quintessential mural of the American Scene," calling it "a *summa*" that "may stand as the representative mural of the decade."[63] Encomia notwithstanding, the meanings and implications of these paintings have not been thoroughly studied. Baigell has deemed Curry's choice to substitute Brown for the freed slave in the Kansas murals as "a logical one." "Brown was a native Kansan," writes Baigell, "evidently a most important native son to Curry, and certainly a fit subject for a panel in the State Capitol."[64] But to characterize John Brown as a "native Kansan" is puzzling in light of the information that remains to us on his life. He was, in fact, born in Torrington, Connecticut; was executed at Charlestown, Virginia; and was buried at North Elba, New York, where his wife and family had been living during the ten years before his death. John Brown never set foot in Kansas until he was fifty-five years old, four years before his death, and he never stayed more than a few months during any of the three known visits he made to the Kansas Territory.[65]

The Kansas claim to John Brown as "a native son" is about as strong as to Coronado and the peripatetic padre. In fact, Curry's opening mural segment unfolds as a cycle of borrowed heroes whose reputations were derived from their impact on the national rather than the local Kansas scene.

Curry had bypassed the verifiably homegrown sagas of "Doc" Brinkley, "Sockless" Jerry, and even the more famous Carry Nation, in favor of tapping into the national keg of colorful characters. "Doc" and Jerry could be dismissed as having relevance only to Kansans who knew their lively pasts. But Carry Nation's hatchet-swinging temperance crusade had won her firm footing in any respectable text on American history published on the eastern seaboard. Curry's objection to her was more likely lack of sympathy with her cause. It is true that Curry had spent his formative years under the strict influence of "a church whose Scotch Covenanter doctrine forbade dancing, theater, novels and card-playing," not to mention that old demon rum.[66] But since his early days in the freewheeling Westport art colony, Curry had abandoned those childhood proscriptions. A typical social evening in Madison, where he worked on the Kansas murals, would be enlivened by "quite a little drinking of cocktails and conviviality, and quite a little dancing." John Curry most assuredly lined up on the side of the cele-brants when the nation's long thirst came to an end with the repeal of prohibition in 1933.[67]

Whereas Curry had no interest in furthering the cause of Carry Nation, he did have a demonstrated interest in working for civil rights for blacks. "The social, political, and economic disturbances of the times," wrote Curry, "have brought forth those artists who, taking their themes from these issues, have produced telling and effective works for the cause of social and political justice."[68] He numbered himself among such artists, and put his brush where his convictions were in a number of controversial paintings produced in the early 1930s. Since 1933, Curry had fed a growing interest in the social content of painting and a belief in the propaganda value of a work of art. That year he had participated in the John Reed Club's exhibition *The Social Viewpoint in Art;* he had lingered around the etching presses of the cartoonist for the Communist *Daily Worker;* and he made paintings for the controversial art exhibition *An Art Commentary On Lynching* held in 1935 amidst a flood of public protest.[69]

The antilynching art exhibition was originally scheduled to open at the Jacques Seligmann Galleries in New York City on February 15, 1935. The show had been arranged by Walter White of the NAACP, in cooperation with the College Art Association, and was timed to open on the same day that the congressional hearings on the Costigan-

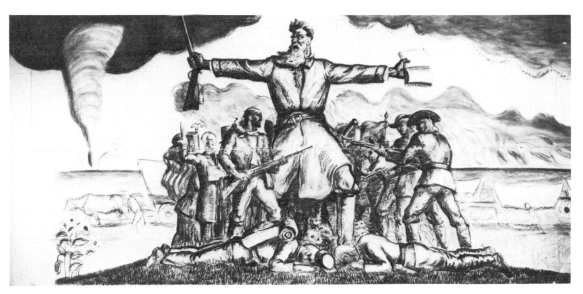

Fig. 55 Full-size cartoon for *The Tragic Prelude,* charcoal on paper, 1940. After sketching a projected image of the scale drawings using lantern slides and a stereopticon, Curry enhanced the details of the drawing in this full-size cartoon.

THE FUGITIVE
by John Steuart Curry

Arthur U. Newton Galleries
Eleven East Fifty-seventh Street
New York City

Galleries open 10:00 A.M. to
5:00 P.M. daily, except Sunday

Price of Catalogue: Twenty-five Cents

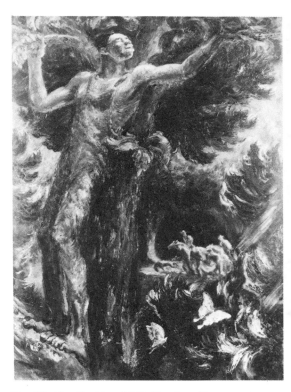

Fig. 56 Cover of the exhibition catalogue for *An Art Commentary on Lynching* featuring Curry's painting *The Fugitive.*

Fig. 57 *The Fugitive,* 1933–40, oil and tempera on canvas. A black man hides in a tree from the pursuing posse in the distance.

Wagner antilynching legislation were scheduled to begin. Four days before the opening, the Seligmann Galleries withdrew its facilities due to an "outburst of opposition." The exhibit was eventually shown at the Arthur U. Newton Galleries on East 57th Street from February 15 through March 2. Pearl Buck lectured at the show's opening, and the exhibition catalogue contained forewords by Sherwood Anderson and Erskine Caldwell. More than three dozen artists contributed works to the exhibition, including such well-known painters as Peggy Bacon, Jose Orozco, Paul Cadmus, Thomas Hart Benton, Reginald Marsh, and George Biddle, and the sculptor Isamu Noguchi. There was also a lithograph by the late George Bellows, *The Law Is Too Slow,* which showed a black man being burned at the stake. The Bellows lithograph had been used in 1929 as the frontispiece for Walter White's book *Rope & Faggot: A Biography of Judge Lynch,* published by Alfred A. Knopf in 1929. On the cover of the catalogue was a reproduction of John Steuart Curry's *The Fugitive* (figs. 56 and 57), one of three works he contributed to the exhibition.[70]

Many of the artists created works especially

for this exhibition, but Curry was among the few who had already painted works on the theme of lynching. At the time of the exhibition, his *Manhunt* (fig. 58, plate 3), 1931, was already in the collection of Arthur B. Spingarn, then vice-president of the NAACP.[71] The painting, done in an eerie color combination of purple and green, shows a posse tracking the scent of a fugitive. In a 1933 lithograph and a painting that he worked on periodically from 1933 to 1940, both entitled *The Fugitive,* Curry returns to the theme of the black man pursued by a lynch mob. A black man, hiding in a tree from the angry mob, dominates the foreground of the painting, a man with outstretched arms that suggest crucifixion. A recent commentator has interpreted Curry's fugitive as "an Americanized noble savage who had been brutally ravaged by whites," or as a symbol of "the black man as the crucified American."[72]

Like those of many other Americans, Curry's sentiments had been aroused by the growing specter of lynchings and mob violence that were everywhere in the news by 1933. Much interest had been stimulated in 1931 by a cause célèbre that came to be known as the Scottsboro affair.

On March 25, nine young black males, ages thirteen to twenty, were forcibly removed from a freight train and brought to the nearby town of Scottsboro, Alabama. A local, all-white jury convicted them of raping two vagrant white women who were on the same train. A hasty trial, thin evidence, and a perfunctory defense by a court-appointed lawyer left eight sentenced to the electric chair and the youngest to life imprisonment. The Communist party's International Labor Defense (ILD) soon intervened and marshaled enough publicity to obtain new trials on the grounds of inadequate defense. The "Scottsboro Boys" spent the next eighteen months in a Birmingham jail while the ILD ballyhooed their plight. Under highly suspect circumstances, the earlier convictions were upheld, but the court appeals kept the case in the news for some time to come.[73]

The Scottsboro affair had the earmarks of a legal lynching, but other, more cruel incidents of mob violence and summary justice were also getting publicity. The lynching death of three black prisoners in Tuscaloosa led to the charge that county officers had actually abetted the mob. In Princess Anne, Maryland, the lynching of George Armwood brought two thousand people out to participate in what the *New York Times* called "the wildest lynching orgy the state has ever witnessed."[74] John Curry was particularly disturbed by the lynching in November of the murderers of Brooke Hart in San Jose, California, which created a nationwide sensation that the NAACP used to launch its campaign for antilynching legislation.[75] Walter White of the NAACP quickly organized a Writers League Against Lynching that was intended to serve as "a hell-raising committee to influence the country through writing, pronouncements, and the like." Among its membership were such familiar names as Dorothy Parker, Sherwood Anderson, Edna Ferber, Erskine Caldwell, and Stephen Vincent Benét.[76]

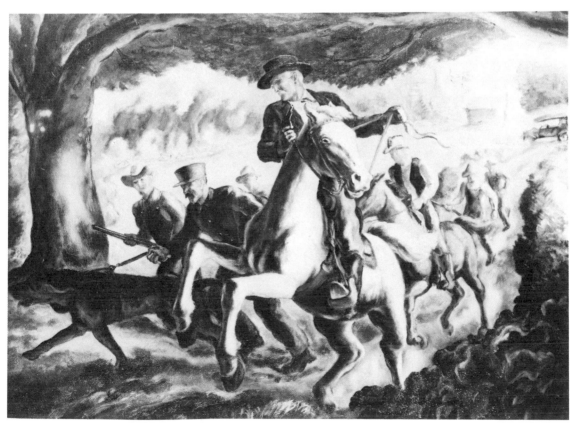

Fig. 58 *The Manhunt*, 1931, oil on canvas. This painting, then in the collection of Arthur B. Springarn of the NAACP, was also exhibited at the antilynching art exhibition.

Concurrent with and perhaps related to this attention to lynching was a renewed interest in the historical figure of John Brown. Benét's own *John Brown's Body,* 1928, had done its part to bring the moulderin' martyr to a new appreciation.[77] But on a quantitative basis alone, there were more poems, plays, short stories, and novels produced about John Brown in the ten years between 1930 and 1940 than in any other decade since the one immediately following his death in 1859.[78] In an era of widely publicized lynchings and racial tension such as that surrounding the Scottsboro affair, the memory of John Brown was infused with a relevance to current events. With the increasing involvement of whites in the black civil rights movement, the historical figure of John Brown provided an appropriate nexus for the collaboration. Many Leftist writers adopted John Brown as an agent of revolutionary reform, particularly for the cause of American blacks. In 1933–34, Michael Blankford and Michael Gold collaborated on a play about Brown called *Battle Hymn,* which

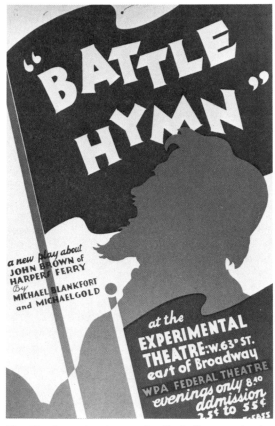

Fig. 59 Promotional poster for *Battle Hymn,* a play in three acts by Michael Blankfort and Michael Gold, presented by the Federal Theatre Project of the WPA.

opened in 1936 under the auspices of the experimental unit of the WPA's Federal Theatre Project. *Battle Hymn* was first produced at the Experimental Theatre on 63rd Street in New York City on May 22, 1936, the week of the eightieth anniversary of the Pottawatomie massacres in Kansas. In this socialist interpretation of Brown's life, "Gold and Blankfort clearly implied that the freeing of Negro slaves by revolutionary violence was a necessary prelude to the emancipation of the white wage slaves of the North," and that the agitational activity of John Brown was a precursor of the modern Communist party, and the Civil War "a forerunner of the coming proletarian revolution."[79] Reviews of the play suggested that "the events of 1936 are not dissimilar from those of 1856."[80] Publicity for the play centered on making the connection between then and now: "The parallel between the problems of John Brown's period and certain problems current today were suggested to newspaper and magazine writers." And "Speakers representing the Federal Theatre were instructed to insist that 'Battle Hymn' is a play with contemporary implications."[81]

Michael Blankford has recalled those "contemporary implications" that made John Brown good subject matter for thirties theater:

The left intellectual, the left creative movement had a great burden to bear and that is the Russian burden. Lenin was hero or Gorki [*sic*] was hero or Trotsky was hero. . . . It seemed to us then that we had to find our own roots in our own revolutionary past in literature or history. . . . And so writers began to look back into our own American traditions, you see, and that's where the Brown thing—and Brown was such a perfect example of that because he wasn't an import, he wasn't a refugee, he wasn't an alien. He was a rock of American rock.

You know, it's self-evident that Brown was a revolutionist in his time, freeing of the slaves, going into the South, and also because he was not an abolitionist in the conventional sense of the word. He was willing to [do violence, because], as he said, 'The sins of this land will not be cleansed except but by blood.' That's a sort of revolutionary circumstance. It had to do with the blacks, it had to do with the revolutionary approach of the blacks. At that time the Communist Party program probably included the notion of a slogan they had . . . 'self-determination for the Black Belt.' And that idea which derived from early Soviet principles about self-determination for nationalities in Russia. So mechanically, so to speak, they took over into this country that idea of self-determination for the Black Belt. . . . Mike Gold might have had that in mind, too.[82]

Gold and Blankfort were not the first to invoke the spirit of John Brown for the cause of radical reform. Eugene Debs had eulogized "the grizzled old agitator" in the early years of the century. In 1908, Debs announced to the press that "the Socialist Party is carrying on the work begun by John Brown." And to his comrades, he posed the

pressing question, "Who shall be the John Brown of Wage-Slavery?"[83] In fact, the era of the 1920s and the 1930s constitutes a second phase of Brown's relationship to the rhetoric of radical reformism. Several Leftist works deal with Brown directly—Michael Gold's *Life of John Brown* (1924), David Karsner's *John Brown: 'Terrible Saint'* (1934), and Muriel Rukeyser's poem, "The Soul and Body of John Brown" (1940). In addition, Brown's symbolic presence inhabits such works as the antiwar novel *Three Soldiers* by Dos Passos (1921), Sinclair Lewis's anti-Fascist novel, *It Can't Happen Here* (1935), and a short story called "The Promised Land" that appeared in the March 1941 *Fraternal Outlook,* the official publication of the International Workers Order.[84] Brown's name appeared frequently in left-wing periodicals such as *New Masses* and the *Daily Worker.*[85] There were allusions to Brown in some of the poems about Sacco and Vanzetti, and in Muriel Rukeyser's 1934 poem, "The Trial," about the Scottsboro case, John Brown was present in her Alabama courtroom.[86]

Rukeyser's later poem, "The Soul and Body of John Brown," grew out of another set of current events from the 1930s. Rukeyser was a free-lance reporter for various radical journals such as *New Masses.* She went to the West Virginia coal mines to cover the story of a widespread outbreak of silicosis among the miners, which had been publicized in newspapers nationwide. Based on her experiences there, she wrote a series of twenty poems under the title *The Book of the Dead* (1936), in which she dramatizes the plight of the miners by contrasting the tragic present with episodes from West Virginia's heroic past—the pioneer settlement, the American Revolution, John Brown's raid on Harpers Ferry, and the Civil War. Brown figures briefly in several of these poems, but Rukeyser explores the relationship between past and present in greater depth in "The Soul and Body of John Brown." With the focus on Brown as a symbol of the revolutionary spirit, this poem encourages and portents a new civil war in which oppressed miners will rise up and sustain the spirit of the crucified hero from their past. The poem's epigraph—"Multitudes, multitudes in the valley of decision" (Joel 3:14)—strikes a parallel between the West Virginia coal miners and the ancient Israelites, referring to Joel's prophecy that Jehovah is about to rescue the Israelites from bondage through war. The rest of the poem updates the prophecy to the coal miners, using Brown as the symbol of the work and integrating him into a contemporary call for social action. "The Soul and Body of John Brown" was published in June 1940 in *Poetry: A Magazine of Verse,* but Muriel Rukeyser sent a typescript of the poem to Curry in February of that year.[87]

From the note that accompanied the poem, it is clear that the typescript was unsolicited. "This poem will appear later in a portfolio of etchings," wrote Rukeyser. "I thought you might be interested in seeing it as it stands, and I send it to you with my compliments. M.R."[88] Rukeyser's timing in writing her expanded poem on John Brown is suggestive. Curry's figure study of Brown for his Kansas murals had just appeared as a full-page color reproduction in the 1939 Christmas issue of *Life.*[89] Then two months later, Rukeyser sent Curry the typescript of her poem. In all probability Rukeyser saw Curry's *John Brown* in *Life* and, from the tone of her correspondence, expected that her poetry would meet with an appreciative audience in John Steuart Curry.

There is no record of Curry's response to "The Soul and Body of John Brown." With the poem's rather obtuse imagery and diction, one wonders if Curry even understood its radical implications. If he did, there is every reason to believe that he would have disapproved of Rukeyser's suggestion that the working classes should rise up in Marxist revolution against their oppressors, led by the spirit of John Brown, a "fanatic beacon of fierceness" whose "life is in the body of the living."[90] In fact, it was just this ability to agitate—to move people to violence for a worthy cause—that Curry feared most about a character such as John Brown. And Curry's decision to paint Brown in this state of arousal, this righteous frenzy, was intended as a warning to Americans who found themselves at the portal of another cruel war in the closing years of the 1930s.

Curry had been brazenly patriotic at the eve of World War I. He was a student at the Art Institute of Chicago in 1917 and 1918, supporting himself by working in the cafeteria. "Everybody talks war and nobody goes," he wrote to his mother. "There is an unpatriotic bunch at the cafeteria. They are all Germans or sympathizers," he complained.[91] By the mid-thirties, however, Curry was a staunch isolationist. From 1928 to 1940, he worked on a painting called *The Return of Private Davis from the Argonne* (fig. 60), inspired by the funeral of a high school friend who had been killed in the Argonne in 1918 and who was one of the first whose body was brought back to Kansas after the war. In 1939, he completed an oil painting, *Parade to War* (fig. 61), in which soldiers march in a ticker-tape parade to the cheers of the crowd. But the faces of the soldiers are death skulls. One soldier in the center of the composition embraces a white-clad young girl who strides alongside him and gazes adoringly into his death-

Fig. 60 *The Return of Private Davis from the Argonne,*
1928–40, oil on canvas.

mask face as though unaware of the doom it portends.[92]

Not a great deal is known about John Steuart Curry's political persuasion. His parents had been staunch Republicans, like most of their fellow Kansans. His eye-opening years in the Westport art colony exposed him to the new, more radical ideologies then in vogue—his friend and neighbor, Van Wyck Brooks, had formed a "socialist local" in Westport. His wife, Eleanor, ran for the Connecticut legislature in the 1934 elections, and in 1936 (the same year Curry sketched his portrait), Brooks himself was the socialist candidate on the ticket.[93] After his arrival in Madison, Curry became a close friend of Governor and Mrs. Philip F. La Follette. Curry was on hand to sketch the spectacular inauguration of La Follette's National Progressive Party at the University Stock Pavilion in 1938, and worked one of the sketches into an oil painting that he inscribed to his friends, Phil and Isen La Follette. (see fig. 62)[94] According to Mrs. La Follette, Curry "identified himself with the Progressive movement and was a faithful reader of the *Progressive.*"[95]

The extent to which Curry sympathized with the Progressive cause in specific issues of domestic affairs is difficult to determine, but with regard to the foreign policy debates that emerged in the late 1930s, Curry, like La Follette and the proponents of America First, was an isolationist of firm convictions.[96] The debate over Roosevelt's foreign policy that began with his "quarantine-the-aggressors" speech of 1937 only intensified with Hitler's march into Czechoslovakia in March 1939. With the fall of France in 1940, America's entrance into the war seemed imminent, and isolationists were beginning to see their worst fears unfold. John Steuart Curry had become preoccupied with his fears of war as early as 1937. In his lecture before the Madison Art Association that spring, he spoke as one desperately racing against time, as though he knew that the halcyon days of peace were numbered: "Just give us time. Give us ten years, and if we can escape the paralyzing hand of war, we [artists] will accomplish something even in that short time."[97]

Even as he spoke, Curry sensed that American artists would not have ten years in which to accomplish their painting renaissance. In the summer of 1938, Curry traveled to Europe because he

wanted to "see Michel Angelo before I begin the Kansas murals."[98] His daughter later recalled that he was very "frightened by what he saw in Germany in 1938," that he "was very edgy" and listened to the radio night and day for news of international affairs. He once got so angry at Franklin Roosevelt, remembers his daughter, that he "went tearing across the room and tripped on something and knocked the radio on the floor, so we were without communication for a while."[99]

For the most part, public opinion was in favor of giving assistance to Great Britain and France. Between May and September 1940, 67 to 76 percent of Americans polled thought the United States should "do everything possible to help England and France except go to war."[100] Congress passed Roosevelt's Lend-Lease Act, which would send war materials to Britain that theoretically would be returned once the conflict was over. Senator Arthur Capper, an isolationist from Kansas, was one of those who vigorously and openly opposed passage of the bill on the grounds that it was sure to pull the United States into the war. Curry wrote to the senator, a long-time friend of his father's, and congratulated him on his isolationist opposition to Roosevelt's proposals. "You're 100% right in your stand on our foreign policy in the Senate," offered Curry.[101]

At the time he began sketches for his Kansas murals, Curry was living under the ominous specter of a war he feared was impending. This deep-seated concern affected the way in which he painted the character of John Brown and the lesson he intended his mural to convey. What he chose to emphasize about Brown's character—and it was a marked departure from any previous pictorial rendition of Brown—was his righteous rage, his fanatical fury, the danger of a self-appointed spokesman of God ready to strike down injustice with the intervention of violence. But Curry was ambivalent about Brown. He identified with and appreciated his cause, but he was terrified of men like Brown who could willingly unloose a Pandora's Box of bloody war in the name of a holy cause. Curry was afraid of the harm that could be wrought by "do-gooders." And it was just

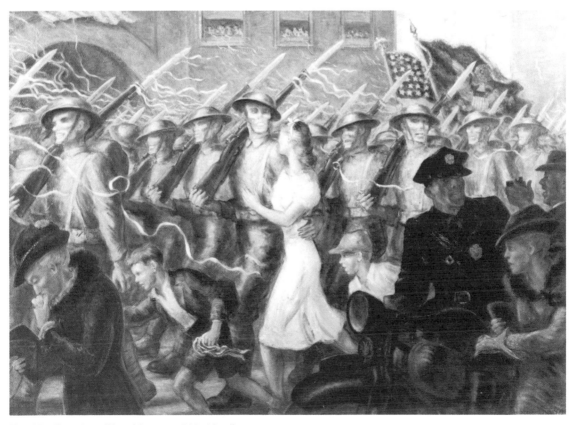

Fig. 61 *Parade to War: Allegory,* 1938–39, oil on canvas. A white-clad young girl marches with death as a woman dressed in black weeps in the foreground.

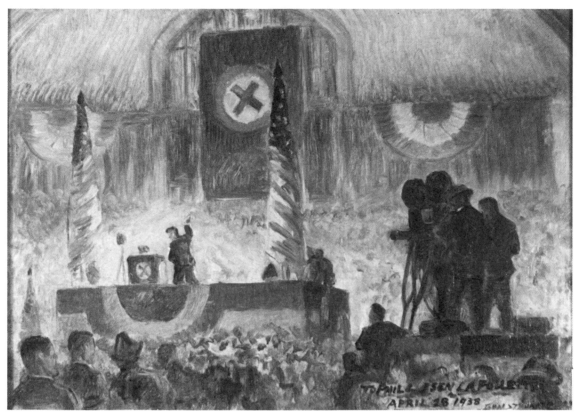

Fig. 62 *First Rally of the National Progressive Party,* 1938, oil on canvas. This political rally took place in Madison on April 28, 1938 and signified the revival of the Progressive party on a national scale.

this aspect of Brown's character—this "missionary zeal"—that made him, to Curry, the quintessential Kansan.

In fact, what Curry found most distasteful in the Kansas character, as he envisioned it, was the sanctimonious fervor of reform. He considered this a native, peculiarly Kansan trait that he consciously tried to suppress in himself. "Mind you," he announced to the people of Wisconsin upon his arrival in 1937, "I am not going to try to 'wreak' any good on the state. To try to 'wreak good' is the quickest way to make people mad."[102] It was just this sense of pious meddling that Curry found peculiarly "Kansan" about John Brown. "I think [Brown] is the prototype of a great many Kansans," wrote Curry. "Some one described a Kansan as one who went about recking [*sic*] good on humanity. This might be the kernel of my conception."[103]

The "someone" to whom Curry referred in this instance was most likely a former Kansas newspaper editor, Charles Driscoll, and the vehicle by which he had made these views part of the

national stereotype about Kansas was a vitriolic essay that had appeared in H. L. Mencken's *American Mercury* in October 1924. In "Why Men Leave Kansas," Driscoll vented his spleen on such "typically Kansas" natives as Amanda Giffin, a figure of no small importance in state and local politics:

About 70 years old, small, withered, wiry, wordy, full of energy and Christian fire. She smashed saloons with Carry Nation a generation ago, and is proud of her magnificent jail record. A street-corner speaker, a powerful and vociferous hater.

She hates Republicans, Henry Allen, club women, the Associated Charities of Wichita, nearly all the preachers, the Catholics, the devil, cigarettes and a long and variegated list of local politicians and office-holders. She draws florid caricatures of the persons she dislikes, and writes very poor rhymes about them, and then she has the stuff printed on leaflets, and sells the leaflets on the streets. Thus she makes an excellent living, and dresses fashionably and in excellent taste.

You will agree that Amanda Giffin would not be possible except in Kansas.[104]

By means of a series of character sketches, Driscoll painted Kansas as the land of Moral Uplift

Fig. 63 *John Brown,* 1939, lithograph, figure study for
the Kansas mural, published in an edition of 250 by the
Associated American Artists in 1940.

and the home of the Lunatic Fringe. The problem with Kansas, said Driscoll, was that the spiritual descendants of John Brown were still running around trying to "wreak good" on humanity:

The State was settled, just before the Civil War, by John Brown and others like him. These settlers migrated from the Atlantic Coast for the express purpose of getting into a fight about slavery. Now, anybody who will drive a covered wagon from Boston to Topeka for the sole purpose of finding a fight has a lot of energy and determination. He is strong for his principles, and he is out to do good. John Brown was that way. There is no truer line in all hymnology than the one that says that 'John Brown's body lies a-mouldering in the grave, but his soul goes marching on.' His soul certainly goes marching on in Kansas. It is on the road day and night.

The heart and core of the Kansas Complex is a pathological desire to do good, to wreak good upon humankind, regardless of the yells . . . to do good in spite of all hell and all humanity. Mixed with this determination there is always a highly religious and emotional temperament.[105]

"I portray John Brown," wrote Curry, "as a bloodthirsty, godfearing fanatic," a dangerous do-gooder who, with "those . . . like him, represented on both sides, brought on the Civil War."[106] Brown's desire to "wreak good" made him the quintessential Kansan of Driscoll's "Kansas Complex." More than anything, Curry feared the kind of wild-eyed, war-mongering fanaticism that could so easily lead a nation to war. Beyond Curry's own fear of and distaste for fanaticism, his belief that it was directly responsible for the outbreak of war should be seen in the context of changing historiography during the 1930s on the causes of the Civil War.

Curry's view is reflective of the revisionist attitudes on causality that emerged during the mid-1930s among historians such as Avery O. Craven and James G. Randall. The revisionists were reacting against the earlier "nationalist tradition" held by the generation of historians born between the late 1840s and 1870, and who had begun to write in the 1890s. With the rise of professionally trained historians, explanations of causality developed in the 1890s differed in turn from the viewpoints of the 1860s, in which each side blamed the other for the war. This new breed of historian (e.g., James Ford Rhodes, Frederick Jackson Turner, Woodrow Wilson, Edward Channing, and John Bach McMaster) analyzed causality with calm, dispassionate judgment. No side was saddled with exclusive blame, and there was the implication that somehow both sides were right. In this context, the cults of Lincoln and Lee emerged simultaneously, with each hailed as an honorable man in his own situation. The nationalist tradition redirected causality of the Civil War to various inanimate forces, not to the actions of ambitious,

greedy individuals. Some historians singled out the spread of the cotton culture, or the influence of physiographic or economic factors, but all seemed to regard causality in the abstract and as inevitable—as deep-seated, fundamental, irreconcilable differences between the sections.[107]

It was one or another version of the nationalist tradition that filled most history books of the first two decades of this century and explained the causation of the Civil War in terms of some sort of "irrepressible conflict."[108] By the 1920s and 1930s, however, a change had taken place in the attitude of the public toward war, especially World War I, and that shift in outlook had a profound effect on historical interpretations of the causes of the Civil War. The revisionist view held that the war had not stemmed from some longstanding, irrepressible sectional conflict, nor had it been inevitable; rather, its causes could be explained in terms of human events and the actions of extremists on each side of the struggle. The interpretation of the crucial role of the extremists in the events of 1860–61 brought such sponsors of compromise as James Buchanan and Stephen A. Douglas out of the closet for a fresh look at their efforts at mediation. George Fort Milton's book, *The Eve of Conflict,* centering on the long-ignored champion of compromise, Stephen Douglas, introduced a catchphrase for the 1930s in his subtitle—"The Needless War."[109] That the Civil War need not have happened became the hallmark of the revisionist point of view.

In 1939, Avery Craven turned the tables on earlier interpretations in a book with a deliberately referential title, *The Repressible Conflict, 1830–1861.*[110] In this book and other of his writings of the 1930s, Craven stated that the sectional differences that did exist did not in themselves explain the outbreak of the Civil War:

Differences—economic, social, and political—did not . . . portend an 'irrepressible conflict' between North and South, to be settled only by bloodshed. The War Between the States in 1861–1865 did not come simply because one exploited free labor and the other slaves; or because a sectional majority refused to respect the constitutional rights of the minority![111]

The real reason why the North and South went to war, Craven asserted, was one of "emotions," "cultivated hostilities," and "hatred between sections." The magnification and emotionalization of issues by extremists agitated the people and produced the situation that led to war. Thus, the outbreak of war "was the work of politicians and pious cranks!"[112]

If the writings of Craven, Randall, and Milton provided the foundation for a new interpretation of the causes of the Civil War, the disillusioned atti-

Fig. 64 John Brown, detail of *The Tragic Prelude,*
1937–42, Kansas Statehouse murals. Curry paints
Brown as one of the extremists and "pious cranks"
fingered by the revisionist historians of the 1930s.

tudes toward war that were common in the 1930s furnished a suitable framework within which such a reinterpretation could rest. Antiwar sentiments ran high in a number of novels, poems, and plays. Many Americans felt their country had been dragged or tricked into entering World War I by propagandists who had excited emotions to induce Americans to fight. As international tensions grew in the 1930s, historians looked to the study of the Civil War with an eye to current events. Isolationists and revisionists alike rejected the inevitability of wars and pointed the finger at extremists bent on rousing people to violence. They viewed past and current world events through the mediation of their own cognitions about the nature of causality. And wars, in their view, were caused by emotionalism, extremist rhetoric, and pious cranks.

Curry's John Brown might well be called the darling of this revisionist viewpoint. For Curry, too, recited the credo that fanatics like Brown and "those . . . like him, represented on both sides, brought on the Civil War."[113] John Brown, as Curry painted him, was the consummate "pious crank." And, as Driscoll had already noted, there were a lot of Brown's spiritual descendants still running around trying to "wreak good" on humanity, no matter what the cost. Curry was afraid of exactly that, as the prospect of war loomed large; Franklin Roosevelt to him was Brown's spiritual heir.

On May 31, 1941, he expressed his fears about America's involvement in the war to an agent of the *New York Daily News*—"In my opinion we are committed to our old Kansas missionary crusading, only on a more magnificent scale."[114] Of his Kansas murals, he said they were both "symbolical" and "historical in more than one sense."[115] He had reconstructed his history with an eye to the present, and the present was looking more and more like another "eve of conflict," like another "tragic prelude." At least a part of what troubled Curry about the past's implications for the present was expressed in more approving tones in a poem by Kenneth Porter, "To the Jayhawkers of the International Brigade":

John Brown of Kansas . . . goes marching on
 his tread is on the plains of Aragon![116]

Chapter 5

American Apocalypse and the "Secular Millennium"

John Brown will mean little to those who do not believe that God governs the world and . . . makes his will known in advance to certain . . . prophetic, heaven-born men.[1]—F. B. Sanborn, 1885

From 1937 to 1941, while he was at work developing his Kansas murals, John Steuart Curry believed that his country was moving inexorably toward a horrible war. As he brooded over this dark moment in American history, childhood teachings stirred in his memory, and images of the Apocalypse appeared, reminding him of the final judgment and the coming Battle of Armageddon. With an eye to current international tensions, Curry retold the story of John Brown in the language of the Apocalypse. For the biblical passage that he painted on the open pages of John Brown's Bible, Curry deliberately chose a quote from the apocalyptic Book of Revelation concerning the Battle of Armageddon and the Last Judgment: "I am Alpha and Omega, the beginning and the ending, saith the Lord, which is, and which was, and which is to come, the Almighty." Curry had given the matter a great deal of thought, and he had even enlisted the help of Richard Forrey of Rockhurst College in Kansas City, who searched the Bible for the exact references of Scripture that could be related to John Brown. Forrey sent Curry a list of verses as suggestions, the first being a quote from Brown himself in a letter to his wife.

1) Remember them that are in bands, as if you were bound with them. Hebrews 13:1
2) We being many are but one body in Christ. Romans 12:5
3) Arise, go towards the South. Acts 8:26
4) Who shall rise up for me against evil doers. Ps. 93:16
5) Thou shalt love thy neighbor as thyself.[2]

Curry passed over Forrey's choices and made his own—emblazoned in red, the bold Greek letters alpha and omega, portents of the end of the world (see fig. 65).

Fig. 65 Greek letters alpha and omega painted in red on the pages of John Brown's Bible, detail of *The Tragic Prelude*. There is blood on John Brown's hands.

Curry had not been the first to see the Civil War as an American Apocalypse, nor to place John Brown at the Final Judgment. The image had appeared earlier in Vachel Lindsay's poem on John Brown in his "Booker T. Washington Trilogy." Lindsay's "John Brown" is a vision, rich in biblical associations:

. . . I've been to Palestine.
 What did you see in Palestine?
Old John Brown.
Old John Brown.
. . . I saw the big Behemoth—
He cheered for Old John Brown.
I saw the big Leviathan—
He cheered for Old John Brown.
I saw the Angel Gabriel
Great power to him assign.
I saw him fight the Canaanites
And set God's Israel free.
I saw him when the war was done
In his rustic chair recline—
By his campfire by the sea
By the waves of Galilee.
I've been to Palestine.
 What did you see in Palestine?
Old John Brown.
Old John Brown.
And there he sits.
To judge the world.
His hunting-dogs
At his feet are curled.
His eyes half-closed,
But John Brown sees
The ends of the earth,
The Day of Doom.
And his shot-gun lies
Across his knees—
Old John Brown,
Old John Brown.[3]

Vachel Lindsay was, in fact, a favorite poet of Curry's. Curry not only knew the "John Brown" poem, he later wrote to Harry Abrams of the Book-of-the-Month Club and asked to illustrate a special edition of the volume of Lindsay's poems in which "John Brown" appeared.[4] Curry resonated to the heavy use of biblical imagery in Lindsay's poetry. Lindsay, like Curry, had been raised in a very religious midwestern home. In fact, Curry was quite familiar with the rigid Protestant sect of Campbellism that had shaped Vachel Lindsay's childhood and later found its way into his poetry.[5] The many Campbellites in Curry's home town of Winchester, Kansas, had fascinated him as a child. When he painted *Baptism in Kansas* in 1928, the painting that launched his Regionalist career, Curry was not, as one might expect, painting a memory of his own church gatherings. He was painting the vivid memory of the strange immersion baptisms of the Campbellites. "The 'Baptism in Kansas'," wrote Curry,

was painted without notes or sketches from memory of a baptism that took place in 1915.

This baptism was on the farm of our neighbor, Will MacBride. It was under the auspices of the Christian church, or Campbellites, as we called them. We were Presbyterians and were sprinkled only, but were interested spectators at all immersion baptisms. . . . At that time the setting, the ceremony, the singing, . . . the emotioned crowd affected me, and years later I put down what my poor abilities permitted me.[6]

Despite the overriding influence of religion in Curry's formative years, and the frequency with which the subject emerges in his painted oeuvre, it would seem that commentators have not paid sufficient attention to the religious underpinnings of much of Curry's art. Curry himself readily admitted that his style "was formed on the King James version of the Bible."[7] Elsewhere he asserted "My religious background has been translated into painting."[8] Specifically, Curry's religious leanings were translated into his paintings in two ways. There are, on the one hand, the rather straightforward genre pictures of religious revival meetings. In 1929, while visiting his parents in Kansas, Curry made a side trip to St. Joseph, Missouri, and made sketches at a meeting of Holy Rollers that resulted in paintings such as *The Gospel Train* (fig. 67).[9] Genre scenes such as this, with Curry as the detached observer, are aimed at documenting religious folkways from a sociological perspective.

It is interesting to note that those rituals that found their way into Curry's art were not scenes from his own religious upbringing, but of different sects that existed alongside his own and seemed strange by comparison. Curry's childhood was deeply religious. His parents had been staunch Scotch Covenanter Presbyterians who attended the Reformed Presbyterian Church in Winchester, Kansas. Curry's sister recalls the intensity of religious activity in the Curry household:

Having come from a very religious background from Scotch ancestry, Church attendance was carried out with a capital C. Sundays were observed with attendance at least twice on that day. There were friendships with the ministers, and the college [the Curry boys attended] was a private one run by a board from the Covenanter church.[10]

But Curry never painted the Covenanters. When he painted religious themes associated with Kansas, it was always someone else's religion. On several occasions he painted the emotional frenzy of the charismatic Pentecostals, or Holy Rollers, a strain of Protestantism at far remove from his own family's solemn and restrained church practices. Curry's mother could never quite understand why he didn't paint his own tradition:

Why don't you paint a Covenanter Communion, John, you know how it is—the pulpit with its flowers, the long table in white—the quiet solemnity over all as we gather

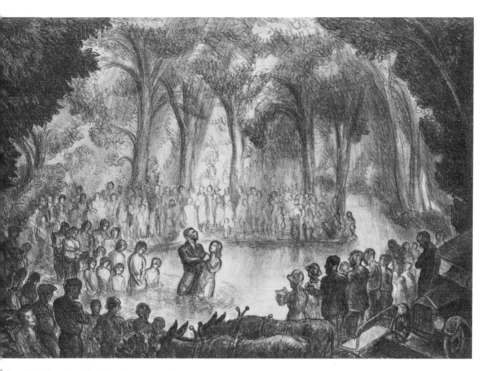

g. 66 *Baptism in Big Stranger Creek,* 1932,
ithograph.

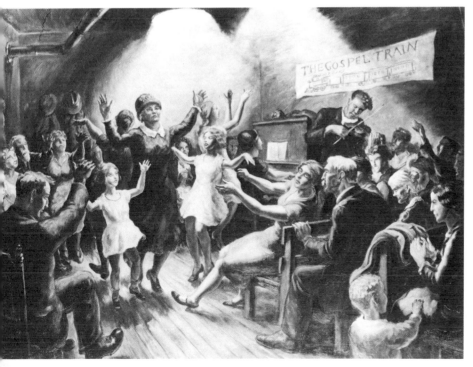

Fig. 67 *The Gospel Train,* 1929, oil on canvas. The
itle derives from a large sign—"The Gospel Train"—
:hat was crudely painted across the front of the
dilapidated store.

for the memorial service. I'm sure it is something Benton and Wood couldn't possibly do.[11]

But quiet solemnity and ascetic restraint were no match for the orgiastic praises of the Holy Rollers or the "dripping wet" salvation of a Campbellite baptism.

The Scotch Covenanters in Curry's home town held to some very strict notions about Christian propriety. Covenanter doctrine forbad "dancing, theater, novels and card-playing."[12] It also insisted that its members "not affiliate with organizations of oath-bound secrecy" such as a fraternity or the Masonic Lodge. The Covenanters held to a literal interpretation of the Bible—they believed that the one hundred fifty Psalms recorded in the Bible were the only songs "appointed by God to be used in His worship," and so they disallowed the use of any hymns written since that time. Similarly, the Covenanters prohibited the use of musical instruments in the worship of God because they found no written evidence that Jesus had authorized their use in the early Church.[13] One can only imagine "the quiet solemnity over all" in the Covenanter gatherings that Curry's mother so aptly described. By contrast, a painting such as *The Gospel Train* captures the reckless abandon of the Holy Rollers. These backwoods believers praise the Lord with foot-stomping, hand-clapping exultation as they bounce to the rhythms of the fiddler and piano-player in the background—seemingly innocent pictorial details that had captured the fascination of the little boy to whom those experiences had been denied. These are Curry's genre paintings of religious folkways, his own selection of intriguing rituals that seemed, at the time, peculiar, somehow forbidden, and intensely interesting.

A second group of paintings with religious referents relies on a much different sensibility. On several occasions, Curry painted what appear to be secular themes, but gave the paintings titles of traditional religious significance. In so doing, he forced the comparison between well-known biblical parables and events in contemporary American life. For example, Curry's early lithograph entitled *Flight Into Egypt* (fig. 68), 1928, conjures up images and associations to the biblical narrative of Joseph, Mary, and Jesus on their journey out of Bethlehem. Curry's picture, however, is not of the nativity group, but rather shows a pioneer family in covered wagon traveling across the American plains. The father walks ahead and leads the horse, while the mother and baby ride. The analogy is drawn here between the biblical flight and the more recent migrations into the American West.

Fig. 68 *Flight Into Egypt,* circa 1928, lithograph.

Fig. 69 *Sanctuary,* 1935, oil on canvas.

Sanctuary (fig. 69)—a title with religious undertones—is a painting of farm animals that have taken refuge on a spot of high ground as the flood waters of the Kaw River rise around them.[14] Curry uses a similar approach in his watercolor, *The Prodigal Son* (fig. 70). In it, a modern farmer in coveralls and hat shovels feed corn to a herd of pigs from the back of a wagon. The setting is obviously twentieth-century rural America, as is evident from the modern barn shown in the background. The title, however, recalls the parable of the wayward son who left his father's house for the lure of the city but returned, penitent, to be greeted by opened arms and the feast of the fatted calf. The story had personal significance for Curry. He painted it in 1929 in New York City when he was homesick. His father had just offered him land and farmstock in Kansas if he would come home and start life anew as a Kansas farmer. Finding himself financially destitute,

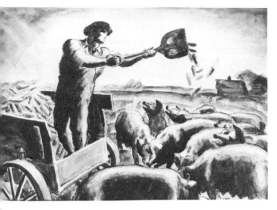

Fig. 70 *The Prodigal Son,* 1929, watercolor. A well-known biblical parable with a modern American setting.

Curry for a while considered the offer but chose instead to remain in Westport. When he finally did return to the Midwest in 1936—as an artist, not a farmer—he spoke metaphorically of himself as the Prodigal Son of the Middle Border, applying the biblical parable to incorporate his own personal history: "I am glad to be associated with the College of Agriculture," he told the citizens of Madison. "While in my youth I fled from the arms of agriculture to the more seductive charms of art; now I return."[15]

In the lithograph, *Mississippi Noah* (fig. 71), 1932–35, Curry again uses a religious title for a secular genre scene. Here he shows a black family afloat on a rooftop amidst the rising floodwaters of the Mississippi River. The solid triangular composition (derived from Gericault's *Raft of the Medusa,* which Curry had studied in the Louvre) culminates in the upraised, suppliant hands of the father. Although the proximate

source for this theme was, no doubt, the recent Mississippi flood of 1927, the subject matter of blacks floating on a rooftop in the floodwaters of the Mississippi was not novel—the scene had been the subject of a popular Currier & Ives print of 1868.[16] But what Curry has done is to invite comparison between current events (recurring floodwaters on the Mississippi) and biblical allegories such as Noah and the Deluge. The disjunction between the title from the biblical past and the contemporary scene depicted suggests that the viewer consider the relationship between the two, seeing each in a new light. On another level, this device speaks to the continuity of human experience. Thomas Craven believed that Curry meant to imply in such paintings "that the battle against nature as he had known it in his boyhood on the plains was comparable to the elemental conflicts described in the Old Testament."[17]

It seems clear that Curry borrowed this technique of conflating religious allegory with contemporary events from certain old master works he admired. He explained the device in a slide lecture that he packaged and presented at speaking engagements during his tenure as artist-in-residence at the University of Wisconsin. Two of his expositions are of particular interest in this regard. Curry's remarks written to accompany a slide projection of Bennozo Gozzoli's fresco *The Shame of Noah* are telling:

Notice that he puts his biblical characters into a setting which is logical and in keeping not with the characters of the Bible but with the artist himself. The artist, in other words, has used a biblical story in such a way as to make it very real and meaningful to his public. Both the artist and his public are acquainted with these farm activities, then into this Florentine scene the artist puts these people from the Bible, and as a result these people from the Bible and the story which they portray become as real as anything else in the contemporary life of the artist.[18]

Curry also remarks on the same device at work in Dürer's *The Return of the Prodigal Son* of 1495:

This is an engraving which is very close in religious spirit and in regionalism to the art which you have just seen in the frescoes by the Italian artist Gozzoli. Durer shows the return of the prodigal son as taking place in a yard almost completely surrounded by typical medieval German farm buildings. Durer, like the Italian artist we have just seen, puts the biblical character into the actual setting which he and his people know as something real so that this is not only a good interpretation of the repentant prodigal, but it is also a good account of a farm scene in Germany in 1495.[19]

These comments apropos of Dürer's approach are about as close as Curry ever came to articulating his own definition of regionalism—reinterpreting the shared myths and longstanding beliefs of

Fig. 71 *Mississippi Noah,* 1935, lithograph, second stone.

one's cultural heritage in terms of personal history and current events in the contemporary life of the artist.

In 1934, Curry's friend Thomas Craven, art critic and ardent promoter of the Benton-Curry-Wood triumvirate, analyzed the development of this approach to picture-making in less circuitous prose than Curry's:

Christian mythology had prescribed a subject-matter which brought the artist into direct contact with an idealism universally shared and professed. Accepting this mythology literally, the artist at first produced only childish concepts or meaningless visions and abstractions; and it was not until skepticism had broken the rigid doctrinaire attitudes of the Church that he was able to connect his subjects with living things and to build an art of human values. *By expressing Christian faiths and myths in terms of his own experiences with his fellow men, the artist remade his subjects: nominally they represented Christian mythology; actually they represented current realities.*[20] [my emphasis]

Craven termed this mode of approach "the symbolical use of personal experiences," and it is this sensibility that emerges in the second group of Curry's religious paintings and, in a similar way, in his Kansas murals.

There is an undertone in the Kansas mural cycle of biblical stories "remade" to incorporate certain current events of the 1930s. The paintings are intended to be read on several levels. There is, in the most obvious way, the presentation of the history of Kansas, from the Spanish explorations to Civil War, through the settlement period, to modern farming. On a second level, there exists a substructure of biblical narrative, in which Curry makes reference (by pictorial means or in his accompanying mural descriptions) to well-known segments of Christian mythology: Moses leading the Israelites out of Egypt into Canaan, the plagues brought upon Egypt when the Pharaoh refused to release the Hebrew slaves, the crucifixion of Jesus Christ, the prophecy of Scripture and the Battle of Armageddon, and the thousand-year messianic age of peace and plenty on earth called the millennium. In Curry's expanded exegesis, John Brown becomes both a new American Moses, sent by God to lead the slaves out of bondage, and a precursor of the crucified Christ; Kansas drought and grasshopper infestations are likened to the plagues of ancient Egypt; and painted scenes of pastoral bliss in Kansas bear the promise of a coming millennium.

With the possible exception of *Flight Into Egypt, The Prodigal Son,* and *Mississippi Noah,* the Kansas mural cycle is richer in religious imagery than any other of Curry's works. One reason Curry established for constructing his Kansas history with a substratum of religious associations lies in the targeted audience of the murals:

Murals and all paintings should be done for the class of people who will have the greatest contact with them. I desire that the murals in the statehouse be understood and appreciated by everyday Kansans, the people who are going to see them.[21]

Curry's audience of "everyday Kansans" would be intimately acquainted with the scriptural events to which he made reference. Religion was still alive in Kansas, and the framework most Kansans used to structure historical time was still a biblical one in the 1930s. Curry relied on the shared knowledge and beliefs of his public—those earnest Scotch Covenanters and Campbellites he left behind—knowing that this audience would recognize and resonate to his references to Christian mythology.

But it is not enough to say that Curry relied on a general melding of biblical and historical symbolism to construct his view of Kansas history. In order to gauge the implications of the biblical and prophetic underpinnings of his history paintings, it is helpful to explore the most proximate sources of his early religious training. For it was during his Kansas boyhood—in the teachings of Protestant fundamentalists—that Curry was exposed to the kind of lingering, essentially nineteenth-century religious world view that would be little understood by his more sophisticated, urban friends of later years. It is, in fact, a very specific biblical eschatology, having its roots in the British millenarianism of the late nineteenth century, that informs Curry's template of Kansas historical events—a view that was still being set forth by his devout Scotch Covenanter parents, and a view that no doubt he felt would still appeal to the Kansas believers he had left behind.

The roots of the particular strain of twentieth-century Protestant fundamentalism that Curry learned as a child have been distilled by Ernest Sandeen in his doctrinal study of American fundamentalism:

The belief that acceptance of the divine authority of a Scripture required that the believer expect a literal rather than a spiritual fulfillment of the prophecies; the belief that the gospel was not intended nor was it going to accomplish the salvation of the world, but that, instead, the world was growing increasingly corrupt and rushing toward imminent judgment; the belief that Christ would literally return to this earth and the Jews be restored to Palestine before the commencement of the millennial age; and the belief that this whole panorama of coming glory and judgment was explicitly foretold in the prophecies.[22]

Several of these themes, as underlying intellectual constructs, are important to an understanding of the cycle of events portrayed in Curry's history paintings. One relevant tenet of fundamentalism is the expectation that prophetic passages of scrip-

ture correspond to literal, observable political world events. Another is the general pessimistic view of civilization in which what is perceived as an increasingly corrupt society will meet with a cataclysmic end, and that only this tragic Armageddon will suffice to bring about the millennial age of peace and prosperity.

An interest in using biblical typology or cosmic drama as a framework for history had developed early on among Protestant theologians and historians.[23] Using apocalyptic scriptures eclectically, and keeping an eye on developments in international affairs, early biblical commentators accomplished a weaving of political and religious motifs into one holy history. It was the French Revolution that had provided the catalyst for the revival of interest in apocalyptic chronologies.[24] Biblical passages on prophetic visions recorded in Daniel 7 and Revelation 13 were traditionally interpreted by Protestants to be two descriptions of the same event—"the tyrannical reign of the pope for 1,260 years."[25] This figure had been derived by using the "year-day theory" of prophetic interpretation, in which the secrets of the scriptures could be unlocked, it was argued, by substituting "year" whenever the word "day" was mentioned in prophetic passages, and by calculating a scriptural "week" as thirty years. Using this formula, Protestant commentators arrived at the figure 1,260 years as the duration of papal hegemony.[26] When in 1798, French troops marched into Rome, establishing a republic and sending the pope into banishment, Protestant commentators were quick to notice that the reign of papal power could be marked at exactly 1,260 years if the date of the rise of the papacy (about which there had previously been no general agreement) were to be assigned to the year A.D. 538, when "Belisarius put an end to the Empire, and Dominion of the Goths, at Rome."[27] Sandeen explains:

Thus we see the special significance of the French Revolution to the student of prophecy. . . . The identification of the events of the 1790s with those prophesied in Daniel 7 and Revelation 13 provided biblical commentators with a prophetic Rosetta stone. At last a key had been found with which to crack the code. There could now be a general agreement upon one fixed point of correlation between prophecy and history. After 1799, in Egyptology as in prophecy, it seemed as though there were no limits to the possibility of discovery. . . . The vast bibliography of prophetic studies published during the first half of the nineteenth century is as bizarre, to modern eyes, as the material interpreted.[28]

Protestant sects subsequently emerged that drew inspiration from their own eccentric readings of the Apocalypse.[29] And howevermuch these prophetic interpretations of history might, indeed, seem "bizarre, to modern eyes," the important fact remains that it was just this kind of rhetoric that John Steuart Curry had heard as a child from the Scotch Covenanter preachers in Kansas.

The Reverend David H. Coulter was one such Kansas prophet, and Curry's acquaintance with religious prophecy can be documented through a curious exchange of letters between the artist and Dr. Coulter's granddaughter, Mary Wickerham. Mrs. Wickerham had initiated the correspondence in 1945 with a letter in which she enclosed a draft of an original stage play she had just written "reconciling the highly idealistic tenets of the Scottish Covenanter . . . with life as I found it."[30] To Curry's surprise, Mrs. Wickerham had named him as the protagonist in her play, and she was writing to ask if he might like to also act the role in a Broadway production she was attempting to arrange. Curry, embarrassed by the whole affair, declined the invitation and also requested that she not use his name in her play. But what is interesting about this series of circumstances is Curry's interest in her grandfather, whom he called "a great and dynamic figure":

I feel that you have a great theme in your supernatural symbolism and also in the character of your grandfather. I remember him well. . . . My mother often tells me of Rev. Coulter's prophecies, and how right he was concerning the first and second world wars. You mentioned the invasion of the West by Orientals in 1999. I had not heard my mother mention this.[31]

One can only guess by what magic formula Dr. Coulter had arrived at the year 1999, and by what creative exegesis of scripture he had predicted that "the invasion of the West by Orientals" would occur in that year. What does seem clear, however, is that Curry associated the religious preoccupations of the Kansans he knew well with this kind of biblical prophecy of world events. Curry, himself, would also have been intimately aware of the Reverend's prophecies. From 1877 to 1908, Dr. Coulter was the pastor of the Reformed Presbyterian Church in Winchester, where the Curry family attended services twice on Sundays.[32] One cannot properly gauge the implications of Curry's Kansas murals without reference to this. Curry may well have become an infidel in adulthood, but in his formative years he was nurtured in Protestant, fundamentalist biblical prophecy that placed America within an apocalyptic framework of universal history.

The Reverend Coulter's biblical prophecies predicting the cataclysms of war were not unusual for his time. Just as there had been in the years immediately preceding the Civil War, there was a dramatic resurgence of interest in various apocalyptic views of history at the eve of World War I.[33] Much of the dramatic wartime interest in millenni-

alism was centered in Chicago, home of the Moody Bible Institute. Beginning in 1917, and lasting for several years, theologians at the Divinity School of the University of Chicago led a fierce assault on the premillennialist teachings of their crosstown rivals at the Moody Institute, thus launching an intense debate that set the stage for the fundamentalist-modernist conflicts that developed in the 1920s.[34] Curry, living in Chicago at the time, found himself in the midst of these millennialist controversies.

From the fall of 1916 to the fall of 1918, Curry was enrolled as a student at the Chicago Art Institute studying under Edward J. Timmons and John Norton. He had left Kansas, all decked out in "a brand new $17.50 'Style-Plus' suit of clothes."[35] Fresh from the farm and the Covenanter church meetings, Curry sought out the companionship of fellow Christians in Chicago. His letters of 1917 to his mother are filled with talk of church services he had attended and other Christians he had met. One letter describes the ser-

mons of Dr. Stone, a "wonderful young minister" Curry had encountered at the Fourth Presbyterian Church in Chicago.[36] Curry apparently found like-minded companionship among the young seminarians at the Moody Bible Institute, and wanted to enlist in the Army with them, as he wrote to his parents in March 1917:

Dear Ma and Dad,

The world moves. I am tempted to join the Army. . . . The enlistment now is for the war and the regulars are going to get the Comission [sic] in the new national army. . . . The Co. of the Church with the Moody Institute fellows will be a fine place to get in.[37]

In 1917, the Moody Institute was a hotbed of premillennialist fervor.[38] John Steuart Curry was clearly involved in some of the discussion. One letter to his mother in February 1917 relates how he has just met a man named Mr. Hausman, and Curry seems disturbed to report that this fellow "goes around talking the . . . postmillenial [sic] coming of Christ."[39]

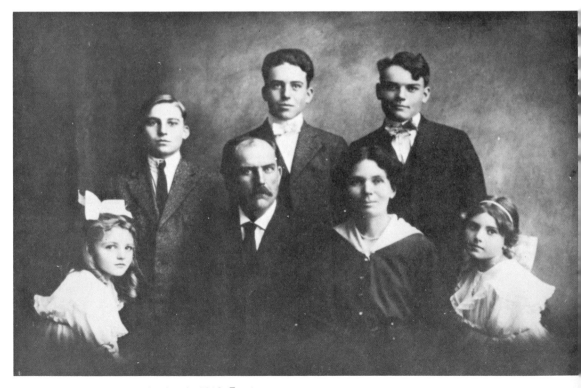

Fig. 72 Curry family portrait taken in 1916. Front row, left to right: Mildred (sister), Smith Curry (father), Margaret Steuart Curry (mother), Margaret (sister); back row, left to right: Paul and Eugene (brothers), and John Steuart Curry.

The acrimony between the pre- and postmillennialists in Chicago is worthy of notice because the issues under discussion were of great interest to Curry at the time, and because it is a biblical structuring of historical time that stands behind his later murals for the Kansas Statehouse. Looking back over Curry's painted works, Thomas Craven later asserted that "his approach to his themes was colored by the religious preoccupations of his people."[40] And in the early years of this century, Curry's "people" were preoccupied with the Apocalypse.

As the country was on the verge of the Civil War, Julia Ward Howe penned her apocalyptic vision, "The Battle Hymn of the Republic," which begins, "Mine eyes have seen the glory of the coming of the Lord."[41] Recent scholarly studies have uncovered the "intensity and virtual unanimity of Northern [Protestant] conviction that the Union armies were hastening the day of the Lord."[42] In a similar way, the years preceding World War I saw a dramatic increase in prophecies that the events foretold in the Book of Revelation were about to be enacted on the global scene.

Those fundamentalists of the premillennialist persuasion looked to developing world events and discerned in them the "signs of the times." They spoke of biblical prophecies in the context of contemporary problems, and all around them these doomsayers saw the omens of decay and disaster that would precede the Second Coming of Christ in judgment. Relying on a literal interpretation of biblical texts, the premillennialists held that the return of Christ and the Final Judgment were imminent, and that the present world would be destroyed and historical time would come to an end before the New World of the millennium would begin.

Premillennialism is a fundamentally pessimistic world view, emphasizing separation from "worldly things" and virtually welcoming the coming cataclysm that will destroy the present evil and issue in the messianic age of peace and plenty for believers.[43] Postmillennialists, however, held a primarily optimistic view with a strong belief in progress. There would be no cataclysmic end to the world, no imminent Second Coming; instead, through progress, human society was even now moving toward a realization of the Kingdom of God on earth. Postmillennialist teachings gained impetus from liberal theology, Darwinian evolutionary thought, and the rise of the Social Gospel.[44] The style of apocalyptic expectation that marked postmillennialism placed social reforms and social justice as the first items on any agenda that aimed to translate the Kingdom of God from expectant hope to historical reality.

The premillennialist prophecies of the Apocalypse coming forth from the Moody Institute while Curry was in Chicago lingered on in fundamentalist enclaves across the nation during the 1920s and 1930s and beyond. The threat of world disaster evidenced everywhere in daily news of international affairs in the 1930s summoned the prophets of doom. In Kansas, there was a radio preacher, Gerald B. Winrod, a Protestant fundamentalist and a "militant premillennialist" with headquarters in Wichita. By 1938, Winrod's magazine, the *Defender,* nourished a constituency of a hundred thousand households on a diet of bigotry, fear, and fundamentalist theology.[45] With an isolationism wedded to biblical prophecy, fundamentalist evangelists announced that the Day of the Lord was at hand.

As he sketched out his murals for the Kansas Statehouse, John Steuart Curry no doubt sensed that an apocalyptic view of history would strike a resonant chord among followers of such back-

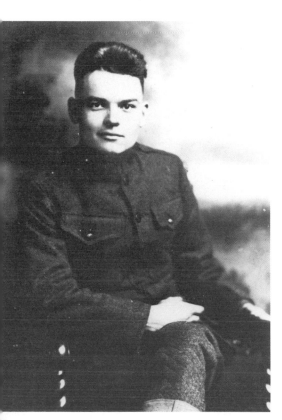

Fig. 73 Photograph of John Steuart Curry in uniform as a volunteer for the Student Army Training Corps at Geneva College, September 1918.

woods Kansas prophets as the Reverend Coulter and his spiritual descendants. Abandoning biblical literalism but retaining biblical referents, Curry built a vision of Kansas history premised on myth and memory. Drawing on the prophetic eschatologies of his youth, he told the history of Kansas in the language of the Apocalypse. Like the old masters Dürer and Gozzoli he so admired, Curry remade his biblical allegories to incorporate relevant events in the "contemporary life of the artist."

If anything seemed like the beginning of Armageddon to a young painter whose childhood was steeped in stories of the Apocalypse, it was the drama unfolding in Europe in 1938. Despite growing tensions abroad, Curry felt that he must go and study the works of Michelangelo before proceeding any further on his Kansas mural sketches. He modeled his John Brown after Michelangelo's *Moses,* intended for the tomb of Pope Julius II. (The tralatitious significance of John Brown as the American Moses held an obvious appeal.) Curry sailed for Paris on June 18, 1938, and went also to Rome, Florence, Amster-

dam, and Munich before returning in September.[4] Europe was on the very edge of war. The universe, as Ellen Glasgow wrote, had come to seem like a "vast lunatic asylum."[47] Curry was terrified of what he saw there. Before he had sailed for Europe, he had prepared only the sketchy oil studies for the murals, mapping out the subject matter and tying down the composition. It was not until he returned from abroad that he began his series of facial character sketches of John Brown in which he tried to capture just the right countenance.[48] The influence of Michelangelo's *Moses* is apparent, all right, but Curry also imbued Brown with all the lunacy of El Duce, all the fury of the Führer. Curry had just witnessed what he felt was the contemporary parallel to the unbridled lunacy of Old John Brown. In sketch after sketch, he tried to capture an image of that wild fanaticism that leads to war. "If [John Brown] were alive today," wrote Curry in 1941, "he would be considered direct from Moscow or Germany."[49]

Curry changed his conception to a beardless Brown (see plate 4) for about three months in late 1938 and early 1939. Brown wore no beard while in Kansas but grew it upon returning to the East to disguise himself after the Pottawatomie massacre in Kansas. Curry knew that Brown was beardless in Kansas from studying daguerreotypes in the State Historical Society. Given his recent experiences in Europe, he might also have been trying to make Brown appear more contemporary by removing the beard, but he returned to the Moses-inspired conception nonetheless.

The Tragic Prelude is Curry's *Apocalypse Now.*[50] Wedding his isolationist fears to biblical prophecy, he paints John Brown at the Battle of Armageddon. In Curry's extended exegesis, World

Fig. 74 Facial study of John Brown for the Kansas Statehouse murals, 1939, red chalk. One of several portrait sketches made just after Curry returned from his trip to Europe in the fall of 1938.

Fig. 75 Henry Simon (b. 1901), *The Three Horsemen,* circa 1941–42, lithograph. Inspired by the four horsemen of the Apocalypse who spread death and destruction, this lithograph depicts Hitler, Hirohito, and Mussolini as modern counterparts.

War II is the imminent cataclysm that will issue in the messianic age of peace and plenty he paints in the closing segment of his historical mural cycle. *Kansas Pastoral* (fig. 76), Act III of the Kansas mural cycle, is a promised land flowing with milk and honey. Curry described this painted rural bliss in a letter that accompanied his mural sketches:

On the west wall stand the ten-foot figures of the young farmer, his wife and children, and back of them the ideal unmortgaged farm home; back of that the night and evening sky.

On the long wall to the south . . . a great reach of the Kansas landscape. In the foreground the Hereford bull, wheat field, feeding steers and hogs, a grain elevator, doves in Osage orange trees. Behind all these are fields of corn and grain running back to the distant hill and the setting sun framed by the great turreted cloud to the north.[51]

Kansas Pastoral is, at first glance, a believable painting of a rural landscape. It is only when examined with a questioning eye that the mural begins to disclose its mythical, millennial dimensions. The most recent writing on Curry presumes his pictures to be statements of fact, "portraits of rural America" intended to "depict the way things really were in the Midwest of that era."[52] That such a charge is rarely leveled against either Thomas Hart Benton or Grant Wood is due in large part to their individual vocabularies of style. Benton's mannerist distortions and elongations of the human body, and Wood's hard-edged geometrizations of it draw attention to the fact that the hand of the artist has intervened between us and the characters in the paintings. Curry's more naturalistic vocabulary of style so convincingly matches our everyday visual world that one is more easily led to equate the world inside the painting with the world outside the painting—that is, to draw a direct line between the image and

the culture it seems to represent. Such is the slippery nature of realism. These assumptions about a naturalistic style in painting are both ahistorical and unmindful of the possibility of wilful manipulation of pictorial motifs by the artist. It is a view whereby all things with a recognizable correlate in our visible world are made to lie together in the Procrustean bed of documentary realism. And, in Curry's case, it is misleading. *Kansas Pastoral* is one such painting of rural life that has long been assumed to be an unmediated reflection of "the way things really were" on a typical Kansas farm in 1937.

Putting aside for the moment the cultural context from which this painting emerged, and looking at the image from a vantage point in the present, one might easily view *Kansas Pastoral* as a benign representation of a typical rural family enjoying a way of life we have come to associate with the great fertile heartland of America. The painting matches a common stereotype of what country life in the Middle West is all about. But Farm Security Administration photographers, for example, were documenting a much different view of rural reality on the plains. When measured against its cultural context—against other social and demographic indices of rural life at the same date—Curry's painting begins to take on mythical dimensions. The fertility and richness of the land in *Kansas Pastoral* stand in telling contrast to actual agriculture conditions in Kansas. When this mural was conceived, Kansas was in the grip of the Great Depression, and the state had been plagued by drought, dust storms, and a scourge of grasshoppers since 1932.[53] Curry's frankly optimistic imagery presented as fact suggests that he was not primarily interested in documenting "the way things really were" on a typical Kansas farm in 1937.

Curry's position with the University of Wiscon-

sin's College of Agriculture had brought him into a circle of progressive reformers who had become increasingly interested in rural family life. The artist's unique appointment was not with the Department of Art, but with the Department of Rural Sociology, where the primary interest of his faculty colleagues was the study of rural family relations. The position had been the creation of the University's Dean of Agriculture, Chris Christensen. Following the model of Danish folk schools, Christensen hoped to change the emphasis of the University "from AGRI-culture to agri-CULTURE" with Curry's help. Christensen's "cultural arts approach" to upgrading rural life was part of a larger effort among a select group of agricultural reformers to urbanize the farm.[54] This group clustered around the American Country Life Association, an institution that since its establishment under Theodore Roosevelt had maintained its urban, progressive reform position that agriculture was far too important a national affair to be left in the hands of farmers. By the mid-1930s, these interventionists had widened their target of influence from a mere interest in the levels of crop production to the complete social engineering of family life on the farm.[55] It is within this framework that Curry's *Kansas Pastoral* can best be understood.

Curry had been interested in programs of social reform since at least 1933—antilynching legislation was high on his agenda for social change. When he arrived on the Wisconsin campus in 1936, he joked with reporters that he had been hired to use propaganda in art to make the cows produce more milk. His paintings, said Curry, may not be about the communist conception of the class struggle, but they were very much concerned with the farmer's constant struggle against an uncertain Nature—a topic he knew much about.[56] For in the very same year that Curry was painting the "ideal unmortgaged" farmscape in *Kansas Pastoral,* the mortgage on his own father's Kansas farm was about to suffer foreclosure.[59] Curry's father fingered the problems he shared with many other Kansas farmers during the 1930s when he described "the toll of the elements—five years of dreadful acts of God; no corn, no cattle; a bank failure and double liability as a stockholder; the money from my wheat crop eaten up by taxes and interest on borrowed money."[58] The picture Curry's father paints with words is far more rooted in the rural realities around him than the picture the artist paints on canvas in *Kansas Pastoral.* But Curry's stated ambivalence about man's relation to a fickle and sublime Nature and his newfound belief in the persuasive powers of paintings had made it easy

for him to embrace the progressive utopian doctrines of the Wisconsin agriculturalists in his Kansas murals. He paints not an unmediated reflection of what he saw when he returned to Kansas in 1937, but rather a hopeful projection into the future of a hostile land controlled by agricultural technologies, as if by some power of sympathetic magic, painting it so could make it come to pass.

In an effort to modernize his imaginary farmscape, Curry made several changes to the composition from his early conception of it in the oil sketches presented to the Murals Commission for review. Most grain storage elevators in the wheat belt in the mid-1930s were of wooden frame construction like the one in his early oil sketch. In the final mural, Curry removed this familiar Kansas structure and painted in a stately new concrete silo of the kind that could be found only on the most up-to-date farms. In a similar way, the omnipresent midwestern windmill that had been used since the late 1870s to harness the most plentiful commodity of the plains (wind) to produce the scantiest (water) was removed by Curry in the finished mural, as the artist suggests the advent of rural electrification to the farm.

Another clue to the anachronism of *Kansas Pastoral* is that the social structure of the rural family depicted is futuristic for its date. It is instructive in this regard to measure the patterns of interaction in the painting against concurrent documentation of trends by social scientists, and also against Curry's painted views of the historical changes in American family life. Curry's mural, *The Homestead* (fig. 79), was completed for the Department of Interior Building in Washington, D.C. in the same year that he was preparing his sketches for the Kansas murals. For a time, in fact, he worked on the Washington mural sketches and the Kansas mural sketches side-by-side at his studio in Madison, Wisconsin. *The Homestead* shows the family of a Civil War veteran who have settled along the banks of the Arkansas River in Kansas following the signing of the Homestead Act of 1862.[59] This frontier family are shown actively making a living upon the land, building their fences and preparing their food. Mother and daughter pare potatoes near a small garden for the family meal. In the background, a young son holds the fenceposts while his father drives them into the ground. An older sister drives the wagonload of spikes while she also keeps an eye on the toddler. Each member of this frontier family is actively working and contributing energy to the productive whole.

The American family had been the object of

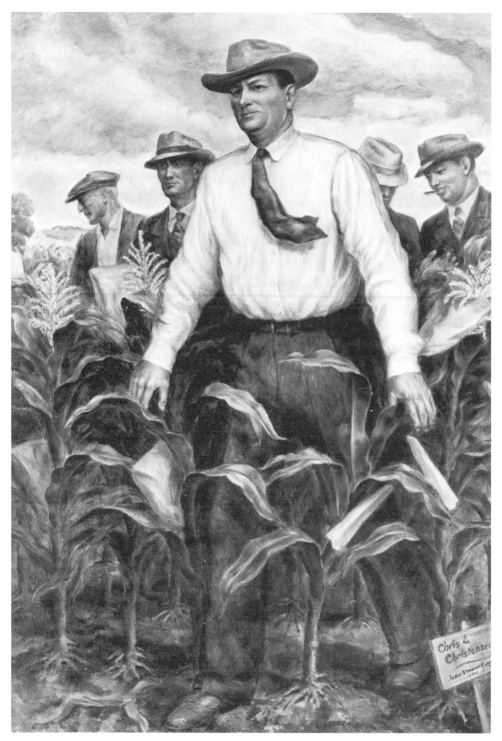

Fig. 77 *Portrait of Chris L. Christensen,* 1941, oil and tempera on canvas. The towering six-foot-six-inch Dean striding through the rows of hybrid corn on the experimental farm of the university, surrounded by other agricultural reformers. Curry suggested that the man with a cigar was probably a machinery salesman.

intense scrutiny by the rapidly developing fields of social science in the 1920s, and had been found wanting. Once a productive and multifunctional institution in a frontier society, as shown in *The Homestead,* it had given over its economic, educational, and recreational functions (so the experts argued) with the advent of industrialization and urbanization. In 1933 the government's publication *Recent Social Trends* characterized the problem:

The various functions of the home in the past served to bind the members of the family together. As they weakened or were transferred from the home to outside agencies, there were fewer ties to hold the members with a subsequent increase of separation and divorce. Divorces have increased to such an extent that, if present trends continue, one of every five or six bridal couples of the present year will ultimately have their marriage broken in the divorce court. This prospect has led to much concern over the future of the family, and prophecies that it will become extinct.[60]

Sociologists further documented that those urban families that had remained intact had evolved an adaptive social solution to this loss of function by reorienting the function of the family toward the emotional and affectional needs of its members, thus changing its primary focus "from institution to companionship," to coin a phrase of the period. In 1933, *Recent Social Trends* expressed hope for the future stability of the urban family in this new emotive function: "With the weakening of economic, social and religious binds in the family, its stability seems to depend upon the strength of the tie of affection . . . the joys and responsibilities of rearing children."[61] Betty Friedan's "feminine mystique" was not purely a phenomenon born of the 1950s. In the minds of social theorists, at least, it had begun to develop long before Rosie the Riveter was ever called out of the home to help win the war.

John Steuart Curry's idealized rural family in *Kansas Pastoral* closely matches the description of the affectionate family identified by the sociologists—one no longer engaged in the toilsome ac-

Fig. 78 Detail sketch for The Unmortgaged Farm, *Kansas Pastoral,* intended for the West Corridor of the Kansas Statehouse.

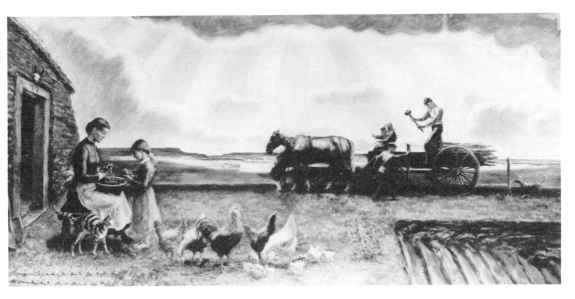

Fig. 79 *The Homestead,* 1937–38, oil and tempera on canvas, mural in the Department of Interior Building, Washington, D.C. (Section of Painting and Sculpture). Men, women, and children work together in the productive, work-oriented frontier family.

Fig. 80 Sketch for the Kansas farmer in *Kansas Pastoral,* 1940, charcoal. Most of the figures in the Kansas murals were drawn from nude models.

Fig. 81 Sketch for the Kansas mother in *Kansas Pastoral,* charcoal.

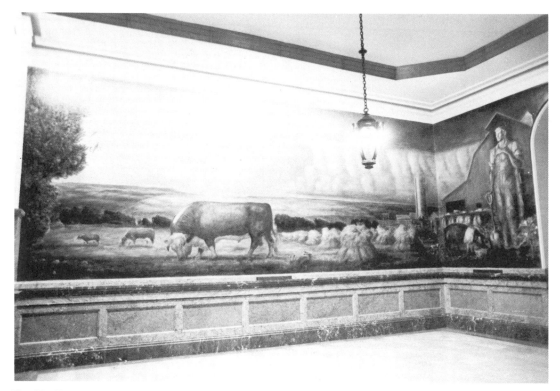

Fig. 82 The Unmortgaged Farm, detail of *Kansas Pastoral,* 1937–42, sections of the south and west walls of the West Corridor, Kansas Statehouse murals. Modern agricultural technology brings bounty and leisure to this idealized farm.

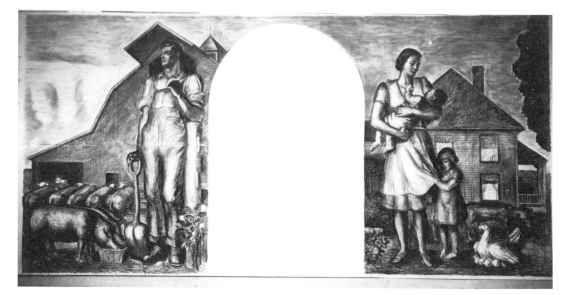

Fig. 83 Preliminary drawing for *Kansas Pastoral,* circa 1940. The arched corridor marks off the separate spheres of men and women in the Kansas farm of the future.

tivities of production and protection. In this agrarian utopia, the new agricultural and domestic technologies have freed the family from the necessities of work. Leisure has finally come to the farm. The farmer stands at rest, leaning on his shovel, overlooking a farm so well ordered that it seems to run itself. The fruits of the harvest are lined up in mechanical precision as covert symbols of mechanization. Even the hogs stand at attention in this efficient environment. Hard labor on the land is no longer a part of this rural world. Curry's friend, Dean of Agriculture Chris Christensen, believed that the great exodus of young people away from the farms following World War I had been due to what he termed a "deep-seated urge to escape a way of life from which all graciousness and pleasure were crowded out by hard work and endless monotony."[62] According to the Wisconsin reformers, at least, it was the promise of leisure that could negate the lure of the city in the minds of the young.

In *Kansas Pastoral,* the modern farm woman is no longer seen as an integral force in the workplace. Curry has used the arched corridor in the middle of the wall as a compositional device to reinforce the content of his mural, as it sharply separates the man's new world of agribusiness from the woman's sphere, dominating the home. Similarly, animal metaphors in the two murals are used to reinforce the content of the works. In *The Homestead,* rooster, chicks, and chickens peck and feed near the foreground as bountiful reminders of their capacity to provide this frontier family with eggs and a number of nice Sunday dinners, besides. But only one chicken appears in *Kansas Pastoral,* shown prominently in the foreground in telling juxtaposition to the Kansas mother, and characterized here as a "mother hen" cuddling her baby chicks. As if a play on the western tradition of female portraiture that a dog shown alongside the sitter symbolizes the fidelity of the woman, or a piece of fruit her fertility, this mother hen becomes an attribute figure symbolic of the theme of loving motherhood shown in the Kansas madonna and child. There is no function being performed by this modern farm wife except the giving of affection.

It seems clear that Curry fully understood the cultural implications of the new and old family patterns. But at the date of this painting, these affectional and child-centered family patterns were not characteristic of rural America, but of urban America. In 1936, following an extensive study of some three thousand families, the White House Conference on Child Health and Protection published a report that identified a dividing line between existing rural and urban family patterns. It

was only the urban family that had shown the growing emphasis on childrearing and that tended toward freer, more intimate interactions among the family members. The survey found that these urban trends differed from an existing rural family pattern that still stressed discipline, respect for authority, and the assignment of duties and responsibilities to all family members, a system having its roots in the productive and work-oriented frontier family.[63]

When viewed against other measures of the fabric of rural family life in 1937, Curry's vision in *Kansas Pastoral* is clearly fictional. Both in the richness of the land and in the structure of the rural family, it comments on its present through its marked disparity to it. In Curry's painted world, he takes that extra leap into the future. His is a carefully defined and logically developed agrarian utopia that takes its cue from the reform doctrines being set forth by the American Country Lifers. Progress in advanced agricultural technology promises to overcome the destructive forces of Nature. The noble yeoman in the World of Tomorrow will reap a harvest of plenty without having to till the soil by the sweat of his brow. The farm wife of the future will be freed from the drudgery of labor as the machine brings leisure to the home. Curry is giving Kansans a social blueprint for the kind of change that agricultural reformers were trying to effect—the new, affectionate family reunited with a well-controlled land. The mythic ideal of the noble yeoman and his family living in fruitful marriage with the land would not be obscured by the dusty realities of the troubled present.

And yet, there *is* a concession to the troubled present made in Curry's Kansas murals. It is disguised in the cloak of historical costume. The panels intended for the central Rotunda of the Statehouse were designed to constitute Act II of Curry's historical epic, featuring the Kansas homesteaders and the settlement period. But local criticism of Curry's view of Kansas history began almost immediately after he had made his sketches available to the news media in 1937, and a legislative battle that lasted for several years ended in the state's refusal to allow him to complete the murals as planned. The focus of the debate was presumably over the removal of some Italian marble wainscoting in the Rotunda in order to make the necessary space for the murals. But the rhetoric actually centered more on local resentment of Curry's portrayal of John Brown and of his intention to portray in the central Rotunda a less than idyllic view of the Kansas past.

Illustrated here are four of the eight panels that Curry had intended to install in the Rotunda (see fig. 86). They exist only in preliminary oil

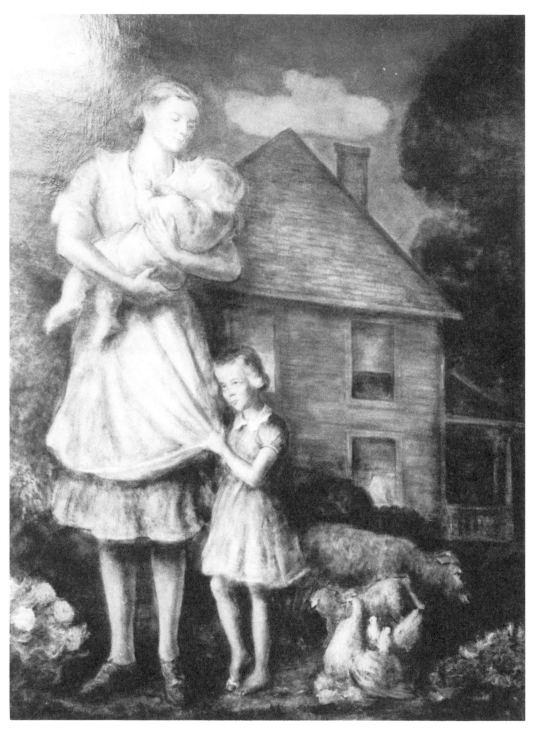

Fig. 84 Kansas Madonna, detail of *Kansas Pastoral*,
1937–42, oil and tempera on canvas, section of the west
wall of the West Corridor, Kansas Statehouse murals.
The triangular pedimental composition unifies the figure
grouping of the farm wife, her children, and the symbolic
mother hen at her feet.

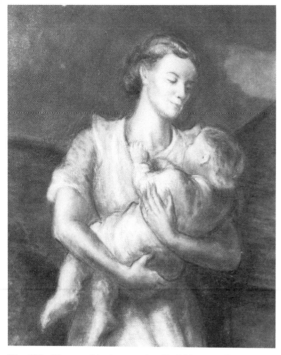

Fig. 85 Kansas Madonna, detail of *Kansas Pastoral,* 1937–42.

sketches. The designs for the Rotunda were paired in idea and composition and were intended to preserve a common horizon line. The four panels were to be installed to the right and left of the East Corridor entrance. On one side were to be two panels depicting the working frontier family. *The Homestead* draws its title and its salient motif from Curry's completed mural in the Department of Interior Building. For this panel he focuses on the prairie wife paring potatoes. Beside it was to be a panel called *Building the Barbed Wire Fences,* which extracts the working father from the same mural. Flanking the entrance on the opposite side were to be two panels that are better understood through Curry's written descriptions of them than through their present sketchy configurations. In describing the panel called *The Plagues,* Curry writes:

Like ancient Egypt, Kansas is at times beset by plagues; in this panel is depicted drought and grasshoppers. In the foreground on the parched earth stand the stalks of stripped and withered corn; before the blazing sun floats the cloud of hoppers.

Paired with *The Plagues* is a panel entitled *Soil Erosion and Dust.*

Sheet erosion and the shoestring gully are two of the great calamities of our nation, and in the Midwestern plains can be added wind erosion. In the foreground of this panel is the clutching hand of erosion directed toward the abandoned farm home. Beyond is the threat-

ening cloud of dust. This panel is designed as a significant warning and voices the concern of government and educational forces interested in preserving the nation's resources.[64]

These four proposed themes for the Rotunda panels should be seen in their direct relationship and intended physical juxtaposition to *Kansas Pastoral,* located in clear sight of the central Rotunda on the adjoining West Corridor walls. The working frontier family intended for the Rotunda serves as a foil to the future family of leisure in *Kansas Pastoral.* Similarly, the depictions of drought, dust storms, and plagues of grasshoppers in the Rotunda panels stand in telling contrast to the lushness of the land enjoyed in *Kansas Pastoral.*

It is of no small significance that Curry divides the two Rotunda panels dealing with the land into the categories of disaster occasioned by a sublime Nature (the plagues) and disaster occasioned by the ignorance of man (soil erosion and dust). For Curry had become interested in the experiments being conducted in soil conservation under the New Deal. In 1936 he had traveled the state of Wisconsin with Dean Christensen, painting canvases of the experiments in contour cropping at the Wisconsin agricultural stations.[65] He was aware of the prevailing theories voiced by Secretary of Agriculture Henry Wallace and others that the responsibility for the soil erosion and consequent dust storms of the 1930s should be placed squarely at the feet of the farmer.[66] The image was one of a virgin heartland defiled by the intrusion of the farmer, whose eastern agricultural techniques were not well suited to farming in the grasslands. The idealization of the noble yeoman was giving way in the 1930s to that of the farmer as ignorant intruder on the natural order. It was dust, not rain, that had followed the plow.

Soil erosion problems were seen as the consequence of a gradual historical process of abuse of the land. In fact, the "sheet erosion and the shoe string gully" of Curry's proposed Rotunda panels are physical realities of the Kansas of the 1930s—not of the settlement period. They were the result of generations of tilling the "once fertile farmland" without regard for farming techniques that would have prevented the destruction of the land.[67] Similarly, the drought and scourge of grasshoppers in the Rotunda sketches were never more an issue than in the 1930s, when Kansas had been plagued mightily by both.[68]

In his Kansas murals, John Steuart Curry has used a nonlinear time reference, and in so doing he short-circuits our initial impressions of historical time. In shifting our perceptions in this way, Curry seems to create a usable past for the people of

Fig. 86 Oil sketches for the unexecuted murals planned for the Rotunda of the Kansas Statehouse, 1937, oil on canvas. Upper left: *The Homestead;* upper right: *Building the Barbed Wire Fences;* lower left: *The Plagues;* lower right: *Soil Erosion and Dust.*

Fig. 87 Sketch of an eroded hill in Barber County, Kansas, circa 1937.

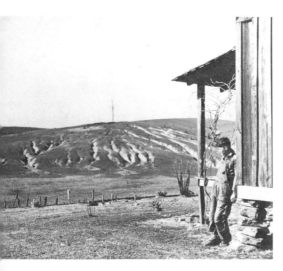

Fig. 88 Soil erosion on a farm in Walker County, Alabama, February 1937, photographed by Arthur Rothstein for the Farm Security Administration.

Kansas. In place of grim reality, Curry presented a hope for the future. The troubling issues of the Kansas present were disguised in the cloak of the past to make them more approachable. In the historical time presented in the pictures, the viewer could presumably see the success of modern Kansas (in *Kansas Pastoral*) in dealing with what were presented as the hardships of the frontier past (in the Rotunda panels). But in actual experience, the message worked in quite a different way. Couched in the historical costume of the Union soldier and the pioneer sunbonnet of the frontier mother lay the Kansas of the 1930s—the Kansas that was characterized by the older, work-oriented family structure and the newer problems of soil erosion and dust.

Viewers located in the Kansas of the "dirty thirties"—viewers such as Curry's own father, in fact—could easily identify the hardships of their all too recognizable present in the Rotunda panels. But they could just as easily envision a hope for a brighter tomorrow in *Kansas Pastoral*. According to the doctrines of the progressive agricultural reformers, all that need be done to bridge the gap between the troubled present and that bright tomorrow was to let go of the past, embrace agricultural technologies, and reorient the family structure to adjust to the changes that the new leisure was sure to bring. Curry's final message for the people of Kansas is both hopeful and intended to persuade. It is, in fact, the propaganda of a new social order—a World of Tomorrow for Rural America. If Kansans will only follow this blueprint for progress, the Kingdom of God is at hand.

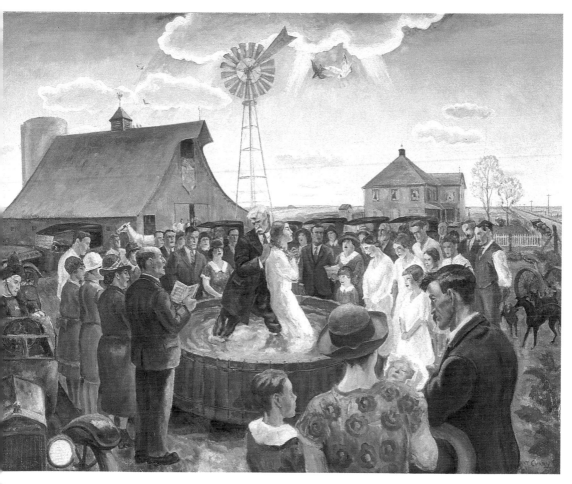

Plate 1

Baptism in Kansas 1928
Courtesy Collection, Whitney Museum of American Art,
New York Acq #31.159

13

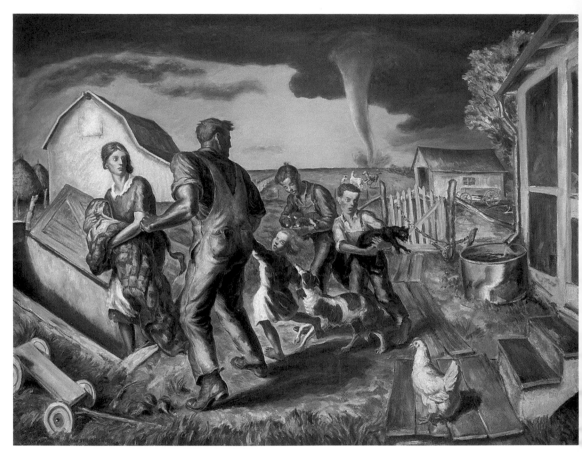

Plate 2

Tornado Over Kansas 1929
Courtesy Collection, Muskegon Museum of Art,
Muskegon, Michigan

Plate 3

The Manhunt 1931
Courtesy Collection, Joslyn Art Museum, Omaha,
Nebraska

15

Plate 4

The Tragic Prelude 1938
Courtesy United Missouri Bancshares, Inc., Kansas City,
Missouri

Plate 5

John Brown 1939
Courtesy Metropolitan Museum of Art, New York, Arthur
Hoppock Hearn Fund 1950

Plate 6

The Tragic Prelude 1937–42
Photo courtesy Jack H. Brier, Kansas Secretary of State

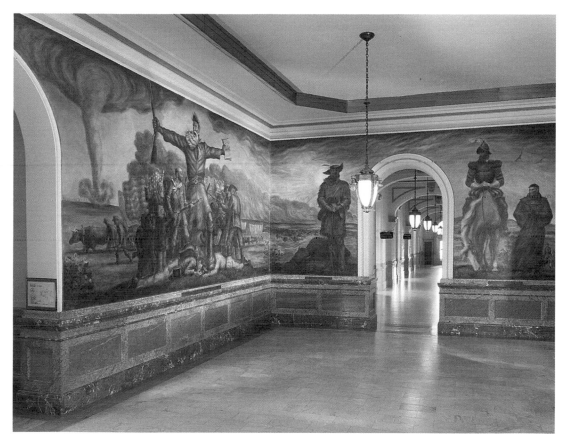

Plate 7

The Tragic Prelude 1937–42
Photo courtesy Jack H. Brier, Kansas Secretary of State

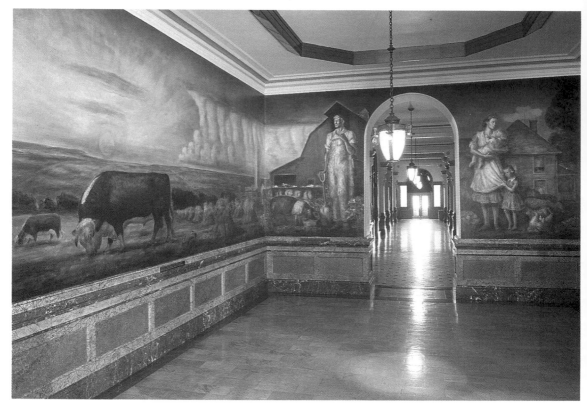

Plate 8

Kansas Pastoral 1937–42
Photo courtesy Jack H. Brier, Kansas Secretary of State

Chapter 6

You Can't
Go Home Again

In 1931, John Steuart Curry had tried to win favor among Kansans by showing them those painted memories of home that had so caught the eye of Gertrude Vanderbilt Whitney in New York. But even the high-powered promotional schemes of his agent, Maynard Walker, could not force a sale among the folks back home. Curry had painted the prairie tornadoes and cattle-trough baptisms that spelled "true Kansas" to his eyes. But to Kansans, Curry's characterizations only fed the slanderous stereotypes that high-minded easterners had long been enjoying at their expense.

This time, Curry thought, it would be different. He had left the Westport art colony and returned to the Midwest. He was wearing overalls and painting among farmers. And he wanted to paint murals for Kansas. They wanted scenes of pastoral bliss, so he gave them scenes of pastoral bliss. Here, at last, in the endless shocks of wheat, Curry gave form to the "Kansas gold" of Coronado's dreams. Calling up associations to the "religious preoccupations of his people," Curry painted a Promised Land, a New Canaan, in *Kansas Pastoral:*

I have been accused of seeing only the dark and seamy side of my native state. In these panels I . . . show the beauty of real things under the hand of a beneficent Nature—and we can suppose in these panels that the farm depicted is unmortgaged, and that grain and cattle prices are rising on the Kansas City and Chicago markets.[1]

Nature beneficent . . . an unmortgaged farm . . . rising grain and cattle prices . . . it was a lot to ask of Kansas in the 1930s. Letters from Curry's family about his parents' home near Winchester suggest how this painting emerged. From his brother, Eugene, in January 1938:

Enclosed is a letter from Alex Denniler. I believe the foreclosure will be started soon. The indebtedness is now over $11,000. If we were inflating, not deflating, it might be worth while holding it off. Under present conditions, and declining farm prices, I wouldn't borrow $5,000 to buy the farm if it could be had at that figure. . . . The only bad result I foresee is a psychological one in the feeling the folks will have that they will be homeless. . . . It is not their fault that price levels have changed and drought years have occurred.[2]

Nature beneficent . . . an unmortgaged farm . . . rising grain and cattle prices . . . Curry fashioned his secular millennium from the hopes and dreams of his people.

But he couldn't quite leave well-enough alone. True to the Kansas character he had described, Curry just had to try and "wreak" a little "good" on the state before he left. He knew what was troubling the Kansas farmer, and he intended to paint it in historical disguise in the Rotunda panels. Sheet erosion, the shoestring gully, wind

erosion, the abandoned farm home, and the threatening cloud of dust—these were the subjects of the panels he had planned, and his written descriptions left no mistake about his reasons for selecting them: "This panel is designed as a significant warning and voices the concern of government and educational forces interested in preserving the nation's resources."[3]

By 1937, Curry had become a crusader for soil conservation. When he arrived in Madison to take his position with the College of Agriculture, he made this quite clear:

I am well aware that the foundation that pays my way here comes from those pine trees, but in this matter we are not blameless. The American Farmer is presented in mural art as a beautiful, noble, and fairly intelligent-looking fellow. My own family have been farmers for generations, and as you can see by the representative before you, were beautiful and noble, but from the amount of good top soil they and their farmer neighbors have sent down the Mississippi or up in the air, I doubt their wisdom.[4]

In the same speech he made known his intention to devote himself to "a propaganda by art . . . that would aid in preserving the natural resources."

Visitors to his Madison studio would be shown how he was accomplishing this:

Repeatedly, during your stroll through the studio, Mr. Curry will show you concrete examples of what he means when he says that art should be made practical. He will tell you, for example, about the sketch he has made of the government soil erosion project in Coon Valley, LaCrosse county.

'I did this one day when I went out on the Coon Valley project with Dean Christensen. See. It shows every phase of what the government is doing out there. There are dams, constructed to stop that ditch zig-zagging through the field, and over there are samples of strip farming.'[5]

In 1933, President Roosevelt allocated five million dollars under the Emergency Public Works Laws to set up a temporary Soil Erosion Service to conduct experiments in soil erosion and flood control. The nation's first watershed demonstration project was established in the Coon Creek area near La Crosse, Wisconsin, where the cultivation of steep slopes and wooded hillsides had resulted in losses of from 75 to 100 percent of the topsoil. In 1934, a Civilian Conservation Corps (CCC) camp was set up in Coon Valley, Wisconsin, to

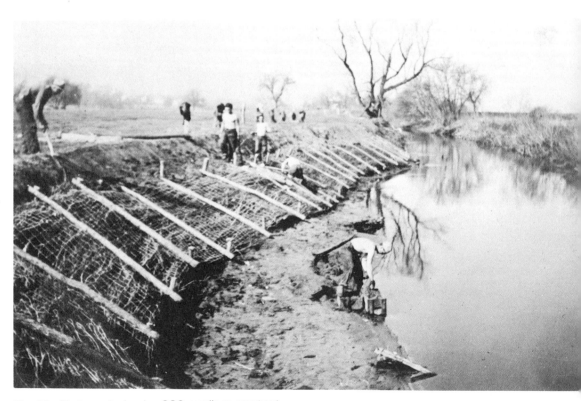

Fig. 89 Photograph showing CCC enrollees constructing angular willow plantings on the eroding bank of a stream on the farm of George Ronken in Coon Valley, Wisconsin, April 1936.

Fig. 90 Contour strip cropping and terracing on the Elmer Manske farm in Chase, Wisconsin, July 17, 1936. One of the first farms in the United States to sign up for the experimental soil conservation program, and the first to have terracing done.

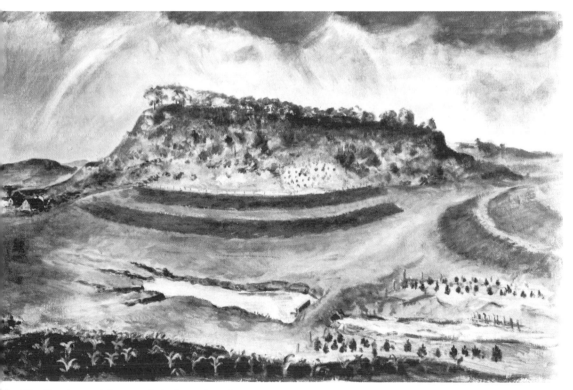

Fig. 91 *Erosion and Contour Strip Cropping,* circa 1937–40, oil on canvas.

help landowners apply conservation methods. Curry toured these soil conservation sites in Coon Valley with Chris Christensen in 1937. Even on trips to his parents' winter home in the Salt River Valley of Arizona, Curry preached the gospel of soil conservation. In an interview with reporters from the *Phoenix Republic,* "the artist called the attention of Arizonians to the advice of the college of agriculture of the University of Wisconsin that some of the land on farms be left rough, that not every swamp be drained and that not every wood lot be chopped down."[6]

One of the last paintings Curry made before his death in 1946 accomplished a melding of his religious imagery and his strong views on soil erosion. Curry offered the painting, called *Moses and the 11th Commandment* (fig. 92), to the Information Division of the Soil Conservation Service of the U.S. Department of Agriculture, headquartered in Milwaukee, for use in a pamphlet on soil erosion. The text of the pamphlet was prepared by W.C. Lowdermilk, assistant chief of the Soil Conservation Service. In 1938 and 1939, Dr. Lowdermilk had undertaken a study of agriculture in countries where the land had been under cultivation for thousands of years. His aim was to find out if information gleaned from these older civilizations could help in solving the soil erosion and land use problems of the United States in the wake of the Dust Bowl. While touring Palestine in 1939, it occurred to him that if Moses had foreseen what was to become of the Promised Land after three thousand years of cultivation, he would have delivered an "Eleventh Commandment":

'Thou shalt inherit the Holy Earth as a faithful steward, conserving its resources and productivity from generation to generation. Thou shalt safeguard thy fields from soil erosion, thy living waters from drying up, thy forests from desolation, and protect thy hills from overgrazing by the herds, that thy descendants may have abundance forever. If any shall fail in this stewardship of the land thy fruitful field shall become sterile stony ground and wasting gullies, and thy descendants shall decrease and live in poverty and perish from off the face of the earth.'[7]

In his proposed panels for the Rotunda of the Kansas Statehouse, Curry planned to preach this gospel with a heavy hand. He was going to show Kansas farmers their sheet erosion and shoestring gullies, their clouds of dust and abandoned farm homes. The panels were "designed as a significant warning" to Kansas farmers, on whom Curry placed the blame for the agricultural troubles of the 1930s. Despite his protests to the contrary, Curry was indeed out to "wreak good" in Kansas through the message in his murals. The irony is that he was surprised when his message met with local resentment.

Fig. 92 *Moses and the Eleventh Commandment,* n.d., oil on paper. Alternately entitled *John Brown Depicted as a Saint,* this painting may have been prepared as an illustration for Stephen Vincent Benét's *John Brown's Body,* which Curry illustrated in 1946, but the painting does not appear in the finished volume.

The theories that stand behind Curry's views on soil conservation were being discussed widely in the mid-1930s. They were, in effect, the views set forth in one of the most important environmental documents of the decade, *The Future of the Great Plains,* a report submitted to President Roosevelt by the Great Plains Committee in December 1936. In it, the committee concluded that the Dust Bowl was a wholly manmade disaster, created by a history of misguided efforts to "impose upon the region a system of agriculture to which the Plains are not adapted."[8] After fifty years of being praised for his heroic husbandry, the sodbuster was now seen as a menace to the nation. These views were widely popularized in films such as *The Plow That Broke the Plains,* released in 1936:

The outline of the finished film . . . was summed up tersely by *Time* following its public release in New York. '*The Plow* begins with lush, billowy grass, ends with the bulk of a dead tree surrounded by sun-baked desert.' Lorentz demonstrated what happened between by showing the arrival of cattle on the four-hundred million-acre pasture of the plains and the inrush of speculators in the wake of the railroads. A homesteader's plow is seen biting into soil held together by the deep roots of the prairie while Chalmers' voice warns, 'Settler, plow at

your peril.' A grizzled farmer watches the first sign of drought without comprehending. Next is seen the war-time sequence. This is followed by the economic boom, during which higher and higher prices are followed quickly by more and more wheat planting as part of the war effort ('Wheat Will Win the War!'), until the grass that once held the plains together has given way to endless open fields under a scorching sun. The result of man's abuse follows. To the accompaniment of [Virgil] Thomson's dirgelike music, Lorentz disclosed the rav-ages of the drifting dust that followed when drought, heat, and winds struck the acres that should never have been plowed.[9]

In 1936, Kansas farmers were clearly on the defensive. They took issue with being saddled with full blame for the dust storms of the 1930s, and they mounted their evidence to disprove the theories of the conservationists. A lengthy article of rebuttal appeared in the Kansas City Star— 'Plow Not to Blame for Dust Storms Say Old-Time Western Kansans." The opening paragraph hints of the deep resentment held by Kansas farmers for the "book-farming" agriculturalists sent by the government to evaluate their problems:

It is a common belief that the plow is entirely re-sponsible for the dust storms which agitated the high plains all through the spring months of 1934 and 1935 and which made their appearance in 1936 as early as mid-February. Scientists sent from Washington to study the dust have grown impatient upon finding weather-bronzed old plainsmen who refuse to let the plow bear all of the blame and who relate experiences in dust and sand storms of sixty and seventy years ago, before the high plains had felt the bite of a plow.[10]

Through his position with Wisconsin's College of Agriculture, Curry had taken the role of self-appointed propagandist for the conservationist po-sition, and he planned his Rotunda panels to relay "the concern of government and educational forces interested in preserving the nation's re-sources."[11] Curry was about to insult and humili-ate the farmers of Kansas by painting his conservationist propaganda in their Statehouse Rotunda. It is no small wonder that he met with resistance.

Those farmers who were angry and defensive from being under attack by agricultural reformers and conservationists comprised one wave of op-position to the Curry murals. But in his missionary zeal to "wreak good" on his home state, Curry managed to step on quite a few more Kansas toes in the process. "It all depends on your poli-tics how you like Curry's John Brown," noted one astute observer.[12] And Kansas "politics" had quite recently been entangled with the Ku Klux Klan. The Klan had experienced a national revival in the 1920s following the appearance of D. W. Griffith's epic film, The Birth of a Nation, adapted from Thomas Dixon's romantic novel of the Ku Klux

Klan, The Clansman.[13] By 1924, the Klan had become so influential that neither the Democrats nor the Republicans, in their national conventions, condemned it. But the gubernatorial race in Kan-sas that year did attract national attention be-cause of the anti-Klan attack made by William Allen White. Editor of the Emporia Gazette and "Kansas keeper of the nation's conscience," White entered the race himself as an independent candidate because neither the Democratic incum-bent nor the Republican challenger would take an anti-Klan position.[14] For the most part, activities of the Ku Klux Klan subsided in the 1930s across the country, but the wave of lynchings that oc-curred just before the antilynching crusades of the early 1930s suggested that the underlying con-flicts were still operative. On April 18, 1932, Rob-ert Read was lynched in Rawlins County, Kansas.[15] In 1937, the Kansas City Star an-nounced, "The long dormant Ku Klux Klan arises to renewed activity, its membership stimulated as ladies take their place beside knights in the hooded ranks."[16] Given Curry's strong convictions about antilynching legislation and social justice for blacks, and the fervent anti-Klan crusades of White and Allen, the decision to paint the John Brown mural directly across from the governor's office in the Statehouse may well have been di-rected at this renewed activity on the part of the Kansas Klan. The hidden agenda behind Curry's firey abolitionist might well have served as an-other "significant warning" to the re-emerging Ku Klux Klan in Kansas.

And yet, Curry's conception of John Brown was sufficiently ambiguous to accommodate the opposing prejudices of an ardent admirer of Brown the "hero" and a disapprover of Brown the "fanatic." Evidence of this can be found by com-paring two viewer responses to Curry's John Brown. Curry sent an inscribed John Brown litho-graph to his friend Lloyd Garrison, great-grandson of abolitionist William Lloyd Garrison and staunch defender of civil rights for blacks. Garrison replies:

Dear John:

I am sitting and looking at your magnificent John Brown with the delicate whirling tornado, the upraised beseech-ing face of the Negro, and the mighty crucifix figure of the hero himself. What a figure! What a face! Nothing since Michelangelo has equalled this in strength and force and daring and great human depth of feeling.[17]

On the other hand, there is the response to the same John Brown image given by another close friend of Curry's, Thomas Craven:

I saw your John Brown—a magnificent job—and your conseption [sic] is the right one. My father, who is a student of J.B. and who knew intimately the last surviver

[sic] of the Harper's Ferry racket—brought me up on the idea that Brown was not only a fanatic but a villain and a murderer.[18]

In fact, the painting exposes Curry's ambivalence about the historical figure of John Brown. There is the wild-eyed fanaticism that Curry so feared, the blood on Brown's hands of which he disapproved, and the bloody conflagration of the "needless" Civil War that Brown had inaugurated. At the same time, Curry models his likeness after Michelangelo's *Moses,* and includes pictorial associations to the crucified Christ and to the popular Whittier legend, with Brown as protector of the slave mother and child who kneel in devotion at his feet. It is, in many ways, a confusing image. Oliver Larkin's later appraisal of the mural uncovers this contradiction: "Could John Curry give the grandeur to his *John Brown* which Michelangelo gave to his *Moses,* in a community which celebrated Brown as a hero but half feared him as a demagogue and a radical?"[19] Given Curry's personal ambivalence, would he have wanted to?

Because of this mural's intrinsic contradictions—contradictions that were inherent in the historical figure of John Brown—it becomes not a narrow didactic message, but a blank screen upon which observers can cast their biases and interpretations and quite likely find something painted there to confirm their individual views. In this sense, *Tragic Prelude* is a democratic form of mural art. In looking at the public reaction to the paintings, one is likely to learn as much about the individual viewer's belief as that of the painter.

Local reaction to the Curry murals had begun almost immediately after the proposed sketches and Curry's descriptions of them appeared in the Kansas press in the fall of 1937. The mural sketches were approved on November 12, 1937, and within the week the papers were carrying reports of early criticism. To start, Curry's Hereford bull in *Kansas Pastoral* was off on the wrong foot. Wichita cattlemen contended that the stance of Curry's bull—with both left legs advanced and both right legs extended backward—resembled more the grazing position of a horse than a bull, and that Curry's sketch showed "a bull standing wrong." One paper helpfully reproduced for its readers a side-by-side comparison of Curry's mural sketch and a photograph of a bull from the International Library of Technology that presumed to show "the way a real bull stands" (see fig. 93).[20] Curry repainted the bull.

The Kansas newspaper editors conceived the idea for the Kansas murals, and actually ended up paying about 70 percent of the costs. But they pretended that it was a truly grass roots phenomenon, and publicized the fact that schoolchildren all over the state were donating their pennies to the cause.[21] With this populist brouhaha, Kansans quite naturally believed the Statehouse murals were "theirs." Quite a few of the "2 million . . . part owners" stepped forward to offer their opinions:

Men with art experience restricted to the time when they dabbed paint on grandpa's barn door, are most liberal with their views. But ladies who daubed the household furniture in an effort to make it look like the picture of something they saw in a magazine, have ideas, too. . . . With a knowledge of perspective gained from the rolling Kansas prairies, some protest the size of the farm woman in [*Kansas Pastoral*]—claim no woman should be taller than a two-story house. . . .

There's the terrible tornado in the background. . . . The snout of the storm reminded a good many statehouse visitors of an elephant's trunk and some of them thought it was a portrayal of the return of the G.O.P. to power with the New Dealers disappearing in the cloud of dust at the foot of the hill.[22]

Some of the literal-minded critics contended that Curry's pigs should have curls in their tails as they ate. Curry, eager to please, visited several Maple Hill farms to observe and sketch the porkers' backsides. After spending another day in Kansas hog lots, Curry decided "that pigs aren't particular whether their tails are marcelled or not," but conceded the point nonetheless and promised to give some of the tails a curl.[23] If he could placate irate citizens by shuffling the feet of his Hereford bull or curling the tails of his painted pigs, it was a small price to pay. He was less willing to compromise on the tornado, the soil erosion, and Old John Brown.

"To this day," affirmed the *Kansas City Times* in 1947, "[Curry's] figure of John Brown . . . will start an argument when any two persons step off the elevator outside the governor's office on the second floor."[24] There were those who still held to hero-worship, like the Reverend A. H. Christensen of Netawaka, Kansas, who was apparently offended by Curry's alignment with the revisionist historians.

My dear Mr. Curry:

. . . your representation of John Brown as reproduced in Life Magazine [see plate 5] is a caricature not only of John Brown, but of the cause for which he fought. Woodrow Wilson in Epochs of American History: Division and Reunion p. 203 states: 'His plan had been one of the maddest folly, but his end was one of singular dignity. He endured trial and execution with manly, even with Christian fortitude.' The picture you give shows a raving maniac, a paranoiac. There are no ifs in history and we must read it as it was and not according to the dictates of some farfetched modern theory.[25]

Far more common was the denouncement that

Curry's Bull Gets Off to Bad Start; Mural Bovines' Feet Just Won't Track

ARTIST SKETCH

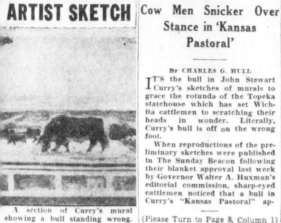

A section of Curry's mural showing a bull standing wrong.

Cow Men Snicker Over Stance in 'Kansas Pastoral'

By CHARLES G. HULL

IT'S the bull in John Stewart Curry's sketches of murals to grace the rotunda of the Topeka statehouse which has set Wichita cattlemen to scratching their heads in wonder. Literally, Curry's bull is off on the wrong foot.

When reproductions of the preliminary sketches were published in The Sunday Beacon following their blanket approval last week by Governor Walter A. Huxman's editorial commission, sharp-eyed cattlemen noticed that a bull in Curry's "Kansas Pastoral" ap-

(Please Turn to Page 8, Column 1)

HOW ANIMAL REALLY STANDS

Photo of a bull from the International Library of Technology. This is the way a real bull stands.

Fig. 93 Newspaper clipping in the John Steuart Curry Scrapbook at the Archives of American Art, source unidentified, circa 1937.

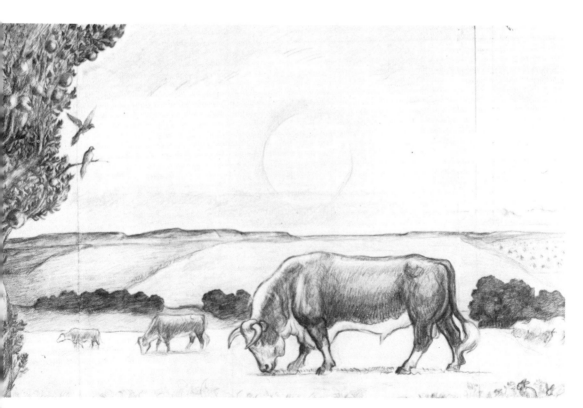

Fig. 94 Revised sketch of grazing bull in *Kansas Pastoral,* 1940. Curry shuffled the feet of this grazing bull to appease Kansas cattlemen.

27

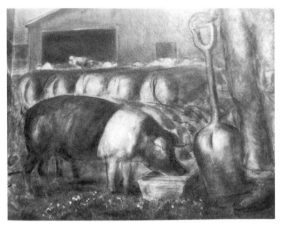

Fig. 95 Feeding Hogs, detail of *Kansas Pastoral,*
1937–42. In May of 1940, as a gesture of accommoda-
tion, Curry reluctantly painted a curl in the tail of the
single Hampshire hog in the foreground; the other tails
remain straight. Note the visual pun in Curry's repetition
of shape between the pigs' rear ends and the farmer's
shovel.

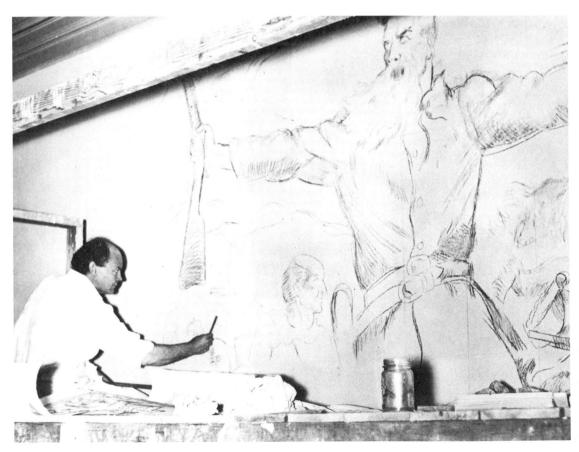

Fig. 96 Photograph of John Steuart Curry on a scaffold
sketching the full-size cartoons of *The Tragic Prelude.*

Fig. 97 In 1974 a rock group featured Curry's John Brown on the cover of the album on which they proclaimed "We are Kansas! Kansas is a band!"

was heard from the floor of the state legislature by Senator Van De Mark of Concordia:

'I don't know how the rest of you feel about John Brown,' said Van De Mark, 'but I think he was an erratic, crazy old coot and a murderer. I don't see any reason to perpetuate his memory. . . . I don't like those atrocities on that wall of horror,' he exclaimed. 'They look terrible to me.'[26]

Senator Clarence Oakes of Independence called the Curry murals "modernistic and cheap." "If that John Brown thing is going to stay," he added, "I suggest that the Bible which he holds be changed to a copy of the Kansas statutes and the title be boldly painted: 'An Irate Taxpayer Awaiting Adjournment of the Legislature.' "[27]

The *Topeka State Journal* hinted of the trouble ahead for John Steuart Curry: "John Brown and John Curry Both in Bad with Legislature— They Dislike Bull, Too."[28] For the most part, the legislators were taking their cue from the voters in their constituencies. Newspaper reports confirmed that Senator Van De Mark's vitriolic "views concerning the late John Brown coincide with those of a good many Kansans."[29] But because the mural commission was being paid for by popular subscription, legislators had little reason to get involved . . . for a while.

Although they had promoted the project as democratic art, as paintings for the people, the progressive newspaper editors knew that they would be asking for trouble if they really conducted business that way. In an early letter to

Curry in May 1937, before the offer was ever formally extended, John P. Harris outlined the plans to Curry and provided the rationale:

It would have been possible, I think, to have secured a legislative appropriation . . . last winter and carry through the project as Missouri has done. To do it by private subscription, however, seems even more desirable and escapes the political angles that otherwise might creep in.[30]

And creep in they did, despite the cautious efforts of the editors. The funds they were raising by public subscription were to go to Curry's salary for completing the project. As they later found out, it was necessary to obtain a legislative appropriation of five thousand dollars to prepare the walls for receiving the murals, to replaster certain areas, to arrange for lighting for the paintings, and to pay for the hanging and installment of the murals. The editors had not counted on this, and it sent William Allen White running to Governor Ratner to collect on some old political favors:

Dear Payne:

There are two things on my mind that make me turn to you urgently for help. First the appropriation for the murals. Please give that every support you can. If we can get that appropriation thru we can work out the rest of the details without trouble. Just pull for the shore please on that appropriation for me.[31]

By whatever backstage arm-twisting, the 1939 appropriation came through. But only $2,810 of the total was allocated that year for expenses incurred, thus the 1941 legislative session was called on to allot the remaining $2,190 to Curry to finish the job.[32] With just a little encouragement from disgruntled voters, senators ran amuck on the Curry murals from the floor of the legislature. Senator Van De Mark vented his spleen on John Brown; Senator Oakes attacked Curry's style as "modernistic and cheap"; and other boisterous politicians in hopes of reelection chimed in:

'My grandmother came to Kansas in 1856,' said Senator Cavaness of Neosho, for many years a newspaper editor. 'I know perfectly well my grandmother didn't wear skirts that came up to her knees.'

'Would it be possible,' asked Senator MacGregor of Barber, 'to have some one saw part of the legs off the bull and make it look like a real Hereford?'

'Maybe,' snorted a senator. 'The sawed off legs could be given the woman and her skirts wouldn't then appear so short.'[33]

And so it went. The unwilling patrons were finally having their say.

But it went further than that. The large body of local Kansans who had always resented Curry's characterizations of the state eventually found a way to stop him from painting government soil erosion projects, grasshopper plagues, and blow-

129

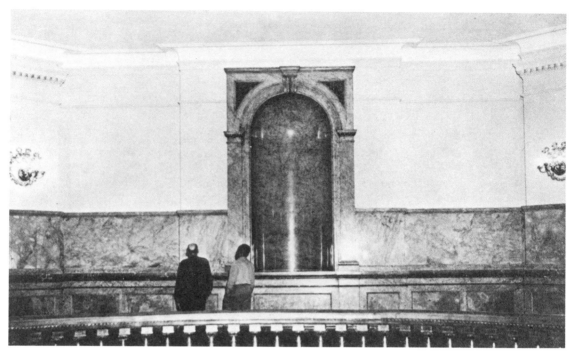

Fig. 98 Photograph of the Statehouse Rotunda taken circa 1958. Curry asked only that the small insert panels above the wainscoting be removed. The marble wainscoting, mopboard, and niches would have remained.

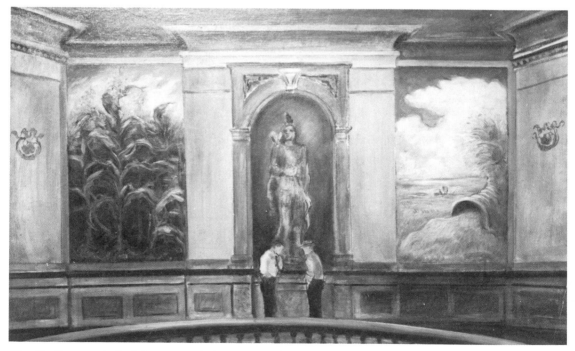

Fig. 99 Two panels depicting corn and wheat proposed for the Rotunda of the Kansas Statehouse, 1937–38, oil on canvas. The sketch shows how Curry intended the panels to replace the marble slabs above the wainscoting.

ing dust storms. The plan for the Rotunda murals had, from the very beginning, depended on the removal of some marble panels above the wainscoting to make room for the murals. This alteration would allow the height and placement of the Rotunda murals to be consistent with those in the adjoining East and West Corridors. The marble slabs targeted for removal were of Siena marble, imported from Italy some forty years before. Beneath the slabs was a base of Lambertin marble wainscoting, also imported from Italy, which would remain beneath the mural panels. These plans were reported in the newspaper coverage of the mural commission from the beginning, and there was a sort of gentlemen's agreement between the Kansas Murals Commission (appointed by the governor and comprised of Kansas editors) and the State Executive Council (elected by voters and responsible for the legislative matters of the mural commission) that the marble slabs would be removed in due time without incident. But such "gentlemen's agreements" have a way of disintegrating when reelection is at stake.

By September 1940, *The Tragic Prelude* and *Kansas Pastoral* were already on the walls and receiving some finishing touches (see plates 7 and 8)[35] Curry planned to return to Kansas the following summer to install the Rotunda panels.[36] But by then too much political pressure to disallow the removal of the Italian marble had already come to bear on the Executive Council. The opposition came from "women's clubs, patriotic groups and conservative lovers-of-the-status-quo at the Statehouse."[37] The Kansas Council of Women, at the suggestion of the American War Mothers, protested the removal of the marble, and issued the following statement:

> The murals do not portray the true Kansas. Rather than revealing a law-abiding, progressive state, the artist has emphasized the freaks in its history—the tornadoes, and John Brown, who did not follow legal procedure.[38]

It should come as no surprise that the statement issued by the Kansas Council of Women does not center on the virtues of Siena marble, but rather on disdain for Curry's murals. There may be little the members could do about the murals that were already installed, but they might be able to keep the depressing realities of the "dirty thirties" out of their Rotunda. It seemed to be common knowledge that "the marble-savers' real purpose was to prevent the Rotunda scenes from reaching canvas."[39] And so the row went on between the forces of progress and the backers of "bathroom marble."[40] All the way from Wisconsin came the

Fig. 100 Photograph of the Kansas Statehouse Rotunda and the West Corridor taken in 1981. In the foreground, the Sienese marble Rotunda and the arched entrance to the West Corridor. Curry's *Kansas Pastoral* is visible in the background.

cry that "Kansas simply can't appreciate good from bum":

Italian marble above American history as only John Steuart Curry has painted? Why?

I have stood, half a dozen times, before Curry's John Brown, and looked at it, half an hour at a time, and heard a thousand trumpets and drums beating 'The Battle Hymn of the Republic' and a million voices singing, '. . . his soul goes marching on.' I have learned more history and more love of my country in one of those half hours than from all the dog-eared texts of my tenderer years.

How long have I watched entranced a slab of Italian marble? Once, I remember stopping to wonder how that green stuff trickled down inside the rock that way, but I couldn't figure it out and I was on my way up to . . . the legislature . . . anyway, so I let it go. . . .

And what is Italian marble for? For statesmen. Not for the people. To make them feel rich and big and secure and solid and like great princes. It is to impress the little people who dare to walk into buildings of state that here is a marble hall and here are powerful and sacred people to whom you must not speak roughly and who you must not ever vote out of office.

Italian marble is better for that than the soul of John Brown. Little people might get ideas from paintings like John Brown, with his flaming-red beard, his powerful arms, his wild hair, his wide, challenging mouth, the cyclone behind him, the beaten but hopeful-eyed slave rising at his feet.

That is bad stuff. Italian marble is safe. It's pretty and noble and safe. It is the right stuff for a rotunda.[41]

And so, the Kansas matrons got "the right stuff" and Curry got his walking papers. A copy of Senate Resolution 20, maintaining the marble, was sent to Curry in Wisconsin by Kansas Secretary of State Clarence W. Miller in April 1941.[42] One local poet laureate, who wished to be known only as "R.J.D.," penned the following summation in the Kansas City Star:

Why Is a Mural?

News note: Controversy is still high over certain scenes depicted in the Curry murals at the statehouse in Topeka.

By all that's High and holy,
By all that's great and small,
Why should folks be fighting
Over pictures on a wall?

It's cheaper, far, and better,
To hang wallpaper there.
Call in the vagrant spiders
Or let the walls go bare![43]

And bare they remained, until long past Curry's death in 1946.[44] Curry left the state, angry and depressed, having issued the following statement:

The work in the east and west wings stands as disjointed and un-united fragments. Because this project is uncompleted and does not represent my true idea, I am not signing these works. I sincerely believe that in the fragments, particularly in the panel of John Brown, I have accomplished the greatest paintings I have yet done, and that they will stand as historical monuments.

To the Mural Commission and to the children who donated their pennies, as well as to all others who have believed in me, I wish to express my appreciation and to assure you that I have done the best I could with the space at my command.

Signed: John Steuart Curry[45]

It was over. Curry's friend, Sam Nook, vice-president of Kansas State College, wrote to him in October 1941, "Evidently you have knocked the dust of Kansas offn your shoes, for which no one can blame you."[46] Curry had now tried on two hard-fought occasions to win appreciation for his art in the state he loved. He would try no more. He was finished with Kansas.

But Kansas was not finished with him. In the wake of Curry's departure remained vicious, acrimonious attacks on the hotshot eastern painter in Kansas clothing who had been run out of town. In 1943, the Topeka Capital was still trying to wring a little more self-satisfaction out of the recent tar and feathering of the long-distance Regionalist. The article, "Page Boys in Mock Session Vote $1.15 to Finish Murals," relayed the important legislative training going on in the Statehouse that spring, where the budding young citizens of Kansas were parroting what their elder statesmen had modeled for them:

Led by Bill McGregor, impersonating his Senator father, an enthusiastic bunch of art critics forced passage of a bill: (1) appropriating $1.15 from the state sewage disposal fund to complete the murals; (2) placing them in all Statehouse rest rooms; (3) and making public apology to frequenters of such rooms for such an imposition but explaining there was no place else suitable for such art.[47]

The mural controversy in Kansas was, according to Curry's widow, "shattering, absolutely shattering. I think it really contributed toward his death."[48] John Steuart Curry died on August 29, 1946, of a heart attack in Madison, Wisconsin, at the age of forty-eight.[49] From the weary reporters of the Topeka Capitol, one last article:

Winchester, Kan., Sept. 1—In the golden sunlight of a Sunday afternoon, one of Kansas' greatest artists, John Steuart Curry, member of a famed triumvirate that included Thomas Hart Benton and Grant Wood, who spread scenes of the Midwest across canvases of the world, came home to be buried in the churchyard of the Reformed Presbyterian Church here.

While some 500 of his fellow Kansans looked on to pay him tribute, the noted artist was lowered into a simple grave, marked only by a granite boulder, that over-looked the windmills, barns, and farm homes which he had portrayed so often . . .

Then the crowd began to drift slowly away from the spot.

A great Kansas artist, who had painted boldly, in vivid and often controversial fashion, was home to stay.[50]

Fig. 101 *Self-portrait,* 1939, lithograph. The artist
against a midwestern landscape, with corn shocks, a
farmhouse, and a windmill in the distance.

Notes

Notes include sources consulted as well as cited.

Preface

1. See Bret Waller, "Curry and the Critics," in University of Kansas Museum of Art, *John Steuart Curry: A Retrospective Exhibition of His Work Held in the Kansas State Capitol, Topeka, October 3–November 3, 1970* (Lawrence: University of Kansas Museum of Art, 1970), 50.

2. On Benton, see Karal Ann Marling, "Thomas Hart Benton's *Boomtown:* Regionalism Redefined," in *Prospects: An Annual of American Cultural Studies,* vol. 6, edited by Jack Salzman (New York: Burt Franklin & Co., 1979); Karal Ann Marling, *Tom Benton and His Drawings* (Columbia, Mo.: University of Missouri Press, 1985); and Erika L. Doss, "Regionalists in Hollywood: Painting, Film, and Patronage, 1925–1945" (Ph.D. diss., University of Minnesota, 1983). On Wood, see Wanda M. Corn, *Grant Wood: The Regionalist Vision* (New Haven: Yale University Press, 1983); James M. Dennis, *Grant Wood: A Study in American Art and Culture* (New York: Viking Press, 1975); and Anedith Nash, "*Death on the Ridge Road:* Grant Wood and Modernization in the Midwest," in *Prospects: The Annual of American Cultural Studies,* vol. 8 (New York: Burt Franklin & Co., 1983), 281–301.

Chapter 1

1. Calder M. Pickett, "John Steuart Curry and the Topeka Murals Controversy," in University of Kansas Museum of Art, *John Steuart Curry: A Retrospective Exhibition of His Work Held in the Kansas State Capitol, Topeka, October 3–November 3, 1970* (Lawrence: University of Kansas Museum of Art, 1970), 30–41. Pickett dates the first actions of the newspaper editors to June 1937, but correspondence between Curry and several of the editors indicates that the invitation had already been extended to him by the first week in May; see John P. (Jack) Harris, *Hutchinson News* (Kans.), to Curry, Madison, Wis., 4 May 1937, and Henry J. Allen, *Topeka State Journal,* to Curry, 19 May 1937, microfilm roll 166, John Steuart Curry Papers, Archives of American Art, Smithsonian Institution, Washington, D.C.; hereafter cited as Curry Papers/AAA.

2. Harris to Curry, 4 May 1937.

3. Allen to Curry, 19 May 1937.

4. The quote is from "A Farm Boy's Wonderful Gift to Kansas: John Steuart Curry's Statehouse Murals," *Kansas City Star,* 6 February 1966, clipping located in a scrapbook (comp. 30 December 1980) in the John Steuart Curry Folder of the Artist Files, Kansas State Historical Society, Topeka; hereafter cited as AF/KSHS.

5. Allen to Curry, 19 May 1937, microfilm roll 166, Curry Papers/AAA.

6. The Jefferson City murals are discussed in Matthew Baigell, *Thomas Hart Benton* (New York: Harry N. Abrams, 1973), 135–44.

7. "U.S. Scene," *Time,* 24 December 1934, 24–27.

8. "Curry of Kansas," *Life,* 23 November 1936, 28–31.

9. General biographical details of Curry's life may

be found in Laurence E. Schmeckebier, *John Steuart Curry's Pageant of America* (New York: American Artists Group, 1943).

10. For the events surrounding the creation of the position and a description of Curry's responsibilities, see "Resident Artist: John Steuart Curry Takes Unique Post to Encourage Rural Painting," *Literary Digest,* 122, no. 16 (17 October 1936), 22–24.

11. Grant Wood's convictions about the supremacy of the Midwest and his efforts to entice Benton and Curry to join him there are discussed in James M. Dennis, *Grant Wood: A Study in American Art and Culture* (New York: Viking Press, 1975), 136–44; see also Wood's "Revolt against the City," 229–35.

12. His raucous return to Missouri is discussed in Baigell, *Thomas Hart Benton,* 138–39. Benton's essay on leaving New York is included in his autobiography; see Thomas Hart Benton, *An Artist in America* (New York: Robert M. McBride & Co., 1937; New York: University of Kansas City Press—Twayne Pub., 1951), 261–69. Benton credits the generation of this anomalous mural commission—offered to him in one of the worst years of the Great Depression—to his father's long-standing political alliances in the Missouri legislature. He discusses the events leading up to the offer in his unpublished memoirs "The Thirties" in the Thomas Hart Benton Papers, Archives of American Art, Smithsonian Institution, Washington, D.C.

13. "Kansas Heals Breach with a Native Son," *New York Herald Tribune,* reprinted in *Topeka Capital,* 10 February 1935, AF/KSHS.

14. John Helm, Kansas State Agricultural College, to Curry, 6 November 1935, microfilm roll 166, Curry Papers/AAA. Curry had recently been informed that he had lost his teaching position at the Cooper Union due to insufficient enrollment; see Austin Purves, Jr., art director, Cooper Union, to Curry, 4 June 1935, microfilm roll 164, Curry Papers/AAA. A draft of a speech Curry delivered in Madison on his arrival gives Curry's account of his attempts to get back to Kansas:

It was my first thought and instinct to return to my native state and my friends strongly advised me to do so. I therefore set about to achieve this. I interviewed my influential friends in the East, and in Kansas William Allen White made an effort to get me a position at the Kansas State Agricultural College, but all these things came to nought.

The above paragraph had been deleted in pencil from the final typescript of the speech—Curry apparently reconsidered the repercussions of announcing to his host institution that he would have preferred to go to Kansas; see "Address at the Agricultural College, Feb. 24, 1937, by John Steuart Curry, Artist-in-Residence," typescript, microfilm roll 165, Curry Papers/AAA. Efforts to bring Curry to Kansas are further documented in Thomas Craven, "Kansas Refuses Curry," *Kansas Magazine,* 1937, 85–87. The proposed position with Kansas State Agricultural College would have been a mural commission to decorate the high-vaulted reading room in the new library building; the most detailed account of this turn of events is given in Kenneth S. Davis, *Kansas: A Bicentennial History* (New York: W. W. Norton & Co., 1976), 191–92.

15. Grant Wood to Curry, 16 April 1936, and 23 April 1936, microfilm roll 168, Curry Papers/AAA.

16. Thomas Craven to Curry, Wednesday, no date; the content of the letter, indicating that William Allen White had been spending all his time recently on the Landon presidential campaign, suggests a date just before the November 1936 election; microfilm roll 166, Curry Papers/AAA. Thomas Craven's critical stance on American art is discussed in Peninah R. Y. Petruck, *American Art Criticism: 1910–1939* (New York: Garland Publishing, 1981), 178–237.

17. Maynard Walker confesses his complicity in the Curry campaign in a letter to Porter Butts, Wisconsin Union, University of Wisconsin, 13 April 1936, microfilm roll 167, Curry Papers/AAA. Walker further discloses that he has "talked with Nesbit" (presumably Dr. Mark Nesbit of Madison, whose wife was a childhood friend of Grant Wood's), and that Nesbit suggested that Curry come out to Madison to discuss possible plans. The position of artist-in-residence eventually materialized for Curry at the University of Wisconsin as a result of these connections.

18. Benton, *Artist in America,* 261–68.

19. Wood's essay is reprinted as an appendix in Dennis, *Grant Wood,* 229–35; see also Dennis's discussion on 143–44, 151–53.

20. The phrase "Return from Bohemia" is the title of a pastel drawing dated 1935 (IBM Collection, New York) in which Wood dramatizes his return to Iowa. Wood's public rhetoric on his Iowa residence is covered in "Grant Wood Explains Why He Prefers to Remain in Middle West in Talk at Kansas City," *Cedar Rapids Sunday Gazette and Republican,* 22 March 1931.

21. The first quote is from Wood's essay, "Revolt against the City," 232; the second from "U.S. Scene," 26. Wood's reception at home was far from one of unconditional positive regard, as a cursory examination of his confrontation with local DAR members will attest, but of the three Regionalists Wood seemed to enjoy the strongest base of local support. A thorough examination of the local support for Grant Wood's art in Iowa is provided by Wanda M. Corn, *Grant Wood: The Regionalist Vision* (New Haven: Yale University Press, 1983), 12–18, 31–33.

22. See Benton, *Artist in America,* 260–68.

23. The quote is taken from the text of Curry's "Address at the Agricultural College, Feb. 24, 1937."

24. "Artists Pocket Change with Pride at Party," *Bridgeport Post* (Conn.), 11 July 1931, and "Fakir Show of Silver Mine Guild," *New Canaan Advertiser* (Conn.), 16 July 1931. Curry was described as a "relentless but side-splitting auctioneer." Dancing and "a collation" followed the sale. Silvermine, a neighboring art colony about four miles from Norwalk, was an old mill stream town where mills had been turned into studios and artists affected a free and easy bohemian style of life.

Curry exhibited his works there regularly during 1930–31; see these and other newspaper clippings in the Curry Scrapbook, BV 2-13-79, box 3, Curry Papers/AAA.

25. A photograph of the young turbaned Curry in full Arabian costume, seated with his arm around artist and concubine Matwell Howe Farnham, appears in an undated newspaper clipping covering the Westport Artists' Masque Ball; see Curry Scrapbook, BV 2-13-79, box 3, Curry Papers/AAA. Some of the artists from the Westport colony, such as Curry, Arthur Dove, James Daughtery, Guy Pène du Bois, Charles Prendergast, Everett Shinn, and Karl Anderson (brother of Sherwood), are featured in the catalogue to the exhibition, *Westport Artists of the Past: A Bicentennial Exhibition, 1976,* organized by the Westport Bicentennial Arts Committee, 12 June–30 June, 1976. Van Wyck Brooks was among Curry's literary friends living in Westport.

26. Harris to Curry, 4 May 1937; "Kansas Heals Breach"; "John S. Curry Is Recognized by Home Folks," *Topeka Capital,* 4 February 1935 (AP release dated 3 February 1935), in AF/KSHS; "Curry of Kansas," *Life,* 28.

27. Charles C. Alexander, *Here the Country Lies: Nationalism and the Arts in Twentieth-Century America* (Bloomington: Indiana University Press, 1980), 180.

28. Biographical details of Curry's early career as an illustrator may be found in Schmeckebier, *Pageant,* 19–24, as a painter, see 35–36; the incident with Daughtery regarding the Russian Academy is also recalled by Curry's widow, see "An Interview with Mrs. John Steuart Curry Conducted by Bret Waller," in University of Kansas Museum of Art, *John Steuart Curry: A Retrospective,* 6–12.

29. Some of these Parisian sketches are illustrated in Schmeckebier, *Pageant,* figs. 24–29, and Curry's life in Paris is discussed on 36–38.

30. Schmeckebier, *Pageant,* 40.

31. Thomas Craven, "John Steuart Curry," *Scribner's Magazine* 103, no. 1 (January 1938), 40.

32. Curry to Margit Varga, *Life,* 28 February 1942, microfilm roll 166, Curry Papers/AAA.

33. Schmeckebier, *Pageant,* 42.

34. See *The Whitney Studio Club and American Art 1900–1932,* catalogue of an exhibition held at the Whitney Museum of American Art, May 23–September 3, 1975 (Lloyd Goodrich, guest curator), 20.

35. Edward Alden Jewell in the *New York Times,* 7 December 1930. The entire text of Jewell's review was reprinted in both the *Wichita Eagle,* 11 December 1930, and the *Topeka Journal,* 20 December 1930; see AF/KSHS.

36. *Whitney Studio Club and American Art,* 7, 20.

37. The photograph appeared in the Rotogravure section of the *New York Times,* 22 November 1931.

38. The phrase is from "U.S. Scene," 24. For an insightful analysis of Benton's *Boomtown* and its relation to Regionalism, see Karal Ann Marling, "Thomas Hart Benton's *Boomtown:* Regionalism Redefined," in *Prospects: An Annual of American Cultural Studies,* vol. 6, edited by Jack Salzman (New York: Burt Franklin & Co., 1981), 73–137.

39. The proximate American source material for this painting and the image's subsequent popularity in American culture are sagely uncovered in Wanda M. Corn, "The Birth of a National Icon: Grant Wood's *American Gothic,*" in *Art the Ape of Nature: Studies in Honor of H. W. Janson,* edited by Moshe Barasch and Lucy Freeman Sandler (New York: Harry N. Abrams, 1981), 749–69.

40. Edward Alden Jewell in the *New York Times,* 23 January 1935, 15.

41. The quotes are taken from "U.S. Scene," 24. The painter from Ohio is Charles Burchfield, who was initially included as a precursor of the new midwestern Regionalism.

42. From "American Regionalism: A Personal History of the Movement," in Thomas Hart Benton, *An American in Art: A Professional and Technical Autobiography* (Lawrence: University Press of Kansas, 1969), 151.

43. Dennis, *Grant Wood,* 144 and fig. 134, errs in dating Curry's trip to Stone City to the summer of 1932. It was not until July of 1933 that Curry made the sketch of Wood that is shown in the photograph that Dennis illustrates. The photograph of Curry sketching Wood, taken by John W. Barry, first appeared in the *Cedar Rapids Gazette* alongside an article documenting Curry's first trip to Stone City and his first meeting with Grant Wood. See Adeline Taylor, "One Famous Artist Sketches Another," *Cedar Rapids Gazette,* 16 July 1933, 4. The sketch of Wood shown in the photograph is signed and dated by Curry, "July 1933"; it is currently in the collection of the Joslyn Art Museum in Omaha, Nebraska.

44. Telephone interview with the photographer, John Barry, Jr., Cedar Rapids, Iowa, 20 June 1982.

45. Such was the making of a "Regionalist." Curry, a highly principled man of staunch Presbyterian upbringing, never quite recovered from the guilty secret of his serendipitous success. Benton discusses Curry's perpetual self-doubting in a handwritten memoir written from Chilmark just after hearing of Curry's death. The two had met in New York in 1926 when Curry attended the exhibition of Benton's American history panels at the Architectural League; see Benton's "John Steuart Curry," manuscript, 12 September 1946, Thomas Hart Benton Papers, Archives of American Art.

46. Walker recalls this turn of events in a communication to the *Kansas City Star,* and he credits the Mulvane's agreement to accept the show to the efforts of a local booster, Mrs. L. D. Whittemore of Topeka; see Maynard Walker, "In Curry Kansas 'Found Its Homer,'" *Kansas City Star,* 2 September 1946, AF/KSHS. The Mulvane Museum agreed to pay expenses to have the exhibition sent on March 15, 1931, from its showing in St. Louis; see Maynard Walker, Ferargil Galleries, New York, to Curry, Westport, Conn., 27 February 1931, microfilm roll 166, Curry Papers/AAA.

47. Maynard Walker, Ferargil Galleries, New York, to Marco Morrow, Capper Publications, Topeka, 14 March 1931, microfilm roll 166, Curry Papers/AAA.

48. Maynard Walker to Senator Arthur Capper, Capper Publications, Topeka, 14 March 1931, and Capper, U.S. Senate, to Walker, 24 March 1931, microfilm roll 166, Curry Papers/AAA.

49. Maynard Walker to William Allen White, Emporia, Kans., 25 November 1931, microfilm roll 166, Curry Papers/AAA; L. T. Hull, Washburn College, Topeka, to Ferargil Galleries, New York, 16 May 1931, microfilm roll 166, Curry Papers/AAA.

50. William Allen White, Emporia, Kans., to Curry, Westport, Conn., 11 July 1930, microfilm roll 168, Curry Papers/AAA. White suggested that Curry come to Kansas City, Lawrence, Wichita, Hutchinson, Emporia, and Salina.

51. Walker, "In Curry, Kansas 'Found Its Homer.' "

52. William Allen White to Curry, 24 November 1931, microfilm roll 168, Curry Papers/AAA.

53. Maynard Walker to R. A. Holland, Kansas City Art Institute, 25 November 1931, microfilm roll 166, Curry Papers/AAA.

54. Maynard Walker to Curry, no date [January 1931?], and telegram, William Allen White to Walker, 19 December 1931, microfilm roll 166, Curry Papers/AAA; and, Florence L. Snow, "Art among Us: The John Steuart Curry Exhibit," *Douglas County Republican* [Lawrence, Kans.], 21 January 1932, AF/KSHS.

55. C. A. Seward, Wichita Art Museum, to Maynard Walker, 18 January 1931; Walker to R. A. Holland, Kansas City Art Institute, 4 November 1931; and Walker to White, 25 November 1931, all from microfilm 166, Curry Papers/AAA.

56. Walker to White, 25 November 1931.

57. "A Kansan's Art Stirs: Dissension Greets Paintings of John Steuart Curry," *Kansas City Times,* 7 December 1931, AF/KSHS.

58. An insightful interpretation of Mabel Dodge Luhan's promotion of the Southwest as a new Garden of Eden is presented by Lois P. Rudnick, *Mabel Dodge Luhan: New Woman, New Worlds* (University of New Mexico Press, 1985). The 1920s also saw the rise of interest in the field of cultural anthropology, and new attention paid to "primitive" Shaker furniture and American folk art. The "adventure in national rediscovery" of the 1930s had begun in the 1920s; various milestones in this phenomenon are covered in Alfred Haworth Jones, "The Search for a Usable American Past in the New Deal Era," *American Quarterly* 23 (December 1971), 710–24. A more penetrating analysis of the experiential dimension of this recovery of America's past may be found in Karal Ann Marling, "A Note on New Deal Iconography: Futurology and the Historical Myth," in *Prospects: An Annual of American Cultural Studies,* vol. 4, edited by Jack Šalzman (New York: Burt Franklin & Co., 1979), 421–40.

59. Ruth Suckow, "Midwestern Primitive," *Harper's,* March 1928, 432–42.

60. Suckow, "Midwestern Primitive," 432–36; block quotes 435–36.

61. Suckow, "Midwestern Primitive," 433, 436.

62. Suckow, "Midwestern Primitive," 436–37.

63. Suckow, "Midwestern Primitive," 437–42.

64. On the "antiques craze" and other manifestations of the rediscovery of America in the 1920s, see Russell Lynes, *The Tastemakers* (New York: Harper & Brothers, 1954), 238–42. Wanda Corn has documented Grant Wood's knowledge of Ruth Suckow's writings in *Grant Wood: The Regionalist Vision.*

65. H. Tracy Kneeland, Hart, Kneeland & Poindexter, Real Estate Brokers, Hartford, Conn., to Curry, 18 November 1931, microfilm roll 166, Curry Papers/AAA.

66. The artist, in fact, never did actually encounter tornado; see "Interview with Mrs. John Steuart Curry," After the success of *The Tornado* Curry's mother wrote him several letters describing in detail the tornadoes she herself had seen; in one letter Mrs. Curry made her own pencil sketch of a tornado for her son, along with this account:

Dear John: You should have been here to paint your own family fleeing to the cave. We stood with one foot on top step and watched the cloud form . . . we saw a large cloud and heard a roaring—out of the cloud a funnel shape cloud formed—the funnel was white rolling steam. Once it parted and came together again. Whenever it touched a cloud of earth rose up—sulphur with it . . . *Debris*—a clock stopped at 10 to 7 time of storm—a baby shoe—a piece of silver—over stuffed furniture a half mile away in the fields—dead hogs—40 chickens blown against a fence. . . . (Mrs. Smith Curry, Boyle, Kans., to Curry, 2 May [1932], microfilm roll 164, Curry Papers/AAA.)

In a letter written on the same date to Curry's wife, Clara, Curry's mother remarks: "I had come to believe that tornadoes and caves in Kansas were myths and believed by Easterners who don't know better but since last night I've lost face. . . ." (Mrs. Smith Curry, Boyle, Kans., to Clara Curry, 2 May [1932], Curry Papers/AAA.)

67. William Allen White to Curry, 18 December 1931, microfilm roll 168, Curry Papers/AAA.

68. Mrs. Henry J. Allen, Wichita, to William Allen White, Emporia, Kans., 16 December 1931, microfilm roll 166, Curry Papers/AAA. White enclosed Mrs. Allen's letter in his own letter to Curry dated 18 December 1931, microfilm roll 168, Curry Papers/AAA. Although Mrs. Allen had said she "did not wish her views broadcast," excerpts of her letter to White were somehow published in the *Kansas City Times,* 13 May 1933, AF/KSHS.

69. *The Autobiography of William Allen White* (New York: Macmillan Company, 1946), 535–38.

70. White, *Autobiography,* 503–4.

71. Kenneth S. Davis, "That Strange State of Mind Called Kansas," *New York Times Magazine,* 26 June 1949.

72. Davis, "That Strange State of Mind Called Kansas," 13.

73. Charles B. Driscoll, "Why Men Leave Kansas," *American Mercury* 3, no. 10 (October 1924), 175–78.

74. Karl A. Menninger, "Bleeding Kansas," *Kansas Magazine,* 1939, 3–6.

75. Davis, "That Strange State of Mind Called Kansas," 13, 50.

76. William Allen White, "What's the Matter with Kansas?" (editorial) *Emporia Gazette,* 11 August 1896. In his famous essay on Kansas, historian Carl Becker also noted that "there is a notion abroad that the state is peopled by freaks and eccentrics." See Becker, "Kansas," from *Essays in American History Dedicated to Frederick Jackson Turner* (New York: Henry Holt & Co., 1910), reprinted in *The Heritage of Kansas: Selected Commentaries on Past Times,* edited by Everett Rich (Lawrence: University of Kansas Press, 1960), 340–59.

77. Menninger, "Bleeding Kansas," 6. Particular concern was expressed over Curry's painting, *Baptism in Kansas.* One local Kansas commentator feared the humiliation that Easterners would assume that all Kansans conducted their baptisms in cattle watering tanks:

One may also see a copy of a photogravure section of the 'New York Times' which shows Mrs. Whitney posed beside one of these pictures which shows a country baptism ceremony in a big farm water-tank instead of the convenient stream of the usual country immersion which doubtless was not there, and one wonders if the Easterners will be thus assured that this is an indigenous custom out here when it only pictures a more or less interesting makeshift. (From Snow, "Art among Us.")

In recent years, Calvin Trillin has offered another perspective on such "Eastern lapses in . . . knowledge of matters Midwestern" in a series of wonderful essays in the *New Yorker* about his home town of Kansas City, Missouri. Trillin isolated a midwestern disease he identifies as "rubophobia—not fear of rubes, but fear of being taken for a rube. Over the years, I have met any number of people in the Midwest who are afraid that when an Easterner describes Midwesterners as very American what he really means is that they seem to be hicks." Trillin's account of the cultural dynamics underlying the boosterism of Kansas City sheds light on the troubles Curry had with his characterizations of the state of Kansas some fifty years earlier. (See, for example, "U.S. Journal: Kansas City, Missouri. Reflections of Someone Whose Home Town Has Become a Glamour City," 8 April 1974; "A Reporter at Large: American Royal," 26 September 1983; and "Department of Amplification," 19 March 1984.)

78. Maynard Walker to Gertrude Herdle, director, Rochester Art Museum, 12 June 1931; Walker to Luigi Vaiani, art critic, *Kansas City Journal Post,* 16 July 1931; Walker to Charles F. Stein, Jr., Baltimore, 8 June 1931, all on microfilm roll 166, Curry Papers/AAA. Curry's drinking is referred to in two letters from Walker to the artist, 17 June 1931, and 24 February 1932, both on microfilm roll 166, Curry Papers/AAA.

79. Curry to Harry Wickey, 13 December 1931, in the Harry Wickey Papers currently in the possession of Ralph E. Sandler, Madison, Wis. I am indebted to Professor Emeritus James Watrous of the University of Wisconsin at Madison for bringing this letter to my attention.

80. Maynard Walker to Curry, 24 February 1932, microfilm roll 166, Curry Papers/AAA.

81. "Paintings by Kansan Honored," *Kansas City Times,* 13 May 1933, AF/KSHS.

82. "Chronology of John Steuart Curry Compiled by Laurence Schmeckebier," microfilm roll 165, Curry Papers/AAA.

83. Craven, "John Steuart Curry," 40; see also "Curry of Kansas," *Newsweek,* 16 November 1943, 80, 82.

84. Craven, "John Steuart Curry," 40. Kathleen Gould Shepherd was the divorced wife of journalist Don Shepherd of Westport, a friend of Curry's; see "Art: Manhattan, Kan., Takes 'Plunge' on Curry's Painting," *Newsweek,* 16 February 1935, 24–25.

85. Maynard Walker, "John Steuart Curry," *Kansas Magazine,* 1947, 72–73.

86. "Art: Manhattan, Kan., Takes 'Plunge,' " *Newsweek,* 24–25.

87. "Kansas Heals Breach." Curry's "jubilant" reaction to the sale is reported in "John S. Curry Is Recognized."

Chapter 2

1. Edward Alden Jewell in the *New York Times,* 4 November 1928.

2. "U.S. Scene," 24–27.

3. Jennie Small Owen, "Kansas Folks Worth Knowing: John Steuart Curry," *Kansas Teacher* 46, no. 5 (March 1938), 33–35. A photograph of Curry and Grant Wood, both in farmers' overalls, appears on the editorial page of the *Kansas City Star* for 27 November 1936.

4. Conwell Carlson, "Curry and Kansas—A Story of Heroic Life," *Kansas City Star,* 22 August 1937, C1.

5. Carlson, "Curry and Kansas," C1.

6. See Karal Ann Marling, *Wall-To-Wall America: A Cultural History of Post Office Murals in the Great Depression* (Minneapolis: University of Minnesota Press, 1982).

7. For an account of the events leading up to the establishment of the Section of Painting and Sculpture, and a description of the selection process for coveted Justice Department commissions, see Belisario R. Contreras, "The New Deal Treasury Art Programs and the American Artist: 1933 to 1943" (Ph.D. diss., American University, 1967), 90–109. Biddle's role in the process and Curry's award of the commission are recalled in George Biddle, *An American Artist's Story* (Boston: Little, Brown and Co., 1939), 268–72.

Curry's mural designs for the Department of Interior Building had received the approval of Secretary Ickes at meetings on 14 and 16 July 1937; see Contreras, "New Deal Art," 211.

8. Owen, "Kansas Folks Worth Knowing: John Steuart Curry," 35.

9. "John S. Curry Is Recognized." The funding drive is referred to in "Wisconsin U. Gets Curry As Artist in Residence: Painter of K.S.C.'s 'Sun Dogs' to Develop Regionalism in Other Midwestern State," *Kansas Industrialist,* 4 November 1936, AF/KSHS.

10. Untitled newspaper article from the *Lawrence Journal-World,* 19 February 1935, AF/KSHS. It was reported that "students of the college have shown keen interest in the selection."

11. "Kansas Calls to Curry," *Kansas City Star,* 30 June 1937, AF/KSHS; "Kansas Heals Breach."

12. "John S. Curry Is Recognized."

13. See "Resident Artist: John Steuart Curry," 23–24. A later newspaper article also confirms that "it wasn't a cash transaction," but claims that Curry traded the painting "for motor car tires"; see "He Talks as He Paints: John Steuart Curry Works on Kansas Murals," *Kansas City Star,* 30 September 1940, AF/KSHS.

14. White's editorial was reprinted in its entirety by the *Topeka State Journal* on 3 October 1936, AF/KSHS; excerpts of the editorial also appeared in Owen, "Kansas Folks Worth Knowing: John Steuart Curry," 34.

15. Kansas faced humiliation on the national level in the pages of *Life;* see "Curry of Kansas," 28.

16. Harris to Curry, 4 May 1937, tells the artist of the editorials already written and states that a dozen papers had already offered financial support; Harris asks Curry, "Would you consider taking a personal part in it?" Allen to Curry, 19 May 1937, tells of the reaction his editorial has received and asks, "Does the matter attract you? Would you be willing to undertake the work if we could create a substantial sum for your compensation?"

17. Curry's positive response is referred to in a letter from Henry J. Allen to Curry, 25 May 1937, microfilm roll 166, Curry Papers/AAA; and a letter from John P. Harris to Curry, 19 May 1937, microfilm roll 166, Curry Papers/AAA, which also asks Curry how much money he would want for the job.

18. Governor Huxman wrote to Curry that Harris and Allen wanted to record Kansas history, and asked the artist to visit him; Walter A. Huxman, governor of Kansas, to Curry, 26 May 1937, microfilm roll 166, Curry Papers/AAA; in a letter to Curry dated 4 June 1937, Governor Huxman suggests a meeting date of June 10. Curry's first visit to Kansas following the announcement of the commission in August was widely publicized in the local papers. It is uncertain whether Curry actually met secretly with the governor on June 10, but a letter from Henry J. Allen to Curry dated 3 June 1937 relates that he was in the governor's office when the governor wrote the aforementioned letter to Curry, and Allen adds that he is glad that Curry is able to come; see microfilm roll 166, Curry Papers/AAA.

19. "KPA project . . . larger-than-life murals," *Kansas Publisher,* January 1980, 15; this informative account of the Kansas Editorial Association banquet was compiled by an intern at the Kansas Press Association; am indebted to Donald M. Fitzgerald, executive director of the Kansas Press Association, for bringing this article to my attention.

20. John P. Harris to Curry, 4 May 1937, microfilm roll 166, Curry Papers/AAA.

21. The list of committee members was published by the Jayhawker Press in August 1937; see "KPA project," 15. The governor appointed the committee the week after the KEA banquet; see John P. Harris to Curry, 19 June 1937, microfilm roll 166, Curry Papers/AAA. That "all the men are newspaper publishers and the women wives of publishers" appears in a letter from Harris to Curry dated 20 July 1937, microfilm roll 166, Curry Papers/AAA. The letterhead of the Kansas Murals Commission, naming the officers, the executive committee, and the members of the commission, was used by Harris for a letter to Curry dated 11 November 1939, microfilm roll 165, Curry Papers/AAA.

22. John P. Harris, "The Ten Big Murals and How They Grew (How Kansas School Children Can Help Place Them in the Capitol)," *Kansas Teacher* 46, no. 5 (March 1938), 36–37.

23. Harris to Curry, 20 July 1937.

24. "Wichita Art Folks Backing Artist Curry," *Wichita Eagle,* 15 June 1937, in the Curry Scrapbook, BV 2-13-79, box 3, Curry Papers/AAA.

25. "Kansas Editors Want Murals," *Kansas Business,* July 1937, 18–19.

26. "Curry Controversy Is Stimulating Interest in Art Thruout Kansas," *Topeka State Journal,* 27 August 1937, AF/KSHS.

27. "Kansas Editors Want Murals," 18–19.

28. Maynard Walker to Curry, 13 September 1937, microfilm roll 167, Curry Papers/AAA. Walker writes, "Is it true that Tom Benton tried to get the Kansas committee to commission one of his associates for the job? . . most dastardly thing I have ever heard of." When Curry's stepdaughter was asked if she could confirm this rumor, she responded, "My father never answered this question"; Mrs. Daniel B. Schuster, Rush, N.Y., to author, 22 March 1982. I am grateful to Mrs. Schuster for her cooperation and candor in responding to my inquiries about her stepfather.

29. Harris, "Ten Big Murals," 36.

30. The proceedings of the meeting were recounted in a letter from Kansas Murals Commission member Leslie Wallace to Curry, 21 July 1937, microfilm roll 166 Curry Papers/AAA.

31. Carl P. Bolmar, "Gleanings from the Field of Art," undated newspaper clipping from the *Topeka Journal* [5 August 1937?], in the Archives of the Kansas State Historical Society, call no. *Art & Artists* K 750 (clippings), vol. 3, 213.

32. "Must Be Sane," *Art Digest* 11, no. 19 (1 August 1937), 13.

33. The views of Kansas artists were reported by the New York *Post* and republished in "Must Be Sane," 13.

34. Curry's early views on subject matter for the murals are quoted in "Iron in Kansas People Must Be Portrayed in Murals, Says Curry," *Topeka Capital,* 5 August 1937, AF/KSHS.

35. William Allen White to Curry, 22 July 1937, microfilm roll 168, Curry Papers/AAA.

36. "Agog over the Murals," *Kansas City Star,* 17 July 1937, Curry Scrapbook, BV 2-13-79, box 3, Curry Papers/AAA.

37. The Brinkley promoters are reported in "Must

*e Sane," 13. Doc Brinkley's goat-gland operations are discussed in Geoffrey S. Smith, *To Save a Nation: American Countersubversives, the New Deal, and the Coming of World War II* (New York: Basic Books, 1973), 7.

38. This information appears in a 12-page booklet, "Kansas Facts," being distributed to Statehouse visitors in March of 1980 by the Kansas secretary of state's office.

39. Davis, *Kansas,* 183–85.

40. In the 1932 election, Brinkley garnered 244,607 votes; Alf Landon, who won the governorship that year, only narrowly defeated the Democratic favorite, 278,581 votes to 272,944; see Davis, *Kansas,* 184–85. Brinkley's role in the rise of Alf Landon is acknowledged in Smith, *To Save a Nation,* 57; also in Donald R. McCoy, *Landon of Kansas* (Lincoln: University of Nebraska Press, 1966), 91–92, 101–4, 106–13; for more on Doc Brinkley, see Gerald Carson, *The Roguish World of Doctor Brinkley* (New York: Rinehart, 1960).

41. "Agog over the Murals." To the considerable embarrassment of many Kansans, Brinkley's rise to fame was taunted in the pages of *Newsweek* as "a new invasion from the lunatic fringe" in a state that was "much given to isms"; see "Isms in Kansas," *Newsweek,* 1 August 1938, 11–12.

42. "Curry Controversy." The Missouri Statehouse murals raised, in Benton's words, "a storm of criticism . . . from good old hidebound, middle-class Missouri conservatives who saw its 'common life' representations as an insult to the state"; see Thomas Hart Benton, "An American in Art: A Professional and Technical Autobiography," *Kansas Quarterly* 1 (Spring 1969), 70–72. Benton reprints a scathing editorial against his murals, "Shame on You, Mr. Benton," in *Artist in America,* 243–45. The Kansas Murals Commission required Curry to obtain approval for his preliminary sketches to avoid such a controversy. The resolution by Senator Barbour of Missouri to sanction the Benton murals originally contracted for Benton to work under the approval of the Missouri State Art Commission. When Benton learned of this condition in the contract, he refused to sign it until the stipulation for approval was deleted; the troublesome clause was removed, and Benton proceeded with a free hand. Benton had resigned from the Treasury Department's Section of Fine Arts project to decorate the Post Office Building in Washington, D.C., because of a similar refusal to work under committee approval. Details of both of these incidents are recounted in Benton's unpublished memoirs, "The Thirties" in the Thomas Hart Benton Papers, Archives of American Art, Smithsonian Institution, Washington, D.C., 40–43.

43. Quoted in "Iron in Kansas People." Curry's specific plans for the layout of the murals was also reported: "There will be fourteen panels, eight of them in the rotunda proper, each will be eleven feet and nine inches high and seven feet and three inches wide. The present marble panels at the bottom will be removed and the wall plastered. Then there will be two panels eight feet and three inches wide and one twenty-nine feet and

three inches wide in the small lobby opening into the main rotunda on the west. In the elevator lobby on the east will be three other panels, one twenty-two feet nine inches wide and one nine feet wide. All of these will be eleven feet and nine inches high.

44. "Iron in Kansas People."

45. Quoted in "Iron in Kansas People."

46. Craven, "John Steuart Curry," 37.

47. Carlson, "Curry and Kansas," C1.

48. Carlson, "Curry and Kansas," C1.

49. These recollections of Dunavant in 1916 are found in a letter from the artist's brother, R. Eugene Curry, of Armonk, New York, to Ms. Dorothy Francis of Marshalltown, Iowa, 13 June 1975; I am very grateful to Mr. Curry for sending me a copy of this and other correspondence for my research and for answering numerous questions about his late brother.

50. Craven, "John Steuart Curry," 37.

51. Curry, text of a radio broadcast over station WHA, Lawrence, Kansas, 13 May 1938, typescript, microfilm roll 165, Curry Papers/AAA.

52. "Iron in Kansas People."

53. Harris, "Ten Big Murals," 36.

54. "Description of Murals for Kansas State Capitol by John Steuart Curry," typescript, Archives of the Kansas State Historical Society, call no. SP725.1, K13, pam. V. "Ad Astra Per Aspera" is the state motto of Kansas, and is translated, "To the Stars through Difficulties."

55. The scale of the preliminary oil sketches is given in Ted Wear, "John Steuart Curry and His Kansas Murals," *American Artist* 4, no. 8 (October 1940), 6. Approval for the sketches is reported in "There'll Be 'No Prettying' in Curry's Kansas Murals," *Wisconsin State Journal,* 13 November 1937, newspaper clipping located in the John Steuart Curry "Name File" of the Iconographic Collection, Wisconsin State Historical Society, Madison, Wis.

56. Harris, "Ten Big Murals," 36.

57. "There'll Be 'No Prettying'."

58. Harris, "Ten Big Murals," 36. The actual price for Curry's Statehouse murals came to $12.20 per square foot; see Harris to Curry, 24 September 1940, microfilm roll 165, Curry Papers/AAA. The salary amounted to a cut in pay for Curry, who had just been paid twenty dollars per square foot for murals painted for the Treasury Department's Section of Painting and Sculpture; see memo to the director of procurement from Edward Bruce, chief, Section of Fine Arts, Treasury Department Procurement Division, Washington, D.C., 25 July 1936, document in the collection of the National Archives, Washington, D.C., Record Group 121 (Records of the Public Building Service), Preliminary Inventory Entry 133, box 547, file "Interior Dept.—Wash., D.C. Folder #1: May–1936 to Dec. 31, 1936."

59. On November 16, the governor's public statement on the murals was also carried by local newspapers across the state; see letter from Leslie Wallace to John Steuart Curry, 19 November 1937, microfilm roll 166, Curry Papers/AAA.

60. W. G. Clugston, "Curry Passes Up Drys and

Brinkley in Planning Capitol Murals but John Brown and Dust Storms Go into Sketches Submitted Today to State Committee in Topeka," *Kansas City Journal-Post,* 12 November 1937, Curry Scrapbook, BV 2-13-79, box 3, Curry Papers/AAA.

Such legislative milestones as the legal ban on the eating of snake meat and the enactment of a law regulating the length of a bed sheet had been brought to the nation's attention in an earlier article about the peculiar character of the state; see W. G. Clugston, "Kansas the Essence of Typical America," *Current History* 25 (October 1926), 14–20.

Chapter 3

1. Quoted in Lawrence Stone, *The Family, Sex and Marriage in England 1500–1800* (New York: Harper & Row, 1977).
2. *Kansas Directory, 1979,* comp. Jack H. Brier (Topeka, Kans.: Office of the Secretary of State, 1979), 84. Many place names in the state disclose its Indian heritage—e.g., "Topeka" means "a good place to dig potatoes"; see Charles C. Howes, *This Place Called Kansas* (Norman: University of Oklahoma Press, 1952), 11.
3. Margaret Whittemore, *Sketchbook of Kansas Landmarks* (Topeka: College Press, 1936), 19.
4. Whittemore, *Sketchbook,* 19.
5. The phrase is used in Nyle H. Miller, *Kansas—The 34th Star* (Topeka: Kansas State Historical Society, 1976), 12.
6. Francis V. O'Connor, ed., *Art for the Millions* (Boston: New York Graphic Society, 1973), 21.
7. See, for example, Jones, "Search for a Usable American Past," 710–24. A contemporary description of the phenomenon is given in the concluding chapter of Alfred Kazin's *On Native Grounds: An Interpretation of Modern American Prose Literature* (New York: Reynal & Hitchcock, 1942), 485–518.
8. See, for example, Karal Ann Marling, "New Deal Iconography," 421–40.
9. John Dos Passos, *The Ground We Stand On* (New York: Harcourt, Brace & Co., 1941), 3.
10. Joseph Wood Krutch, "The Usable Past," *Nation* 138, no. 3580 (14 February 1934), 191–92.
11. See Van Wyck Brooks, "On Creating a Usable Past," *Dial* 64 (11 April 1918), 339, 341. John Steuart Curry was certainly aware of the work of Van Wyck Brooks. Curry was a friend and neighbor of his in Westport. Brooks lived on Kings Highway, and had settled in Westport in 1921; Curry lived there from 1924 to 1936. In 1936, just before leaving Westport to take his post at the University of Wisconsin, Curry made a striking portrait sketch of Van Wyck Brooks; Curry's friendship with Brooks is mentioned in James Hoopes, *Van Wyck Brooks: In Search of American Culture* (Amherst: University of Massachusetts Press, 1977), 143.
12. Krutch, "Usable Past," 191–92.
13. Further discussion of both mythic and ideologi-

cal uses of the past in the period between 1890 and 1940 may be found in Warren Susman, "History and t[] American Intellectual: Uses of a Usable Past," *Americ[] Quarterly* 16, no. 2, part 2 (Summer 1964), 243–63.
14. Quoted by Karal Ann Marling in "New Deal Iconography," 424.
15. Both quotes are from Lionel Trilling, "Manners[] Morals, and the Novel," in *The Liberal Imagination: Es[] says on Literature and Society,* Lyceum Edition (1950[] reprint, New York: Charles Scribners' Sons, 1976), 20[]

An explication of what is meant by the "intrinsic meaning" of a work of art is given in Erwin Panofsky, *Studies in Iconology: Humanistic Themes in the Art of[] the Renaissance* (New York: Oxford University Press, 1939), 3–31.
16. "Kansas Historical Markers," *Kansas Historica[] Quarterly* 10, no. 4 (November 1941), 342.
17. "Kansas Historical Markers," 343.
18. "Kansas Historical Markers," 339–40. For a so[] cial history of auto tourism in the 1930s, see Warren James Belasco, *Americans on the Road: From Autocamp to Motel, 1910–1945* (Cambridge, Mass.: MIT Press, 1979). An insightful treatment of auto tourism in[] the Midwest during the 1930s may be found in Anedith Nash, "*Death on the Ridge Road*: Grant Wood and Modernization in the Midwest," in *Prospects: The Annual of American Cultural Studies,* edited by Jack Salz[] man, vol. 8 (New York: Burt Franklin & Co., 1983), 28[] 301.
19. Roy F. Bailey, " 'To the Stars through Difficulties': Accomplishments of Kansas Shown by Historical Markers," *Kansas Teacher* 50, no. 9 (May 1942), 28.
20. Bailey, "Accomplishments of Kansas," 28.
21. The words are those of Bailey, but they are offered in explanation of Mrs. Ratner's strong support o[] the new proposal; see Bailey, "Accomplishments of Kansas," 28. In 1980, officials of Kansas were still quic[] to point out with some apparent relish that the Coronad[] visit was "80 years before the Pilgrims landed at Plymouth Rock"; see *Kansas Directory,* 84. The connection is also made in "Kansas Facts."
22. Bailey, "Accomplishments of Kansas," 28.
23. For an in-depth look at the revival of interest in[] George Washington during the 1930s, see Karal Ann Marling, "Of Cherry Trees and Ladies' Teas: Grant Wood Looks at Colonial America," in *The Colonial Revival in America,* edited by Allen Axelrod, (New York: W[] W. Norton, Winterthur Books, 1985), 294–319. Marling[] book, *George Washington Slept Here,* forthcoming fro[] Harvard University Press, also promises to be an invalu[] able treatment of this subject.
24. Paul A. Jones, *Coronado and Quivira* (Lyons, Kans.: Lyons Publishing Co., 1937), 1.
25. "Kansas Editors Want Murals," 18.
26. "Kansas Editors Want Murals," 18.
27. The phrase is from Jones, *Coronado and Quivira,* 1.
28. See Paul I. Wellman, "Admiral Paul Jones Brings Coronado Back to Kansas," *Kansas City Star,* 1[] May 1941, 12C.
29. Wellman, "Admiral Paul Jones," 12C.

30. Wellman, "Admiral Paul Jones," 12C; see also F. L. Pinet, "Paul Jones, Navigator," *Kansas Teacher* 45, no. 5 (October 1937), 20.

31. Wellman described the distinctive haircut in detail:

A word about that Pawnee haircut. It is achieved by virtually shaving the Jones cranium to a point near the top of the skull, where the hair is permitted to grow in its natural unregimented style—which means straight up. The effect is like the roached mane of a mule—or the roached scalplock of a Pawnee Indian of the old days, say the days when the Pawnees visited Coronado at somewhere near the site of present day Lyons. The Pawnee haircut, on the Jones head, achieves a uniquely spectacular, not to say scenic effect. The knobs and valleys of the terrain below the scalplock would fascinate a phrenologist, not to say a geologist, while the whole aspect, including the genial smile of the countenance below, is half-fierce and half-whimsical. Paul Jones likes it and so do the people who like Paul Jones. (12C)

32. Wellman, "Admiral Paul Jones," 12C.

33. Wellman, "Admiral Paul Jones," 12C.

34. The phrase is from Wellman, "Admiral Paul Jones," 12C.

35. For a full account of the development of the Coronado Cuarto Centennial Commission, see "History of the Coronado Celebrations," in George P. Hammond, *Coronado's Seven Cities* (Albuquerque: United States Coronado Exposition Commission, 1940), 77–82. See also M. Sue Kendall, "Gold's Fool and God's Country: The Coronado Craze of 1940–41," in *Prospects: The Annual of American Cultural Studies,"* vol. 11, edited by Jack Salzman, (New York: Cambridge University Press, 1986).

36. Federal support for the Coronado celebrations was not immediately forthcoming. In June 1938, President Roosevelt even vetoed a measure that called for the coinage of 100,000 commemorative half-dollars. Eventual federal support for the Coronado celebrations was linked to a turnabout in foreign policy late in the same year, when the federal government "began to stress the development of more cordial relationships with other American republics"; see Hammond, "History of the Coronado Celebrations," 78–79.

37. Hammond, "History of the Coronado Celebrations," 79–80.

38. Hammond, "History of the Coronado Celebrations," 80.

39. Hammond, "History of the Coronado Celebrations," 78–80.

40. Eddie Sherman, "Coronado Marches Again," *Journal of the National Educational Association* 29, no. 5 (May 1940), 142–43.

41. Pinet, "Paul Jones," 20.

42. Paul Jones was interviewed by A. B. MacDonald in "Tracing the March of Coronado through Kansas," *Kansas City Star,* 16 February 1936; news of the interview was reported in the *Kansas Historical Quarterly* 5, no. 2 (May 1936), 220.

43. Wellman, "Admiral Paul Jones," 12C.

44. Paul Jones, as quoted in Wellman, "Admiral Paul Jones," 12C.

45. Wellman, "Admiral Paul Jones," 12C.

46. "Kansas Historical Notes," *Kansas Historical Quarterly* 10, no. 1 (February 1941), 108.

47. "Kansas Historical Notes," 108.

48. Bailey, "Accomplishments of Kansas," 28.

49. Jones, *Coronado and Quivira,* 1.

50. For example, one such letter from Paul Jones to Curry is dated 5 March 1941, microfilm roll 165, Curry Papers/AAA.

51. Jones to Curry, 5 March 1941; Curry to Paul Jones, 10 March 1941, microfilm roll 165, Curry Papers/AAA; Curry to Paul Jones, 19 March 1941, microfilm roll 165, Curry Papers/AAA. "Admiral Paul Jones Brings Coronado Back to Kansas" was the headline of Wellman's article in the *Kansas City Star,* 18 May 1941, 12C.

52. The quote is taken from Bailey, "Accomplishments of Kansas," 28. My mention of Bert Statzer refers to the character in Ruth Suckow's short story, discussed in chapter 1.

53. "The Great American Roadside," *Fortune* 10, no. 3 (September 1934), 53–63, 172, 174, 177. Eleven Curry illustrations appeared with the article. They ranged from picturesque genre scenes of tourist cabin camps to some more abstract, cubo-realist montages of signboard art that featured "signifiers" of the roadside experience (i.e. "Gas," "Slow—Curve," "Tourists Rooms," "Bar-B-Q") flattened to the surface of the canvas, as though so many Burma Shave signs had been conflated in a collage.

54. "Great American Roadside," 54.

55. "Great American Roadside," 58–59.

56. "Great American Roadside," 58.

57. The quote is from "Great American Roadside," 177.

58. "Great American Roadside," 55.

59. "Kansas Historical Notes," 108.

60. "Kansas History in the Press," *Kansas Historical Quarterly* 9, no. 3 (August 1940), 328.

61. The phrase is from David Donoghue, "Coronado, Onate, and Quivira," *Mid-America: An Historical Review* 17, no. 2 (April 1936), 88–95.

62. See, for example, David Donoghue, "The Route of the Coronado Expedition in Texas," *Southwestern Historical Quarterly* 36 (1929), 181–92; "Coronado, Onate, and Quivira," 88–95; *The Location of Quivira,* reprinted from the *Panhandle Plains Historical Review* of 1940 for the library of the Kansas State Historical Society. All of these writings by Donoghue were noted in the *Kansas Historical Quarterly*: see "Recent Additions to the Library," vol. 11, no. 3 (August 1942), 310; "Catholic First Things in Kansas," vol. 8, no. 2 (May 1939), 208; and especially vol. 5, no. 3 (August 1936), 326, which reports: "David Donoghue of Ft. Worth Texas writes in April 1936 number of *Mid-America* of Chicago, discounts 'Quivira in Kansas idea'."

63. Donoghue, "Coronado, Onate, and Quivira," 88.

64. Donoghue, "Coronado, Onate, and Quivira," 91, n. 8.

65. The phrase appears on the roadside historical marker near Herington, Kansas; see "Kansas Historical

Markers," 343.

66. See, for example, "Catholic First Things in Kansas," 208; "Kansas History in the Press," 328. In all fairness, the Coronado Cuarto Centennial Committee accepted the possibility of a Kansas route after taking into account the disparate testimonies of fifty historical experts on the location of Quivira. The Kansas Murals Commission was fully aware of the controversy—Paul Jones discussed the relative merits of the claims advanced for locating Quivira in Kansas or Texas in an illustrated article published in the *Hutchinson News* (Kans.), 7 January 1940.

67. Bailey, "Accomplishments of Kansas," 28.

68. Msgr. Michael Schine in the *Catholic Historical Review* 2 (1916), 18 as reported in "Bypaths of Kansas History," *Kansas Historical Quarterly* 8, no. 2 (May 1939), 208.

69. See Jones, *Coronado and Quivira*, 144–46; the competing claims to the site of the Padre's gravesite are also reported in a feature article on Father Padilla by Cecil Howes, "This Month in Kansas History," *Kansas Teacher* 50, no. 6 (February 1942), 38–40; this article is illustrated by a reproduction photograph of the Coronado-Padilla panel of John Steuart Curry's Kansas murals.

70. See Cecil Howes, "Father Padilla Died as a Christian Martyr in Kansas 400 Years Ago," *Kansas City Times,* 24 December 1936. The relative merits of the claims made by the cities of Council Grove and Herington and a photograph of one of the monuments may be found in Howes, *This Place Called Kansas,* 18–21, chapter 3, "The First Christian Martyr of Kansas."

71. See Carlos E. Castañeda, *Our Catholic Heritage in Texas,* vol. 1 (Austin, 1936), 105–15; this research and other aspects of the debate over the site of Padilla's martyrdom are discussed in Fr. Angelico Chavez, O.F.M., *Coronado's Friars* (Washington, D.C.: American Academy of Franciscan History, 1968), 85–86; see also chapter 3, "Fray Juan de Padilla," 14–17.

72. Cecil Howes, "Coronado's Expedition to Kansas Started 400 Years Ago This Week," *Kansas City Times,* 20 February 1940.

73. "Coronado Rides Again," reported in the *Kansas Historical Quarterly* 10, no. 2 (May 1941), 214; "Cuarto Centennial Entrada," was issued on 30 June 1941, as reported in the *Kansas Historical Quarterly* 10, no. 4 (November 1941), 423; the review of *Coronado and Quivira* reported in the *Kansas Historical Quarterly* 10, no. 1 (February 1941), 110–11; information on lecture "The Artist and Coronado" in letter of Mrs. Byron Hubbard, Chase, Kans., to Curry, 26 March 1941, microfilm roll 165, Curry Papers/AAA; Coronado pageant reported in the *Kansas Historical Quarterly* 10, no. 4 (November 1941), 428.

74. Victor Murdock, "Hosts of Kansans to Find Coronado Show Next Year to Top New Mexican Effort," *Wichita (Evening) Eagle,* 7 October 1939, as reported in the *Kansas Historical Quarterly* 9, no. 1 (February 1940), 106. The Coronado Cuarto Centennial Celebration in New Mexico is discussed in "On the Trail to New Mexico," *Kansas Teacher* 49, no. 2 (May 1940), 31–32.

75. This legend about Padre Padilla, along with a description of his clothing, is recounted in a book published in Topeka just before Curry made his mural sketches; the Curry conception of Padilla matches that description: "A Spanish priest, Juan de Padilla, in brow cassock and grass sandals, accompanied Coronado in his expedition. Although a horse was offered him, the young Franciscan preferred to plod along on foot"; see Whittemore, *Sketchbook,* 16. It is also interesting to note this author's opening paragraph in the chapter entitled "Coronado in Kansas," to document the prevalence of the rivalry already indicated between Kansas and East Coast claims to the important events of American history: "The year 1941 marks the four hundredth anniversary of the exploration of Kansas by Francisco Vasquez de Coronado, the first white man to set foot on the prairies of the Southwest. This was almost a century before the Pilgrims landed at Plymouth Rock." (15)

76. Both quotes from untitled newspaper article written by Jessie Hodges, n.d., in the AF/KSHS, 18 verso.

77. "Coronado Arrived in Kansas Astride a Scrub Pony?" *Topeka Capital,* 28 May 1940, AF/KSHS.

78. Quoted in "Coronado Arrived in Kansas."

79. Phil Stong, *Horses and Americans* (New York: Frederick A. Stokes Company, 1939), 198, 200. In fact the Palomino was not recognized as a legitimate breed until 1949; see "Palomino Breed Recognized," *The Cattleman* 35, no. 8 (January 1949), 112.

80. Curry has been assumed to be the son of a Kansas farmer; however, in his portrait of his father, he portrays him as a stockman, wearing riding boots and carrying a whip, leading an Appaloosa by the reins—see the painting, *Kansas Stockman,* 1929, oil on canvas, Whitney Museum of American Art, New York. We have already noted the Westport, Connecticut, milieu that flavored the development of Curry's early Regionalist oeuvre. Just as interesting in this respect is Curry's attraction to the land and culture of the American Southwest. Although one is hard pressed to discover it in subsequent writing on the artist, it would seem that John Steuart Curry had as many childhood ties to the Arizona desert as he did to the pigs-and-chickens vision of the Kansas on his canvases. The Smith Currys had owned homes in both Kansas and Arizona since John was a small boy. After 1908, the family would routinely leave Kansas in the autumn to spend the winter months at their ranch near Scottsdale, Arizona (see Oren Arnold, "Farm Boy into Artist," *Family Circle* 17, no. 23, [6 December 1940], 10–11, 19). In 1938, in the midst of the depression, the Curry family farm in Kansas went under threat of foreclosure, and the elder Currys retired to Scottsdale (Eugene Curry to John Steuart Curry, 30 January 1938, microfilm roll 164, Curry Papers/AAA; Mrs. Smith Curry to John Steuart Curry, 7 May 1938, microfilm roll 164, Curry Papers/AAA). Taking time off from working on the Kansas murals, John would visit his parents in Arizona. There, among the flora and fauna of the Great American Desert, he would go sketching at Squaw Peak, or capture the likeness of a Mexican cowboy in the blacksmith shop on the nearby DC Ranch (Arnold, "Farm Boy into Artist," 11, 19; the same author

notes that Curry's first painting was made in 1912 in Arizona, not Kansas, in "Portrait of a Mother," *Farm Journal* [May 1955], 105–6). Early in 1940, just before beginning to paint the Coronado panels in the State-house, Curry announced to reporters from the *Phoenix Republic* that he planned to establish a winter home in the Salt River valley of Arizona. He planned to renovate a two-story adobe house that had long been vacant, and to paint in the Arizona desert ("J. Steuart Curry Planning to Paint in Arizona Desert," newspaper clipping from unidentified source, 31 March 1940, located in name file "John Steuart Curry" of the Iconographic Collection at the Wisconsin Historical Society). Since his interests and experience lay beyond the confines of Kansas, Curry needed little encouragement to paint Coronado into his murals and to commemorate the heritage of the American Southwest.

81. *The Steeplechaser,* 1927, oil on canvas, illustrated in Schmeckebier, *Pageant,* fig. 147; "Curry Sketches Prize Stallion at Stock Show," *Milwaukee Sentinel,* 2 December 1937, newspaper clipping on microfilm roll 165, Curry Papers/AAA; for the Stock Pavilion see Schmeckebier, *Pageant,* 190.

82. See frontispiece, "Wisconsin Belgians, from a painting by John Steuart Curry, from studies made at the Annual Little International Livestock Show, Wisconsin College of Agriculture" in Stong, *Horses and Americans.*

83. In Stong, *Horses and Americans,* facing 12; in Jones, *Coronado and Quivira,* facing 51; see also 208.

84. The prevalence of starvation among livestock on the plains is discussed in Donald Worster, *Dust Bowl: The Southern Plains in the 1930s* (New York: Oxford University Press, 1979), especially chapter 7, "When the Cattle Ate Tumbleweed," 108–17.

85. For an analysis of the evolution of heroes, horses, and costumes in Hollywood westerns, see George N. Fenin and William K. Everson, *The Western: From Silents to the Seventies,* 2d ed. (New York: Grossman Publishers, 1973), 149–55, 193–225.

86. Invoice 4349, United Costumers, Inc., 6011 Santa Monica Blvd., Hollywood, Calif., to Curry, 15 January 1940, microfilm roll 164, Curry Papers/AAA.

87. An analysis of the popular stereotypes in Thomas Hart Benton's first Regionalist painting may be found in Marling, "*Boomtown,*" 73–137.

Chapter 4

1. Coronado and his entourage are referred to as the "first tourists" to Kansas by Roy F. Bailey in "Accomplishments of Kansas," 28.

2. An early instance of this compositional device may be found in the painting *Dempsey and Firpo,* 1924, by George Bellows. In it, the surface of the canvas is emphasized by the lines of the fighting ring and the lights in the background—the action then spills into the viewer's space by placing an audience in the shallow foreground and by having the fighter falling out of the ring into the lap of the viewer. The composition may be compared with a pre–Armory Show rendition of a similar theme in *Stag at Sharkey's,* 1907, in which the action of the picture takes place on a horizontal plane within the confines of the painted canvas. These two images are conveniently reproduced together in Barbara Rose, *American Art Since 1900,* 1975 ed. (New York: Praeger Publishers, 1976), figs. 3-13, 3-15. I owe these observations of the Bellows painting to the keen analytical eye of Karal Ann Marling, who first brought this compositional device to my attention, and who elaborates its qualities with greater justice in an aforementioned article on Thomas Hart Benton; see Marling, "*Boomtown,*" 92–98.

3. John Steuart Curry, "What Should the American Artist Paint?" *Art Digest* (September 1935), 29.

4. "God's Angry Man" is the title of a novel about John Brown; see Leonard Ehrlich, *God's Angry Man* (New York: Simon and Schuster, 1932); David Karsner's biography of Brown is entitled *John Brown, Terrible 'Saint'* (New York: Dodd, Mead and Co., 1934); Melville refers to Brown as "the meteor of the war" in the poem "The Portent" (1859) from *Poems* (London: Constable and Co., 1924), 5.

5. "John Brown Marches on in Row over Murals," *Fresno Bee* (Calif.), 28 October 1941, AF/KSHS.

6. The Revelation of Saint John the Divine, King James Version, 1:8.

7. Curry, Madison, Wis., to Mrs. Byron Hubbard, Chase, Kans., 27 March 1941, microfilm roll 165, Curry Papers/AAA.

8. "Description of Murals for Kansas State Capitol."

9. For a chronology of the life of John Brown, see *John Brown,* edited by Richard Warch and Jonathan F. Fanton (Englewood Cliffs, N.J.: Prentice-Hall, 1973). My account of these events relies primarily on the introduction, which provides an analytical look at various positions taken by historians.

10. Warch and Fanton, *John Brown,* 8.

11. Roger Butterfield, *The American Past* (New York: Simon and Schuster, 1976), 146.

12. Also "Bloody Kansas"; see Davis, *Kansas,* especially chapter 3, "Bleeding Kansas."

13. Quoted in Warch and Fanton, *John Brown,* 8.

14. Warch and Fanton, *John Brown,* 8.

15. Warch and Fanton, *John Brown,* 9.

16. See Stephen B. Oates, *To Purge This Land with Blood: A Biography of John Brown* (New York: Harper & Row, 1970), 290–352.

17. Quoted in Louis Ruchames, ed., *A John Brown Reader* (London: Abelard-Schuman, 1959), 12; see also John J. McDonald, "Emerson and John Brown," *New England Quarterly* 44, no. 3 (September 1971), 377–96.

18. Quoted in Ruchames, *John Brown Reader,* 12; see also Gilman M. Ostrander, "Notes and Documents: Emerson, Thoreau, and John Brown," *Mississippi Valley Historical Review* 39, no. 4 (March 1953), 713–26.

19. From "The Battle Hymn of the Republic" by Julia Ward Howe, quoted in Ernest Lee Tuveson, *Redeemer Nation: The Idea of America's Millennial Role* (Chicago: University of Chicago Press, 1968), 197–98. Tuveson discusses the apocalyptic imagery of the Civil

War in his chapter "The Ennobling War," 187–214. The subject has been treated in greater depth in James H. Moorhead, *American Apocalypse: Yankee Protestants and the Civil War, 1860–1869* (New Haven: Yale University Press, 1978).

20. John Steuart Curry, as quoted in Ted Wear, "John Steuart Curry," 5–8.

21. William Allen White is quoted by Curry in the latter's "Description of Murals for Kansas State Capitol."

22. William Allen White editorial, *Emporia Gazette,* 25 April 1922, quoted in Davis, *Kansas,* 170–71.

23. White, *Emporia Gazette,* 25 April 1922.

24. Leverett Wilson Spring, *Kansas: The Prelude to the War for the Union* (Boston: Houghton, Mifflin & Co.; Cambridge, Mass.: Riverside Press, 1888).

25. John J. Ingalls, quoted in Cecil Howes, "This Month in Kansas History," *Kansas Teacher,* 50, no. 5 (January 1942), 26.

26. That Mechem's play won the coveted Anderson award is mentioned in Jennie Small Owen, "Kansas Folks Worth Knowing: Kirke Mechem," *Kansas Teacher* 47, no. 5 (November 1938), 30–32. Mechem was the secretary of the Kansas State Historical Society during the time that John Curry was doing his research there on John Brown. One of Curry's drawings of the head of John Brown was used in the jacket design for Mechem's play; see pamphlet, "Announcing a Kansas Magazine Book *John Brown*—a Play by Kirke Mechem" (Manhattan, Kans.: Kansas Magazine Pub. Assoc., 1939), microfilm roll 168, segments 0598–0600, Curry Papers/AAA.

27. Kirke Mechem, *John Brown: A Play in Three Acts* (Manhattan, Kans.: Kansas Magazine, 1939), 20.

28. The *Harper's* sketch is reprinted in *America's Front Page News 1690–1970,* edited by M. C. Emery, R. S. Schuneman, E. Emery (Minneapolis: Vis-Com, 1970), 24.

29. One of these Onthank paintings is now in the Boston Athenaeum; see Oswald Garrison Villard, *John Brown: 1800–1859* (New York: Alfred A. Knopf, 1943), frontispiece and xiii.

30. The painting is illustrated, along with Curry's John Brown panel, in Cecil Howes, "This Month in Kansas History," *Kansas Teacher* 51, no. 2 (October 1942), 80–83.

31. This portion of the Whittier poem was reprinted in James C. Malin, "The John Brown Legend in Pictures: Kissing the Negro Baby," *Kansas Historical Quarterly* 8, no. 4 (November 1939), facing 340. The so-called Whittier legend is discussed in Leslie Albert Wardenaar, "John Brown: The Literary Image" (Ph.D. diss., UCLA, 1974), 96–99. Whittier's "Brown of Osawatomie" was the most popular poem on Brown of the nineteenth century, according to Cecil D. Eby, Jr., "Whittier's 'Brown of Osawatomie,' " *New England Quarterly* 33 (1960), 452–61.

32. Robert S. Fletcher, "Ransom's John Brown Painting," *Kansas Historical Quarterly* 9, no. 4 (November 1940), 343–46. The painting is illustrated in James C. Malin, "The John Brown Legend in Pictures: Kissing the Negro Baby," *Kansas Historical Quarterly* 9, no. 4

(November 1940), 339–42ff. (Malin wrote two articles of the same title, one year apart; the latter is an update of the former.)

33. Fletcher, "Ransom's John Brown," 343–44.

34. Currier & Ives, *John Brown,* color lithograph, 1863; Currier & Ives, *John Brown—The Martyr,* color lithograph, 1870; both mentioned in Malin, "John Brown Legend," 1940, 339–42.

35. See Malin, "John Brown Legend," 1940, 342; also, "John Brown," *Negro History Bulletin* 1, no. 1 (October 1937), 4.

36. See Malin, "John Brown Legend," 1939, 340; 1940, 340, 342.

37. "Thomas Hovenden," in Matthew Baigell, *Dictionary of American Art* (New York: Harper & Row, 1979), 173.

38. The replica was owned by Albert Rosenthal, and its exhibition is reported in Malin, "John Brown Legend," 1939, 340.

39. That year Curry exhibited *The Fence Builders,* painted in 1922; see "Chronology: John Steuart Curry," in Joseph S. Czestochowski, *John Steuart Curry and Grant Wood: A Portrait of Rural America* (Columbia: University of Missouri Press, 1981), 125.

40. Howes, "This Month in Kansas History," 51, no. 2 (October 1942), 80–83.

41. See Richard D. McKinzie, *The New Deal for Artists* (Princeton: Princeton University Press, 1973), 111. It is doubtful that Curry could have known of the Ishigaki mural, or of another concurrent mural centering on the life of John Brown being installed in the post office of Brown's birthplace of Torrington, Connecticut. "Episodes in the Life of John Brown" was the subject of a three-panel mural painted by Arthur Covey in 1937 under sponsorship of the Treasury Department's Section of Fine Arts. Rendered in what Marling has termed "The American Guide approach to the hidden lives of the famous," the Covey mural bypassed the Whittier legend altogether and showed, in Marling's words, "an ordinary little boy and an ordinary lady standing before an old-fashioned house." Marling's further description of the Covey murals follows:

The first panel shows his boyhood life; Brown was born in Torrington on May 9, 1800. The second scene shows Brown at age 38, making his first public speech on the slavery issue. In the center panel, Brown is surrounded by a group of slaves he kidnapped from their masters and, in an 82-day trek, moved from Missouri to Canada. Covey took the story in part from Oswald Garrison Villard's *Fifty Years After* (Marling, *Wall-to-Wall,* 194–95, 197, 237 n. 14).

In the 1940s, the iconography of John Brown was expanded greatly by artists such as Horace Pippin, Jacob Lawrence, and Charles White.

42. The circumstances surrounding the commissioning of the Justice Department murals by the Treasury Department's Section of Fine Arts, and the invitation to John Steuart Curry to paint two panels there, may be followed in Contreras, "New Deal Art," 99ff.

43. Edward Rowan, superintendent, Section of Painting and Sculpture, Treasury Department, Washington, D.C., to Curry, Westport, Conn., 22 March 1935, and Rowan to Curry, 13 February 1936. National Archives and Records Service, Record Group 121, Entry 133, box (121)408, file: "John S. Curry—Dept. of Justice Bldg., Wash., D.C."

44. The saga of Curry's struggles to secure approval for his Justice Department mural sketches is further recounted in Contreras, "New Deal Art," 144–49.

45. Curry to Edward Rowan, 16 March 1936, National Archives and Records Service, Record Group 121, Entry 133, box (121)408, file: "John S. Curry—Dept. of Justice Building, Wash., D.C."

46. That the Section of Fine Arts steered a careful course to avoid public controversies is discussed throughout Marling's *Wall-to-Wall America*.

47. The description of the Pusterla incident is quoted from McKinzie, *New Deal for Artists*, 111.

48. See Thomas Cripps, *Slow Fade to Black: The Negro in American Film, 1900–1942* (New York: Oxford University Press, 1977), 258–61; David Levering Lewis, *When Harlem Was in Vogue* (New York: Alfred A. Knopf, 1981), 245.

49. The quote belongs to Cripps, *Slow Fade to Black*, 251.

50. The quote is from Loren Miller, "Uncle Tom in Hollywood," *Crisis* 41, no. 11 (November 1934), 329, 336; see also Victor Daly, "Green Pastures and Black Washington," *Crisis* 40, no. 5 (May 1933), 106, for other stirrings of discontent among the black community.

51. Charles Moore, chairman, Commission of Fine Arts, to Edward Rowan, 30 March 1936, National Archives and Records Service, Record Group 121, Entry 133, box (121)408, file: "John S. Curry—Dept. of Justice Building, Wash., D.C." In fairness to Curry, it is worth noting that the gesture of religious expression of the freed slaves was not the racial slur Moore imagined it to be—Curry had shown the same kind of expressions in his paintings of religious revival meetings among white rural people (e.g., *The Gospel Train*).

52. *Justice Defeating Mob Violence* was Curry's original title for the mural, as noted in a letter from Edward Rowan to Curry dated 15 May 1936, National Archives and Records Service, Record Group 121, Entry 133, box (121)408, file: "John S. Curry—Dept. of Justice Building, Wash., D.C." The panel has also been called *Justice versus Mob Violence* in the *Section of Fine Arts Guide to Murals and Sculpture in Washington, D.C.,* pamphlet published by the Federal Works Agency, Public Buildings Administration, Washington, D.C., n.d., 4 (National Archives and Records Service, Record Group 121, Entry 135, box 203(90), unmarked file). It was called *Law versus Mob Rule* in *Art Guides: Justice Building*, pamphlet published by Art in Federal Buildings, Inc., Washington, D.C., n.d., 17 (Library of the Department of Justice Building, Washington, D.C., call no. ND2638.W3A7). Matthew Baigell refers to the same mural under the title *The Majesty of the Law* in his article, "The Relevancy of Curry's Paintings of Black

Freedom," in *John Steuart Curry: A Retrospective*, 19–29.

53. Lloyd Kirkham Garrison, interview with author, New York City, 22 December 1981. Curry's daughter recalls the close friendship between her father and Lloyd Garrison in "An Interview with Mrs. Daniel Schuster Conducted by Bret Waller," in University of Kansas Museum of Art, *John Steuart Curry: A Retrospective*, 17. Biographical information on Lloyd Garrison may be found in "Lloyd Garrison, Labor Trouble Shooter," *Milwaukee Journal*, 14 January 1946, and "Civil Rights Champion: Lloyd Kirkham Garrison," *New York Times*, 20 April 1963, both in "Garrison" clipping file at the Archives of the University of Wisconsin Memorial Library.

54. Dean Lloyd K. Garrison, "How the Painting Came to Be in the Law Building," typescript, in "John Steuart Curry" file at the Archives of the University of Wisconsin Memorial Library. Curry charged $6,500 for the mural. Mr. Garrison later identified the anonymous donor as Robert Uihlein of Milwaukee, in an interview with the author, 22 December 1981.

55. This incident is recollected by Robert O. Hodgell in an essay for the exhibition catalogue, *John Steuart Curry, 1897–1946*, an exhibition held January 19–February 23, 1973, at the Madison Art Center; a copy is in the Kohler Art Library, Elvehjem Museum of Art, University of Wisconsin.

56. Edward Rowan to Curry, 14 October 1935, National Archives and Records Service, Record Group 121, entry 133, box (121)408, file: "John S. Curry—Dept. of Justice Building, Wash., D.C."

57. My use here of "De Lawd" alludes to the dialect used in Connelly's *Green Pastures*, and to the general stereotyping of black dialect that became a source of much controversy.

58. Cecil Howes, "This Month in Kansas History," *Kansas Teacher* 50, no. 5 (January 1942), 26. The attributes Curry gives Brown to hold are exactly those mentioned in Mechem's aforementioned play. In act 1, scene 1, John Henry Kagi, Brown's first lieutenant, delivers the following lines:

Let not thy right hand spy upon the left!
Within thy right, a Bible for the soul,
Within thy left, a rifle for the soil,
Pray God both profit! (4)

The image also appears in a poem by another native Kansan, Edgar Lee Masters. In *Lee: A Dramatic Poem*, published in 1926, John Brown plays a symbolic role as Lee's tormentor. Ormund, an immortal sage who serves as a choral commentator in the poem, gives the following description of Brown: "One hand of him is gripped around a rifle; He holds the Bible in the other hand." (New York: Macmillan Co., 1926), 70–71.

59. The symbolism was not lost on Curry's audience. Curry received a letter of admiration from a Mr. Van Ault, who had seen the preparatory study for John Brown illustrated in *Life*. Mr. Van Ault wrote that his grandfather, who had been the toll keeper at the Har-

pers Ferry Bridge, had been John Brown's first prisoner at Harpers Ferry. In support of Curry's conception, he wrote that his "Grandfather called him the 'Cyclone of Kansas' "; Van Ault, Van Ault's Arcade, Petersburg, Va., to Curry, 23 December 1939, microfilm roll 164, Curry Papers/AAA.

60. The quote is from Curry, "Article for 1945 Sketch Book of Kappa Pi Honorary Fraternity: The Effect of Drawing on the Finished Painting," 15 November 1944, typescript, microfilm roll 166, Curry Papers/AAA.

61. Carl Sandburg, *Storm over the Land: A Profile of the Civil War* (New York: Harcourt, 1939). Another use appears in *God's Angry Man,* Ehrlich's novel about John Brown:

Darkly on the horizon creep the deep low sounds; louder,
faintly louder; as creep the sullen mutterings of a distant storm.
The voices of grief and revulsion rise, from the North the South from the farthest West in the land of the brothers tragically cloven.
And in the sky there are portents, and signs like flames (344)

62. Quoted in *Topeka Daily Capitol,* 23 May 1942.

63. Matthew Baigell, *The American Scene: American Painting of the 1930s* (New York: Praeger Publishers, 1974), 74; and "Paintings of Black Freedom," 27.

64. Baigell, "Paintings of Black Freedom," 27.

65. The dates of John Brown's trips to Kansas and his places of residence seem to be among the few uncontested facts about his life.

66. The quote is from David Arnold, "Agony and the Artist Unrewarded," *Topeka Capital-Journal,* 31 October 1976, AF/KSHS.

67. The quote is from Lloyd K. Garrison, interview with author, 22 December 1981. Another recollection is given by Curry's assistant, Roger Hodgell, in his essay for the Madison Art Center's Curry exhibition catalogue:

There were also social occasions in the rambling white farmhouse out on Seminole Highway—impressive affairs to the undergrad-apprentice in the corner—deans, college presidents, writers, musicians—managed graciously by Kathleen who spoke of making John a 'spearhead of culture' and born [sic] with a somewhat alcoholic impatience by John who, in spite of his bright-eyed cherubic look always seemed ill at ease behind the inevitable bow tie.

For a social history of prohibition, see Thomas M. Coffey, *The Long Thirst: Prohibition in America, 1920–1933* (New York: W. W. Norton & Co., 1975). Murals commissioner Paul Jones, one recalls, was also "a wet of profound convictions" in a state that was notoriously dry. It was bad enough that *Fortune* had put the banner "Bone Dry" on its map for thirsty travelers along "The Great American Roadside," telling them what to expect when they bellied up to the bar in Kansas. With all the earnest attempts to siphon off tourists to New Mexico with the Coronado campaign, civic boosters in Kansas would be unwise to call attention to the embarrassing

situation of being "Bone Dry." The reputation Curry and his progressive patrons wished for Kansas would not be furthered by a ten-foot figure of Carrie Nation wielding hatchet.

68. Curry's "Speech before the Madison Art Association, January 19, 1937," typescript, microfilm roll 165, Curry Papers/AAA.

69. John Kwiat, "John Reed Club Art Exhibition," *New Masses* (February 1933), 23–24, Gertrude Benton "Art and Social Theories," *Creative Arts* 12, no. 3 (March 1933), 216–18. The cartoonist was Jacob Burck and the connection between Curry and Burck is described in an essay by Edward Laning for *East Side, West Side, All Around the Town* (Tucson: University of Arizona Museum of Art, 1969). Curry praises the work Burck in the essay, "Curry's View: What Should the American Artist Paint?" 29. For details on the controversial antilynching exhibition, see "An Art Exhibit Against Lynching," *Crisis* 42, no. 4 (April 1935), 106; "Protests Bar Show of Art on Lynching," *New York Times,* 12 February 1935.

70. Further information on the antilynching art exhibition may be found in: "Mysterious Protests Bar 'Lynching Show,' " *Art Digest* 9, no. 10 (February 1935), 14; "Art Commentary on Lynching," *Art News* 33, no. 21 (2 February 1935), 13; "To Show Lynching Art," *New York Times,* 13 February 1935; "Lynching as a Japanese Sculptor Sees It," *Christian Century* 52, no. 7 (13 February 1935), 196–97; "Art as a Cure for Lynching," *Christian Century* 52, no. 16 (17 April 1935), 516–17; "Art: Lynching Show Opens in Spite of Opposition 'Outburst,' " *Newsweek* 5, no. 8 (23 February 1935), 19, with illustrations.

A copy of the exhibition catalogue for *An Art Commentary on Lynching,* held at the Arthur U. Newton Galleries, February 15–March 2, 1935, may be found in the "Lynching" folder at the Schomburg Collection, New York Public Library.

For a discussion of the antilynching art exhibition in the larger context of the antilynching reform movement of the 1930s, see Robert Lewis Zangrando, "The Effort of the National Association for the Advancement of Colored People to Secure Passage of a Federal Anti-Lynching Law, 1920–1940" (Ph.D. diss., University of Pennsylvania, 1963), 286–303, and his *NAACP Crusade against Lynching, 1909–1950* (Philadelphia: Temple University Press, 1980), 125–38. The antilynching movement of the 1930s is also treated in some depth in George Brown Tindall, *The Emergence of the New South: 1913–1945* (Baton Rouge: Louisiana State University Press, 1967), 543–606; Jacquelyn Dowd Hall, *Revolt against Chivalry: Jesse Daniel Ames and the Women's Campaign against Lynching* (New York: Columbia University Press, 1979); Harvard Sitkoff, *A New Deal for Blacks: The Emergence of Civil Rights as a National Issue, vol. 1: The Depression Decade* (New York: Oxford University Press, 1978), 268–97. Eleanor Roosevelt's visit to the antilynching art exhibition is discussed in Joseph P. Lash, *Eleanor and Franklin* (New York: W. W. Norton & Co., 1971), 674–75.

Thomas Hart Benton's painting, although illustrated in several of the articles in the art presses, never appeared in the exhibition. Zangrando cites a letter from Benton that states that it was "left out of season in his country cottage, it suffered the effects of inclement weather and a leaky roof, and was damaged beyond repair." (Zangrando, "Anti-Lynching Law," 293 n. 85)

The Bellows lithograph was, by then, quite famous. It had been used on the dustcover and as the frontispiece of Walter White's book on lynching, and an illustration of it appeared in the advertisements for the book; see Walter White, *Rope & Faggot: A Biography of Judge Lynch* (New York: Alfred A. Knopf, 1929), and advertisement in *Crisis* 36, no. 3 (March 1929), 103.

71. The catalogue for the exhibition lists *Manhunt* as on loan from the collection of Arthur B. Springarn; *The Fugitive,* 1933, was on loan from Ferargil Galleries; Benton, Orozco, Marsh, and the late Bellows were the other artists who had painted lynching scenes prior to the planning of the exhibition, as reported in "Art: Lynching Show Opens in Spite of Opposition 'Outburst,' " 19.

72. Baigell, "Paintings of Black Freedom," 21.

73. For a full account of the Scottsboro case, see Dan T. Carter, *Scottsboro: A Tragedy of the American South* (Baton Rouge: Louisiana State University Press, 1969); Curry's interest in the Scottsboro affair is reported in Schmeckebier, *Pageant,* 255.

74. *New York Times,* 19 October 1933, 1:5. For more on the Tuscaloosa lynchings, see Zangrando, *NAACP Crusade against Lynching,* 103.

75. Curry's interest in the San Jose lynching is mentioned by Schmeckebier, *Pageant,* 255. The publicity surrounding the San Jose mob murder is discussed in Zangrando, *NAACP Crusade against Lynching,* 104, and Sitkoff, *New Deal for Blacks,* 280.

76. The quote belongs to Walter White, in Zangrando, "Anti-Lynching Law," 286, 287–88.

77. Stephen Vincent Benét, *John Brown's Body* (New York: Doubleday, Doran & Co., 1928). In 1946, Curry prepared illustrations for a special edition of Benét's *John Brown's Body* published by the Limited Editions Club of New York City. For an account of how the commission came to be, see "The Monthly Letter of the Limited Editions Club," no. 202 (November 1948). 4 pages.

78. My quantitative analysis is taken from table 9 of Joy K. Talbert's doctoral dissertation, "John Brown in American Literature" (University of Kansas, 1941). The table, which appears on page 590, is reproduced below:

Table 9: Periods of Interest (as Revealed by the Number of Selections)

Decade	Poems	Plays	Short Stories	Novels
1859–1869	161	5	1	5
1870–1879	6	0	0	1
1880–1889	17	0	0	7
1890–1899	17	5	0	7
1900–1909	5	2	0	12
1910–1919	16	2	2	2
1920–1929	14	3	1	9
1930–1940	19	14	7	15
	255	31	11	58

79. The quote is from the description of *Battle Hymn* in Morgan Y. Himelstein, *Drama Was a Weapon: The Left-Wing Theatre in New York, 1929–1941* (Westport, Conn.: Greenwood Press, 1976), 93–95. A script of the play may be found in the Federal Theatre Project Records, Institute on the Federal Theatre Project and New Deal Culture, George Mason University, Fairfax, Va.: typescript "Battle Hymn" A Play in Three Acts by Michael Blankfort and Michael Gold, as presented by the Experimental Theatre of the Federal Theatre Project, New York, 1936, Federal Theatre Playscript no. 4 (October 1936).

80. *New York Times,* 23 May 1936, 12:1.

81. Promotion Notes in "Battle Hymn" Production Report, Play Bureau, Federal Theatre Project, Work Projects Administration, prepared by Rus Arnold for the Experimental Theatre, PNB box 9, Federal Theatre Project Records, Institute on the Federal Theatre Project and New Deal Culture, George Mason University, Fairfax, Va.

82. "Transcript of Interview with Michael Blankfort," by Lorraine Brown for the Research Center for the Federal Theatre Project, July 22, 1977, Hollywood, Calif., first tape, side 1, 1–6, Federal Theatre Project Records, Institute on the Federal Theatre Project and New Deal Culture, George Mason University, Fairfax, Va.

83. Quoted in Leslie Albert Wardenaar, "John Brown: The Literary Image" (Ph.D. diss., UCLA, 1974), 325–27.

84. For the role of John Brown in these works, see Talbert, "John Brown in American Literature," 440–42, 582, 613, 662–65, 732; see also Wardenaar, "John Brown: The Literary Image," 336–57.

85. For example, Philip Cornwall, "Decoration Day," *Daily Worker* (28 May 1935); Harry Feld, "Tom Joad," *Daily Worker* (6 May 1940); Beatrice Goldsmith, "The Ballad of John Brown," *Daily Worker* (26 December 1939); Earl Conrad, "I Heard a Black Man Sing," *Daily Worker* (29 May 1941); Earl Conrad, "The Growth of the Great John Henry," *Daily Worker* (30 June 1941).

86. Wardenaar, "John Brown: The Literary Image," 336; Talbert, "John Brown in American Literature," 441–42. The Rukeyser poem is reprinted in *Social Poetry of the 1930s,* edited by Jack Salzman and Leo Zanderer (New York: Burt Franklin & Co., 1978), 252–59.

87. The analysis of Rukeyser's difficult Imagist poem is taken from Wardenaar's lengthy explication, in

"John Brown: The Literary Image," 348–57; see also Talbert, "John Brown in American Literature," 440–43.

Muriel Rukeyser, "The Soul and Body of John Brown," *Poetry: A Magazine of Verse* 56, no. 3 (June 1940), 115–20. The chapter reference in the published Rukeyser poem (Joel 4:14) is an error—the quotation is from Joel 3:14.

88. Muriel Rukeyser, New York City, to Curry, Madison, Wis., February 1940, with enclosure, "The Soul and Body of John Brown," typescript, 6 pages, microfilm roll 168, frame 0611, Curry Papers/AAA.

89. See "John Curry: He Paints at Wisconsin as Artist-in-Residence," *Life* 7, no. 26 (25 December 1939), 34–37. Full-page reproduction faces 34.

90. Rukeyser, "Soul and Body of John Brown," 115.

91. "Excerpts from John Steuart Curry letters by Mildred Curry Fike, October 1972," typescript, box 1 of 1 (November 1975), Curry Papers/AAA.

92. Schmeckebier reports that Curry had read and was stimulated by Alfred Noyes's antiwar poem, *Victory Ball.*

93. Raymond Nelson, *Van Wyck Brooks: A Writer's Life* (New York: E. P. Dutton, 1981), 219. See also my chapter 3, note 11.

94. The oil sketch is currently in the collection of the Madison Art Center.

95. Isabel B. La Follette, "A Room of Our Own," *Progressive* (21 October 1946), 11. Curry's wife verifies that he was an avid reader of La Follette's paper in "Interview with Mrs. John Steuart Curry," 6.

96. For Philip La Follette's isolationist views and the activities of the America First Committee, see *Adventure in Politics: The Memoirs of Philip La Follette,* edited by Donald Young (New York: Holt, Rinehart and Winston, 1970), 257–70; also, Patrick J. Maney, *"Young Bob" La Follette: A Biography of Robert M. La Follette, Jr., 1895–1953* (Columbia: University of Missouri Press, 1978), 203–9, 243–50.

97. "Speech before the Madison Art Association."

98. Curry to Henry Allen, 25 April 1938, microfilm roll 165, Curry Papers/AAA. Curry sailed June 18 to Paris, and went also to Rome, June 23; to Florence, July 1; and to Amsterdam via Munich, July 15. See Curry to Chris Christensen, 3 June [1938], microfilm roll 167, Curry Papers/AAA.

99. "Interview with Mrs. Daniel Schuster," 16.

100. Hadley Cantril, ed., *Public Opinion 1935–1946* (Princeton: Princeton University Press, 1951), 971.

101. Senator Capper's opposition to lend-lease is discussed in Davis, *Kansas,* 196–97. Curry to Arthur Capper, U.S. Senate, 17 December 1940, microfilm roll 165, Curry Papers/AAA.

102. Curry as quoted in "Wisconsin's Artist in Residence," *Milwaukee Journal,* 10 January 1937.

103. Curry to Mrs. Kate M. Pearson, Hartford, Conn., 4 September 1941, microfilm roll 165, Curry Papers/AAA.

104. Driscoll, "Why Men Leave Kansas," 175–78.

105. Driscoll, "Why Men Leave Kansas," 178.

106. Both quotes are from Curry's letter to Rev. A.

H. Christensen, 12 January 1940, microfilm roll 165, Curry Papers/AAA.

107. My discussion of the historiography of the causation of the Civil War draws heavily on an invaluable treatment of the subject by Thomas J. Pressly, *Americans Interpret Their Civil War* (New York: Free Press, 1965), 149–221.

108. The phrase has become a catchword for this point of view; it was the title of a volume in the "nationalist tradition" by a member of the second generation of trained historians: Arthur Charles Cole, *The Irrepressible Conflict 1850–1865* (New York, 1934), discussed in Pressly, *Americans Interpret Their Civil War,* 224–26.

109. George Fort Milton, *The Eve of Conflict: Stephen A. Douglas and the Needless War* (Cambridge: Riverside Press, 1934).

110. Avery Craven, *The Repressible Conflict, 1830–1861* (Baton Rouge: University of Louisiana Press, 1939).

111. Avery Craven, "Coming of the War between the States: An Interpretation," *Journal of Southern History* (August 1936), quoted in Pressly, *Americans Interpret Their Civil War,* 313.

112. Avery Craven, quoted in Pressly, *Americans Interpret Their Civil War,* 314–15.

113. Curry to Christensen, 12 January 1940.

114. Curry to Miss Doris Fleeson, *New York Daily News,* Washington, D.C., 31 May 1941, microfilm roll 164, Curry Papers/AAA.

115. "Description of Murals for Kansas State Capitol."

116. Kenneth Porter, "To the Jayhawkers of the International Brigade," *Kansas Magazine,* 1939, 97. J. C. Furnas writes, "Then and now the Spanish Civil War is called 'dress rehearsal' for World War II," and he discusses the reactions of American pacifists and isolationists to the Loyalist cause in *Stormy Weather: Crosslights on the Nineteen Thirties* (New York: G. P. Putnam's Sons, 1977), 539–60.

Chapter 5

1. F. B. Sanborn quoted in J. C. Furnas, *The Road to Harpers Ferry* (New York: W. Sloane Associates, 1959), 372.

2. Curry's reference to Alpha and Omega is taken from the Revelation of Saint John the Divine, King James Version, 1:8; also, 1:11, 21:6, 22:13. For the other five scriptural passages see Richard Forrey, Rockhurst College, Kansas City, Mo., to Curry, 24 June 1940, microfilm roll 165, Curry Papers/AAA.

3. Vachel Lindsay, "John Brown," in *Collected Poems,* rev. ed. (New York: Macmillan Co., 1925), 164–66. For more on apocalyptic interpretations of the Civil War, see Moorhead, *American Apocalypse.*

4. Curry had just backed out of an agreement to illustrate a limited edition of Dante's *Inferno* because he could not relate to the subject matter. He wrote to Abrams with his own short list of books he would most like to illustrate. Lindsay's poetry was among the first

titles he mentioned; see Curry to Harry Abrams, Book-of-the-Month Club, 30 June 1943, microfilm roll 166, Curry Papers/AAA. Abrams eventually offered Curry a commission to illustrate *My Friend Flicka* and *Thunderhead* (not on Curry's list of requests), which he did, but he never got the chance to illustrate Lindsay's book of collected poems.

5. Vachel Lindsay's strict religious upbringing in the Campbellite faith and its influence on his poetry is discussed in Ann Massa, *Vachel Lindsay: Fieldworker for the American Dream* (Bloomington: Indiana University Press, 1970, especially 6–7, 49–67.

6. Curry to Margit Varga, 28 February 1942.

7. Curry, as quoted in Thomas Craven, "Religious Artist of the Kansas Prairie," *New York Herald Tribune,* 21 November 1943, VI, 5.

8. Curry to Mary Wickerham, 23 July 1945, microfilm roll 164, Curry Papers/AAA.

9. A number of these sketches and another oil painting, *Prayer for Grace,* are illustrated in Schmeckebier, *Pageant,* 100, figs. 50–56. A lithograph based on *The Gospel Train* is illustrated in Ann C. Madonia, *Prairie Visions and Circus Wonders: The Complete Lithographic Suite by John Steuart Curry* (Davenport, Iowa: Davenport Art Gallery, 1980), fig. 18.

10. My brackets; the college to which she refers is Geneva College in Beaver Falls, Pennsylvania. The quote is from "Excerpts from John Steuart Curry Letters by Mildred Curry Fike, October 1972," typescript, box 1 of 1, acq. 11/75, Curry Papers/AAA.

11. Mrs. Smith Curry to "Dear Children," undated, microfilm roll 164, Curry Papers/AAA.

12. Arnold, "Agony and the Artist Unrewarded."

13. "Who Are the Covenanters?" in the pamphlet, "Semi-Centennial of the Reformed Presbyterian Church of Winchester, Kansas," edited by Delber H. Elliott, present pastor, 8 September 1918, in the Library of the Kansas Historical Society.

14. *Sanctuary* was illustrated in "Curry of Kansas," 30. The caption alongside the photograph emphasized "the intemperate Kansas weather as the Kaw River, near the elder Curry's home, floods."

15. Curry, "Speech before the Madison Art Association."

16. Curry also made an oil painting entitled "The Mississippi" in 1935 (based on the design of his lithograph) that is currently in the collection of the St. Louis Art Museum; for the Currier & Ives print see *'High Water' in the Mississippi,* lithograph, 1868, reproduced in H.T. Peters, *Currier & Ives: Printmakers to the American People* (Garden City, N.Y., 1942), plate 34.

17. Craven, "Religious Artist of the Kansas Prairie."

18. Typescript of lecture notes on forty-eight slides for use in public lectures; slide 16, Bennozo Gozzoli, *The Shame of Noah,* 1485, microfilm roll 168, Curry Papers/AAA.

19. Typescript of lecture notes, slide 18, Albrecht Dürer, *The Return of the Prodigal Son,* 1495.

20. Thomas Craven, "Art and Propaganda," *Scribner's* 95, no. 3 (March 1934), 189–94.

21. Curry as quoted in James S. McDermott, "Critics May Muff Raves on Paintings," *Topeka Journal,* 27 June 1939, AF/KSHS.

22. Ernest R. Sandeen, *The Roots of Fundamentalism: British and American Millenarianism, 1800–1930,* (Chicago: University of Chicago Press, 1970), 39.

23. See William H. Goetzmann, "Time's American Adventures: American Historians and Their Writing Since 1776," *American Studies International* 19, no. 2 (Winter 1981), 5–47; especially 5–9.

24. Sandeen, *Roots of Fundamentalism,* 5–7.

25. Sandeen, *Roots of Fundamentalism,* 6.

26. Sandeen, *Roots of Fundamentalism,* 6 n. 5.

27. Edward King, *Remarks on the Signs of the Times* (London, 1798), as quoted in Sandeen, *Roots of Fundamentalism,* 7. For more on the historical interpretation of the 1,260 days, see Tuveson, *Redeemer Nation,* 1–25. For an extended account of the prophetic Protestant response to the French Revolution in America, see Nathan O. Hatch, *The Sacred Cause of Liberty: Republican Thought and the Millennium in Revolutionary New England* (New Haven: Yale University Press, 1977).

28. Sandeen, *Roots of Fundamentalism,* 7–8.

29. See, for example, Sandeen, *Roots of Fundamentalism,* 7–41; also, George M. Marsden, *Fundamentalism and American Culture: The Shaping of Twentieth-Century Evangelicalism: 1870–1925* (New York: Oxford University Press, 1980).

30. Mary Wickerham, Chicago, to Curry, 18 July 1945, microfilm roll 164, Curry Papers/AAA.

31. Curry to Mary Wickerham, 23 July 1945. The interest of Scots Presbyterians in biblical prophetic studies of world political events is noted by Sandeen, *Roots of Fundamentalism,* 8–9.

32. Biographical information on the Reverend David Coulter may be found in "Semi-Centennial of the Reformed Presbyterian Church of Winchester, Kansas."

33. A recent study of the apocalyptic interpretation of the Civil War, and one that includes mention of earlier bibliographic sources, is Moorhead, *American Apocalypse.* For a discussion of the social context of apocalyptic views of history, see Charles H. Lippy, "Waiting for the End: The Social Context of American Apocalyptic Religion," 37–63, and other essays in *The Apocalyptic Vision in America: Interdisciplinary Essays on Myth and Culture,* edited by Lois Parkinson Zamora (Bowling Green, Ohio: Bowling Green University Popular Press, 1982). For the resurgence of premillennialist apocalypticism at the eve of World War I, see Marsden, *Fundamentalism,* especially chapter 16, "World War I, Premillennialism, and American Fundamentalism: 1917–1918," 141–53. Sandeen, in *Roots of Fundamentalism,* also notes that the twenty years before World War I saw millenarianists at their peak of national influence (226).

34. Marsden, *Fundamentalism,* 141–44.

35. Schmeckebier, *Pageant,* 12–13.

36. Curry to Mrs. Smith Curry, 12 February 1917, folder 19, "Letters 1917, John Steuart Curry to family," box 1 of 1, 11/75, Curry Papers/AAA.

37. Curry to Mr. and Mrs. Smith Curry, 12 March 1917, from "Excerpts from John Steuart Curry Letters by Mildred Curry Fike, October 1972," typescript, box 1 of 1, acq. 11/75, folder 19, "Letters 1917, John Steuart Curry to family," Curry Papers/AAA.

38. Marsden, *Fundamentalism*, 141–53.

39. Curry to Mrs. Smith Curry, 12 February 1917, Curry Papers/AAA.

40. Craven, "Religious Artist of the Kansas Prairie."

41. For a discussion of apocalyptic imagery in the "Battle Hymn," see Tuveson, *Redeemer Nation*, 196–202.

42. Moorhead, *American Apocalypse*, x.

43. A more complete analysis of the premillennialist position may be found in Sandeen, *Roots of Fundamentalism;* also Lippy, "Waiting for the End," 54–58.

44. Lippy draws the distinction between pre- and post-millennialists in "Waiting for the End," especially 52; also, Tuveson, *Redeemer Nation*, 232–33. For more on the Social Gospel in the period under question, see Henry F. May, *Protestant Churches and Industrial America* (New York: Harper & Brothers, 1949), and Paul A. Carter, *The Decline and Revival of the Social Gospel* (Ithaca, N.Y.: Cornell University Press, 1954).

45. Winrod is characterized as a "militant premillennialist" in Sydney E. Ahlstrom, *A Religious History of the American People*, vol. 2 (Garden City, N.Y.: Image Books, Doubleday & Co., 1975), 418. A pro-Nazi fascist, Winrod ran for a Kansas seat in the U.S. Senate in 1938, and attracted a sizable following; see Davis, *Kansas*, 185, and the coverage of Winrod in "The Kansas Isms," *Newsweek* (26 September 1938), 11.

46. Curry to Henry Allen, 25 April 1938. Curry sailed June 18 to Paris, went to Rome June 23, to Florence July 1, and to Amsterdam via Munich July 15; see Curry to Christensen, 3 June [1938].

47. Ellen Glasgow to Mrs. Howard Mumford Jones, 27 September 1938, quoted in William E. Leuchtenburg, *Franklin D. Roosevelt and the New Deal* (New York: Harper & Row, 1963), 285 n. 34.

48. Curry returned in September and did not begin the character sketches for Brown until December 1938; Curry to Reeves Lewenthal, New York City, 6 July 1943, microfilm roll 165, Curry Papers/AAA. For the detailed studies of John Brown, Curry also relied on historical photographs of Brown; Curry to Allen, 26 September 1939. For his live model, he used a young agricultural economics student at the University of Wisconsin named Irving Doudna (called "Dopey Doudna" according to Curry, who chose the young student because he found "his head structure . . . to be similar to that of John Brown,") typescript, "John Brown, a Detail Study for the Kansas State Capitol mural, oil on canvas, 45″ × 69″," microfilm roll 165, Curry Papers/AAA. A red chalk sketch of Brown, illustrated on the April 1941 cover of *Dem-courier Magazine*, is currently in the collection of Dr. and Mrs. H. Kent Tenney of Madison, Wis., who kindly allowed me to view it in their home.

49. Curry to Mrs. Wilbur (Beth) O'Neill, Winchester, Kans., 15 April 1941, microfilm roll 165, Curry Papers/

AAA. The slave mother and child, which Curry added to the murals shortly before installing them, is probably a late concession to the famed Whittier legend.

50. The reference is, of course, to Francis Ford Coppola's film. Norman Cohn, in his important work, *The Pursuit of the Millennium*, rev. ed. (New York: Oxford University Press, 1970), convincingly argues that interest in apocalyptic and millennial ideas correlates directly with periods of social instability or transition such as economic depression, class conflict, or war. The same point is argued by Tuveson (*Redeemer Nation*, 199), who singles out the expansionist era, the Civil War, and World War I as times of particularly high interest in apocalyptic interpretations of political events. See also the views of social scientist Michael Barkun in *Disaster and the Millennium* (New Haven: Yale University Press, 1974). John Steuart Curry was creating his murals for Kansas at the eve of World War II, another onerous period in America's history, and it should come as no surprise that a man of his intense religious background should entertain apocalyptic notions in his history paintings. The fact that certain prophecies about World War I failed to materialize in the Second Coming of Christ had left most fundamentalists undaunted, and similar prophecies resurfaced at the eve of World War II. A group of social psychologists have studied the cognitive processes that permit such disappointed believers to go on believing when their doomsday date passes without incident; see Leon Festinger, Henry W. Riecken, and Stanley Schachter, *When Prophecy Fails: A Social and Psychological Study of a Modern Group that Predicted the Destruction of the World* (Minneapolis: University of Minnesota Press, 1956).

51. "Description of Murals for Kansas State Capitol."

52. See, for example, Joseph S. Czestochowski, "John Steuart Curry's Lithographs: A Portrait of Rural America," *American Art Journal* 9, no. 2 (November 1977), 68–82.

53. W. F. Zornow, *Kansas: A History of the Jayhawk State* (Norman: University of Oklahoma Press, 1957), 256. For an overview of agricultural conditions during the depression, see *Agriculture in the United States: A Documentary History, v. 3: War, Depression, and the New Deal, 1914–1940*, edited by W. D. Rasmussen (New York, 1973), especially 2062–2907. The discussion of *Kansas Pastoral* that follows has been presented in a similar form by M. Sue Kendall, "John Steuart Curry's *Kansas Pastoral:* The Modern American Family on the Middle Border," in Czestochowski, *John Steuart Curry and Grant Wood*, 36–41.

54. Telegram, Chris Christensen to Curry, 16 September 1936, microfilm roll 168; Maynard Walker to Porter Butts, Wisconsin Union, University of Wisconsin, 13 April 1936, microfilm roll 167, Curry Papers/AAA.

55. For the events surrounding the creation of the new position and a description of Curry's responsibilities, see "Resident Artist," 22–24. The *Proceedings* of the American Country Life Association and its organ, *Rural America*, contain the terms of debate regarding farmers

and rural problems. Of special interest is the 1939 presidential address to the American Country Life Association delivered by Chris L. Christensen, in *Rural America,* September 1939, 3–7. See also Merwin Robert Swanson, "The American Country Life Movement, 1900–1940," (Ph.D. diss., University of Minnesota, 1972). The cultural conflicts inherent in urban attempts to produce rural reforms are discussed in Don S. Kirschner, *City and Country: Rural Responses to Urbanization in the 1920s* (Westport, Conn.: Greenwood Pub. Corp., 1970), and in David B. Danbom, *The Resisted Revolution: Urban America and the Industrialization of Agriculture, 1900–1930* (Ames: Iowa State University Press, 1979).

56. "Impatient to Feel Spring and the State's Soil, Curry Comes to Campus," *Wisconsin State Journal* 1 (4 December 1936), 16.

57. Eugene Curry to John Steuart Curry, 30 January 1938, microfilm roll 164, Curry Papers/AAA.

58. The artist's father, Smith Curry, is quoted in Craven, "John Steuart Curry," 37.

59. For more on the mural for the Department of Interior, see Schmeckebier, *Pageant,* 308–11.

60. Chief among those who argued along these lines were sociologists William Ogburn and Ernest Groves; for an analysis of the sociological writings on the family in this period, see Paula Fass, *The Damned and the Beautiful* (New York, 1977), especially chapter 2; also Christopher Lasch, *Haven in a Heartless World* (New York, 1977), especially chapter 2. The quote is taken from the President's Research Committee on Social Trends, *Recent Social Trends in the United States* (New York, 1933), vol. 1, xlii.

61. The phrase "from institution to companionship" belongs to sociologist Ernest W. Burgess; see Lasch's discussion in *Haven,* 31–33. The quote is from the President's Research Committee on Social Trends, *American Civilization Today: A Summary of Recent Social Trends,* edited by John T. Greenan (New York, 1934), 72. See also John Dollard, *The Changing Functions of the American Family, 1900–1930* (Chicago: University of Chicago Press, 1931).

62. Chris L. Christensen, "Will He Want to Stay Home?" *Successful Farming* (April 1944), 10–11.

63. White House Conference on Child Health and Protection, *The Adolescent in the Family,* edited by Ernest Burgess (New York, 1934); and *The Young Child in the Home,* Chair John B. Anderson (New York, 1936). These findings are discussed at length in Fass, *Damned and the Beautiful,* 88–114.

64. Both quotes from "Description of Murals for Kansas State Capitol," 3.

65. Curry's tours with Dean Christensen to the soil erosion projects are documented in a letter from Christensen to Curry dated 3 April 1937, microfilm roll 168, Curry Papers/AAA.

66. See, for example, Donald Worster's discussion of conservationist ideology during the 1930s in *Nature's Economy: The Roots of Ecology* (San Francisco, Sierra Club Books, 1977), 233–52. I am grateful to William H. Goetzmann for calling this important book to my atten-

tion. This indictment of midwestern farmers is also the theme of the Resettlement Administration's documentary film directed by Pare Lorentz, *The Plow That Broke the Plains,* of 1936.

67. The phrase belongs to Henry A. Wallace, "Rural Poverty: Remarks at the General Assembly of the Council of State Governments," 23 January 1937, U.S. Dept. of Agriculture Press Release 1060–37, in Rasmussen, *Agriculture in the United States,* 2845–53. Wallace's views on the gradual development of soil erosion due to farmers' abuse of the land is also presented in this press release.

68. See Zornow, *Kansas: A History,* 276; F. W. Schruben, *Kansas in Turmoil: 1930–1936* (Columbia: University of Missouri Press, 1969), 47–65.

Chapter 6

1. "Description of Murals for Kansas State Capitol," 3.

2. Eugene Curry to John Steuart Curry, 30 January 1938; also letter to Curry from his mother, 7 May 1938, microfilm roll 164, Curry Papers/AAA, from which the following passage is taken: "We will probably get rid of most of our hogs this week. When we got the pigs prices were 10.75 and now when we are selling they are 7.65 or such. What luck the farmer has." See also "AAA Dilemma: Tobogganing Prices Spread Discontent in Wheat Bowl," *Newsweek* 25 July 1938, 33.

3. "Description of Murals for Kansas State Capitol," 3.

4. "Speech before the Madison Art Association."

5. From "John Steuart Curry: 'He puts farm life on canvas,' An interview by Blanche Overlien (given during the Homemaker's Hour on Wisconsin State Stations, W-H-A and W-L-B-L)," typescript, radio circular of the Extension Service of the College of Agriculture, University of Wisconsin, July 1937, copy in the Archives of the University of Wisconsin.

6. Reported in "J. Steuart Curry Planning to Paint in Arizona Desert," unidentified newspaper clipping, "John Steuart Curry," "Name file," Iconographic Collection, Wisconsin State Historical Society, Madison, Wis.

7. Anita Zentner, Soil Conservation Service, USDA, Milwaukee, to Curry, n.d., and reply of Curry to Anita Zenter, 10 June 1946, microfilm roll 164, Curry Papers/AAA. The quote is from W. C. Lowdermilk, "Conquest of the Land through 7,000 Years," Agriculture Information Bulletin No. 99, U.S. Department of Agriculture, Soil Conservation Service (Washington, D.C., Issued Aug. 1953, reprinted 1978).

8. Quoted in Worster, *Nature's Economy,* 231.

9. Robert L. Snyder, *Pare Lorentz and the Documentary Film* (Norman: University of Oklahoma Press, 1968), 36–37.

10. "Plow Not to Blame for Dust Storms Say Old-Time Western Kansans," *Kansas City Star,* 9 March 1936, D18; see also Roy V. Scott, *The Reluctant Farmer* (Urbana: University of Illinois Press, 1970).

11. "Description of Murals for Kansas State Capitol," 3.

12. Untitled newspaper articles written by Jessie Hodges, n.d., in AF/KSHS, 18 verso.

13. For more on the twentieth-century revival of the Klan, with special relevance to Kansas, see Lila Lee Jones, "The Ku Klux Klan in Eastern Kansas during the 1920's," *Emporia State Research Studies* 23, no. 3 (Winter 1975), 5–41.

14. White is called "Kansas keeper of the nation's conscience" in Jones, "The Ku Klux Klan in Eastern Kansas during the 1920's," 19. See also, "William Allen White's War on the Klan," *Literary Digest* 83, no. 2 (11 October 1924), 16; White, *Autobiography,* 631; on the Klan and the election of 1924, see F. W. Schruben, *Kansas in Turmoil: 1930–1936.* (Columbia, Mo.: University of Missouri Press, 1969), 180–89. Governor Allen in 1922 had waged his own war on the Klan; see "Why Kansas Bans the Klan," *Literary Digest* 75, no. 6 (11 November 1922), 13. Both White and Allen were later instrumental in sponsoring the Curry murals.

15. Genevieve Yost, "History of Lynchings in Kansas," *Kansas Historical Quarterly* 2, no. 2 (May 1933), 182–219.

16. "The Ku Klux Klan Goes 'Ko-ed'," *Kansas City Star,* 15 August 1937.

17. Lloyd Garrison to Curry, 22 May 1940, microfilm roll 166, Curry Papers/AAA.

18. Thomas Craven to Curry, 7 February [1939], microfilm roll 166, Curry Papers/AAA.

19. Oliver Larkin, *Art and Life in America,* rev. ed. (New York: Holt, Rinehart and Winston, 1966), 429.

20. "Argue on Curry," *Topeka State Journal,* 19 November 1937, AF/KSHS; "Curry's Bull Gets Off to Bad Start," unidentified newspaper clipping, Curry Scrapbook 1935–39, BV 2-13-79, Curry Papers/AAA. To appease the barnyard critics, Curry sent his assistant, J. T. Mathieson, on a research expedition to Shawnee County, Kansas in May of 1940 to gather data on the correct grazing stance of purebred bulls.

21. William Allen White to Don Anderson, 2 June 1942, microfilm roll 168, Curry Papers/AAA.

22. The "two million . . . part owners" is noted in "The Curry Murals Produce Material for a Controversy," *Kansas City Star,* 21 April 1939. The block quote is from A. L. Shultz, "Murals Annoy Barn Painters," *Topeka Journal,* 15 April 1939, AF/KSHS.

23. See "Artist Curry Is Putting a Curl in the Pigs' Tails," *Topeka Capital,* 18 May 1940; "Artist Curry Brushes Up on Subject of Pigtail Kinks," *Topeka Capital,* 3 September 1940, "Curry's Murals Attract Comment and Criticism From Kansas Farm Folks," *Abilene Daily Reflector,* 3 June 1940.

24. Jessie Benton, "Great Figure of John Brown Dominates Controversy over Paintings of Kansan," *Kansas City Times,* 23 August 1947, AF/KSHS.

25. A. H. Christensen, minister, Methodist Church, Netawaka and Wetmore, Kans., to Curry, 10 January 1940, microfilm roll 165, Curry Papers/AAA. Christensen refers to a preliminary study of Brown for the Kansas mural that appeared as a full-page color reproduction in the December 25, 1939 issue of *Life.* The caption called attention to the symbolic "Kansas twister" on the horizon and to Curry's portrayal of Brown's "messianic fervor." The painting was shown at the Whitney Museum and then shipped to San Francisco for exhibition at the Golden Gate International Exposition in 1940.

26. Quoted in "Kansas Senators Take Potshots at Curry Murals in Statehouse," *Kansas City Times,* 1 April 1941, AF/KSHS.

27. "Kansas Senators Take Potshots."

28. "John Brown and John Curry Both in Bad with Legislature—They Dislike Bull, Too," *Topeka State Journal,* 31 March 1941, AF/KSHS.

29. "Can't Leave John Out," *Ft. Scott Tribune* (Kans.), 14 May 1941, AF/KSHS.

30. John P. Harris to Curry, 4 May 1937, microfilm roll 166, Curry Papers/AAA.

31. William Allen White to Gov. Payne Ratner, quoted in Robert Townsend, "The John Steuart Curry Murals," *Topeka Capital,* 11 February 1951, AF/KSHS.

32. "Marble Blocks Artist Curry's Kansas Murals," *Topeka Capital,* 29 June 1941, AF/KSHS.

33. Quoted in "John Brown and John Curry Both in Bad with Legislature."

34. The plans to remove the marble to make room for the murals in the Rotunda is reported, among other places, in "Iron in Kansas People Must Be Portrayed." See Leslie Edmonds, State Highway Dept., Kans., to Reeves Lewenthal, New York, 14 August 1940, microfilm roll 165, Curry Papers/AAA, which says, "The members of the Executive Council besides the Governor are independently elected. . . . They have not gotten over their fears of possible political reprisals in the event the marble is removed."

35. Curry's preliminary drawings (see fig. 54) had been made to the exact proportions of the final mural, on a scale of two inches to the foot. Grid lines were then superimposed on the drawings as they were photographed, and lantern slides were made. On May 18, 1940, Curry began to sketch directly on the walls of the Statehouse using these lantern slides projected from a stereopticon. He did most of his sketching at night because the image would not appear in daylight. Because of the narrowness of the East Corridor, Curry had to mount the stereopticon in the elevator across the hall from the John Brown segment. Even then, the figure of John Brown alone had to be put on eight different lantern slides for projection. Curry's rather innovative approach to mural making was featured in the October 1940 issue of *American Artist.*

36. This timetable is reported in the *Topeka Journal,* 24 September 1940, AF/KSHS.

37. "Marble Blocks Artist Curry's Kansas Murals."

38. Quoted in "John Steuart Curry Murals."

39. The quote is from "Marble Blocks Artist Curry's Kansas Murals."

40. That Curry's backers referred to it as "bathroom marble" is mentioned in "$50,000 for Coyotes, Naught for Murals," *Topeka Journal,* 1 March 1943, AF/KSHS.

41. The quote is from Roy L. Matson in the *Wisconsin State Journal,* reprinted in "Wisconsin Feels Hurt over Way Kansas Officials Kicked Curry's Murals Around," *Topeka Capital,* 31 May 1942, AF/KSHS.

42. Clarence W. Miller, secretary of state, to Curry, 2 April 1941.

43. "Why Is a Mural?" *Kansas City Star,* 9 June 1941, AF/KSHS.

44. In 1976, the Kansas legislature commissioned another native Kansan, Lumen Martin Winter, to create murals for the Rotunda. The marble panels of the Curry controversy are still in situ, and Winter's murals are made on a smaller scale to conform to the restricted space. The themes for the eight new panels in the Rotunda are sufficiently innocuous to avoid controversy. Winter's panels are devoted to Col. John C. Fremont, the Sacking of Lawrence, Threshing, Sowing, Commerce, Well Digging, Education, and the Governor's Mansion.

45. Quoted in "Curry Will Not Sign Kansas Murals," *Topeka Capital,* 24 May 1942, AF/KSHS.

46. Sam Nook to Curry, 27 October 1941, microfilm roll 166, Curry Papers/AAA.

47. "Page Boys in Mock Session Vote $1.15 to Finish Murals," *Topeka Capital,* 4 March 1943.

48. "Interview with Mrs. John Steuart Curry," 10.

49. "Kansas' Famed John Steuart Curry Is Dead," *Topeka Daily Capital,* 30 August 1946, AF/KSHS.

50. "John Steuart Curry Buried at Winchester in Community Typical of Kansas He Loved," *Topeka Capital,* 2 September 1946, AF/KSHS.

A Note on Sources

The papers of John Steuart Curry, including a collection of over four thousand items, are currently located at the Archives of American Art, Smithsonian Institution, Washington, D.C. A great bulk of the material has been microfilmed, although much of it is under restricted classification.

Since the Curry murals were sponsored by Kansas newspaper editors, there is more than average coverage of the whole Curry affair in the local presses. The Library of the Kansas State Historical Society has compiled a weighty clipping file of local newspaper coverage of Curry's activities in Kansas, a tool that was invaluable to my own research.

Mary Scholz Guedon has compiled an annotated bibliography on the Midwestern Triumvirate entitled *Regionalist Art: Thomas Hart Benton, John Steuart Curry, and Grant Wood: A Guide to the Literature* (Metuchen, N.J.: Scarecrow Press, 1982). While it does not include the most recent writings of Regionalist scholars cited in my notes, Ms. Guedon's guide will nevertheless be quite useful to anyone interested in pursuing the topic further.

Selected Bibliography

Books

Belasco, Warren James. *Americans on the Road: From Autocamp to Motel, 1910–1945.* Cambridge: MIT Press, 1979.

Benét, Stephen Vincent. *John Brown's Body.* New York: Doubleday, Doran & Co., 1928.

Benton, Thomas Hart. *An American in Art: A Professional and Technical Autobiography.* Lawrence: University Press of Kansas, 1969.

————. *An Artist in America.* New York: Robert M. McBride & Co., 1937; New York: University of Kansas City Press—Twayne Pub., 1951.

Corn, Wanda M. *Grant Wood: The Regionalist Vision.* New Haven: Yale University Press, 1983.

Danbom, David B. *The Resisted Revolution: Urban America and the Industrialization of Agriculture, 1900–1930.* Ames: Iowa State University Press, 1979.

Dennis, James M. *Grant Wood: A Study in American Art and Culture.* New York: Viking Press, 1975.

Fass, Paula S. *The Damned and the Beautiful.* New York: Oxford University Press, 1977.

"History of Coronado Celebrations." In *Coronado's Seven Cities,* edited by George P. Hammond, 77–82. Albuquerque, N. Mex.: United States Coronado Exposition Commission, 1940.

Jones, Paul A. *Coronado and Quivira.* Lyons, Kans.: Lyons Publishing Co., 1937.

Kirschner, Don S. *City and Country: Rural Responses to Urbanization in the 1920s.* Westport, Conn.: Greenwood Pub. Corp., 1970.

University of Kansas Museum of Art. *John Steuart Curry: A Retrospective Exhibition of His Work Held in the Kansas State Capitol, Topeka, October 3–November 3, 1970.* Lawrence: University of Kansas Museum of Art, 1970.

Madonia, Ann C. *Prairie Visions and Circus Wonders: The Complete Lithographic Suite by John Steuart Curry.* Davenport, Iowa: Davenport Art Gallery, 1980.

Marling, Karal Ann. *Wall-to-Wall America: A Cultural History of Post Office Murals in the Great Depression.* Minneapolis: University of Minnesota Press, 1982.

————. *Tom Benton and His Drawings.* Columbia: University of Missouri Press, 1985.

Moorhead, James H. *American Apocalypse: Yankee Protestants and the Civil War, 1860–1869.* New Haven: Yale University Press, 1978.

Oates, Stephen B. *To Purge This Land with Blood: A Biography of John Brown.* New York: Harper & Row, 1970.

Pressly, Thomas J. *Americans Interpret Their Civil War.* New York: Free Press, 1965.

Ruchames, Louis, ed. *A John Brown Reader.* London: Abelard-Schuman, 1959.

Sandeen, Ernest R. *The Roots of Fundamentalism: British and American Millenarianism, 1800–1930.* Chicago: University of Chicago Press, 1970.

Schmeckebier, Laurence E. *John Steuart Curry's Pageant of America.* New York: American Artists Group, 1943.

Schruben, F. W. *Kansas in Turmoil: 1930–1936.* Columbia: University of Missouri Press, 1969.

Worster, Donald. *Nature's Economy: The Roots of Ecology.* San Francisco: Sierra Club Books, 1977.

Zamora, Lois Parkinson, ed. *The Apocalyptic Vision in America: Interdisciplinary Essays on Myth and Culture.* Bowling Green, Ohio: Bowling Green University Popular Press, 1982.

Articles

"An Art Exhibit Against Lynching." *Crisis* 42, no. 4 (April 1935): 106.

"Art: Manhattan, Kan., Takes 'Plunge' on Curry's Painting." *Newsweek,* 16 February 1935, 24–25.

Bailey, Roy F. " 'To the Stars Through Difficulties': Accomplishments of Kansas Shown by Historical Markers," *Kansas Teacher* 50, no. 9 (May 1942): 28.

Brooks, Van Wyck. "On Creating a Usable Past." *Dial* 64 (11 April 1918): 339, 341.

Corn, Wanda. "The Birth of a National Icon: Grant Wood's *American Gothic.*" In *Art the Ape of Nature: Studies in Honor of H. W. Janson,* edited by Moshe Barasch and Lucy Freeman Sandler, 749–69. New York: Harry N. Abrams; Englewood Cliffs, N.J.: Prentice-Hall, 1981.

Craven, Thomas. "Art and Propaganda." *Scribner's* 95, no. 3 (March 1934): 189–94.

———. "Kansas Refuses Curry." *Kansas Magazine,* 1937, 85–87.

———. "John Steuart Curry." *Scribner's* 103, no. 1 (January 1938): 40.

"Curry of Kansas." *Life,* 23 November 1936, 28–31.

Curry, John Steuart. "What Should the American Artist Paint?" *Art Digest* (September 1935): 29.

Davis, Kenneth S. "That Strange State of Mind Called Kansas." *New York Times Magazine,* 26 June 1949.

Driscoll, Charles B. "Why Men Leave Kansas." *American Mercury* 3, no. 10 (October 1924), 175–78.

"The Great American Roadside." *Fortune* 10, no. 3 (September 1934).

Harris, John P. "The Ten Big Murals and How They Grew (How Kansas Children Can Help Place Them in the Capitol)." *Kansas Teacher,* March 1938, 36–37.

"Isms in Kansas." *Newsweek,* 1 August 1938, 11–12.

"John Curry: He Paints at Wisconsin as Artist-in-Residence," *Life* 7, no. 26, (25 December 1939): 34–37.

Jones, Alfred Haworth. "The Search for a Usable American Past in the New Deal Era." *American Quarterly* 23 (December 1971): 710–24.

Jones, Lila Lee. "The Ku Klux Klan in Eastern Kansas during the 1920's." *Emporia State Research Studies* 23, no. 3 (Winter 1975): 5–41.

Kendall, M. Sue. "John Steuart Curry's *Kansas Pastoral:* The Modern American Family on the Middle Border." In *John Steuart Curry and Grant Wood: A Portrait of Rural America,* edited by Joseph S. Czestochowski, 36–41. Columbia: University of Missouri Press, 1981.

———. "Gold's Fool and God's Country: The Coronado Craze of 1940–41." In *Prospects: The Annual of American Cultural Studies,* vol. 11, edited by Jack Salzman. New York: Cambridge University Press, 1986.

"Kansas Editors Want Murals." *Kansas Business,* July 1937, 18–19.

Krutch, Joseph Wood. "The Usable Past." *Nation* 138, no. 3580 (14 February 1934): 191–92.

Lindsay, Vachel. "John Brown." In *Collected Poems,* rev. ed. New York: Macmillan Company, 1925.

Malin, James C. "The John Brown Legend in Pictures: Kissing the Negro Baby." *Kansas Historical Quarterly* 9, no. 4 (November 1940): 339–42.

Marling, Karal Ann. "A Note on New Deal Iconography: Futurology and the Historical Myth." In *Prospects: An Annual of American Cultural Studies,* vol. 4, edited by Jack Salzman, 421–40. New York: Burt Franklin & Co., 1979.

———. "Thomas Hart Benton's *Boomtown:* Regionalism Redefined." In *Prospects: An Annual of American Cultural Studies,* vol. 6, edited by Jack Salzman, 73–137. New York: Burt Franklin & Co., 1981.

"Must Be Sane." *Art Digest* 11, no. 19 (1 August 1937): 13.

Nash, Anedith. "*Death on the Ridge Road:* Grant Wood and Modernization in the Midwest." In *Prospects: The Annual of American Cultural Studies,* vol. 8, edited by Jack Salzman, 281–301. New York: Burt Franklin & Co., 1983.

"Resident Artist: John Steuart Curry Takes Unique Post to Encourage Rural Painting." *Literary Digest* (17 October 1936): 23–24.

Rukeyser, Muriel. "The Soul and Body of John Brown." *Poetry: A Magazine of Verse* 56, no. 3 (June 1940): 115–20.

Suckow, Ruth. "Midwestern Primitive." *Harper's,* March 1928, 432–42.

"U.S. Scene." *Time,* 24 December 1934, 24–27.

Walker, Maynard. "John Steuart Curry." *Kansas Magazine* (1947): 72–73.

Wear, Ted. "John Steuart Curry and His Kansas Murals." *American Artist* 4, no. 8 (October 1940): 6.

"William Allen White's War on the Klan." *The Literary Digest* 83, no. 2 (11 October 1924): 16.

Dissertations

Contreras, Belisario R. "The New Deal Treasury Art Programs and the American Artist: 1933 to 1943." Ph.D. diss., American University, 1967.

Doss, Erika L. "Regionalists in Hollywood: Painting, Film, and Patronage, 1925–1945." Ph.D. diss. University of Minnesota, 1983.

Keesee, Vincent A. "Regionalism: The Book of Illustrations of Benton, Curry and Wood." Ph.D. diss., University of Georgia, 1972.

Swanson, Merwin Robert. "The American Country Life Movement, 1900–1940." Ph.D. diss., University of Minnesota, 1972.

Talbert, Joy K. "John Brown in American Literature." Ph.D. diss., University of Kansas, 1941.

Wardenaar, Leslie Albert. "John Brown: The Literary Image." Ph.D. diss., UCLA, 1974.

Zangrando, Robert Lewis. "The Efforts of the National Association for the Advancement of Colored People to Secure Passage of a Federal Anti-Lynching Law, 1920–1940." Ph.D. diss., University of Pennsylvania, 1963.

Newspapers

Abilene Daily Reflector	1940
Cedar Rapids [Iowa] *Sunday Gazette and Republican*	1932–33
Douglas County Republican (Lawrence, Kansas)	1932
Emporia Gazette	1896, 1922, 1936
Ft. Scott Tribune [Kansas]	1941
Kansas City Journal-Post	1931, 1937
Kansas City Star	1936–41, 1946
Kansas City Times	1931–41, 1947
Lawrence Journal World	1935
Milwaukee Sentinel	1937
New York Evening Post	1930
New York Herald-Tribune	1935, 1943
New York Times	1928–1931
Topeka Capital	1932–41, 1946, 1951
Topeka State Journal	1930–43
Wichita Eagle	1930, 1937, 1939
Wisconsin State Journal	1937, 1942

Index

Note: Numbers in italic refer to illustrations.